Remembering
Jack

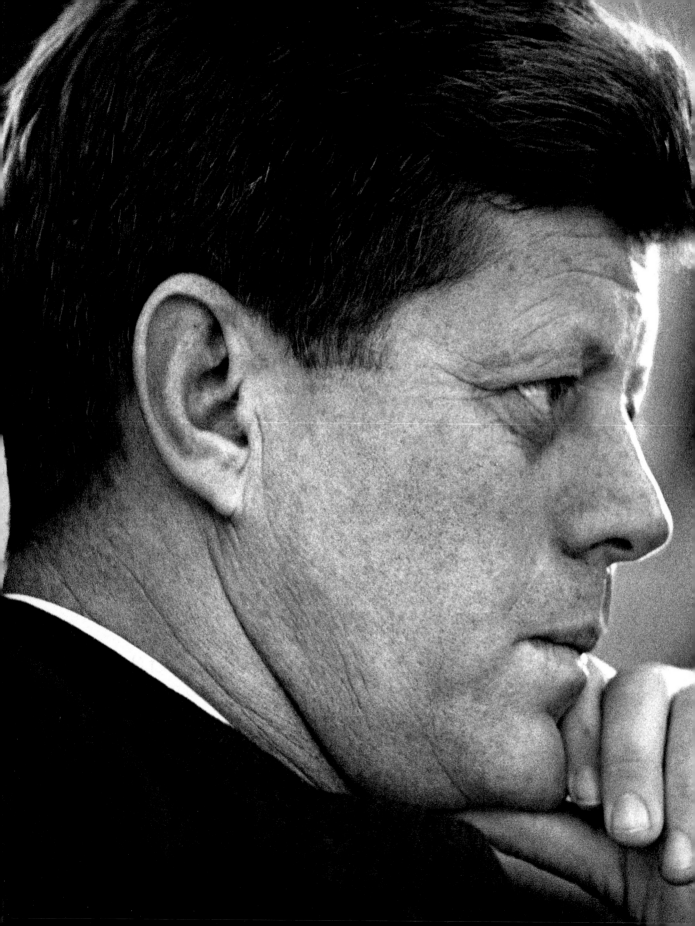

Intimate and Unseen
Photographs
of the Kennedys
Jacques Lowe

Remembering
Jack

Introduction and
Commentary
Hugh Sidey

Foreword
Robert F. Kennedy Jr.

The Lost Negatives
Thomasina Lowe

Afterword
Tom Wolfe

A Bob Adelman Book

Bulfinch Press
AOL Time Warner Book Group
Boston | New York | London

In remembrance of my father, Jacques Lowe,
and his great subject, President John F. Kennedy,
and the ideals they shared.
Thomasina Lowe

Art Direction and
Photography Editing:
Michael Rand
Book Design:
Adam Brown

Photographs copyright © 2003
by the Estate of Jacques Lowe

Introduction and text
copyright © 2003 by
Hugh Sidey and
Bob Adelman Books, Inc.

"My Friend" by
Robert F. Kennedy Jr.
copyright © 2003 by
Robert F. Kennedy Jr.

"The Lost Negatives" by
Thomasina Lowe
copyright © 2003 by
Thomasina Lowe

"Farewell" by Tom Wolfe
copyright © 2003 by
Tom Wolfe

Compilation copyright © 2003
by Bob Adelman Books, Inc.

First Edition

ISBN 0-8212-2849-8

Library of Congress Control
Number 2003103055

Bulfinch Press is a division of
AOL Time Warner Book Group

Separations: Quad Graphics
Printed by EBS in Verona, Italy

Contents

My Friend Robert F. Kennedy Jr.

My first memories of Jacques Lowe begin when I was two and a half years old. He was in so many of my original memories . . . and he was such an important part of my childhood.

It's a great tribute in my view to my family—to my father, to my Uncle Jack, and to my grandfather—that they were able to recognize the genius in Jacques Lowe. And he always marveled that they would invite him on those initial trips, and they would never tell him what to photograph. And it's because they saw the original photographs he did of my father back in 1956, and they knew that he was an artist.

This was a time in our history when even our greatest photographers were not really recognized as artists. They were journalists or recorders. Grandpa and his children were able to see that Jacques had something special, and they trusted him for his art as much as for his friendship, which he unerringly earned and never violated. He was such a wonderful friend to my family during that period.

As Teddy has said, Jacques played a critical role in explaining the Kennedy family to the rest of America. And I think he was able to do that better than anybody, better than Arthur Schlesinger or Ted Sorenson or Dick Goodwin or any of the friends that we had around who were recording—many of them with admiration—what my father and my uncles were trying to do at that time.

Jacques, because of his special touch, was able to tell the story in a way more people could understand. Those photographs—and we all recognized this fact in my family—ultimately helped President Kennedy get elected.

I often cringe, and I think members of my family who knew the players also cringe, when we see documentaries and films that have been done about my family. They never get it right. They always miss something. But Jacques's photographs never missed anything. They were beautiful, and I'm so grateful to him personally for making those photographs because they validate wonderful memories of my own childhood. A lot of people come to the members of my generation, my brothers and sisters and my cousins—so many of us lost parents during that period and afterward when we were still young. Those people say, "Wasn't that a terrible tragedy?" I don't think that any member of my family has ever spent even a moment in self-pity for the things we went through at that time.

We had wonderful lives and wonderful childhoods. Our lives were adventures that I think all of us are grateful for. They were really magical. Jacques's photographs are so valuable to me because they validate that. One of the great advantages that I have over millions and millions of people who lost their fathers or lost an important parent at a young age is that, growing up, I was surrounded by people who had recorded my father's deeds and who could explain his life and his visions. Jacques's pictures make those memories concrete.

My father pulling my little sister on a donkey with his shirt off, praying as we did every night with hands folded, having tickle tumbles on the bed and pillow fights, talking to my uncle at the White House or on his plane, the *Caroline K*, playing football in the backyard, and all those other things, but for Jacques, would be kind, distant, and fading memories that I would always question, I would always strain to verify: Did that really happen? Was it really like that? With Jacques's photographs, I don't have to wonder. That is such an extraordinary gift, Jamie, Victoria, Kristina, Thomasina, and Sacha, that your father gave to our family.

We will always be grateful to you for giving him up to us during that period so he could.

Jacques was a wonderful friend. I feel like he was part of my family, and I feel like I lost a member of my family when he passed away. He was a guy who really was the keeper of many of these memories. I will, along with my wife and my children, be grateful for the things he brought to our lives.

When I think about Jacques, I think that God must have really loved the Kennedy family, to have given us such a friend.

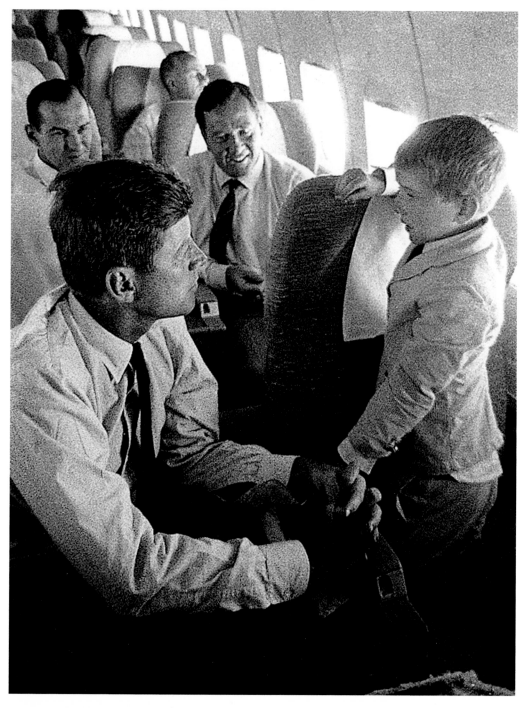

Flying home after the 1960 Democratic Convention, John Kennedy has a serious chat with his nephew, Bobby Jr.

7

The Lost Negatives
Thomasina Lowe

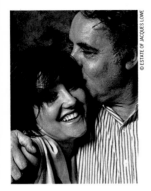

I was in my father's studio just a few blocks from the World Trade Center on September 11, 2001, when my world and the world we live in changed forever. Within hours of the plane hitting Tower 1, news anchors began a refrain: "You'll remember where you were on 9/11, the way people remember where they were the day Kennedy was shot."

Countless times I had heard people tell my father where they were when JFK died, their recollections an expression of how deeply they had been affected by their president's death. Four decades later, two tragic moments in American history intersected for me in a very personal way. Deep within the rubble of what used to be the World Trade Center sat a safe filled with more than forty thousand negatives of President John F. Kennedy and his family. Those slips of film were my father's life work, each one a reminder of an era when, as my father often said, "people still believed in something."

There are no words to describe how attached my father was to his Kennedy negatives. They defined who he was as a person and as a photographer. When he moved to Europe in 1968, he purchased an extra plane ticket so they could sit at his side while traveling. Later, back in New York again to set up his studio, he tried to have them insured, but no insurance company dared. Those images were priceless, their value beyond calculation. So he stored them in a fireproof bank vault in the World Trade Center.

I went with him on countless occasions to the J.P. Morgan Chase Bank vault to retrieve or return negatives. There was always an air of solemnity in the room when he reached for one of the many manila envelopes as though what we were about to see and touch would bring us closer to something historic. Back out on the street, walking up West Broadway, he clutched his treasure trove until it was safe and sound in his studio.

In his cautiousness, however, he could not have foreseen 9/11. And not even that fortified safe tucked in a vault could protect his work from the inferno that raged within the World Trade Center. Although 5 World Trade Center still stood when the blaze was extinguished, it was condemned to demolition, the safe irretrievable. I campaigned for the rubble to be sifted; months passed and I waited. Then, early in February 2002, the bank called. "Your safe has been found."

I went to claim it, clinging to the hope that some contents — anything — might have been rescued. To my surprise and horror, what I found was a safe, surrealistically intact, with its door open and a symmetrical hole where the lock had been. I peered in. It was empty.

America lost its innocence with the assassination of President Kennedy, tragically followed by the deaths of Bobby Kennedy and Martin Luther King Jr. Amid that turmoil, my father lost his belief in the United States, which had welcomed him with open arms after his escape from Nazi Germany. The sadness and disappointment

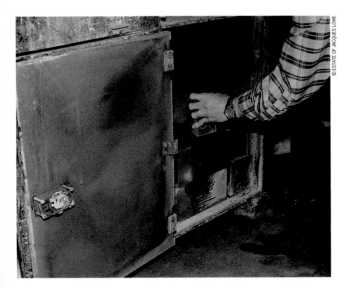

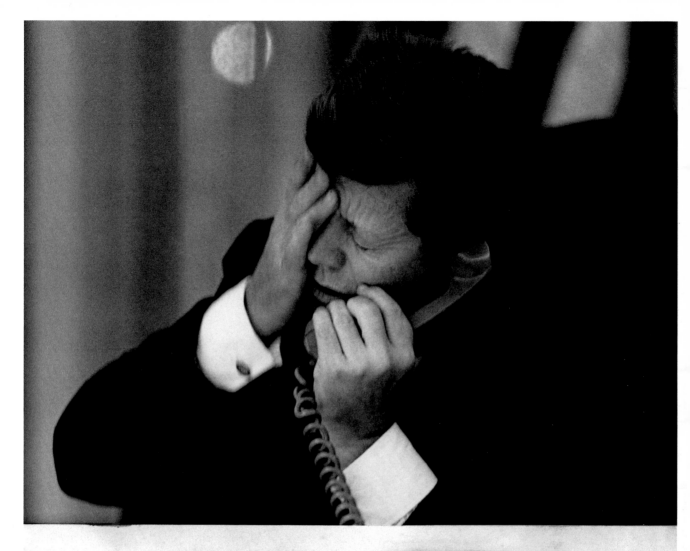

"**They're doing a Report No. 2?**"
Is Jacob Lowe at the White - House again?
m. My best regards - John F. Kennedy

Above left: Dad and daughter Thomasina affectionately embrace as they celebrate her college graduation.
Left: The safe that once contained Jacques's negatives, when first viewed by Thomasina Lowe.
Above: An amusing inscription by the president, "Is Jacques Lowe at the White House again?"

that followed the deaths of his heroes prompted him to return to Europe in 1968. Still, my father gained comfort from a belief that his Kennedy archives would serve as a reminder to Americans of their wonderful potential.

In May 2001, I lost my father. Following his death, I pledged to uphold his legacy by sharing with others the wonder of his work and the story it tells of a president we loved because, in my father's words, "he empowered each one of us to believe we could make a difference." Although my father's collection of more than forty thousand negatives has been destroyed, all is not lost. Many of his choice prints remain, as well as all the contact sheets. With the help of modern technology, we have been able to retrieve the images in this book, many of them published here for the first time. We have done this, in part, as a tribute to my father. We have also done it as a tribute to a proud and hopeful chapter in our history.

Introduction
Hugh Sidey

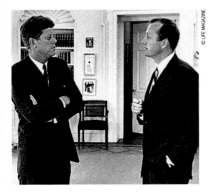

John F. Kennedy was eager and ready to be president when the nation embraced him—with a lot of encouragement and guidance from Kennedy.

Jacques Lowe, meanwhile, was a photographer ready to record history with his cameras, a youngster from the dark edges of society. An immigrant buffeted by war and with little formal education, he learned his trade as an intern in the shadow of professionals like Arnold Newman before he marched out on his own. "How I got through those two years, I can't remember," Jacques said of his apprenticeship. "But I had a good time."

It was in the U.S. Senate, as Jacques plunged into an assignment covering Senate racket hearings, that the photographer's path crossed that of the Kennedys. Jacques landed in Washington unsure of what was ahead but aware that he had to move with the news and create his own openings. He caught the eye of Bobby Kennedy and quickly fell into step.

Riding on the Senate subway one day in 1958 when he was the junior senator from Massachusetts, John Kennedy—or Jack, as he was known—mused about himself and four other Democratic hopefuls going through the political charade of reluctance, vowing not to run "until it is clear the American people want me," as one or another of them often said. A grinning Kennedy scoffed, "All of us concluded long ago that the nation cannot live without us." In his case, it proved true.

Jacques virtually was on a full-time retainer as Jack's political campaign started, first in relative calm and obscurity, then late in a frenzy of national coverage. Jacques rode the caravan all the way.

This kind of insider photojournalism during a campaign was something new. Most politicians were fearful of letting journalists into their smoke-filled rooms or on their campaign trains. They felt more comfortable with the regular Washington press corps photographers, who gathered at designated spots with their bulky Speed Graphics cameras to snap a few face shots. By contrast, magazine photographers had begun the conversion to 35-millimeter cameras, small and efficient, and as probing as the human eye.

The Kennedys were not frightened by 35-millimeter intimacy. Indeed, as this book attests, they loved the art form and understood that those honest images enhanced their own fast-moving story.

The United States was a changing country at that time. The old guard that guided the nation through World War II was leaving the stage to be replaced by a new generation. Young G.I.s who fought in the war then went to college in unprecedented numbers had emerged with a new and ardent idealism about the possibilities of world peace. It was a time when young men and women—Jack Kennedy among them—wanted to bring their energy and vision into government.

Jacques captured a total family effort leading to Jack's

final victory. From father Joe and mother Rose Kennedy, to brothers Bobby and Ted and sisters Eunice, Jean, and Pat, as well as all their spouses and children, this was a campaign machine unlike any seen before in America. Jacques's landscape embraced not only the home bases of Washington, New York, and Hyannis Port on Cape Cod, but once Kennedy entered the White House, it spread even to Europe.

This rich and meaningful book, so full of famous images of the vibrant Kennedy family, was born out of tragedy. For nearly six years, Jacques Lowe served as the family's photographer, the man they summoned for special events and the one for whom they opened their homes, letting him capture even private moments as Jack Kennedy began his climb to the presidency.

The forty thousand negatives reflecting this amazing odyssey were an incalculable national—and, for Jacques, personal—treasure. Jacques intended to dip into them for a new book marking the fortieth anniversary of Jack Kennedy's assassination, but the photographer's own death interrupted the process.

This book was begun shortly after Jacques's death as a tribute to him. The initial idea was to look through Jacques's contact sheets—marking the first time anyone but Jacques himself had done so—with an eye for discovering overlooked nuggets. But a year into the process, it was discovered that his negatives had been destroyed in the September 11, 2001, terrorist attacks, literally incinerated.

Initially, the loss of the negatives seemed an insurmountable hurdle, but advances in digital scanning offered the possibility of enlarging the contact images. Jacques's Tribeca loft on Duane Street contained prints and contact sheets from his years trailing Kennedy. Boxes were filled with familiar and famous prints. At least one box was stuffed with photographs that had never been published.

The contact sheets within this treasure trove sparked a notion: to cull images from them and republish many of the most notable pictures, complemented by some of their contact sheets, to create a unique "moving picture" of each photo shoot. These sequences reveal the flickers of emotion and the changing body language of the camera's subjects. Photographs in the book reproduced with a black edge are the contact sheets or are frames enlarged from them. Jacques's red editing marks on the original contact sheets offer insight as to his thoughts on each series.

This book is a publishing experiment and, when laid out and assembled, it sparked excitement beyond anyone's first hopes. You can spot the little shifts of eyes and hands, the moments of mischief that are missing when only a single image is viewed. There is occasional irritation and laughter, before or after the selected picture. Those flashes of emotion marred the proscribed moment and, as a result, were edited out at that time. Now, however, they speak to us.

The famous pictures are, well, still wonderfully famous and appealing and will live indelibly in American history. This book, through those images, enriches our understanding of the special years when the remarkable Kennedy family captured not only the U.S. presidency but also minds and hearts around the world.

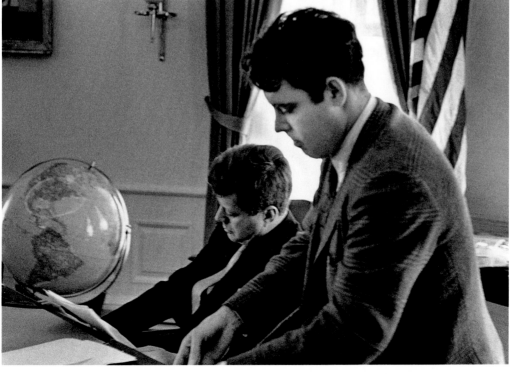

Far left: Hugh Sidey chats with President Kennedy during an interview in the Oval Office. *Left:* Jacques and Jack during an assignment at the White House.

On Assignment
Washington and Hickory Hill

Robert F. Kennedy, 30, was edging onto the national stage and Jacques Lowe, 26, was emerging as a supremely talented photographer when they met in the summer of 1956.

You could say it was luck that brought together this unlikely pair: an untutored, half-Jewish kid, who hid from the Nazis with his mother in Germany during World War II then immigrated to the United States, and a man born into position and privilege, feeling his way uncertainly into public life under the prodding of his father, Ambassador Joseph P. Kennedy, a man who had accumulated one of the world's largest fortunes, estimated at $300 million.

Jacques, as a winner of *Life* magazine's young photographers contest, found himself in demand among magazines wanting images of Bobby Kennedy. The young politician was a contradictory figure—he started out working for notorious Communist-hunting Senator Joseph McCarthy, then became majority counsel for Senator John McClellan's select "rackets committee" investigating corruption in the Teamsters union.

The colorful sparring between slight, sharp-nosed Bobby (sometimes dismissed by critics as "the ferret") and union toughs Dave Beck and Jimmy Hoffa proved high drama as it played out in the Senate's famed Caucus Room.

Three assignments in a single week took New Yorker Jacques to Washington to photograph Bobby in action and, in passing, to snap a few frames of his older brother, John F. Kennedy, a committee member who had made an unsuccessful but memorable bid for the Democratic vice presidential nomination that year. Jacques was met by a restrictive roster of rules as to where and when pictures could be taken, and the committee's verbal exchanges unfolded across a dim ten yards of space—hardly the conditions for dramatic photographs.

Back then the Caucus Room was blue with cigarette smoke. Photographers say it took an extra F-stop some days to cut through the haze. The cameramen, consigned to the floor in front of the Senate inquisitors and ordered to remain unobtrusive, hunched down and crawled around in search of camera angles.

Bobby, even then developing a sharp eye for Kennedy imagery, loved Jacques's pictures. It was a time when photojournalism and the art of the picture story were celebrated, when naturalness and truth supplanted the posed and phony. Bobby fed into this by introducing a new tradition to Washington: He invited his staff and select journalists and photographers to his estate of huge hickory trees and rolling hills in McLean, Virginia. There, around the swimming pool, at the tennis court, or while devouring barbecue, they discussed tactics for the rackets hearings, then broke for touch football or horseback riding or family rituals with Bobby, his wife Ethel, and their growing crew of children.

At no time in Bobby's short, but brilliant, rise to power was anything given higher priority than his family. The young father, a deeply religious man, eagerly directed the family fray, corralling escaped animals or gathering toys from the lawn and, in the evenings, helping to transform his children from smudged ruffians to scrubbed angels on their knees for bedtime prayer. Patriarch Joseph Kennedy once complained, "None of my kids give a damn about making money and I don't blame them." Jacques had never seen anything like this and his camera lens captured this confluence of politicking with exuberant family play as he followed the caravan from Bobby's Hickory Hill estate to the Kennedy family compound in Hyannis Port, Massachusetts.

Jacques presented Bobby with 124 large prints of the family as a thank you for the Kennedy hospitality. An ecstatic Bobby asked for another set to give his father on his 69th birthday. Joseph P. Kennedy declared the pictures "the most wonderful present" he had ever received, then asked the photographer to do the same for his other son, John. That assignment would usher Jacques, with his talented eye, into one of the great epics of American history.

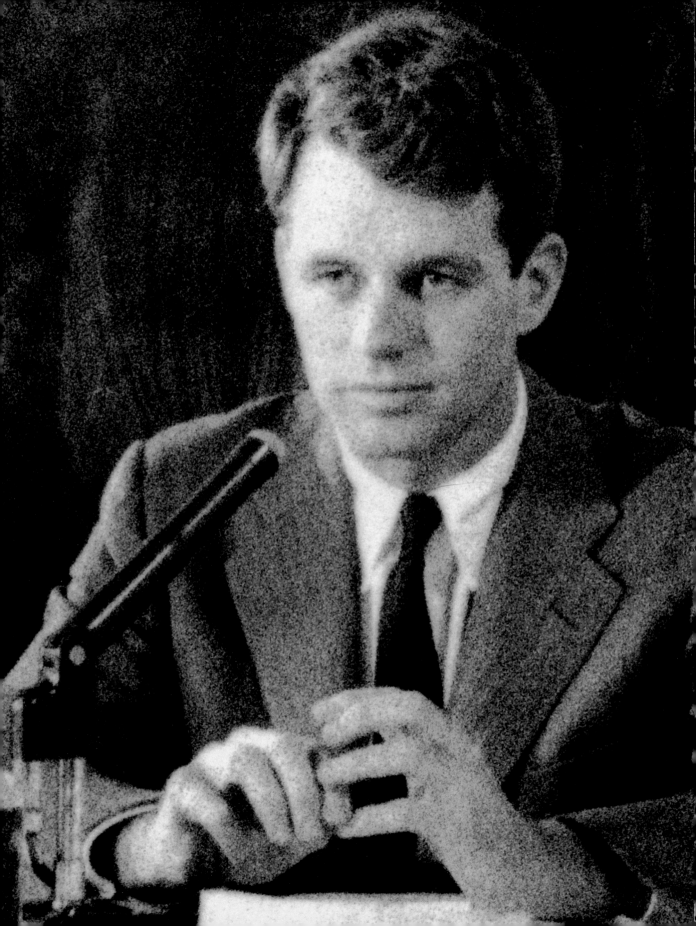

Previous page: Bobby Kennedy takes his seat in 1956 as majority counsel on Democratic Senator John McClellan's Select Committee on labor racketeering. RFK's boyish demeanor is deceptive.

Below: Verbal fireworks erupt at the hearings, but not frequently.

Breaks in the proceedings were always a welcome relief from the tedium. *Right:* Arizona Senator Barry Goldwater, chewing on his pencil as he studies documents, and Majority Counsel Bobby Kennedy flank the rackets committee chairman, Arkansas Senator John McClellan.

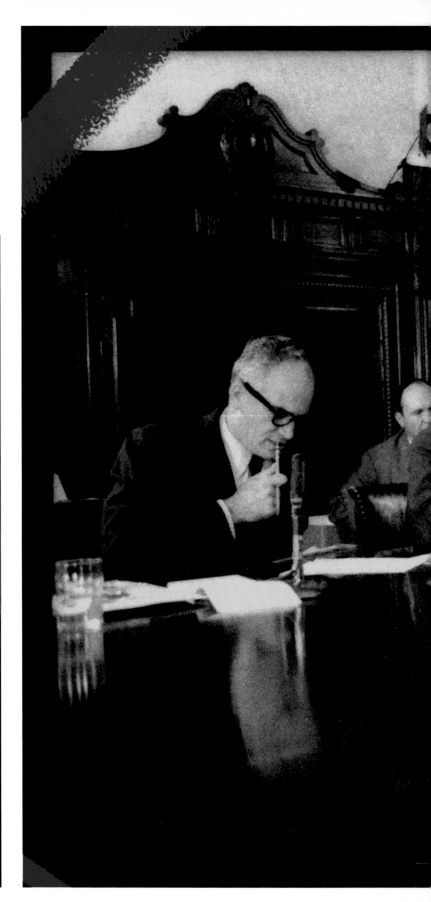

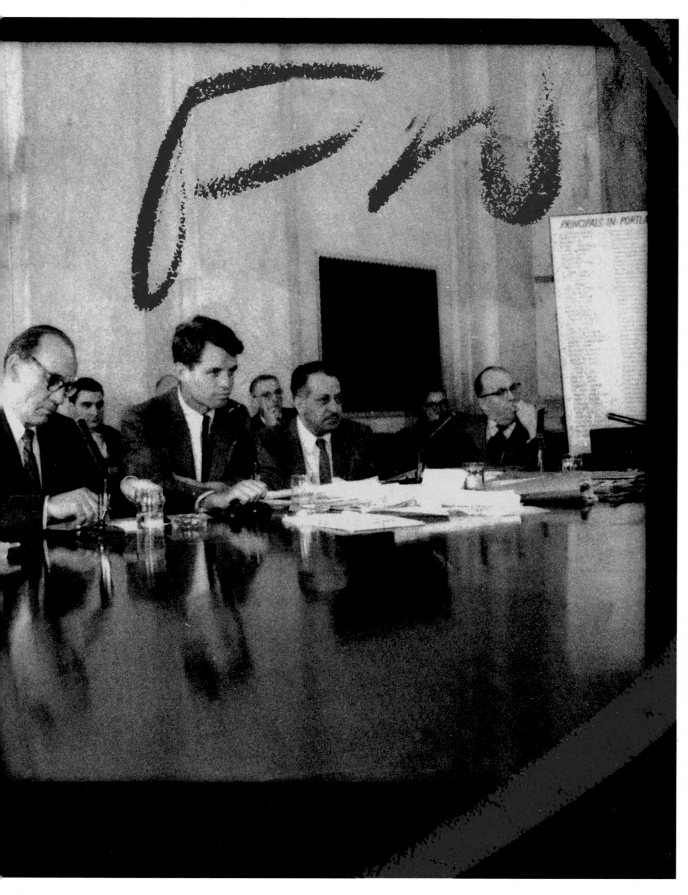

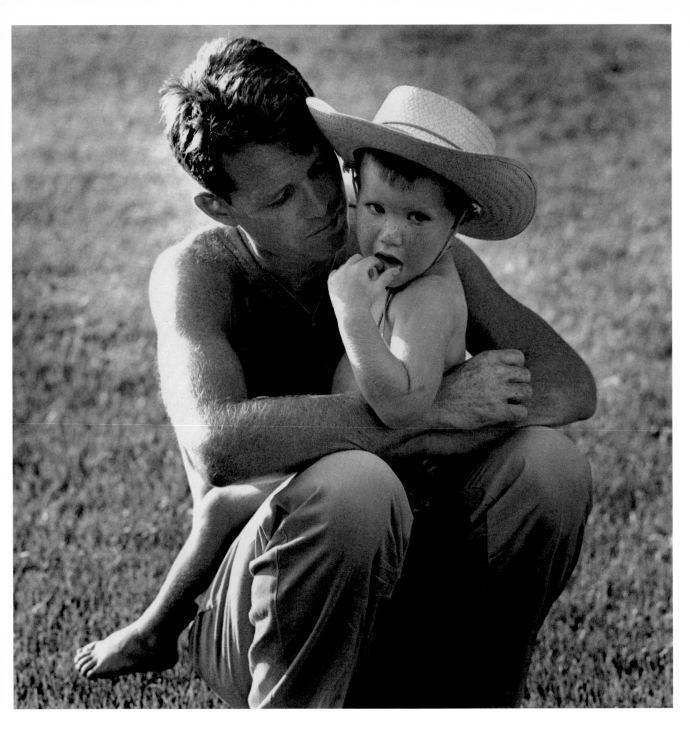

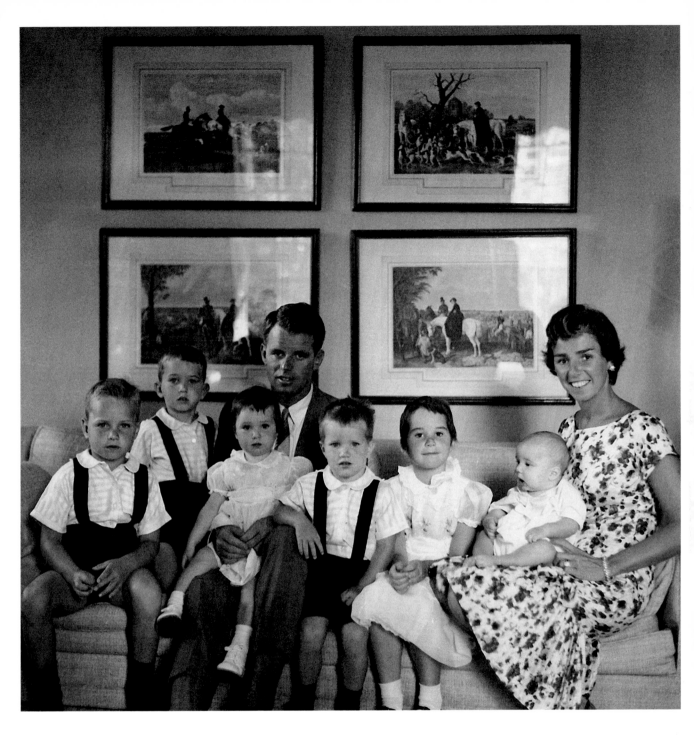

Bobby comforts son David after a family tussle in 1958. The Kennedy children were admonished to be tough but, when there was an injury, Bobby was quick with a hug and a kiss.

Bobby and Ethel's brood would nearly double from when this photo was taken. From left, the children are Joe, Bobby Jr., Courtney, David, Kathleen, and baby Michael.

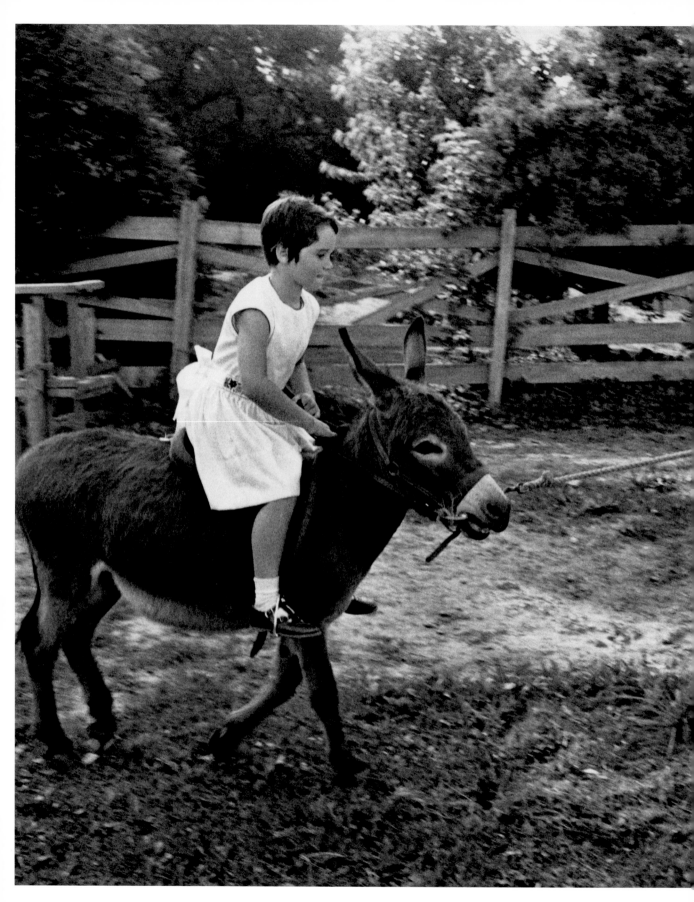

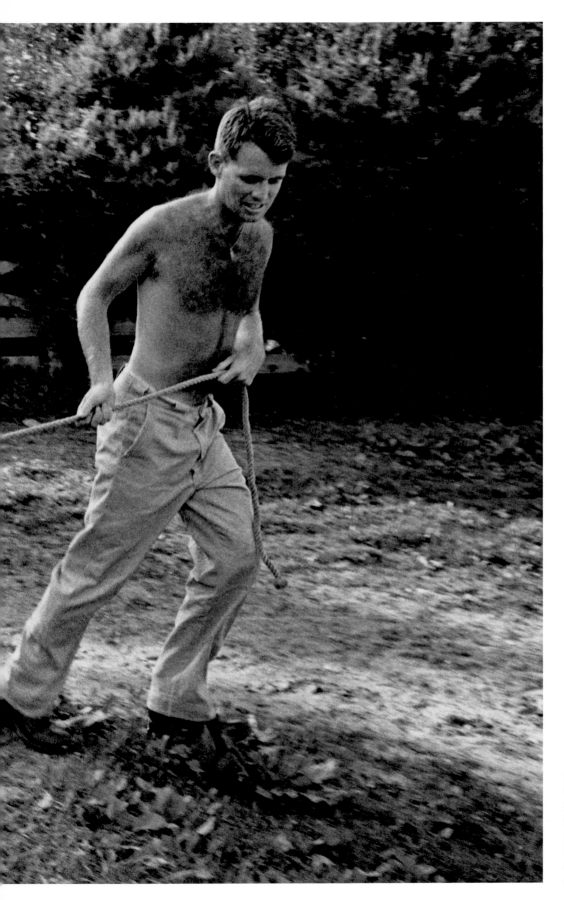

Kathleen may be dressed
for a party, but when
the impulse for sport
hits this family, nothing
stands in the way.
Bobby contributes some
muscle of his own to
get the donkey moving.

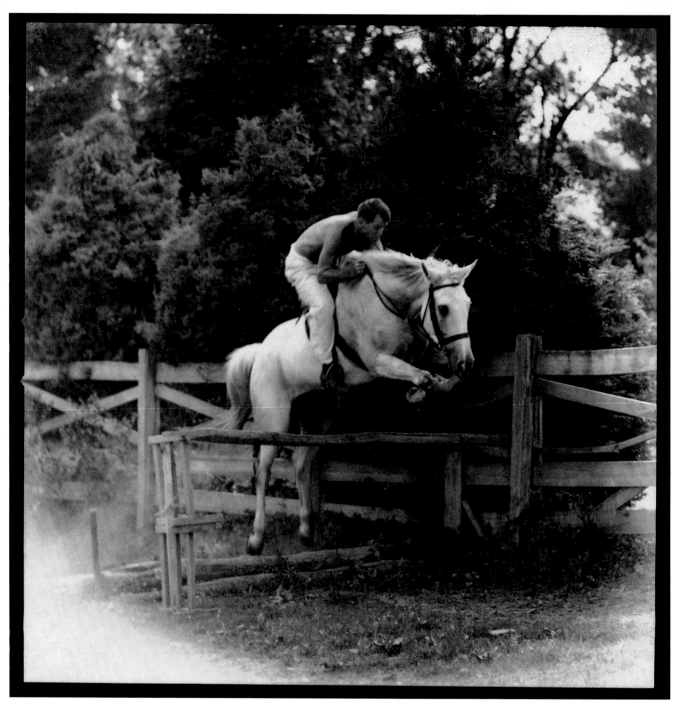

Competition permeates
almost everything the
Kennedys undertake,
sometimes pitting husband
against wife, as here at
Hickory Hill. Much to the
consternation of her friends,
Ethel threw herself into
the physical contests even
during her pregnancies,
which were almost
constant in those days.

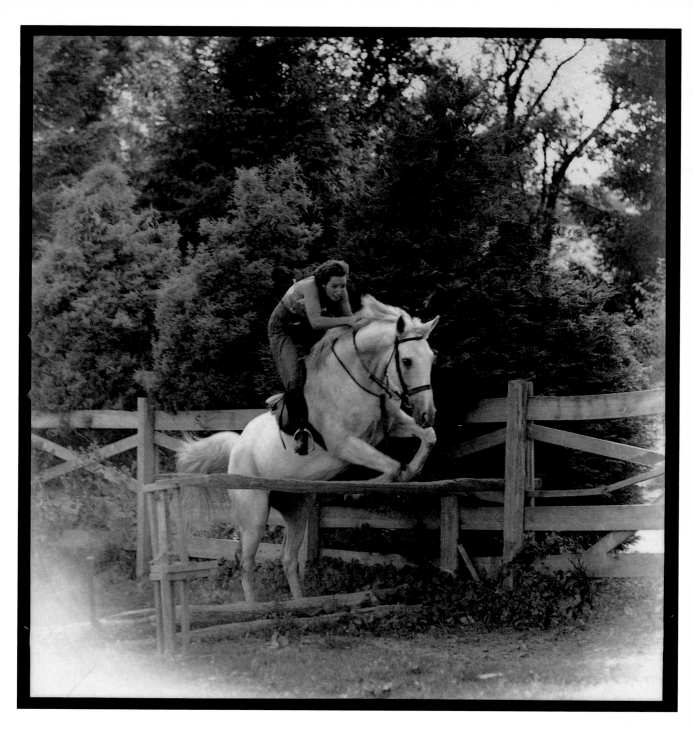

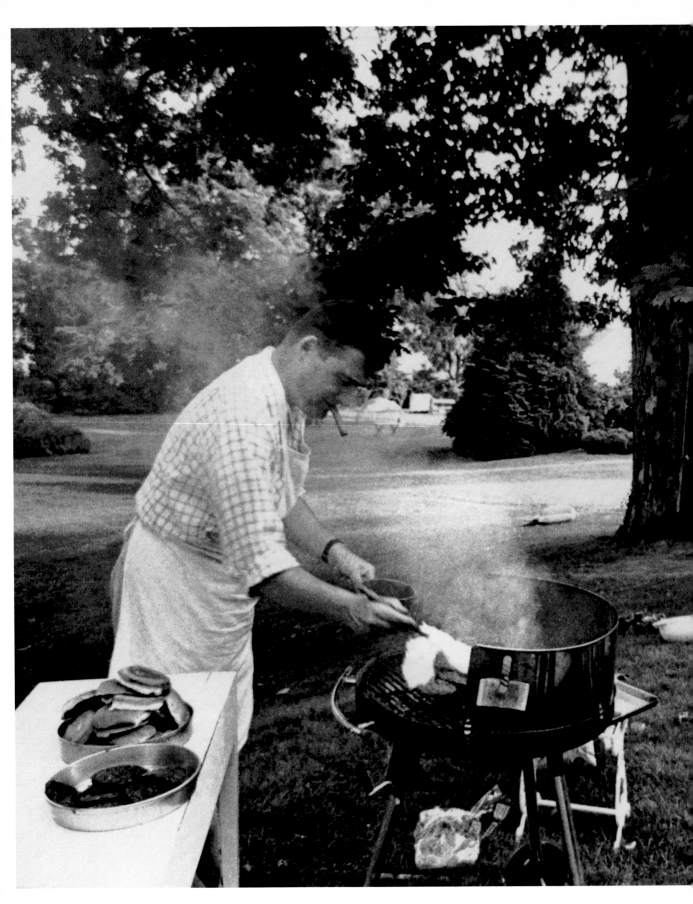

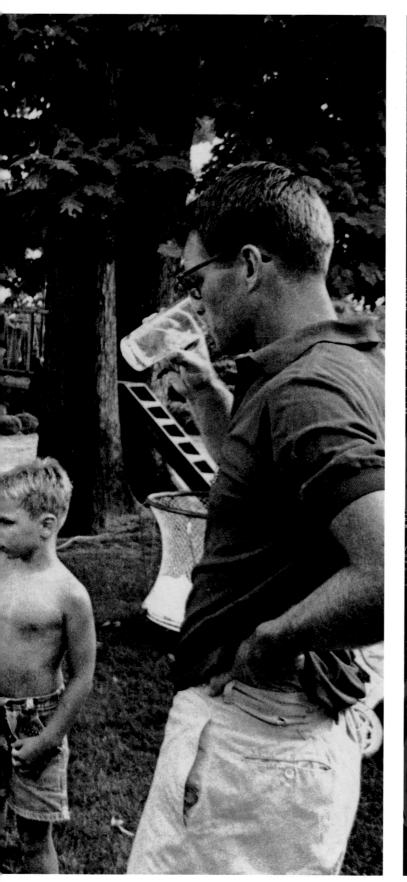
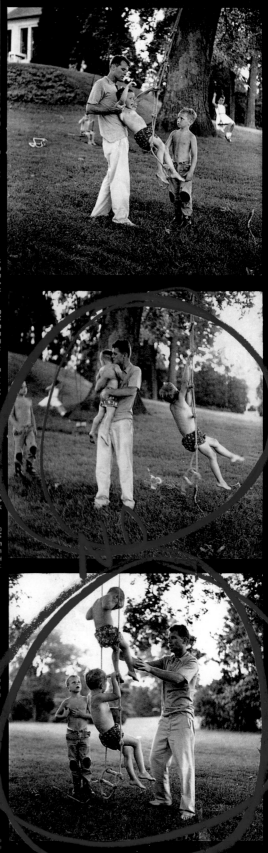

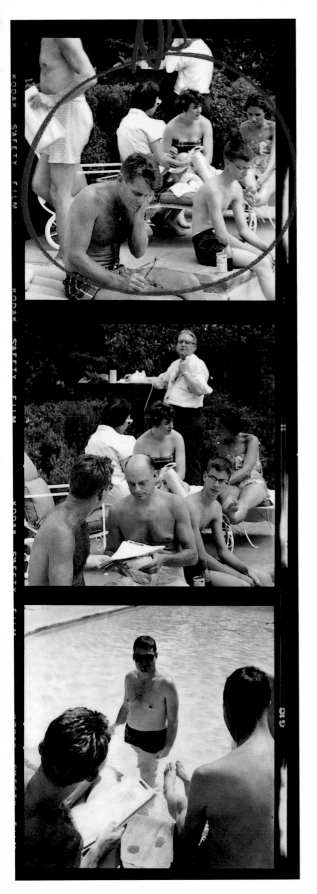
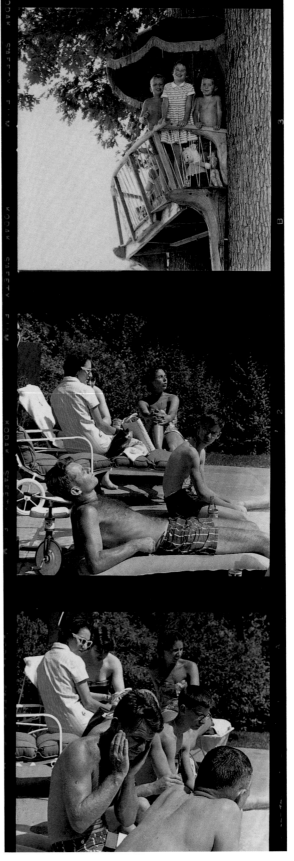

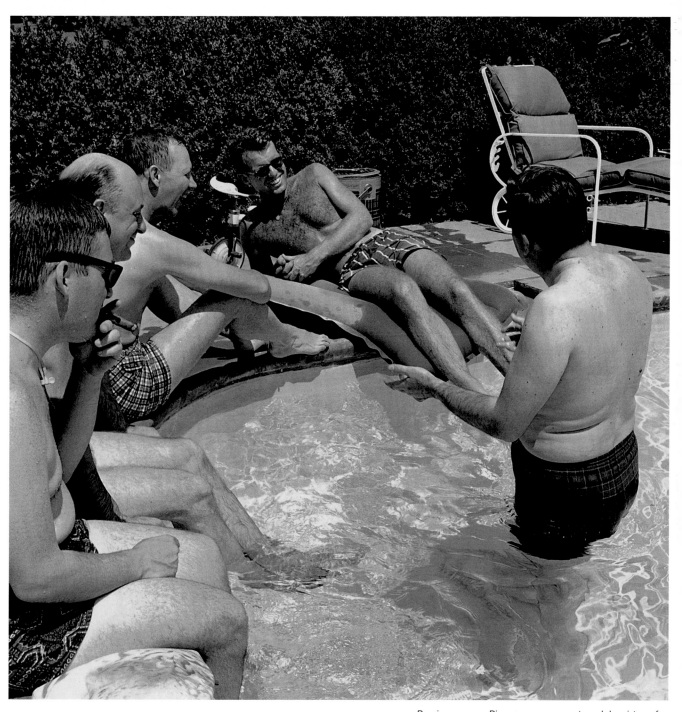

Previous pages: Pierre Salinger, a staff member of the Senate rackets committee and later John F. Kennedy's press secretary, handles barbecue duties at Hickory Hill in the summer of 1958. Salinger not only fancied himself a cigar connoisseur but claimed to be an expert cook by virtue of his French heritage.

Left and above: Parents, children, and staff mix business and pleasure around the Kennedy pool, one of Hickory Hill's myriad of playscapes, which also included a tree house with its own sun umbrella.

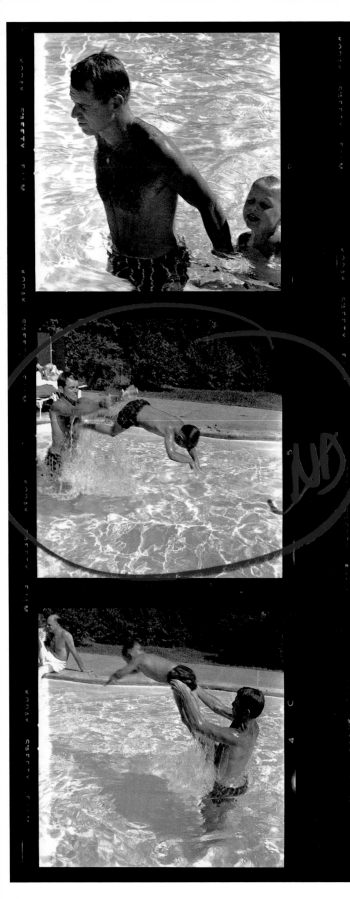

Swimming, leaping, diving, and splashing, the Kennedys never stray far from the water, be it a swimming pool or the sea. While Bobby tosses children, Ethel offers little David a gentler romp in the pool. Jack Kennedy would tell people he met in the mountains or on the high plains that the salt content of ocean water matched that of man's blood—a sure sign one was meant for the other.

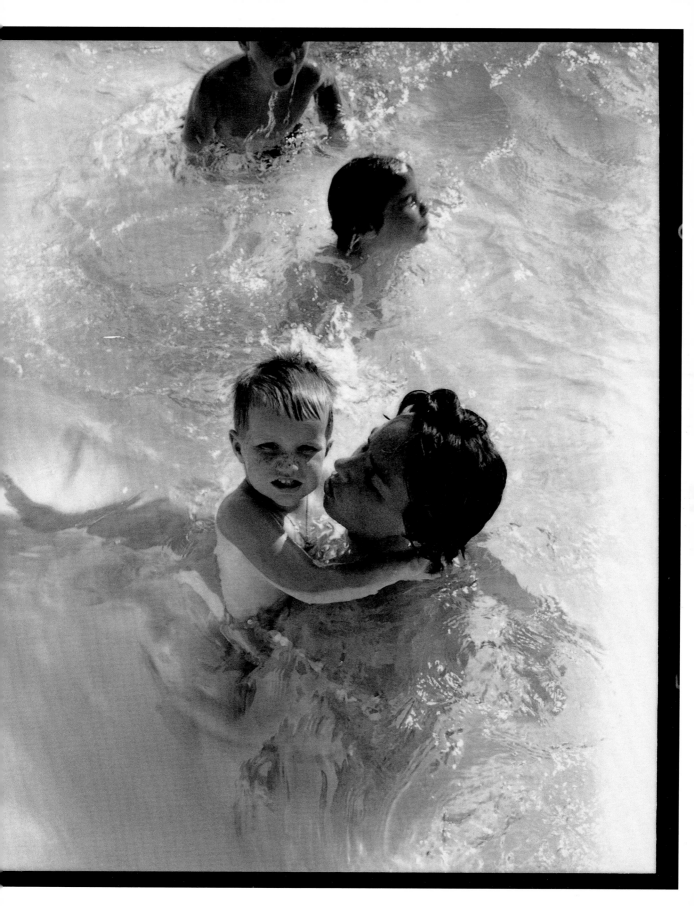

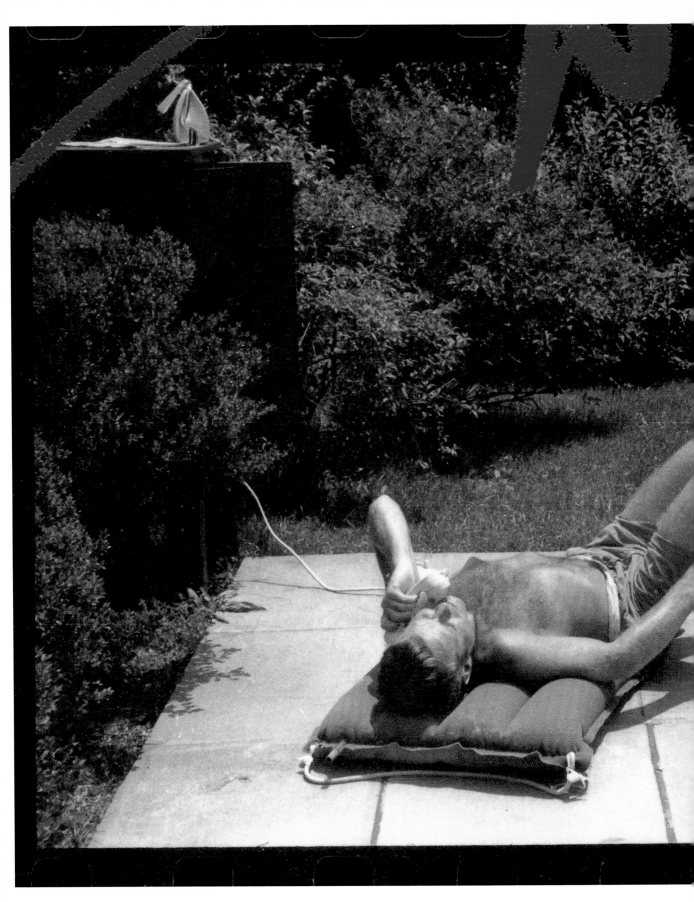

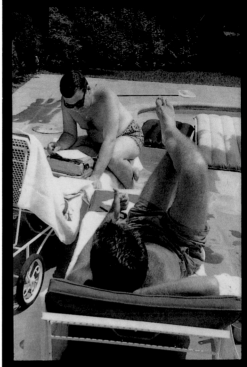

Left: A tanned Bobby, in one of his familiar poolside postures, soaks in the sun while connected to his essential work tool, the phone. A switchboard hidden in the bushes lets him play while retaining his communication lifeline. *Above:* Even lounging in a chair by the pool, Bobby stops to attend to business with rackets committee staffer Pierre Salinger.

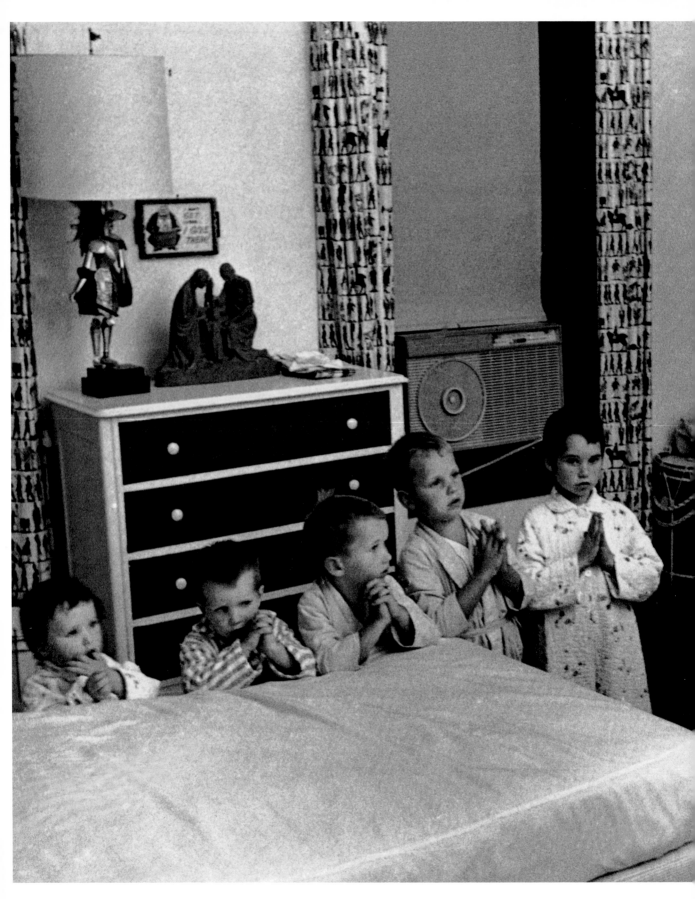

Bobby and Ethel lead
their children in bedside
prayers. It is likely
that this tranquil 1958
interlude was set up for
Jacques's purposes.
Below: The moment of
prayer plays against
a scene the photographer
walked into when a pillow
fight erupted—and the
parents jumped right
into the fray.

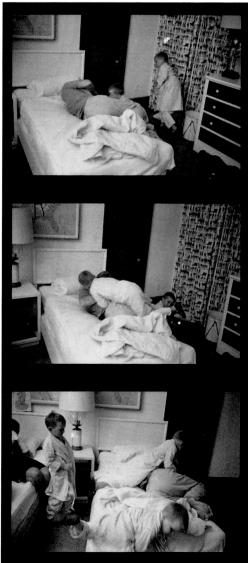

First Meeting
Hyannis Port and Bronxville

Jacques Lowe's images of John F. Kennedy during his quest for political power and his ascent to the presidency form one of the most vivid slices of history in the last century. Jacques was the only photographer allowed continuous access to crucial campaign councils, as well as to intimate family rituals and celebrations. Since JFK's death, these pictures have become deeply etched in the public mind, an enduring part of the Kennedy legend.

But Jacques's first encounter with "the other son," as father Joe Kennedy put it when arranging the meeting, was not encouraging. Old Joe had more or less decreed that on a July day in 1958, at his Hyannis Port house, Jacques would shoot a sequence of pictures of Jack—as JFK was known to family and friends—wife Jacqueline, and their daughter Caroline that would be every bit as compelling as those Jacques took of Bobby's family.

That encounter marked Jacques's first official meeting with the senator, who rushed in, wearing a pinstripe suit, between campaign stops during his Senate reelection bid, which was calibrated to be a base for Kennedy's 1960 run for the White House. The senator was harried and grumpy but felt obligated to go through with the photo shoot.

Jacques took portraits of the senator followed by a number of combinations with Jackie, Caroline, and patriarch Joe, but he was not happy with what he thought he had captured on film. He stayed overnight at Hyannis Port, then hurried back to New York the next morning to develop the film, prepare the contact prints, and await what he was sure would be rejection. After months passed with no word, it looked certain that he had bungled the job. He wrote off the Kennedy contact.

Unexpectedly one evening, however, Jack Kennedy phoned and asked Jacques to stop by the family's New York apartment. Kennedy, wrapped in a towel, met Jacques at the door and apologized for his brusqueness at their first meeting. As the senator pronounced the pictures "great," Jackie, splashing in the tub down the hall, trilled out a greeting to the photographer. With the contact sheets spread across the floor before him, Kennedy—still in his towel—selected prints for political and family uses, including one for that year's Christmas card.

By that time Jackie emerged from the bath, the three had a drink, and Jacques left about 1:30 in the morning dazed by the encounter. Whether he realized it or not at the time, he had been launched on a great adventure.

Family formed the core of Jack Kennedy's political life and Jacques soon understood that the professional and private lives of the Kennedys merged. Father Joe once told a reporter that a man generally had only a few true friends in a lifetime and his best bet was to depend on his family. Father, mother, brothers, sisters, and in-laws all joined the campaign crusade and family affairs often became public affairs, enhancing the image of power and glamour that carried Kennedy toward his goal.

It wasn't long before a reluctant Jacques found himself photographing yet another Kennedy brother, Ted, at his 1958 wedding to Bronxville, New York, beauty Joan Bennett. The photographer initially turned down old Joe's request, explaining that he shied from weddings because of their circus atmosphere. But Joe prevailed, agreeing to a high fee. The wedding turned out as Jacques feared: a crowd scene with clamoring photographers and artificial light, which he abhorred. Joe did not like the pictures and suggested that Jacques reduce his fee. Jacques reminded the ambassador that he never wanted the assignment in the first place, and the Kennedy patriarch paid up in full. Even these "disappointing" pictures would take a prominent place in the Kennedy gallery.

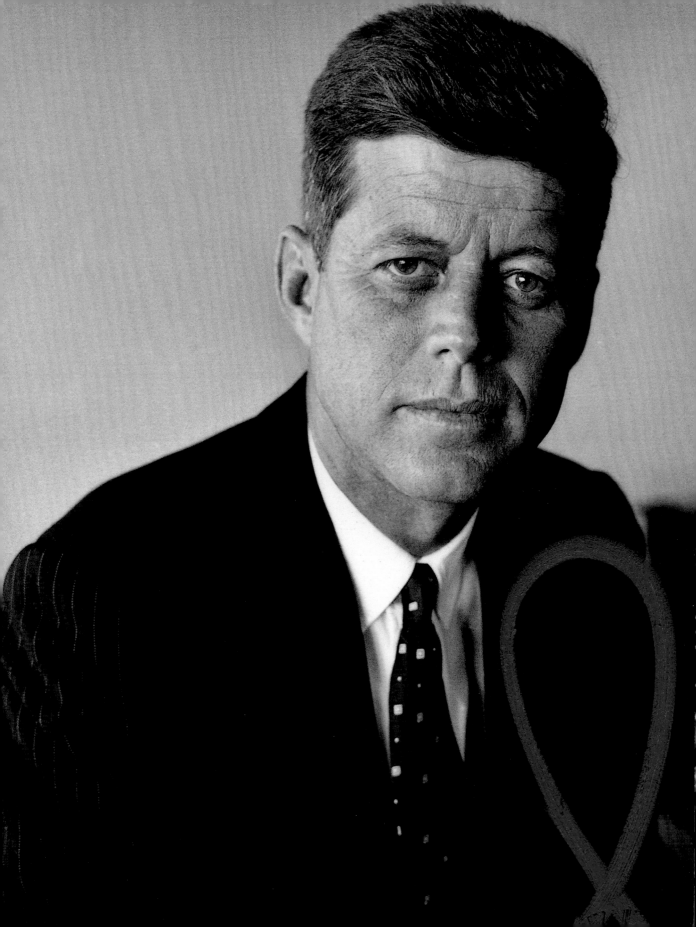

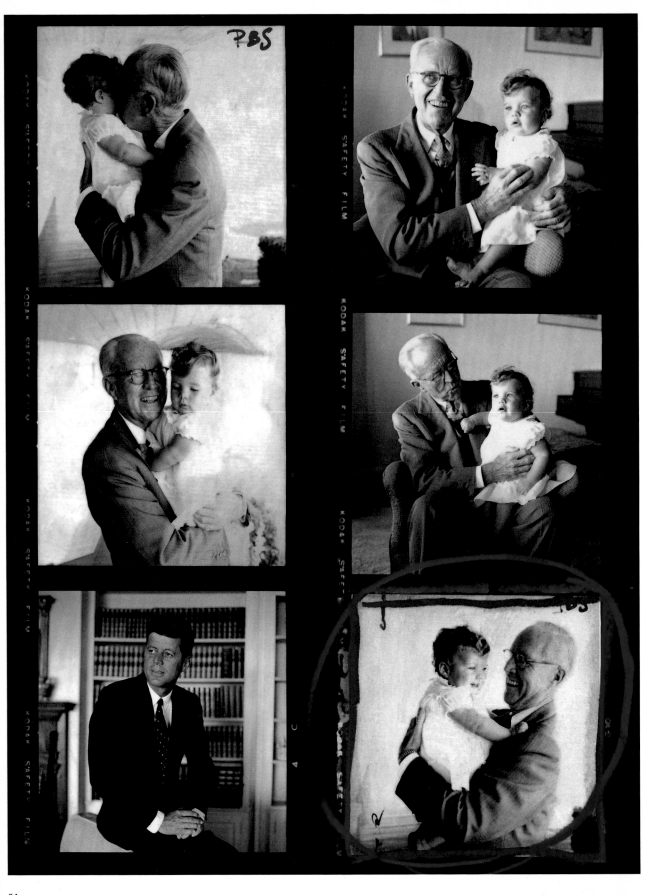

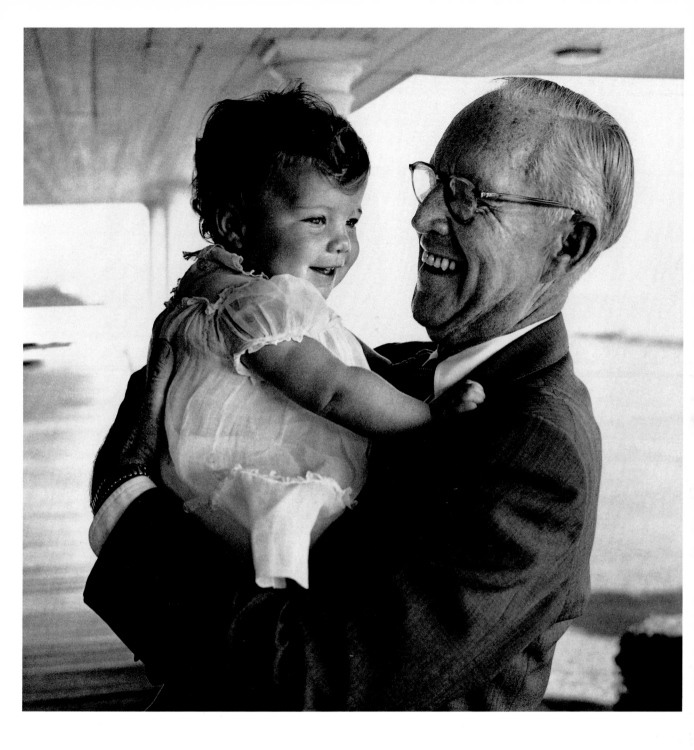

Jacques's first one-on-one encounter with Jack, a lengthy shoot requested by father Joe Kennedy, took place at the elder Kennedy's Hyannis Port home.

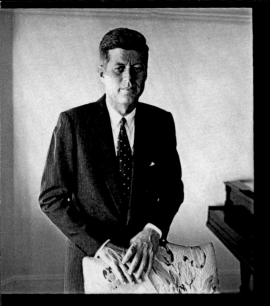

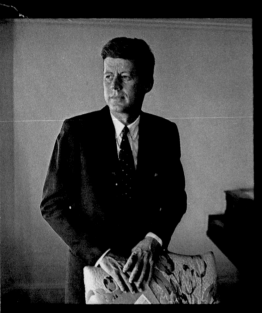
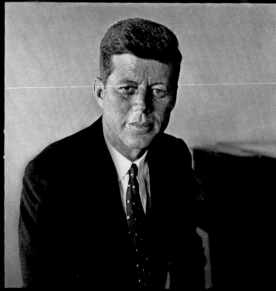
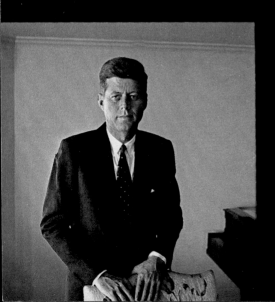
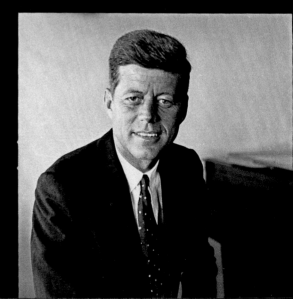

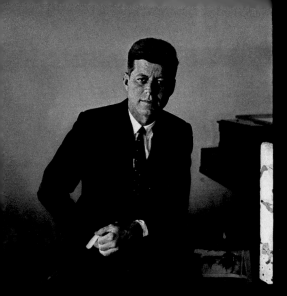
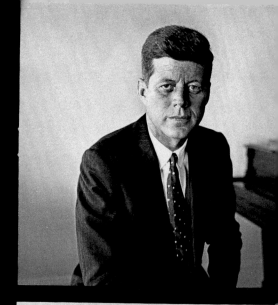
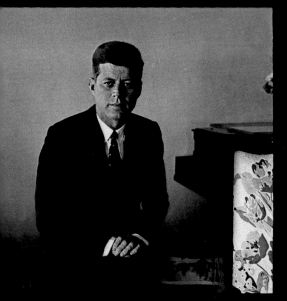
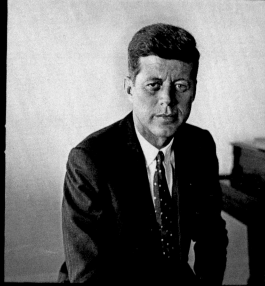
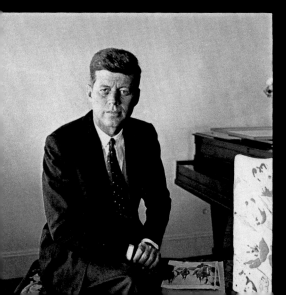
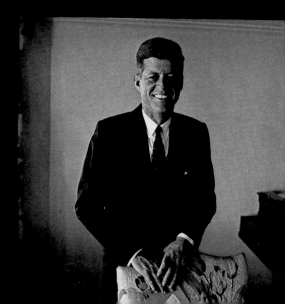

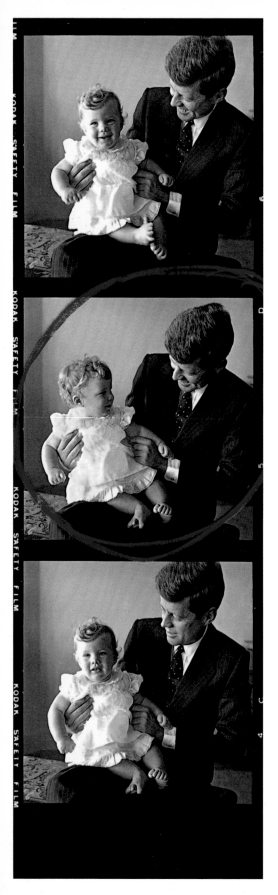

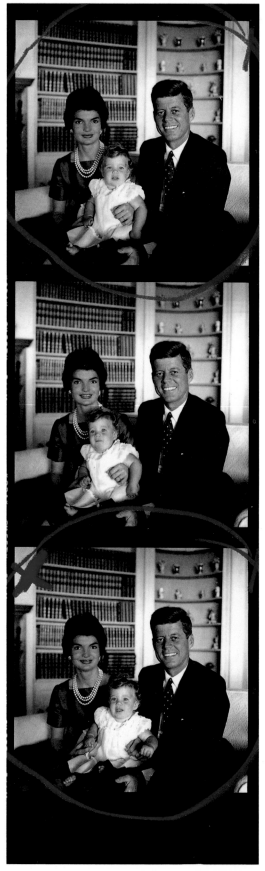

Pre
Ke
re
ev
so
Rig
Ca
wa
an
pla
pe
Alt
dis
ph
Ja
wi

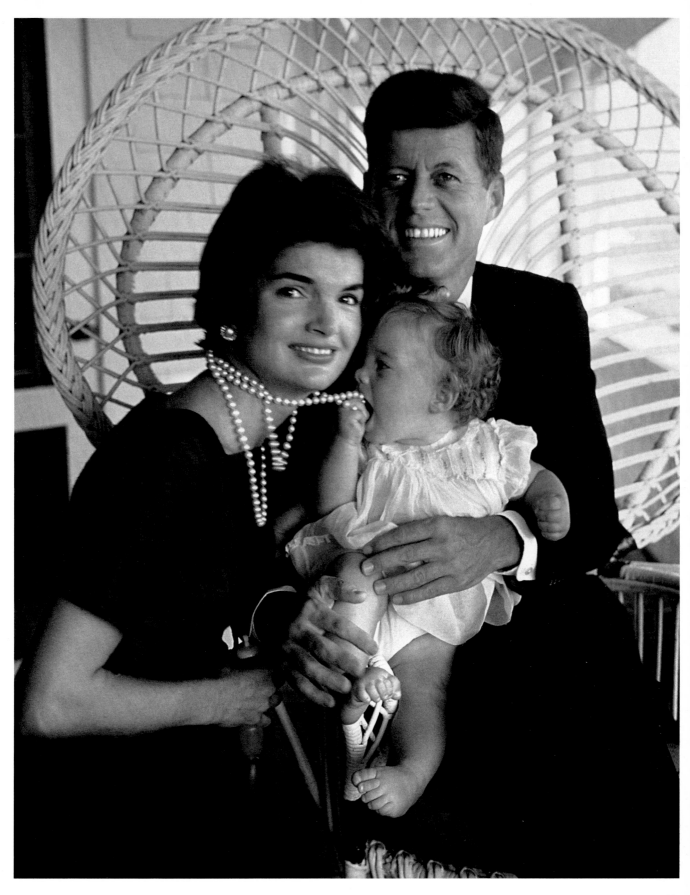

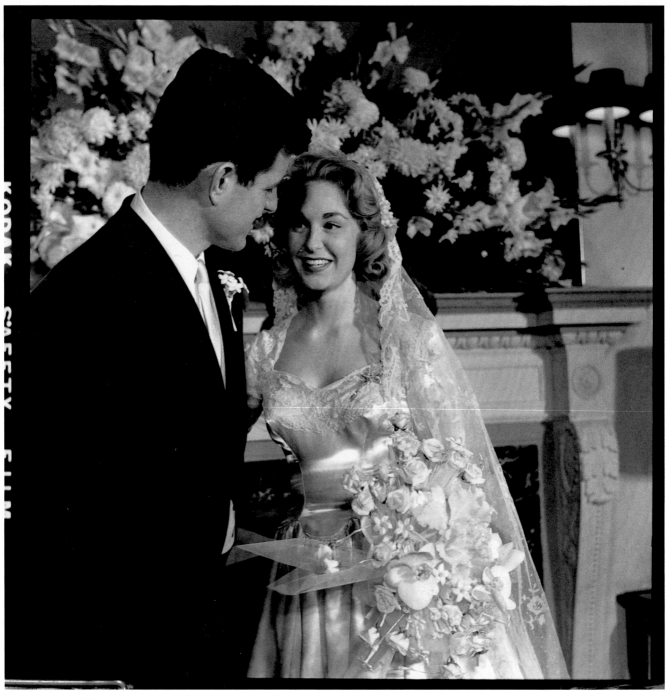

Joan Bennett and Edward
Kennedy, the youngest of the
Kennedy brothers, celebrate
their November 1958 wedding
at the Bronxville Country Club
in New York with the whole
Kennedy clan in attendance.
Society columnists called
this one of the most important
and beautiful weddings in
years, describing the bridal
couple as dazzling.

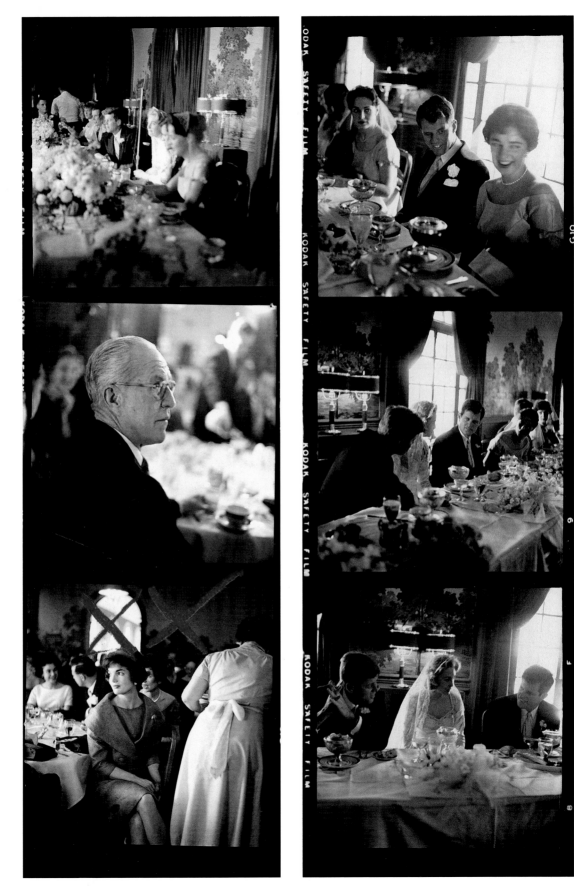

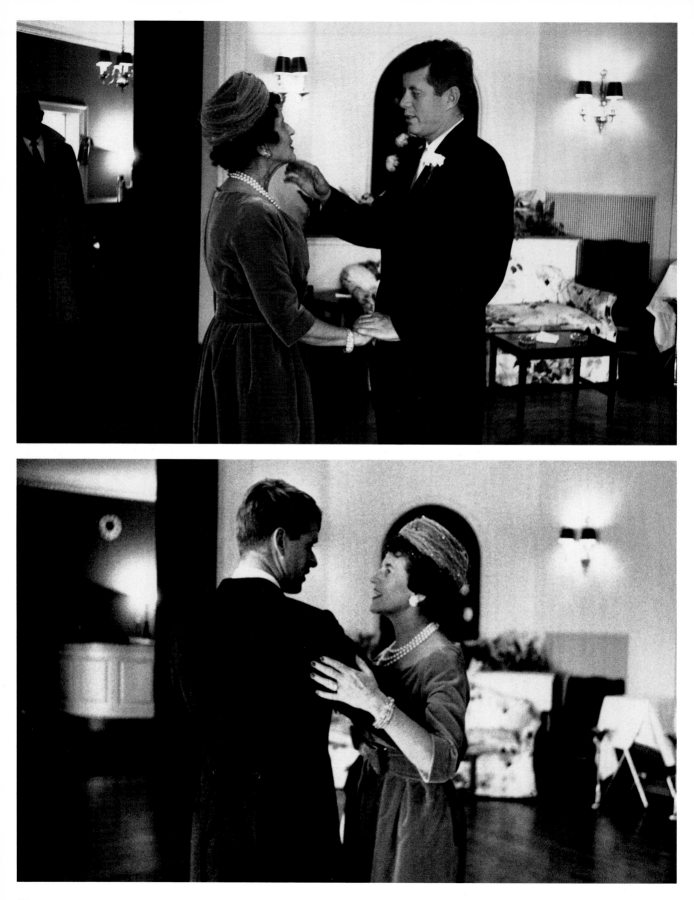

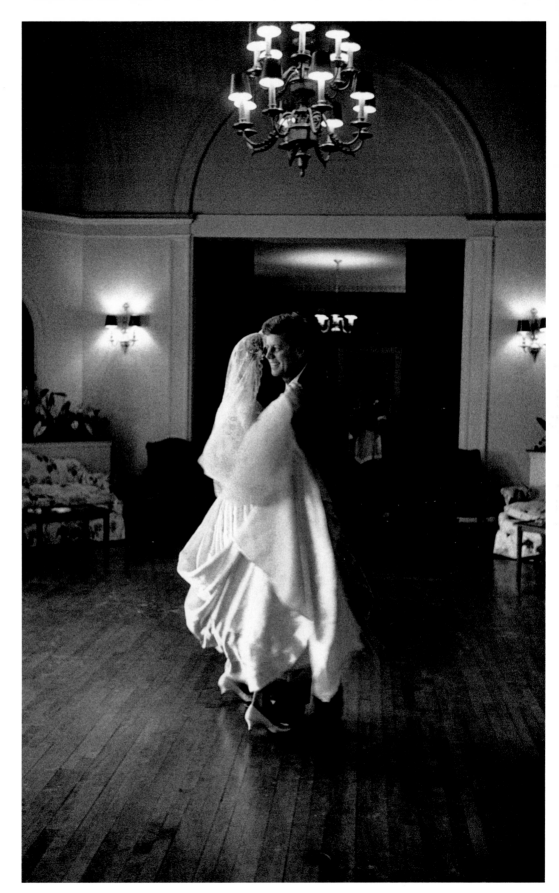

On the dance floor, brothers Jack and Bobby turn their attentions to the mother of the groom, even though neither son was known as a great dancer. Jack dances with his new sister-in-law in what may be the last photograph of JFK on a dance floor when he was not immersed in some sort of state function.

Jack and Jackie at Home

Washington, D.C., and Georgetown

The first images of what would become a revolutionary political crusade were simple and deceptively homespun for someone attached to one of the world's richest families. The huge apparatus forming behind John F. Kennedy's drive for the presidency was obscure on purpose, a campaign headquarters buried at the foot of Capitol Hill in an ugly structure named the Esso Building.

The senator lived with Jackie and daughter Caroline in an old and elegant three-story Georgetown home of fading red brick, wood shutters, high ceilings, creaking floors, and narrow rooms. The home at 3307 N Street, though expensive, was hardly outstanding for that neighborhood and always seemed in need of a touch-up.

A sometimes neighbor was W. Averell Harriman, the railroad multimillionaire and Democratic workhorse who emerged as a key player in Franklin Roosevelt's New Deal era. (Averell later held several posts in the Kennedy White House.) Another was Ben Bradlee, then *Newsweek* magazine's bureau chief, who would become the legendary executive editor of the *Washington Post* during the Watergate scandal that forced Richard Nixon from the White House.

Jackie was in familiar territory. She had spent girlhood years across the Potomac River on the Virginia estate of her stepfather, Hugh Auchincloss. She attended the Holton-Arms School not far from the couple's Georgetown home and roamed the environs briefly as an inquiring photographer for the *Washington Times-Herald*. And it was in Georgetown, at a dinner hosted by journalist Charles Bartlett and his wife, Martha, that Jacqueline Lee Bouvier met her husband.

Reporters knew where the senator lived and that the young couple occasionally entertained close friends and neighbors, all very subdued and simple, although touched by Jackie's grace and beauty. But the rest of the world was unaware of the place.

Jackie or a nanny could be spotted wheeling Caroline in a carriage across the cracked sidewalks of the neighborhood.

Special acquaintances invited inside the couple's home found a loving and tender mother. Jackie had never done housework—and she did not change that habit—but she spent hours in joyous romps with a plump and gurgling baby fascinated with Jackie's ever-present string of pearls, an image caught dozens of times by Jacques Lowe.

Had the Washington press corps looked closer it would have noted that Jackie, at only 29 early in 1959, was one of the youngest political wives in the capital. She possessed a fresh and exotic beauty that exploded on the world once her husband became a viable presidential candidate. The young Mrs. Kennedy liked life intimate, quiet, and rich. But she would not have that soothing mix very long.

Designer clothes of bright colors and subtle lines enhanced her beauty. They also sparked a media ripple when it was rumored that the price tag for her elegance ran into tens of thousands of dollars. Those first years were marked by interludes of ease with family and friends. But as Jack's campaign intensified, he was gone so often that Jackie would later say, "Politics was sort of my enemy."

The office end of John Kennedy's world was equally modest by today's standards: Suite 362 in the Senate Office Building (not yet named for powerful Georgia Senator Richard Russell). The senator's faithful secretary, Nebraska-born Evelyn Lincoln, presided genially outside his office, a spartan chamber with a nautical motif, the standard gallery of political pictures and, more times than not, peopled with political henchmen and favor seekers.

The office contained two items key to the Kennedy story, the rocking chair prescribed for the senator's bad back and the half-shell of a coconut upon which Kennedy scratched the location of his shipwrecked *PT-109* crew in the Pacific during World War II. Sometimes when talking about the problems of the world, he picked up the shell and cradled it for a moment.

Still, there was impermanence about the place. Kennedy was not a member of the Senate "club" nor did he want to be. He was just moving through on his way to the White House.

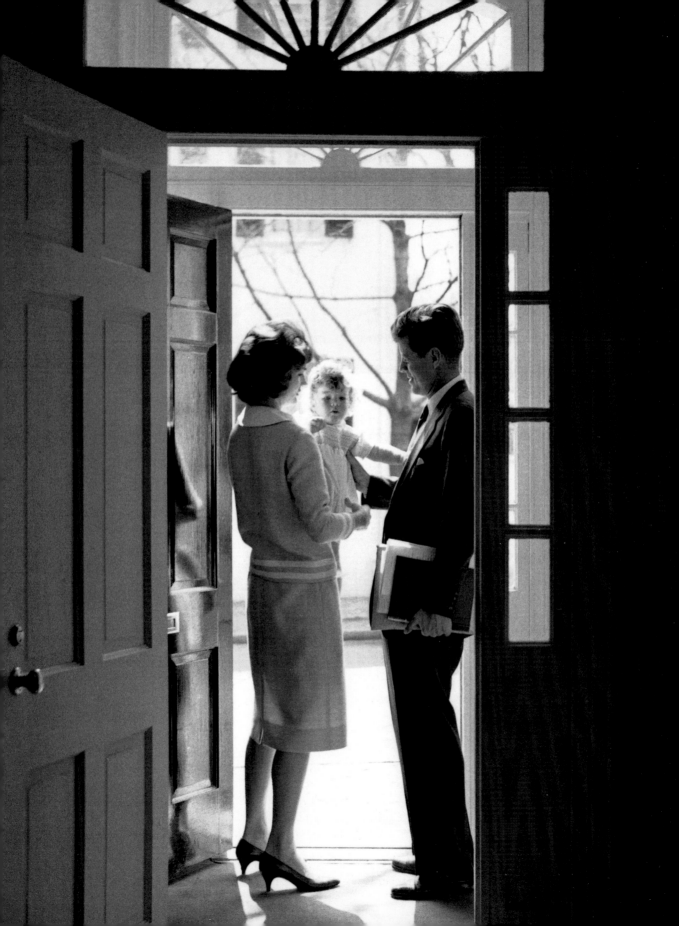

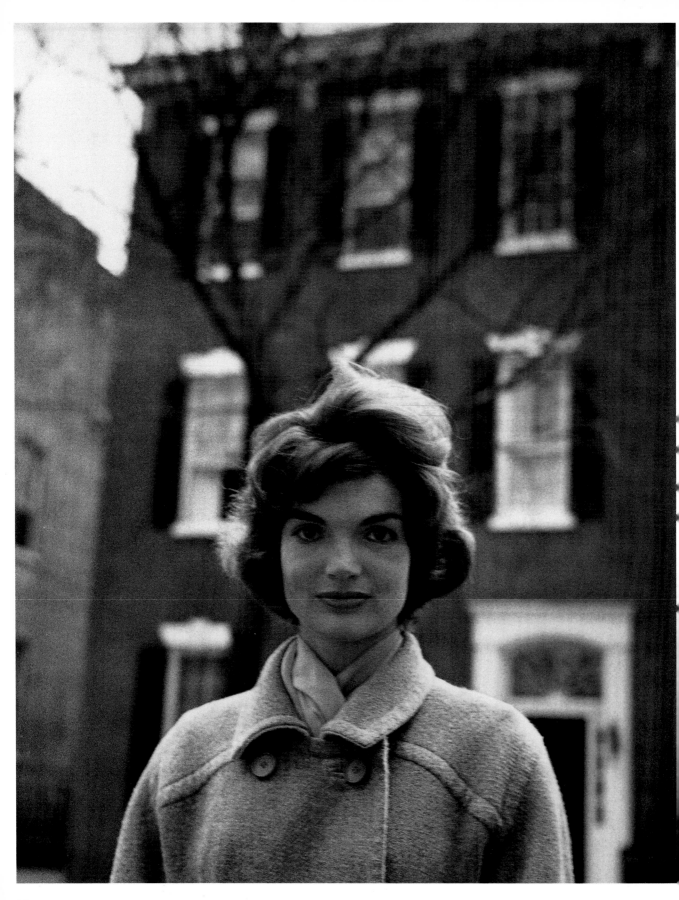

Previous page: Jackie, Caroline, and Jack pause in the doorway of their Georgetown home before the senator heads off to his office on Capitol Hill. This is 1959, before the rush of the presidential campaign made such peaceful moments rare. Later, from this same doorway, President-elect Kennedy would announce his cabinet appointments to journalists clustered outside on the snowy street.

Left: At only 29, Jackie's style—simple but elegant—already is established. Although she opted for cloth coats over fur, her closets were filled with designer labels. *Right:* As a nanny and Jackie take Caroline on a spring walk, Jack calls down from a second-story window of their Georgetown home.

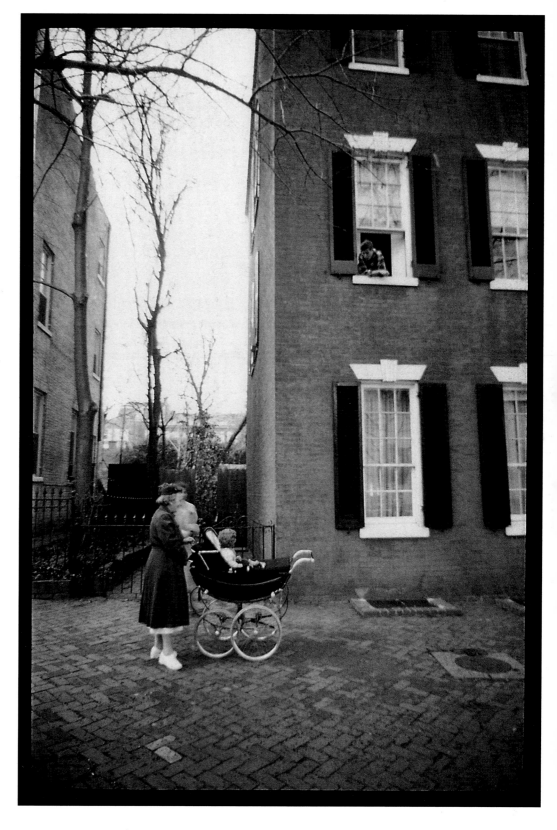

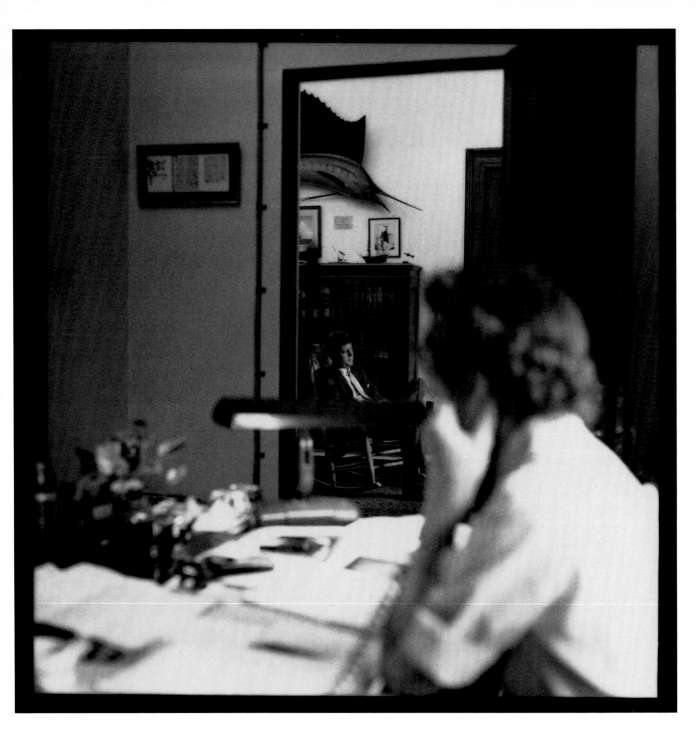

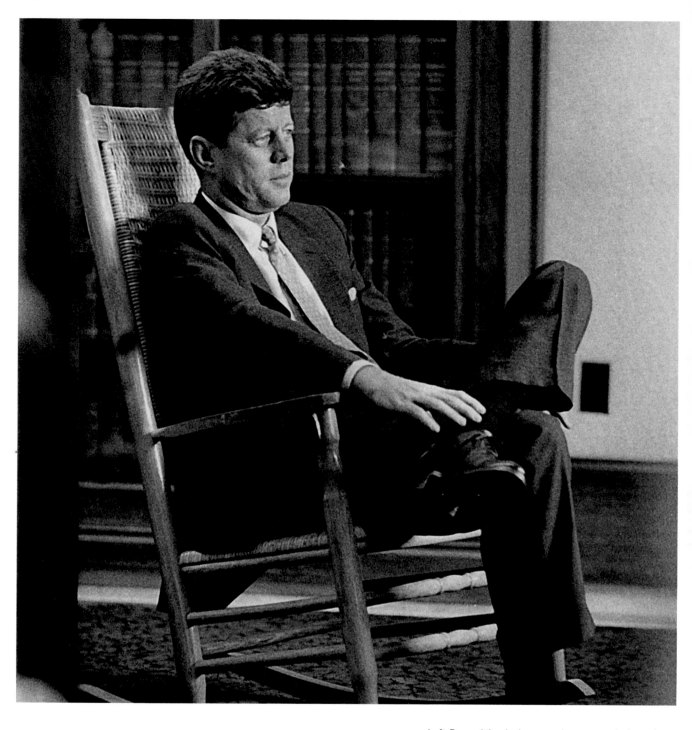

Left: Beyond the desk of Evelyn Lincoln, who would remain Kennedy's secretary for the rest of his public career, the senator in office Number 362 sits among model ships, political cartoons, and family photographs. Kennedy caught the mounted sailfish on his honeymoon in Acapulco, although he was not much of a hunting or fishing enthusiast.
Above: Kennedy often spoke with visitors while rocking in the famous chair prescribed by his doctor, Janet Travell, to ease his chronic back pain.

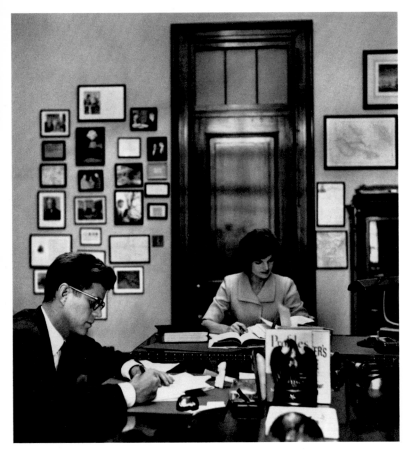

Above: Jackie pitched in at Jack's Senate office when she could, reading references and researching material for speeches. On the foreground of Kennedy's desk sits the coconut shell on which he scratched the location of his shipwrecked *PT-109* crew. As his career progressed, Jack rarely permitted photos showing him in his reading glasses. *Right:* Secretary Evelyn Lincoln joins Jack and Jackie in what looks more like a posed shot than a spontaneous slice of their workday. On the wall behind them is a picture of Daniel Webster, one of Kennedy's heroes.

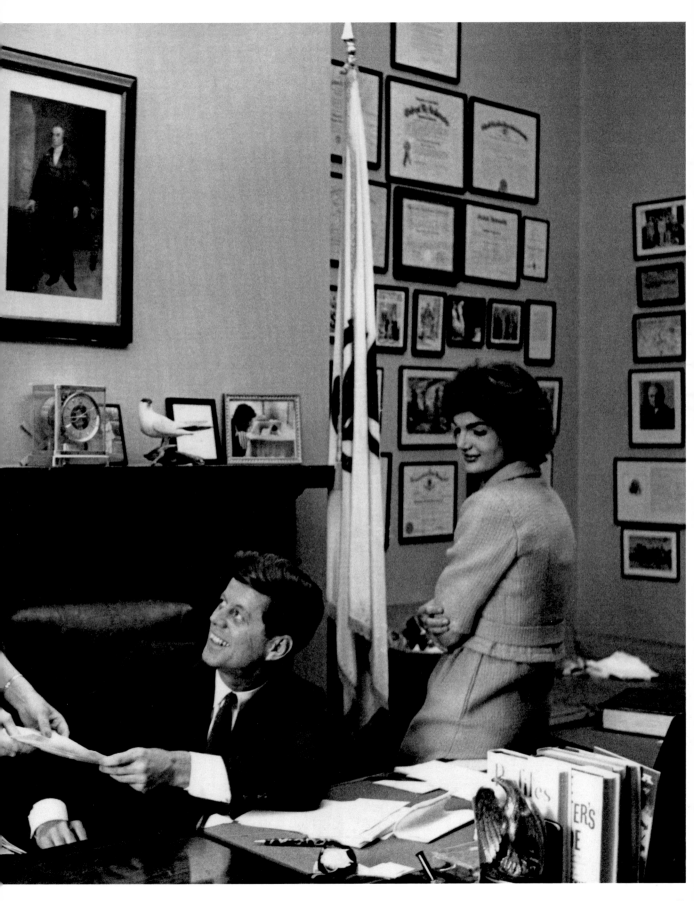

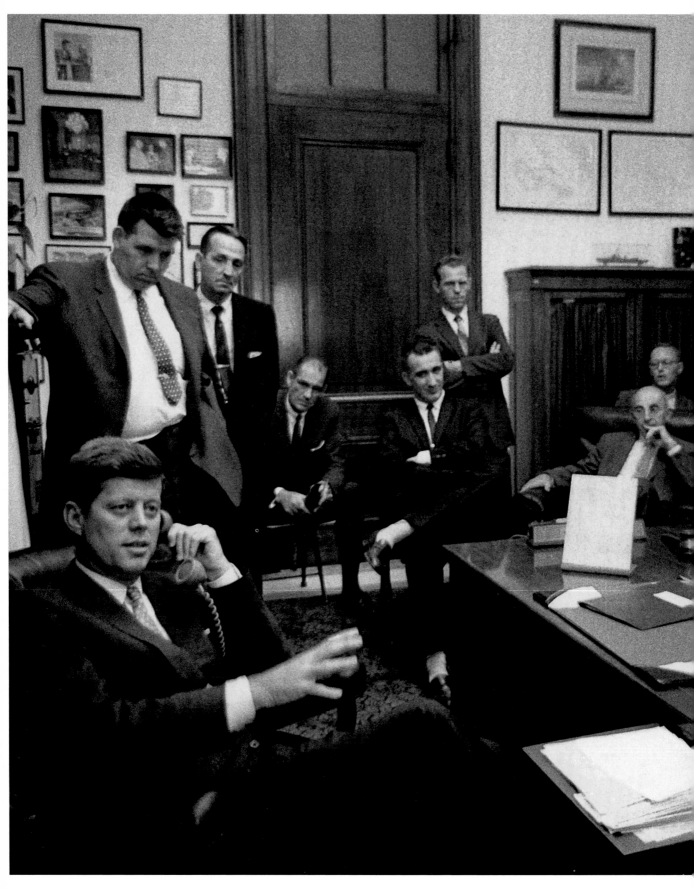

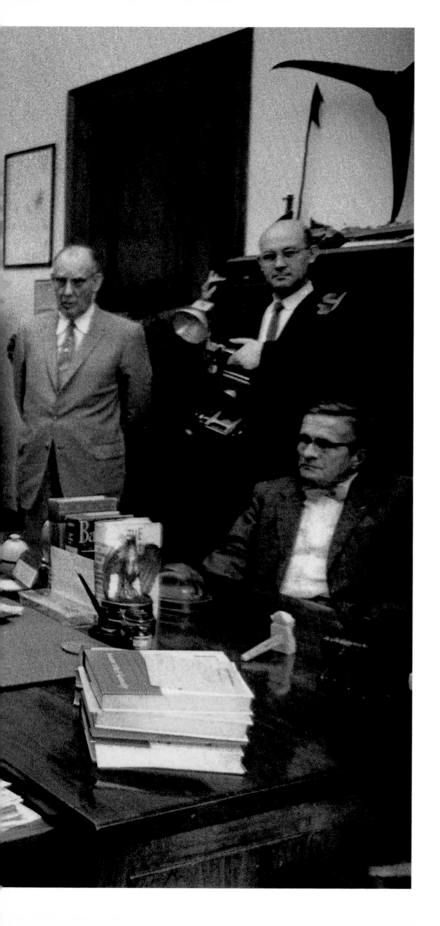

Kennedy's office had an open door most of the time, resulting in gatherings like this in 1958, when union officials crowded in to talk to the young senator. Kennedy, on the phone, is most likely getting a reading from a Senate colleague on an issue worrying organized labor.

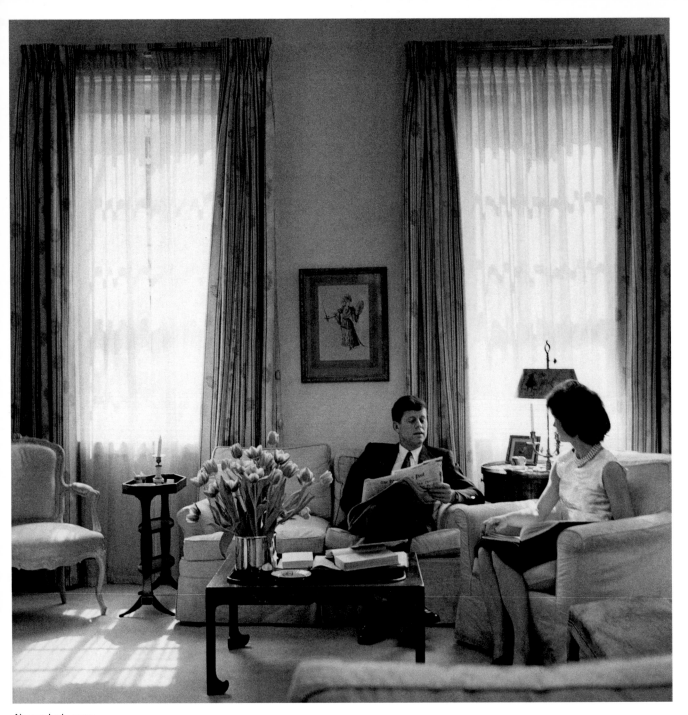

Above: Jack, more
often than not with
a newspaper in hand,
chats with Jackie in
their high-ceilinged living
room. Fresh flowers
were a passion with
the senator's wife.
Right: Jackie staked
out a private niche
of her own in their
Georgetown home.

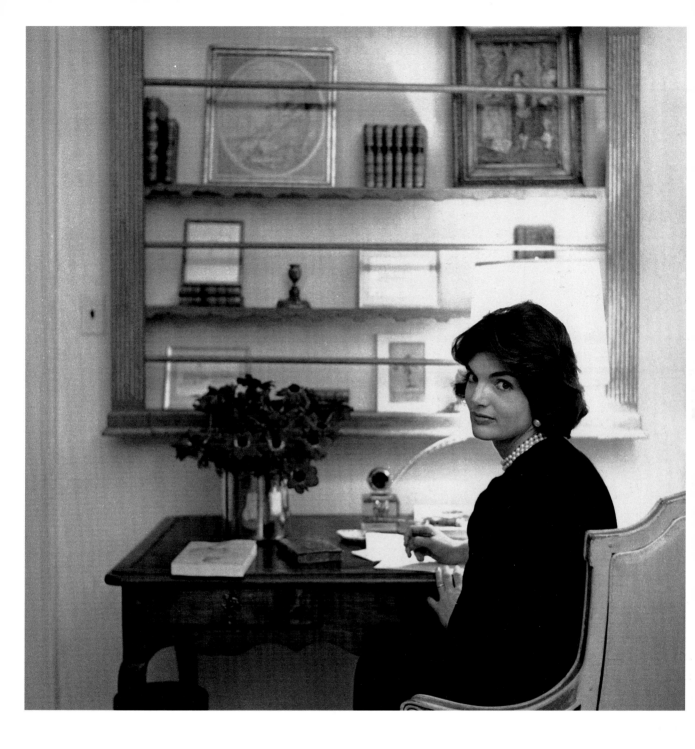

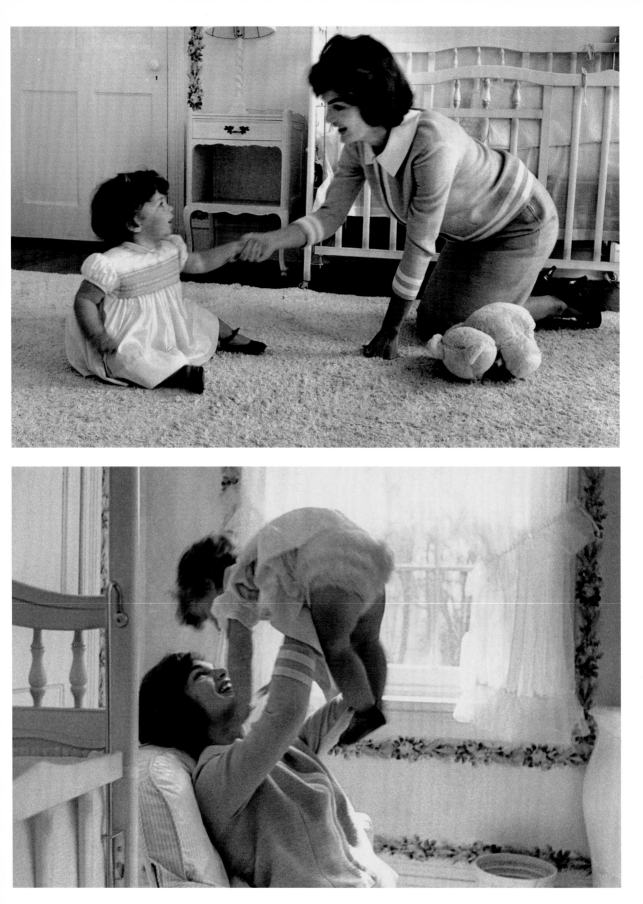

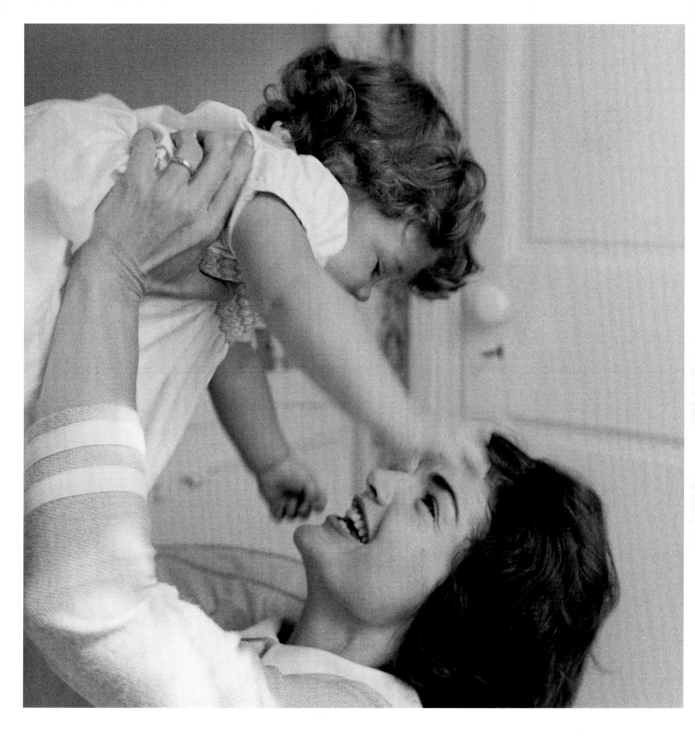

Jackie cherished time alone with her baby daughter. Here she plays with Caroline in the nursery of the 3307 N Street home.

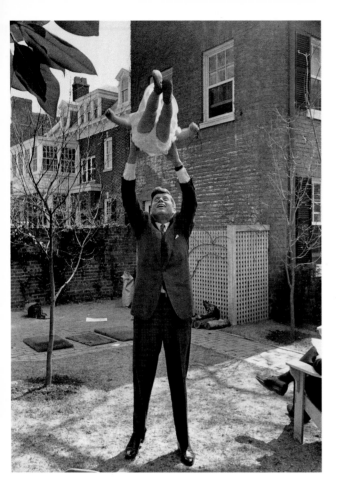

Above: Jack tosses Caroline into the air in their backyard in the fall of 1959 before the campaign kicked off and the politician found himself with less time for his young daughter. Back problems would also limit the physical roughness of their later play.
Right: A mirror reflects the happiness of the young father during a family moment.

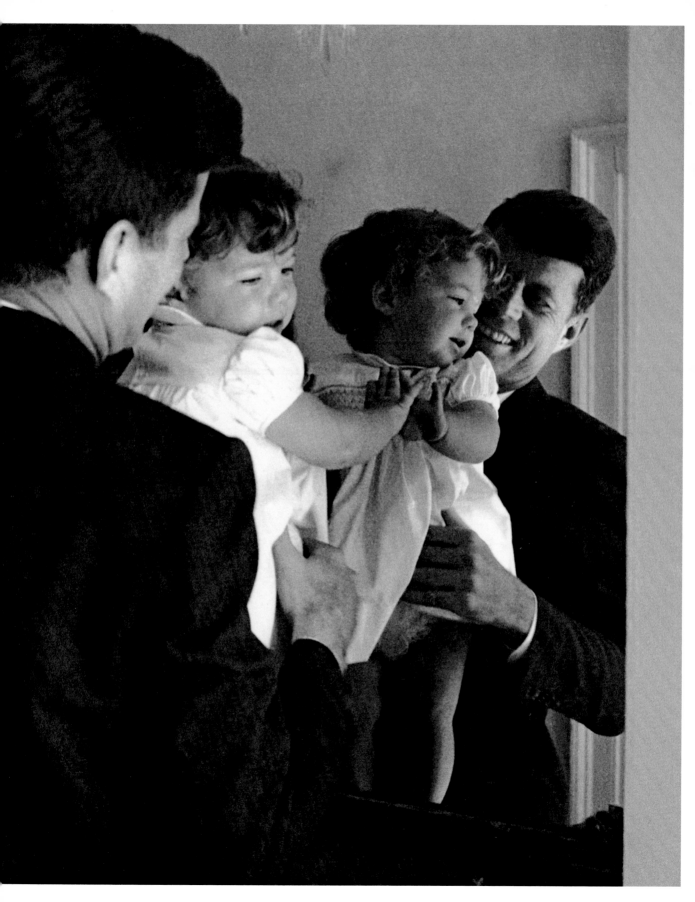

Testing the Waters

California, West Virginia, Oregon, and Nebraska

It's not certain when the presidential seed was planted in Jack Kennedy's mind. Perhaps it was August 1944 when the family learned that older brother Joseph Jr., a Navy pilot, had been killed on a dangerous mission over the English Channel. Father Joe had singled out his namesake to climb the political ladder. Jack was next in line.

Still, although Jack had created his own war legend the year before on *PT-109*, the torpedo boat cut in two by a Japanese ship on night patrol in the Pacific Ocean, he was at first drawn to journalism. He went to Europe at the end of World War II as a correspondent for the Hearst newspapers and penned perceptive columns on the problems of keeping the peace.

He talked of writing for a publication such as *Fortune* magazine or mused that his father could buy a newspaper and make him publisher. But old Joe Kennedy, who once claimed he had enjoyed his own public service far more than accumulating wealth, pushed his son into politics.

Jack rose from the House of Representatives to the Senate, but it was in his Irish genes to shoot even higher. "If you are in this game," he said later, "go for Number One. You settle for anything less and that is where you will end up."

The tedious legislative process, with long discussions, compromises, and delays, was not to his liking. "The White House is where the action is," he once said. "That is where you can get things done." On the way to that goal, he would pass through four phases: a testing of the national waters to measure his appeal as a presidential candidate; the primary elections to prove whether he could garner delegates for the national convention; the convention itself where he would have to stave off last-minute political assaults and amass enough delegates for the nomination; and, finally, the campaign to win the support of a nation.

The United States is a huge and diverse land, and Kennedy faced a tiring marathon journey through factories and farms and down desolate Main Streets and booming boulevards. He would kiss babies and listen to hard luck stories; there would be thousands of hands to shake and hundreds of autographs to sign. He would survive on bad coffee and meet in stuffy rooms with the local political activists ready to help assemble his national campaign. "It was like a whorehouse," he complained after a stop in West Virginia where he held court in a hotel bedroom, greeting a steady stream of female boosters.

Jackie joined him, adding beauty and grace to some stops, but she was an uncertain traveler. She did not like political campaigning and looked for chances to escape. Indeed, there were times she was defiant, keeping her thin, tailored New York style even on a day in Milwaukee when the temperature hit 20 below zero and the local women showed up in parkas.

Kennedy's journeys were eased by a gift from his father: use of the family airplane, which Jack dubbed the *Caroline* after his toddler daughter. Travel on the twin-engine turbo prop let Jack confer in private with aides, engage in interviews with reporters, and even lounge in luxury. A fetching flight attendant was on hand to tuck him in on long flights, rub Mrs. French's Hair Preservative into his famous thatch, or serve steaming bowls of his favorite food, fish chowder. "Costs less," he used to chuckle, when asked about the private plane. Given his wild schedule, he was correct.

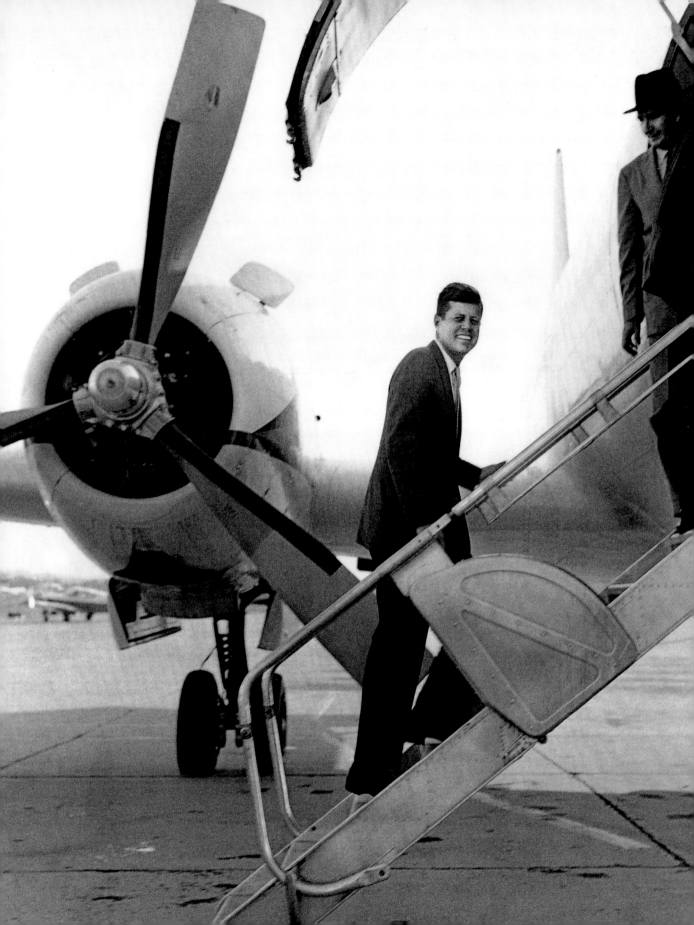

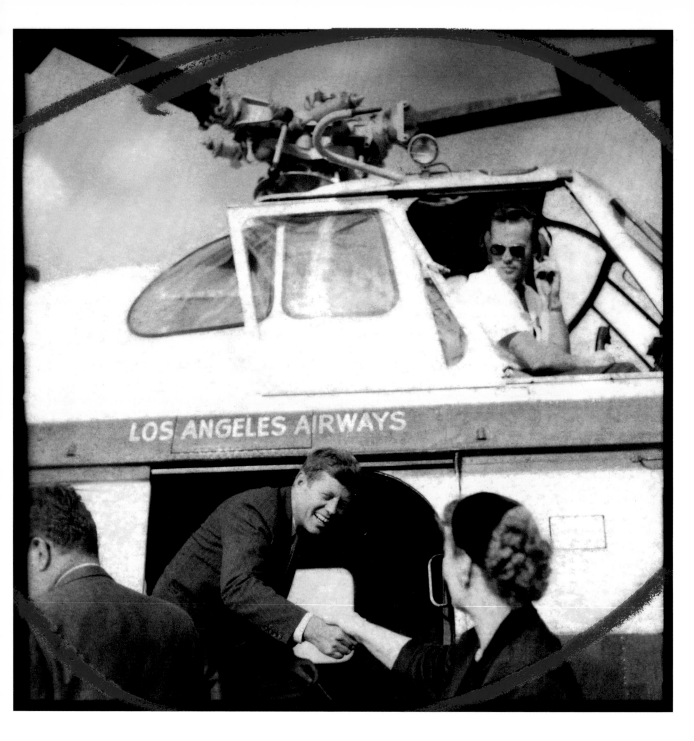

Previous page: Long-time Kennedy aide and friend, Dave Powers, waits at the top of the steps as JFK boards the family plane he renamed the Caroline for his campaign.

Above: Kennedy takes a helicopter to avoid clotted Los Angeles freeways during one campaign outing. Right: The candidate uses his time on the chopper to grant an interview to a reporter.

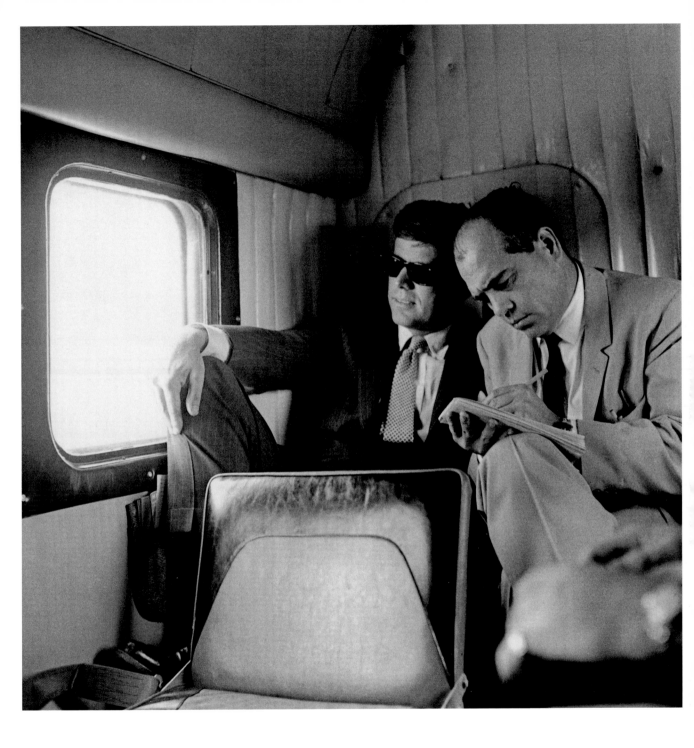

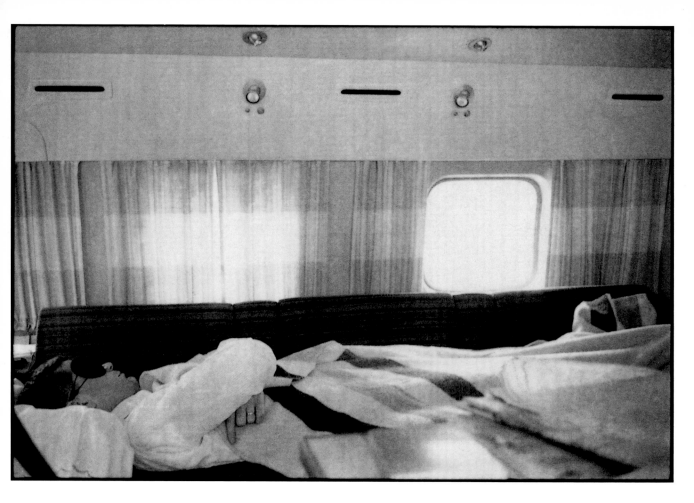

Above: Jack stretches out on his bed in the *Caroline* during the West Virginia primary in April 1960. The plane's comfortable set-up allowed the presidential-hopeful to grab naps during an otherwise exhausting campaign.

Right: Kennedy, who traveled with a sleep mask, his favorite foods, and several changes of clothes, dresses before landing at a campaign stop in California. When the aging *Caroline* was retired in 1967, it was given to the Smithsonian Institution.

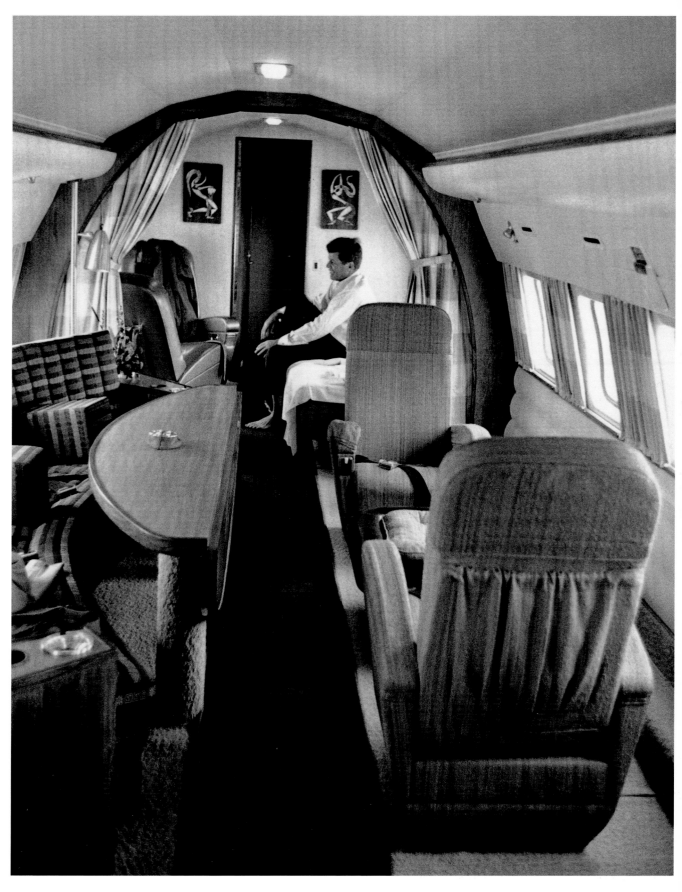

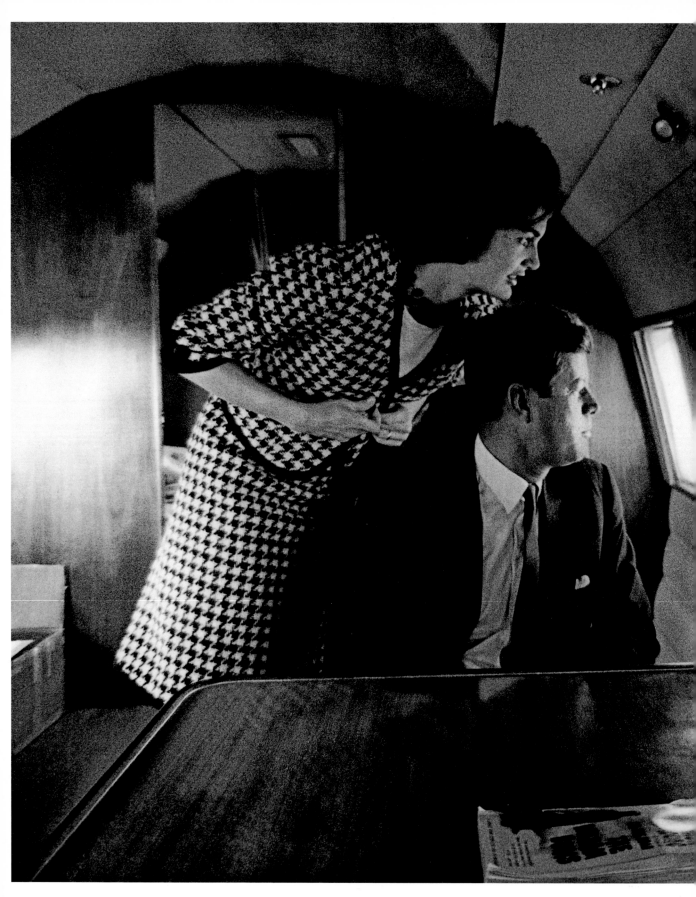

Jackie and Jack button up and survey the scene outside as they arrive in California in the spring of 1960. The size of crowds at the airports often indicated the level of enthusiasm (or lack of it) that would follow. They also were on the lookout for friends who would come to greet them.

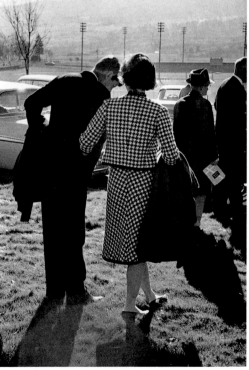

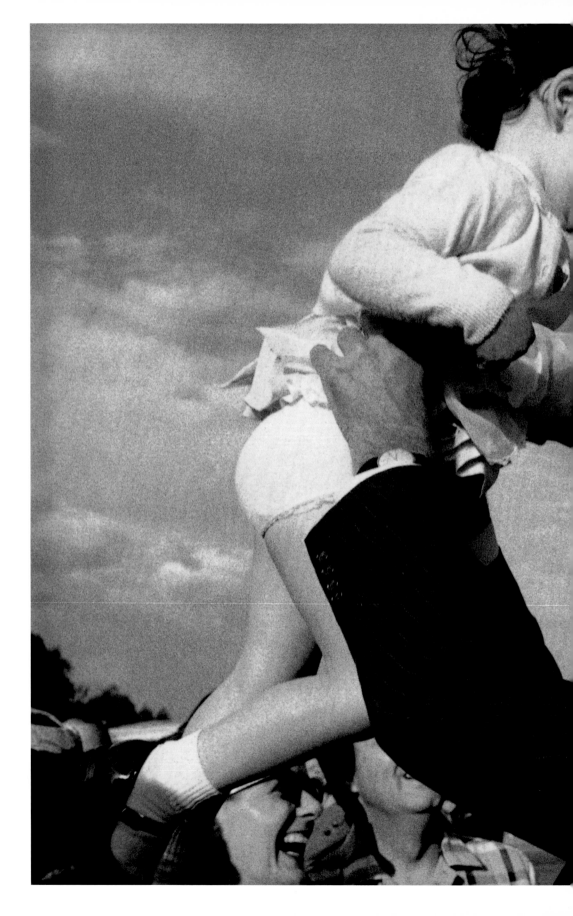

Jack was not an exuberant baby kisser, but in Bakersfield, California, he does his best to show not only enthusiasm but his athletic vigor as well. The crowd eats it up.

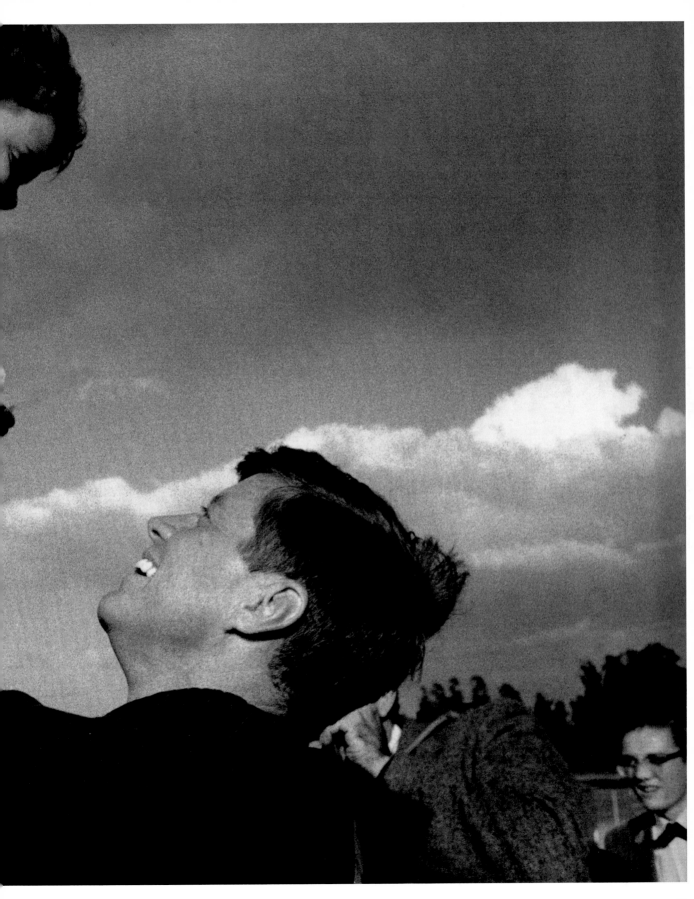

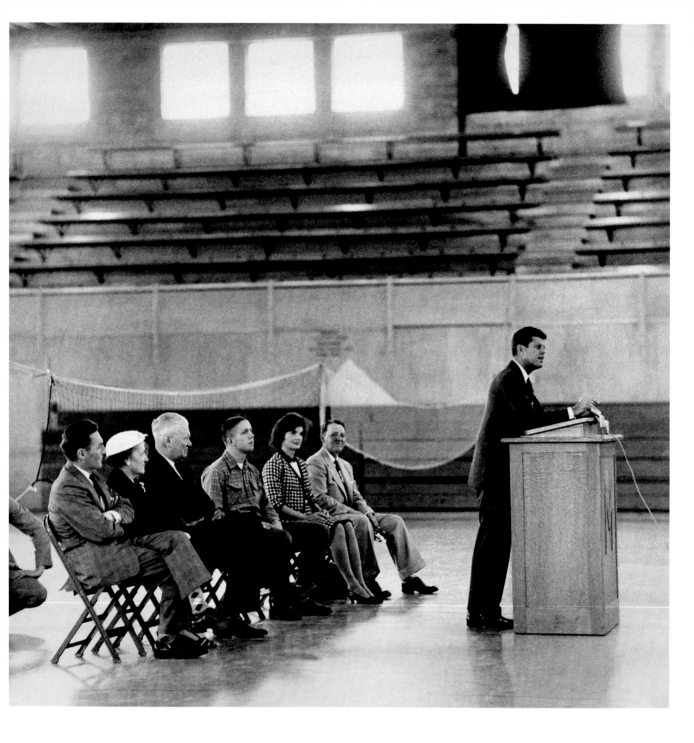

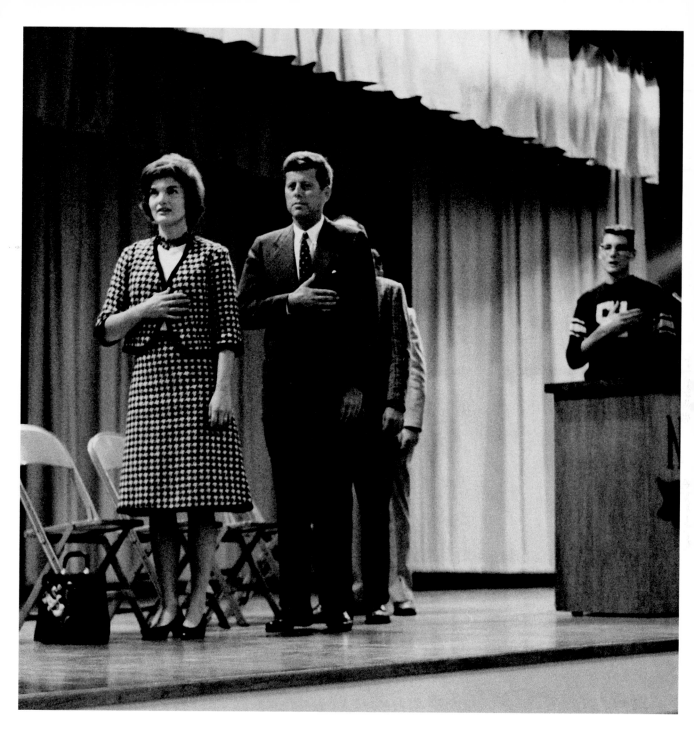

Kennedy went in and out of dozens of rallies held in high school auditoriums, like this one in California. The empty bleachers were a reminder of the long fight ahead. Standard procedure repeatedly put Jack and Jackie on stage reciting the Pledge of Allegiance with one or two local political leaders, the high school superintendent, and the student body president.

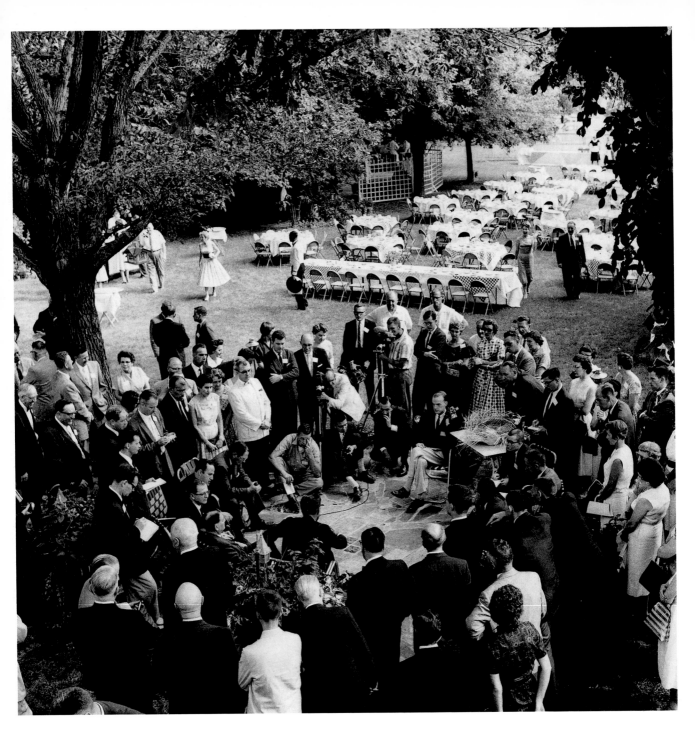

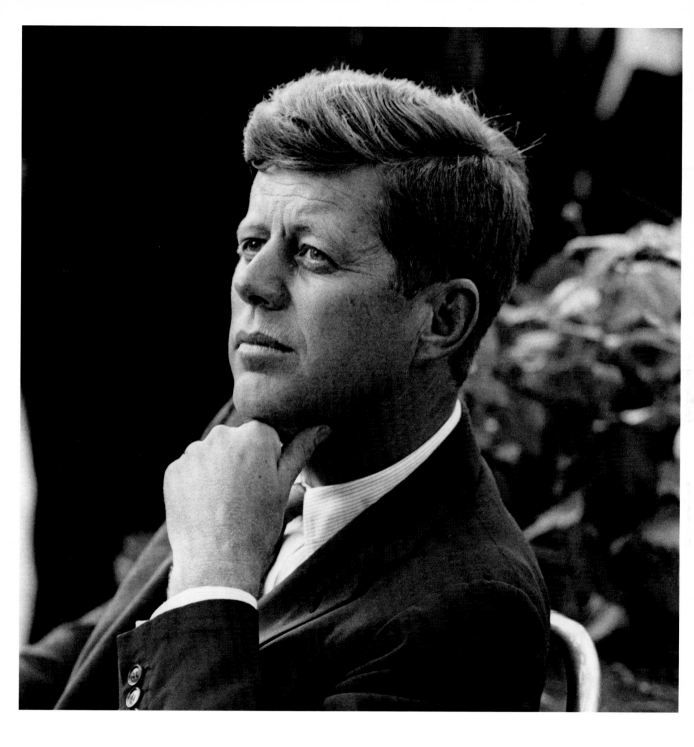

Left: Jack holds a press conference In Omaha, Nebraska, in 1959. The presidential contender was rarely caught off guard; he read so much about national and world events he usually knew more than his questioners.

Above: Jack listens intently to a reporter's questions. He said those exchanges gave him a feel for the issues that most concerned voters in a region. JFK's handlers so loved this photo by Jacques that they adopted it for a campaign poster.

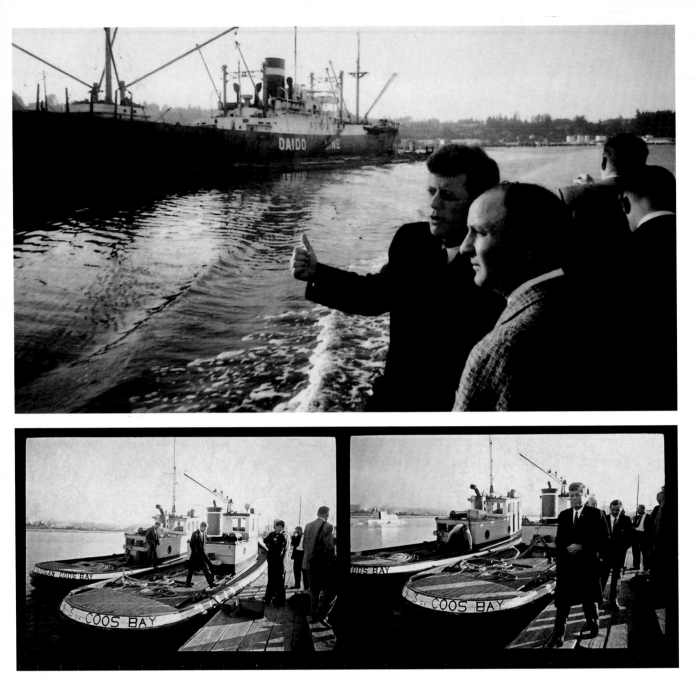

Above: After addressing a small and hostile audience of longshoremen in Coos Bay, Oregon, in the fall of 1959, a forlorn Kennedy tours the docks, trying to make the best of a gloomy situation. When Jacques quipped, "Well, no fan mail… from this meeting," Kennedy exploded and railed about the difficulties in reaching blue-collar workers. Jack would eventually win over many labor supporters. *Right:* Jacques's picture of a dejected JFK staring into the water became one of the most famous of the campaign.

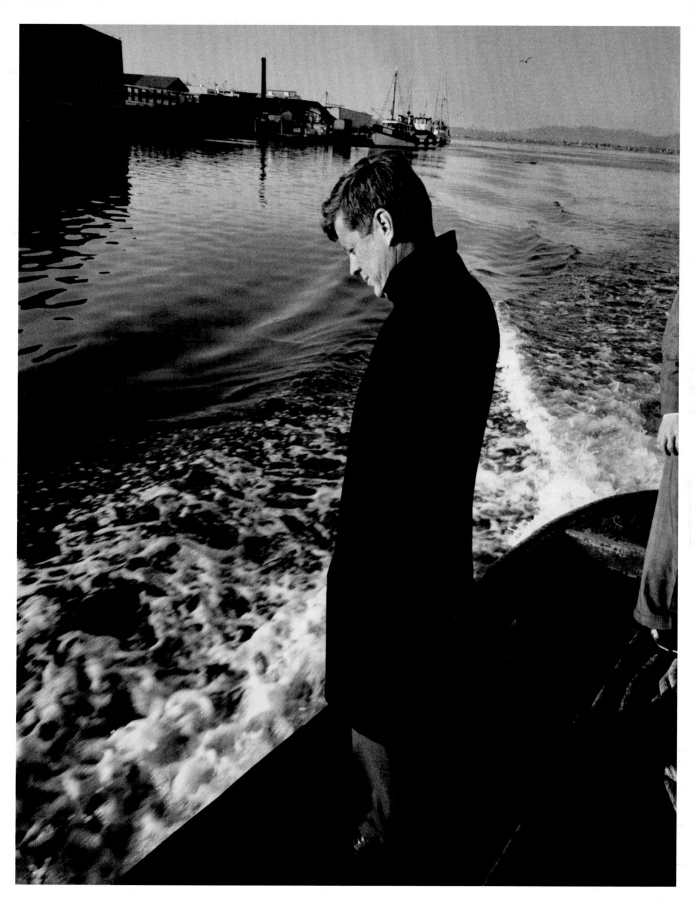

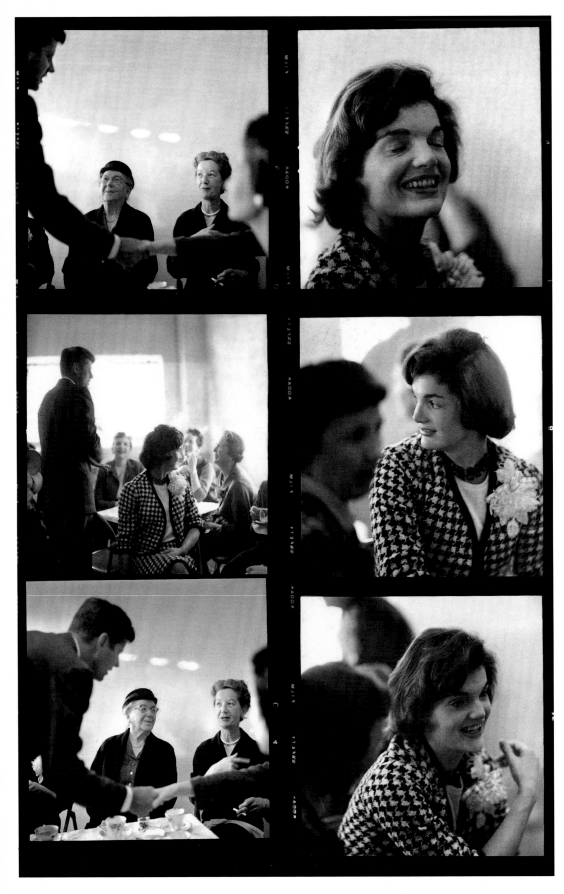

Left: Jack and Jackie Kennedy work a sparse crowd in Oregon in the fall of 1959. When Jackie felt in the mood, she was an effective campaigner with almost any segment of society.

Right: Jackie talks with Oregon longshoremen who were unfriendly to her husband but are polite and attentive to her. While on the campaign trail, Jackie never altered the way she acted, dressed, or talked to accommodate any group. The people she met usually appreciated that honesty.

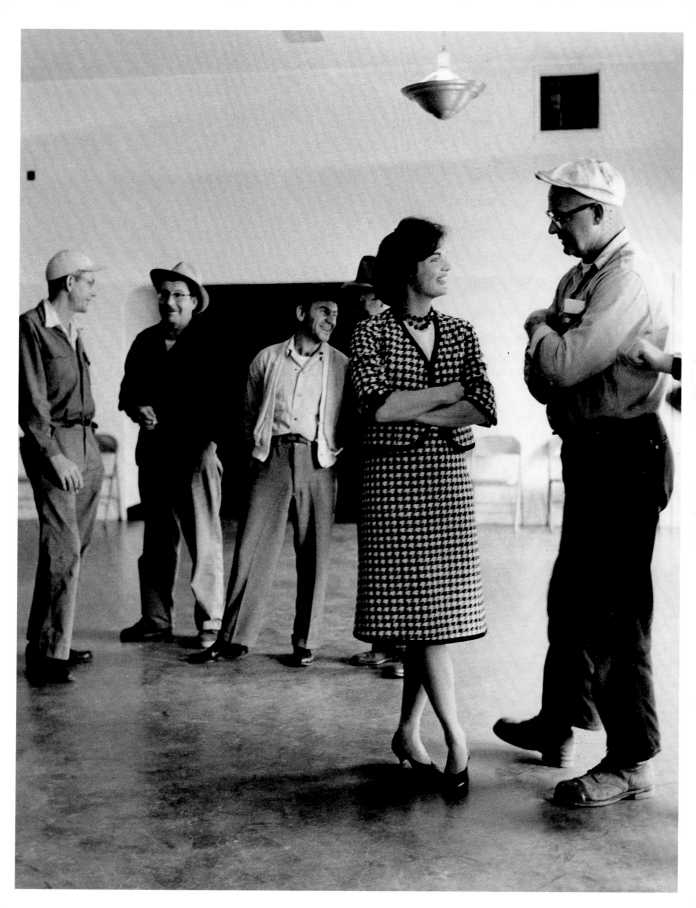

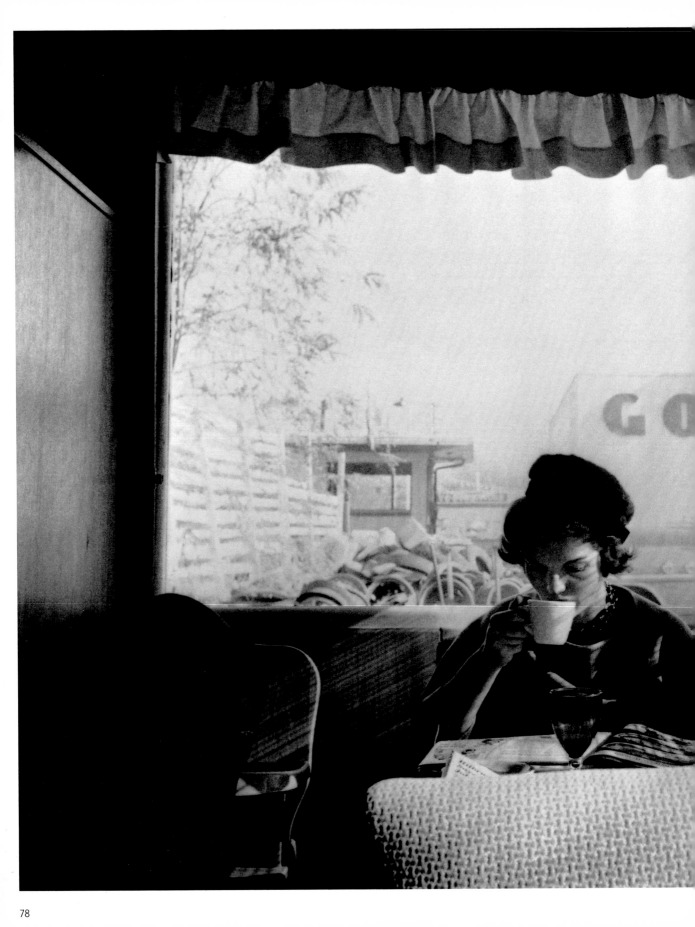

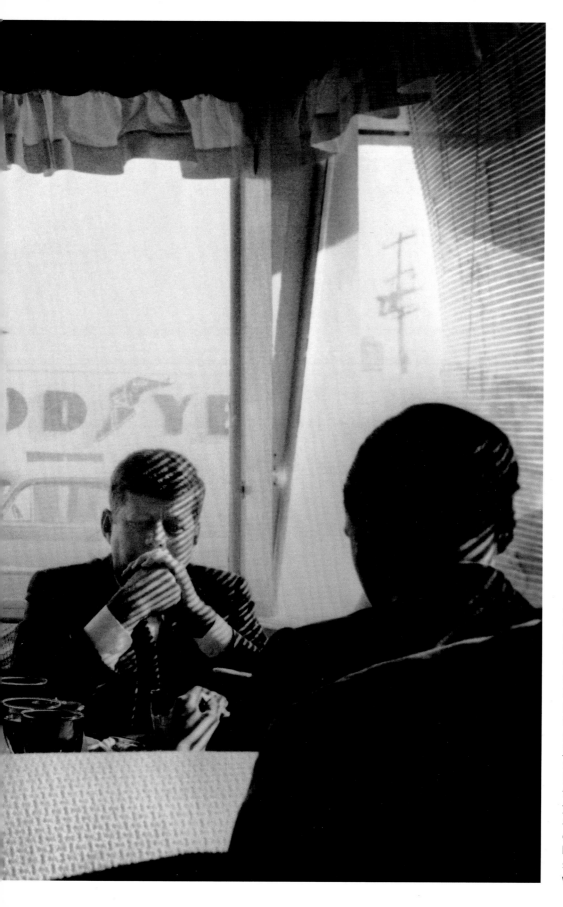

Jack and Jackie were virtual unknowns in much of the country in the late fall of 1959. In an Oregon town, eating breakfast with brother-in-law Steve Smith, one of the campaign managers, they are unrecognized by other diners. They had just come from Sunday mass and a night at the Let 'Er Buck Motel across the road. In less than a year, that early loneliness and anonymity would dissipate and they would be instantly spotted and swamped by admirers wherever they went.

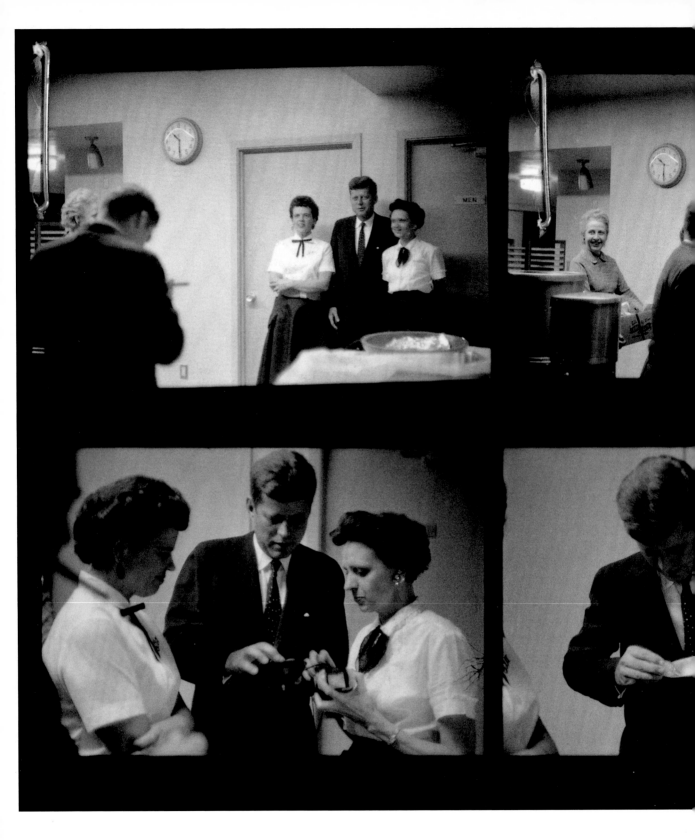

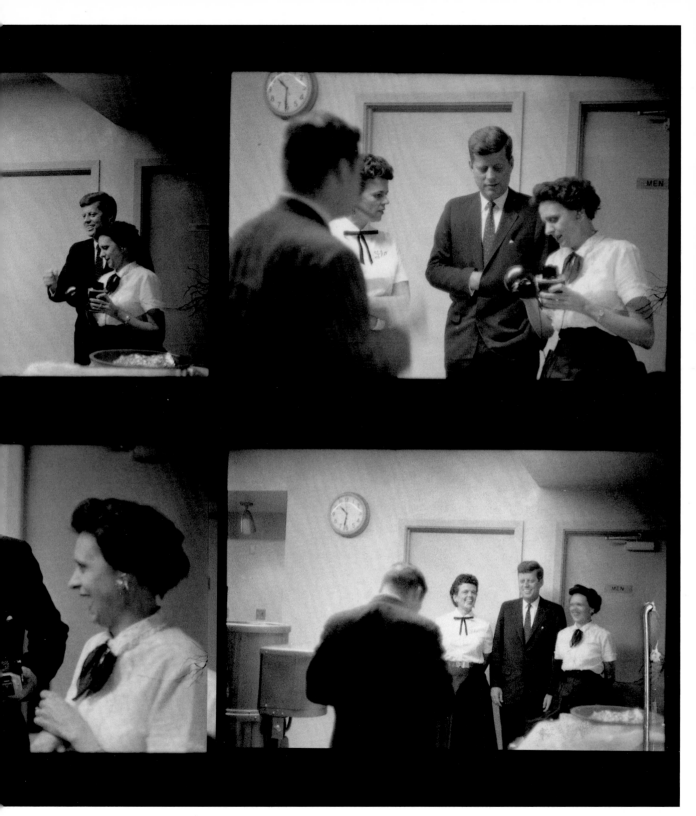

Previous pages: Jack helps a supporter load a camera so she can have her photo taken with him. Camera-happy audiences were something noticed—and remarked upon—by all the candidates. Republican Richard Nixon once lamented, "I should have bought Kodak stock before this campaign began."

Right: Jackie whispers to Jack during a fundraiser in Pendleton, Oregon. She had a good eye and a good ear for political nuances. She also had a hilariously wicked tongue at times. Jack's look suggests that he would like to laugh but does not dare.

Overleaf: JFK, Jackie, and aides Dave Powers and Pierre Salinger arrive in Portland, Oregon, on a cold day in 1959 to find a crowd of only three supporters—including Congresswoman Edith Green talking to Salinger in the center. Undaunted, Jack flashes his best smile. He later claimed this was his favorite campaign photograph.

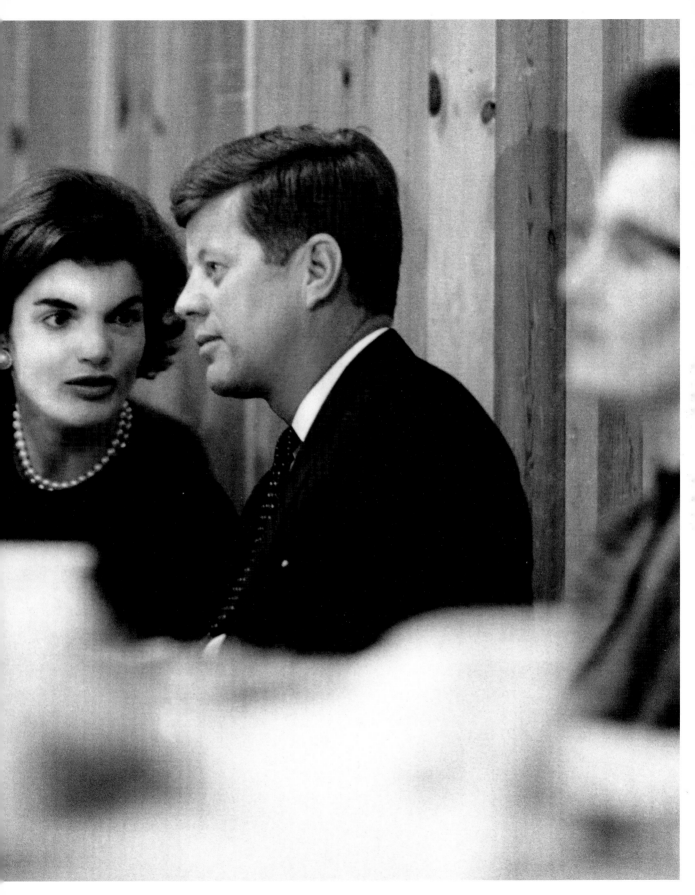

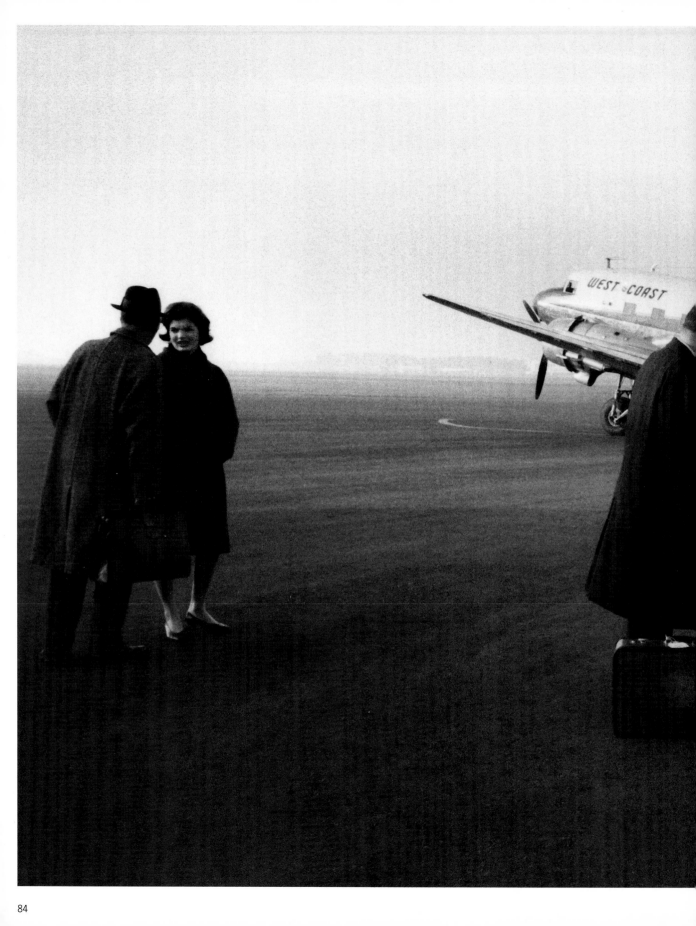

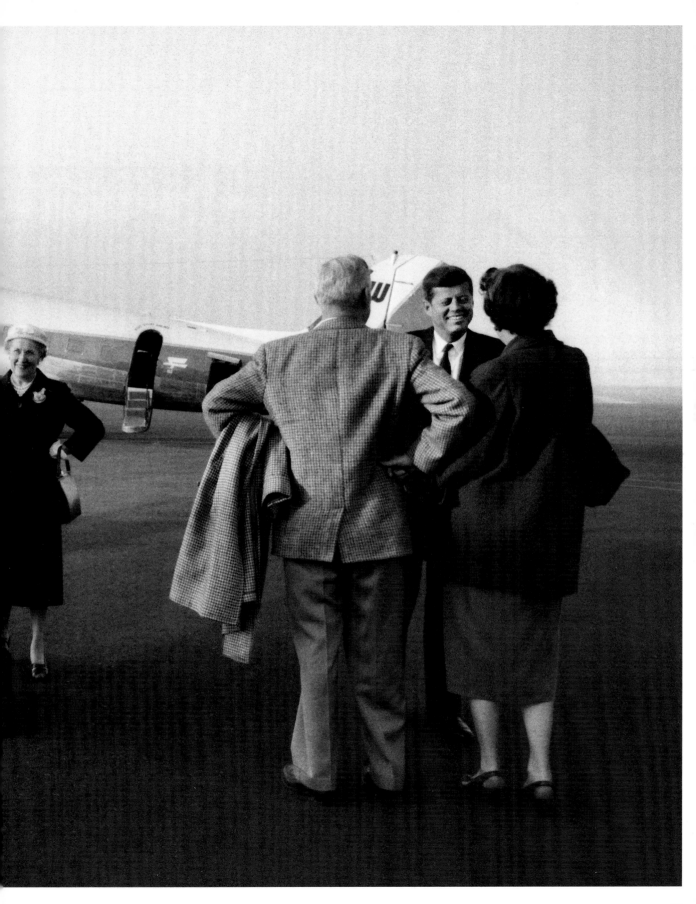

Primaries

Washington, D.C, Wisconsin, Illinois, California, and West Virginia

The state primary elections were devised to let the people select their delegates to the national political conventions, preventing the old party bosses from choosing the presidential candidates through back-room wheeling and dealing.

When Jack Kennedy set his sights on the White House, 16 states held primaries. He elected to run in seven of them to prove his national appeal and gather delegates before the convention in Los Angeles, California. He was certain to be carved up by the party hacks if he did not arrive on the convention scene with a hefty group of backers.

Kennedy dreaded the March-to-June primary battles. They were expensive, tiring, and fraught with endless travel—often into deserted airports or to slimly attended rallies. At times, Jack wondered if he and his young band of insurgents could really bring off a political upset, unseat the old pols, and, as he would repeatedly say, "get this country moving again."

Kennedy's primaries stretched from New Hampshire and Maryland to California and Oregon. Fellow New Englanders gave him the win in New Hampshire. But results in Wisconsin, a state bordering Minnesota, the home base of challenger Senator Hubert Humphrey, were indecisive and hinted at a strong anti-Catholic turnout. This worried Jack; he feared his religion might be an obstacle, as it had been for others seeking the presidency, including his father, who in the 1930s considered challenging incumbent Franklin Roosevelt. Asked what the Wisconsin returns meant, the senator muttered, "We have to go through every [primary] and win every one of them."

West Virginia, next on the calendar, was home to country folks and coal miners. But Kennedy surprised even himself, winning big in a state projected to be a hotbed of Protestant prejudice. With West Virginia under his belt, most experts calculated he was on his way to more primary victories and the nomination.

Jacques Lowe was a part of this early adventure, catching Kennedy's shifting moods on the plane or on those lonely stretches of tarmac. Aloft, the senator would read papers, suck on one of his small cigars, or just stare out the windows, mulling private thoughts about his mission.

Campaigns are a pastiche of speeches, smelly gyms doubling as meeting halls, off-key high school bands, worn motels, and bad food at Rotary luncheons and in coffee shops. That was not the world of any Kennedy. Jackie in particular was a stranger here; Caroline became her lifesaver. It wore on Jack, but it also offered him a necessary education about his country. "What's it like coming back here?" he asked a reporter as his plane settled on the Iowa prairie. "I am not sure I understand it. Give me an ocean and a beach. That I know."

One day he would clamber onto heavy machinery to face working men in their dirty pits and shafts. The next night he'd don black tie and join his Hollywood friends, led by Frank Sinatra, who had given him a campaign song set to the melody of "High Hopes."

Throughout the primaries, Jack kept a sense of humor about the strange life he'd chosen. Once in Charleston, West Virginia, he noted a crowd bigger than his had gathered across the street. A friend, sent to investigate, reported that the people were clustered around television broadcaster David Brinkley. Kennedy shook his head, laughed, and said: "See how far I have to go?"

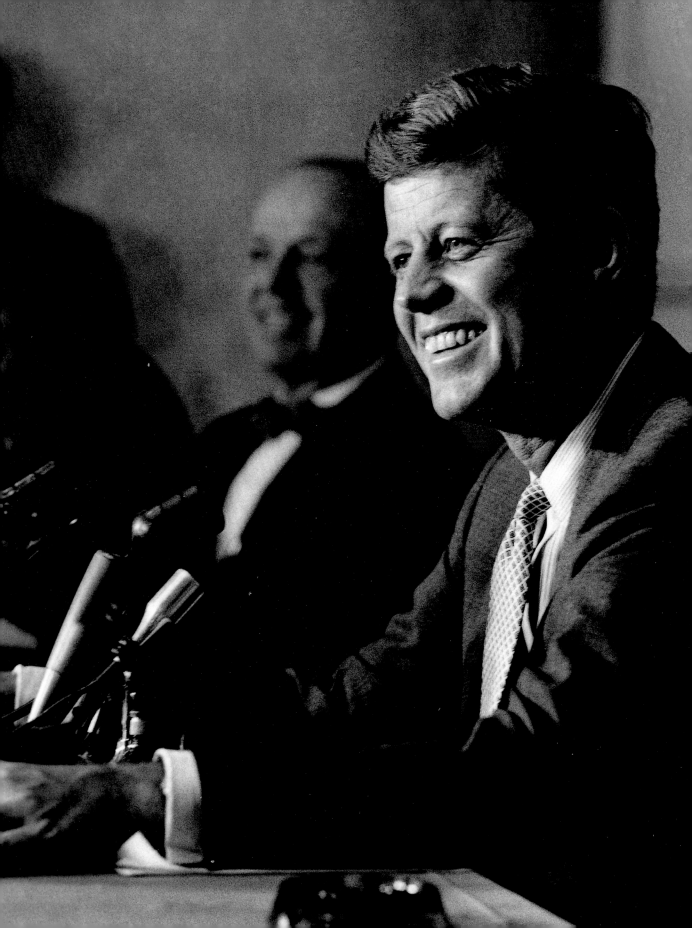

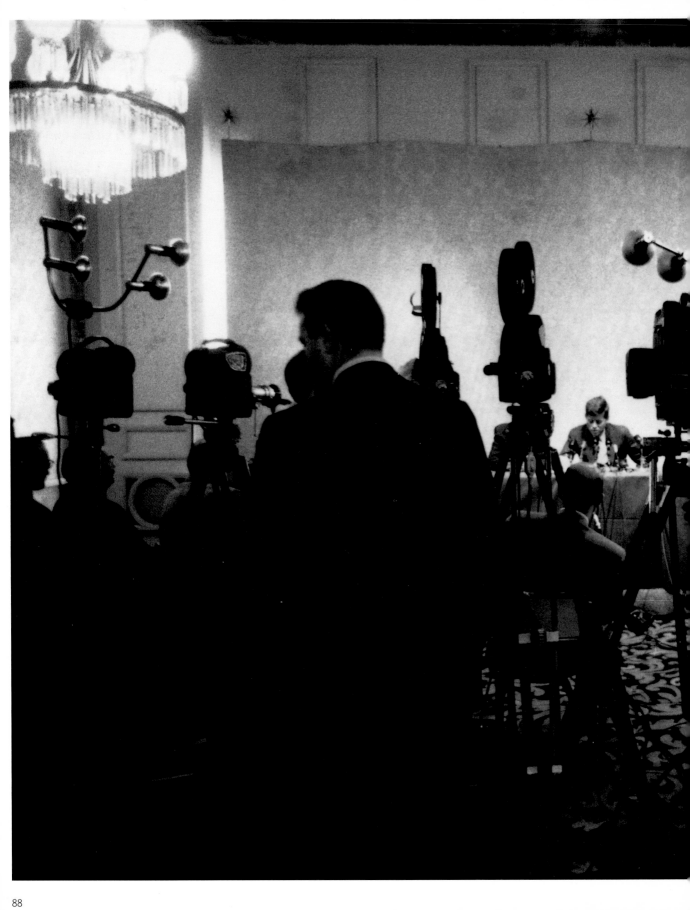

Previous page and left: Jack announces his intention to run for president at a crowded press conference in Washington, D.C., on January 2, 1960. He was tanned and rested after a Jamaican holiday, and his humor was at the ready. At 42, he was the youngest presidential contender in U.S. history. At 43 (his birthday was May 29), he became the youngest person ever nominated and elected U.S. president.

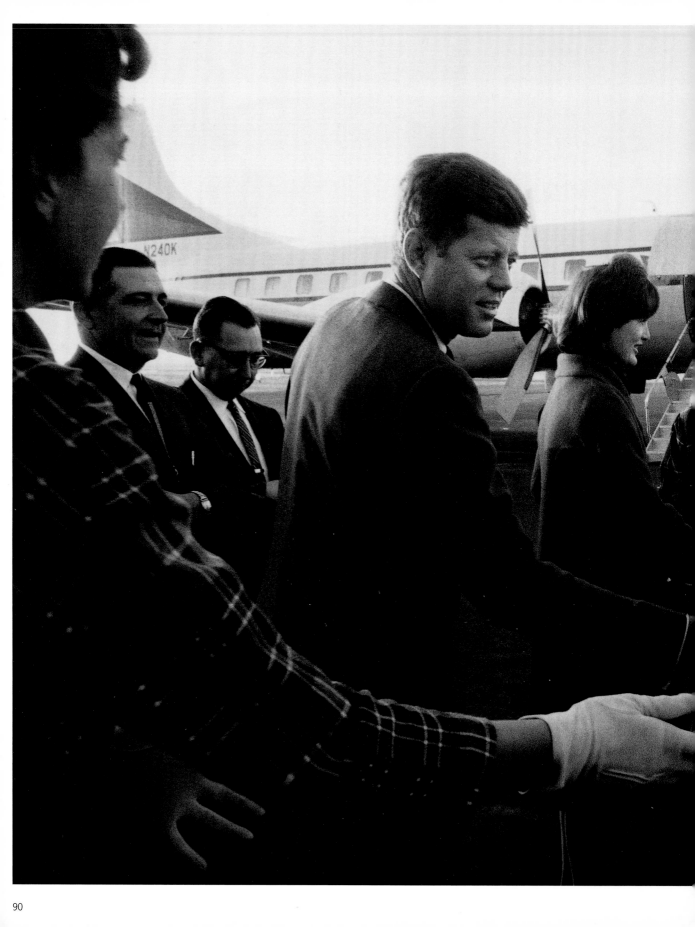

One of Kennedy's first
stops after announcing
his intention to run for
president was Wisconsin,
a key state in his primary
election schedule.
In Wisconsin, he and
Jackie disembark
from the *Caroline* into
a crush of supporters.

Left: Kennedy balances a coffee cup, likely at a morning meeting, during his spring of 1960 swing through Wisconsin.
Above right: JFK had an earnest and interested look for every potential voter.
Below right: Long tables fill the room at a fundraiser. Good people and bad food characterized many of these events.

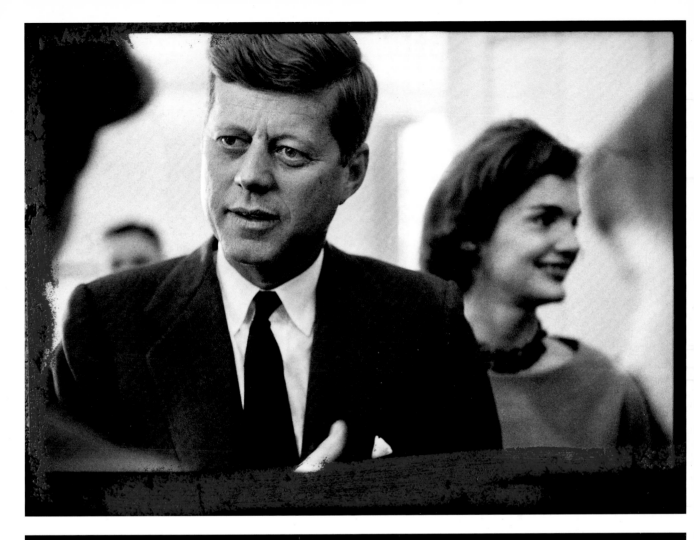

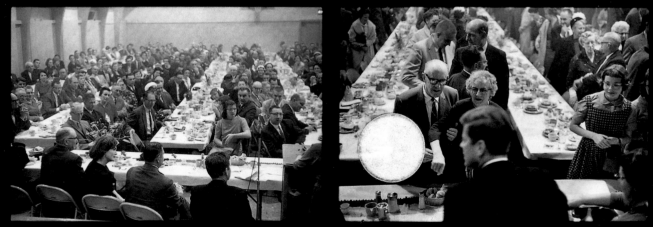

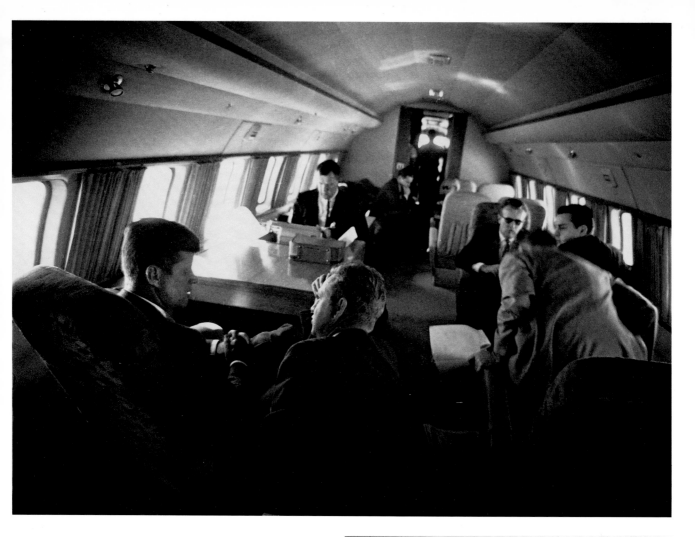

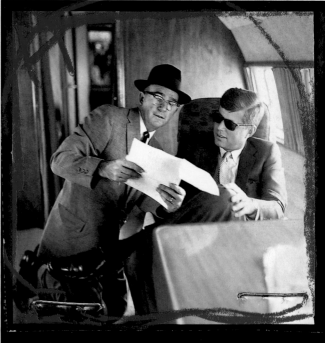

Above: The cabin of the *Caroline* was generally a busy place. In the spring of 1960, the senator finds himself flying with aides and members of the press. *Right:* Talented Dave Powers, Kennedy's long-time aide, confers with Jack. Powers often used his quick humor to keep spirits high. *Far right:* Kennedy grabs a look at a newspaper while flight attendant Janet Des Rosiers tends to the plane's passengers, like Press Secretary Pierre Salinger in the foreground.

Overleaf: Jackie looks up from Jack Kerouac's *The Dharma Bums* to talk to Jack, who is savoring a bowl of his favorite fish chowder aboard the *Caroline*.

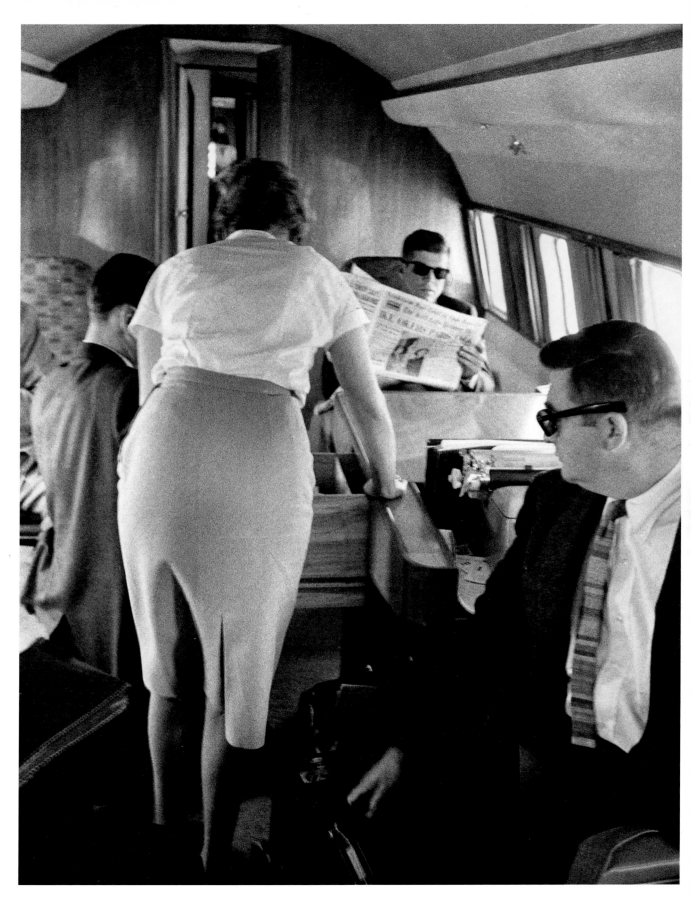

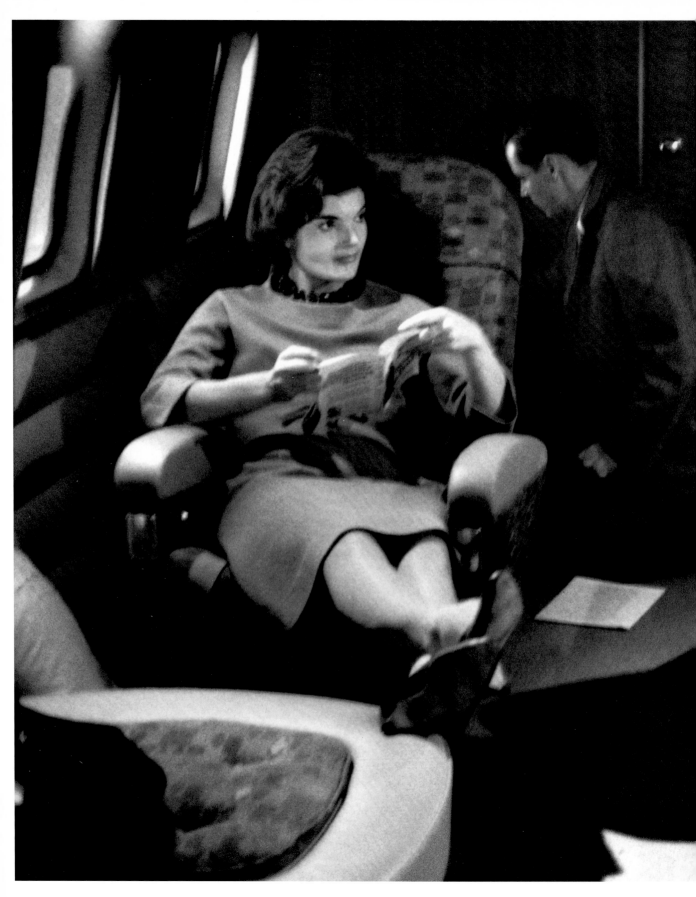

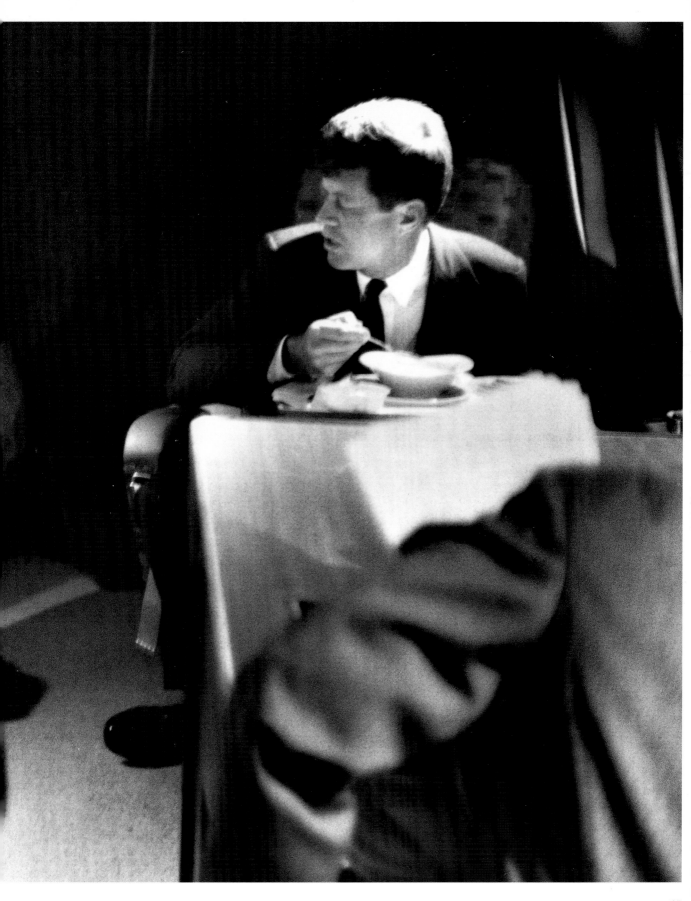

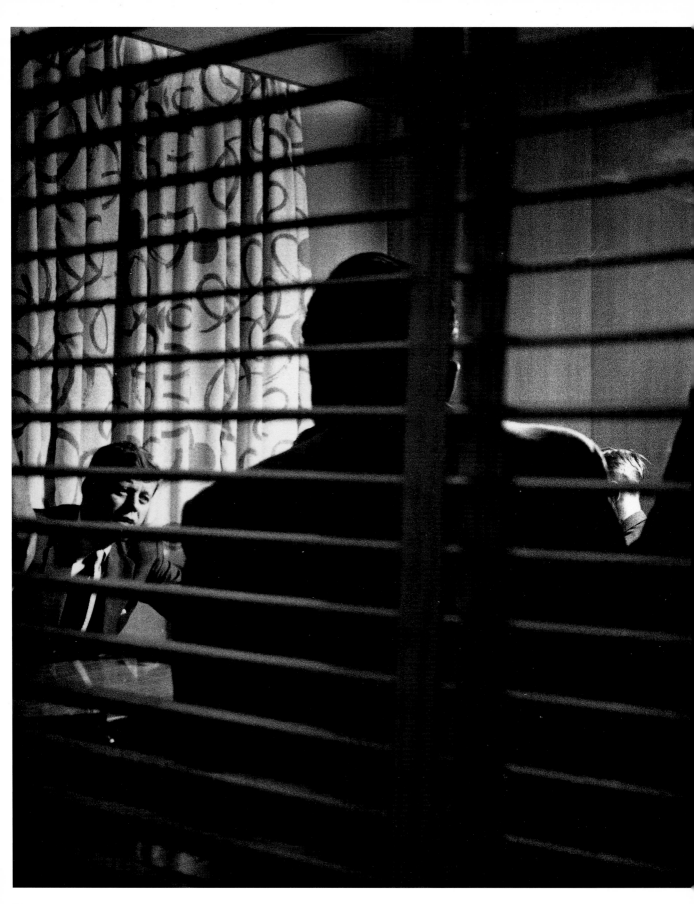

Jack holds a strategy session with his staff in the Chicago airport before flying on to Wisconsin. Events moved fast in the spring of 1960, which was crowded with primaries.

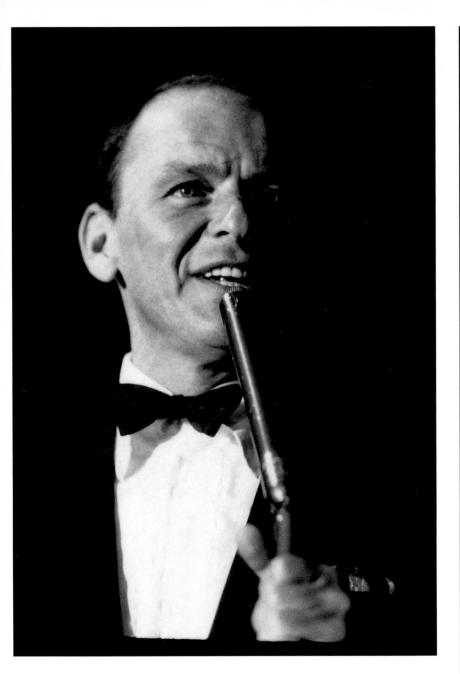

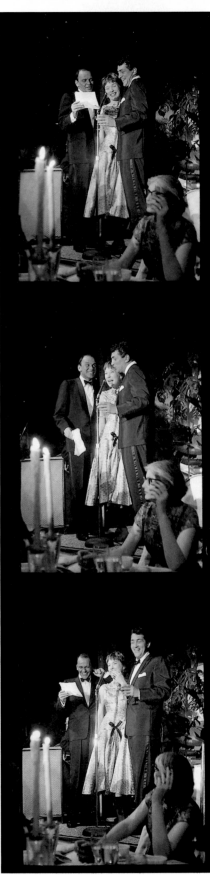

Hollywood stars Frank Sinatra, Shirley MacLaine, and Dean Martin add glitz to this Jefferson-Jackson Day dinner in California in the spring of 1960. The Jeff-Jack gatherings, one of the Democratic Party's historic celebrations and fundraisers, were usually dreary affairs. But not this year—and Kennedy loved the celebrity touch.

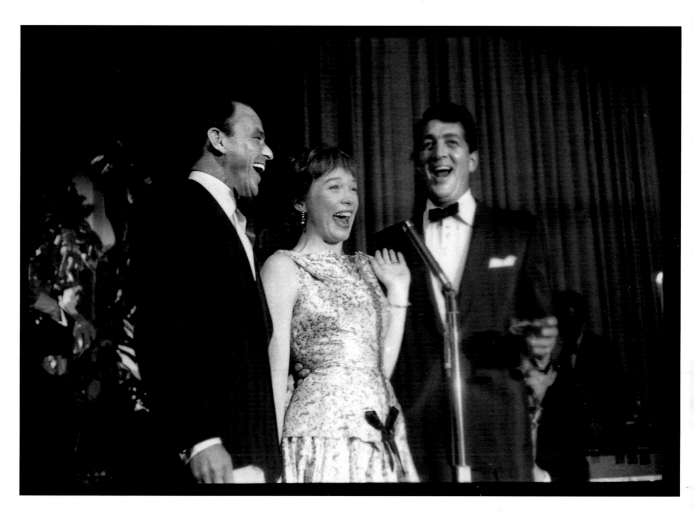

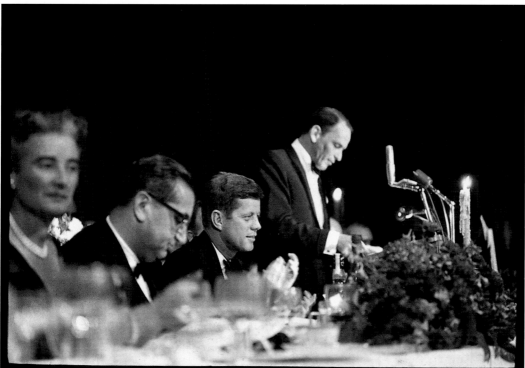

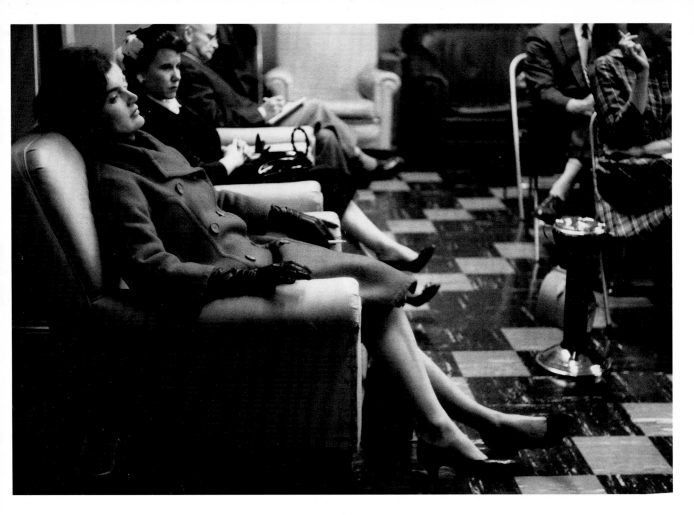

Jackie steals a few
minutes of rest on
a foray into California
early in 1960 while the
senator finds a chair
from which to address
skeptical labor leaders
at a Hilton hotel.

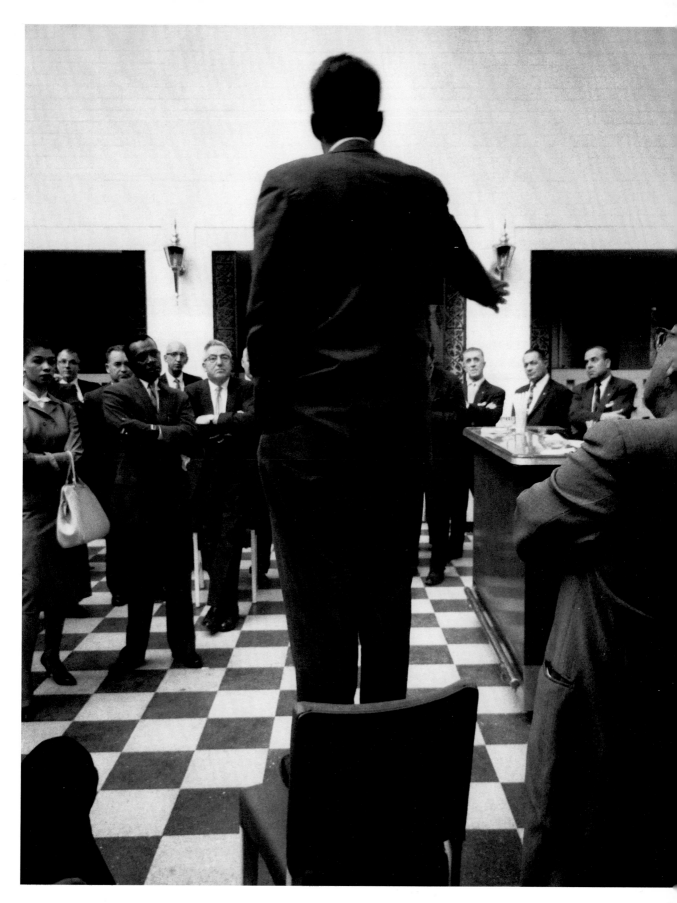

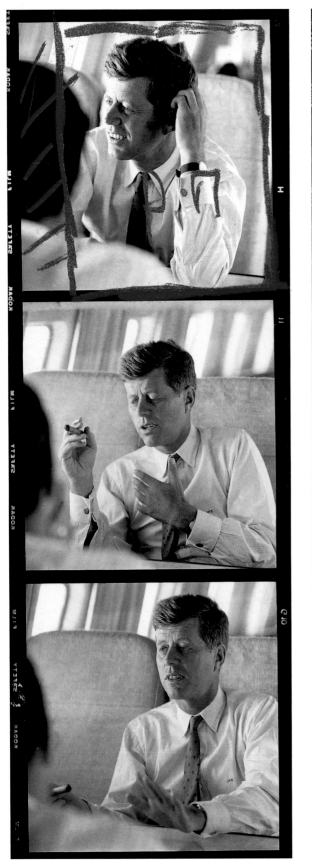
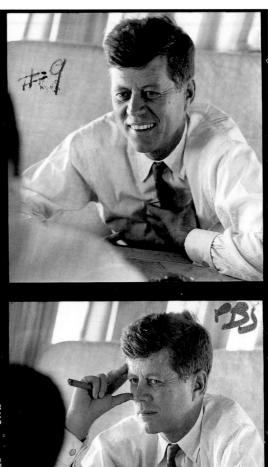

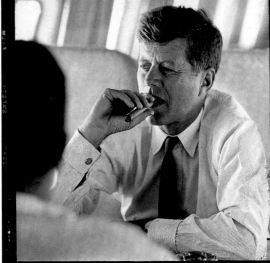

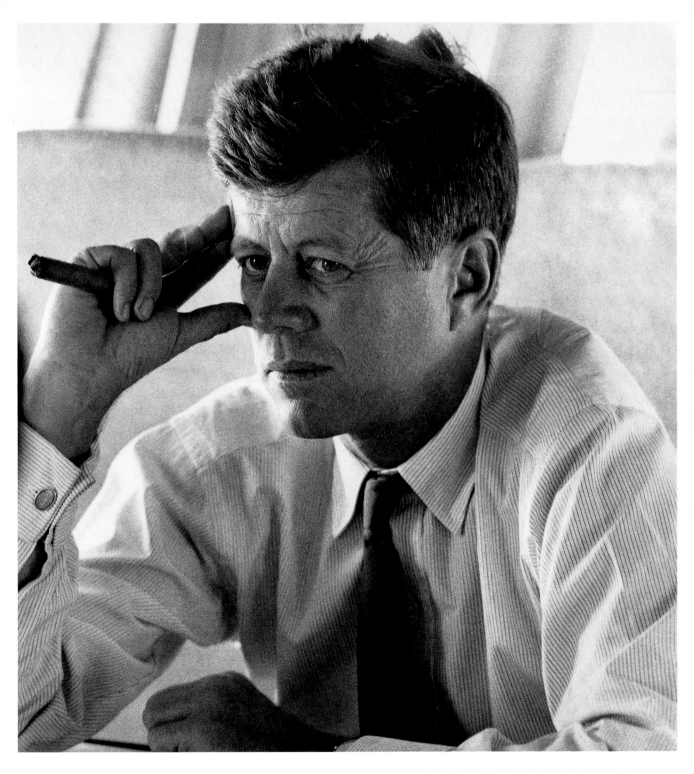

Jack Kennedy's emotional range is caught in this sequence by Jacques Lowe, taken while flying out of West Virginia en route to Nebraska in the spring of 1960. The candidate listens, laughs, questions, ponders, responds, and evaluates. Jack's cigars, lit or not, were calming props during this campaign drama but were rarely seen in public.

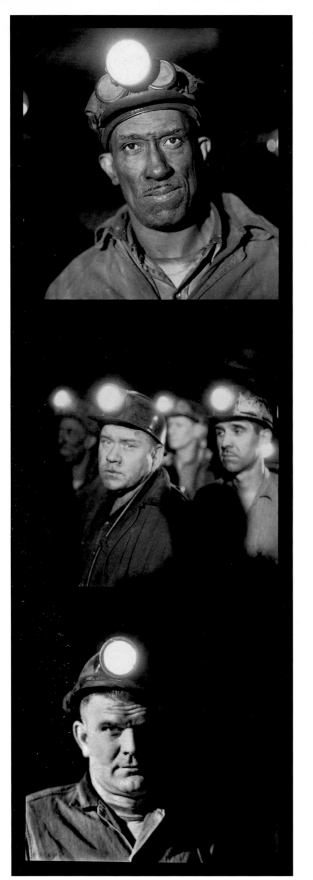
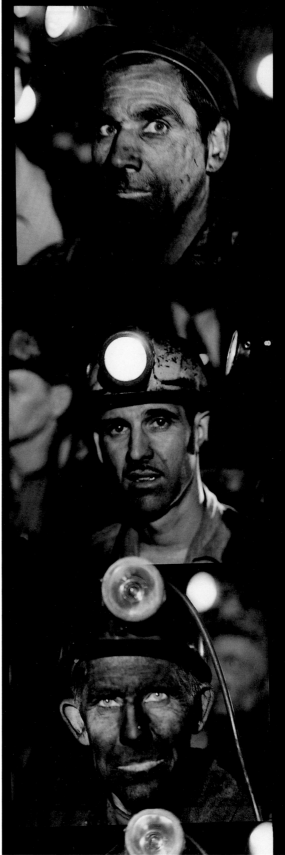

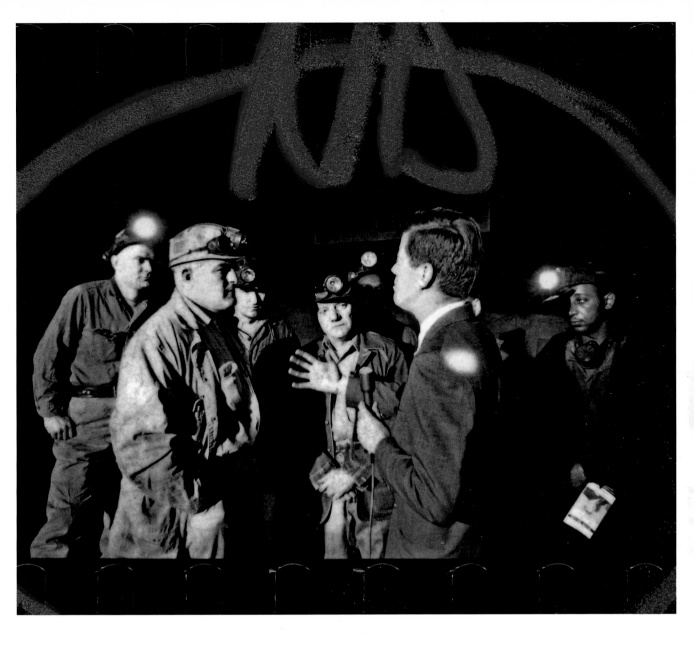

Kennedy's campaign days frequently stretched 20 hours, beginning at dawn at a factory gate and, in this case in April 1960, still active at midnight as the candidate shows up at a West Virginia mineshaft to catch the shift change. Unlike today's politicians, Kennedy never adjusted his clothing to fit the surroundings. When asked why he always showed up in his gray suits, he once replied, "That's me. I keep it that way."

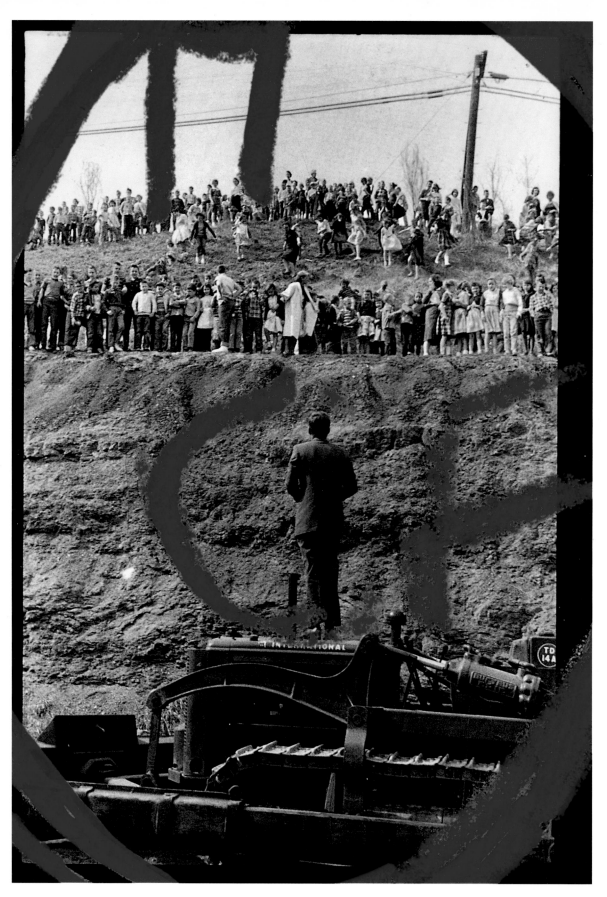

While traveling from Parkersburg to Charleston, West Virginia, Kennedy spotted a group of grade-school students waiting with their teacher along the road. He stopped his motorcade and climbed onto a tractor (with some help) to give them a short speech. Little of what he said could be heard but the kids had their moment—and it would surely be related to their parents that evening. The impulsive act also gave photographers a welcome change of scene.

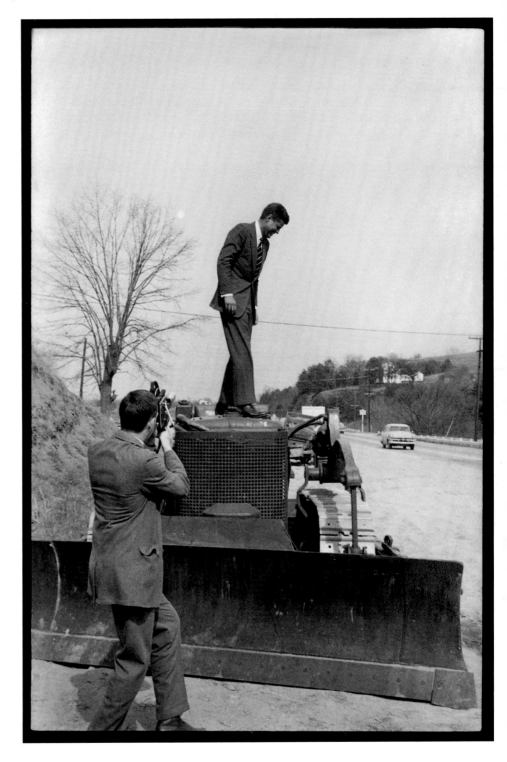

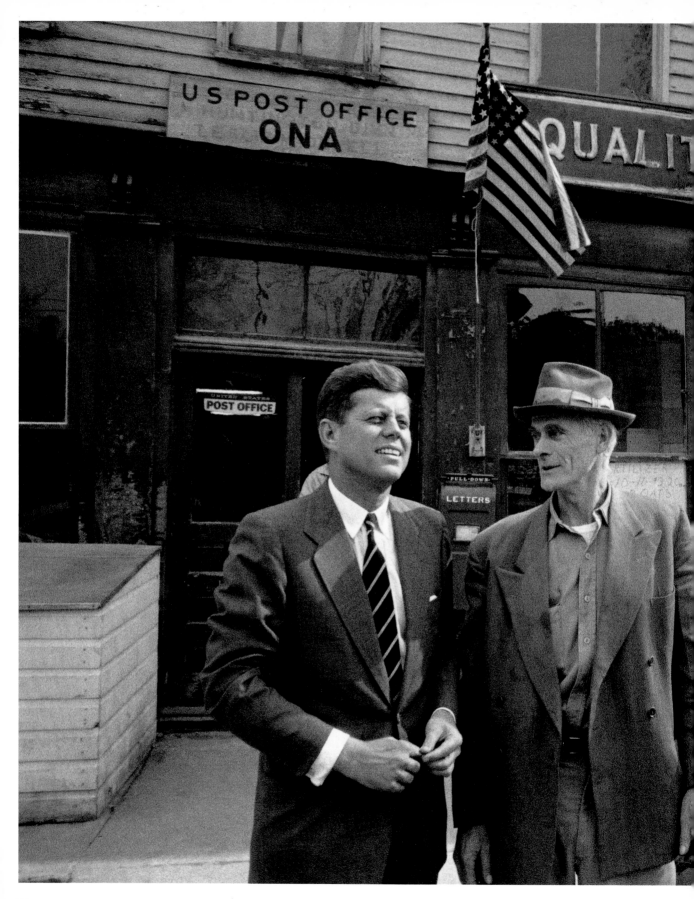

There were only three homes in the West Virginia town of Ona but Kennedy spotted a voter or two on the streets and ordered his car to stop so he could shake their hands. Jacques had fallen behind the motorcade just minutes before and he drove through Ona twice before he realized the candidate was still there. JFK was fascinated with such poor communities, often wondering what kept the people there and what could be done to improve their lives. He considered visits to hamlets like Ona as part of his education for the White House.

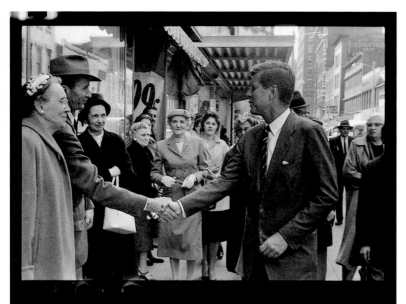

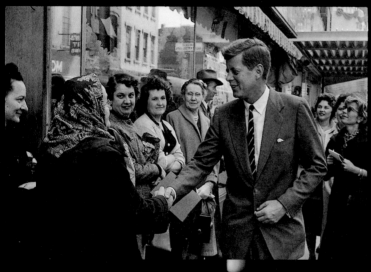

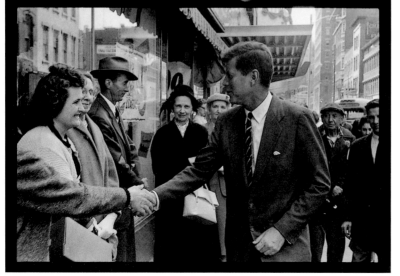

Left: In West Virginia, there were endless hands to shake, endless smiles to dispense.
Right: Jacques Lowe caught this image, a favorite of Jack's, during an April 1960 stop in Charleston, West Virginia, just days before Kennedy won the primary. JFK has been claimed by a supporter and is enjoying it, as local pols and reporters follow along. Years later, Caroline Kennedy Schlossberg presented a copy of this photo to President Bill Clinton, who put it in his "Kennedy corner," a collection of Kennedy family memorabilia in Clinton's private study on the second floor of the White House.

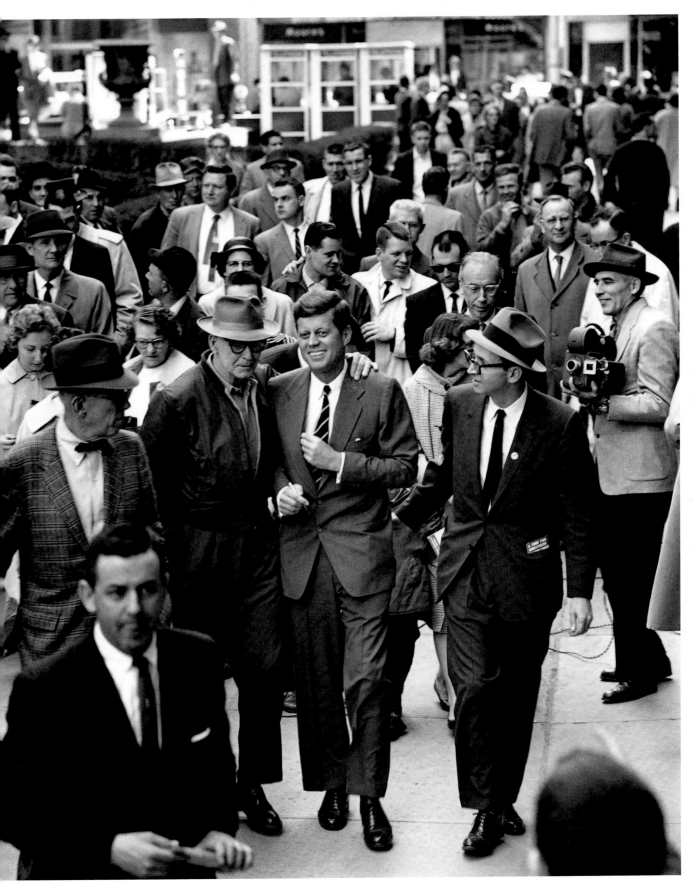

Democratic Convention

Los Angeles and Boston

The Democratic National Convention of 1960 turned out to be more show business than politics. By most counts, the Kennedy crew arrived at the Los Angeles convention site with 600 of the 761 delegates needed to win the nomination for president.

Beyond that, according to Larry O'Brien, ranking member of the now-famed "Irish Mafia," Kennedy's political operatives from Boston, Jack had been tested and was viewed with respect and affection by a growing number of Americans.

The 4,509 delegates and alternates joined 4,750 members of the media and thousands of party workers and fans to form a political camp meeting estimated at 45,000 by Los Angeles officials. The joyous partisans threw a monster party in search of a hero.

The Kennedy clan, with kids, wives, and groupies in tow, took the spotlight draped in red, white, and blue. Hollywood also turned out in numbers; young starlets like Angie Dickinson and Jill St. John lent their pulchritude to the Kennedy cause. Old Democratic bulls like Speaker of the House Sam Rayburn and Chicago Mayor Richard Daley stalked the convention floor with their usual dour expressions. One sensed that they understood a new wind was buffeting their parched political landscape.

Even Eleanor Roosevelt, FDR's stalwart widow, showed up to stoke memories of Democratic glory, although she was doubtful of the young Kennedy. There were suspicions that she favored either two-time loser Adlai Stevenson, who lurked in the wings, or Lyndon Johnson, who was trying to stir a rump movement on the floor.

For the most part, however, the convention was orchestrated from Suite 8315 of the Biltmore Hotel where Bobby Kennedy, O'Brien, Kenny O'Donnell (another Irish Mafia member), and Pierre Salinger, a transfer from Bobby's rackets committee staff and later Kennedy's White House press secretary, presided over a network of party footmen.

Within hours after Jack landed in Los Angeles, Pennsylvania Governor David Lawrence, a legendary party elder, pledged the final big bloc of delegates. When Bobby left Lawrence's hotel suite, he strode down the hotel's dim corridors with a smile on his face, pumping his right fist into the open palm of his left hand and proclaiming, "It's over, it's over. We've got it." And they did.

Before the nomination became official, however, aging Democratic diehards pushing for yet a third nomination for the hapless, but beloved, Stevenson mounted a floor demonstration. It made for great television, but little else. As balloons soared, bands blared, and conscripted students chanted "We want Stevenson," O'Donnell watched with journalists from above the floor. "See any delegates out of their seats?" O'Donnell asked. "Very few. Don't worry." The benign storm passed as he predicted.

Meanwhile, the Senate majority leader, Texan Lyndon Johnson, had a vain hope that Kennedy would be seen in the convention's raucous combat to be weak and uncertain. He challenged the New Englander to a debate before the Texas delegation and opened the confrontation by reciting his Senate accomplishments. Kennedy punctured Johnson's small balloon with one beautiful incision: "I agree. We need to keep him in the Senate."

The only real unknown at the convention was the identity of Kennedy's running mate. Before going to Los Angeles, Jack viewed Lyndon Johnson as "the most able man" for consideration, but believed LBJ meant it when he vowed he would "never, never, never accept the vice presidential nomination."

So Kennedy settled on Missouri Senator Stuart Symington, although protocol required that LBJ first be offered the nomination. Johnson startled everyone by accepting. Bobby and his big city labor friends were anguished, but the Boston-Austin axis had been chartered and it held. As Johnson told it, Speaker of the House Sam Rayburn, who was "just like a daddy to me," advised him to reject the offer. But the next morning, Rayburn threw open the bathroom door as Johnson was shaving and ordered him on the ticket. A stunned Johnson questioned the change in opinion. "I'm a hell of a lot smarter this morning than I was last night," Rayburn replied. He was that, and Lyndon Johnson helped bring victory.

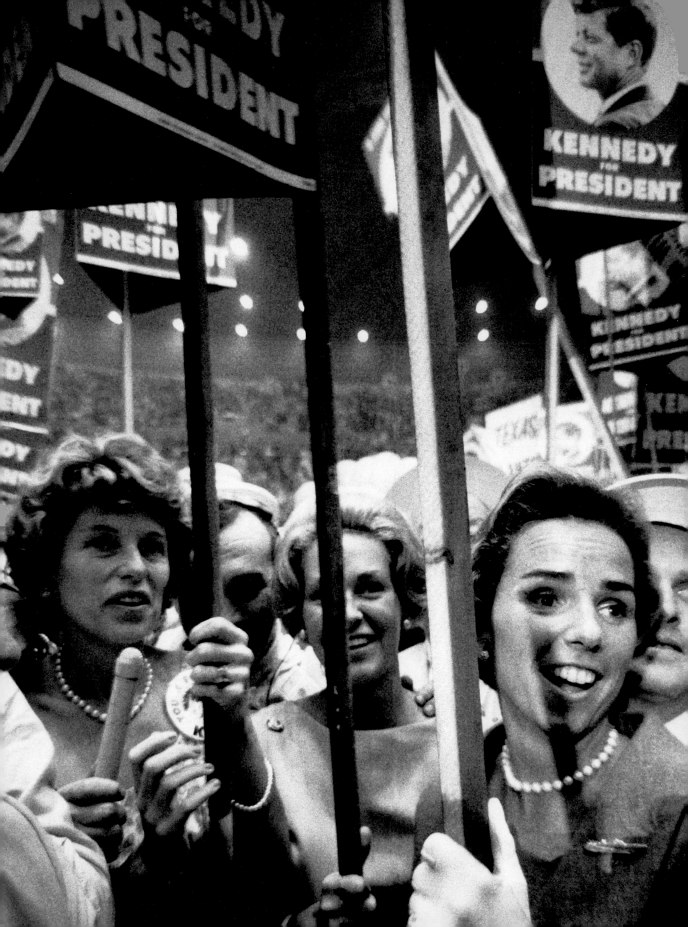

Previous page:
The Kennedy women, including Eunice, Joan, and Ethel, rally for Jack as the Democratic National Convention opens on July 11, 1960, at the Los Angeles Memorial Sports Arena.

Right: Bobby talks with two early supporters of JFK's presidential bid, Connecticut Senator Abraham Ribicoff and John Bailey, the Democratic state chairman for Connecticut.

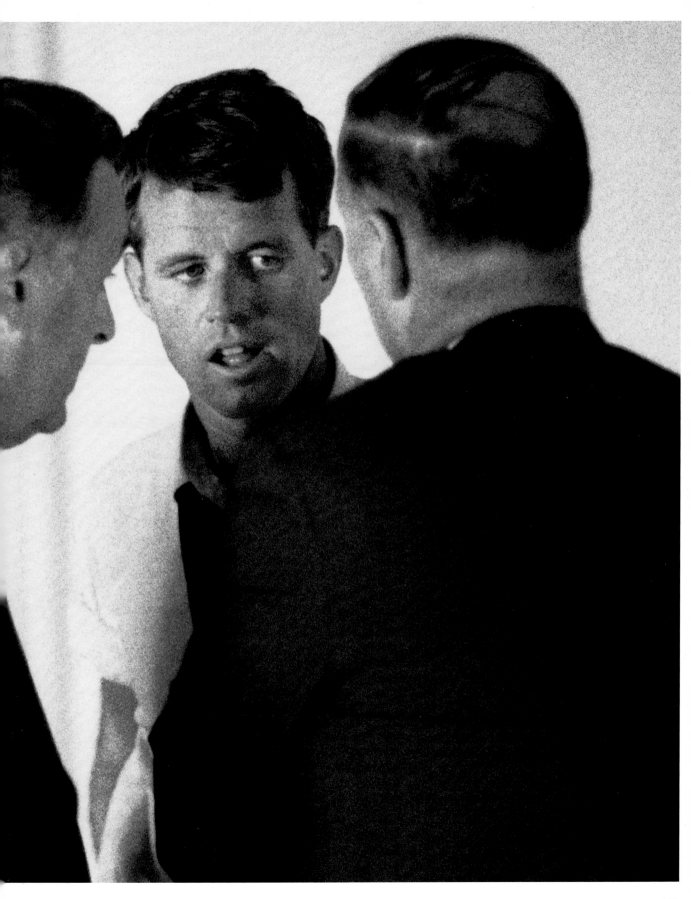

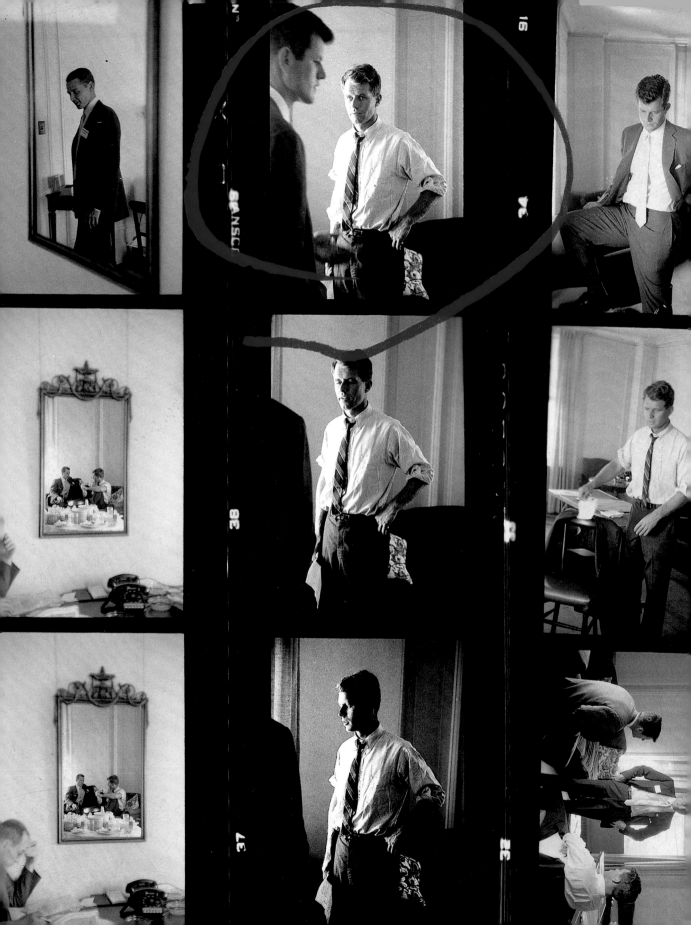

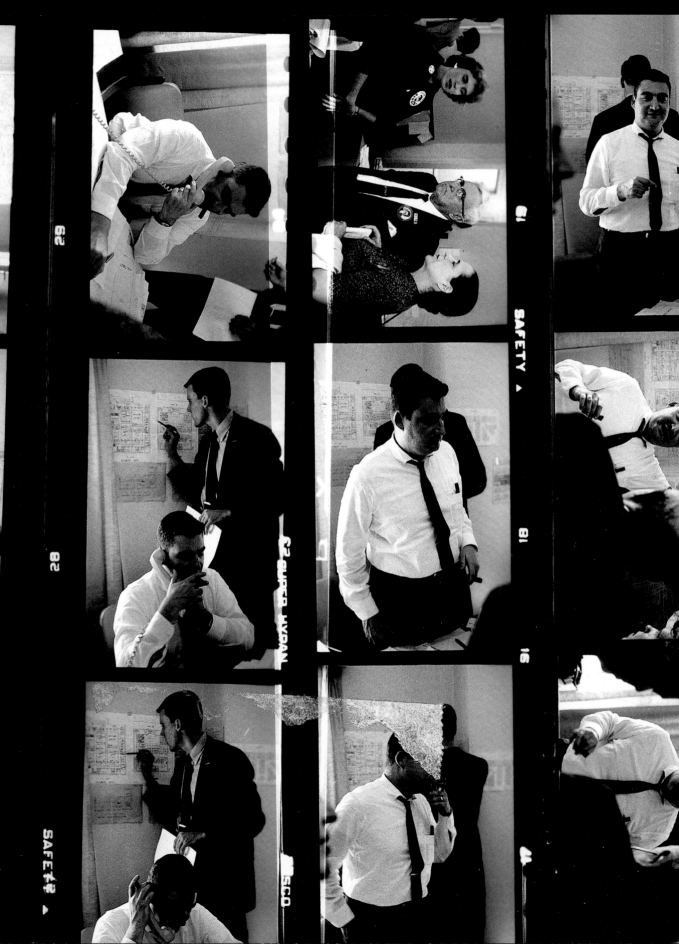

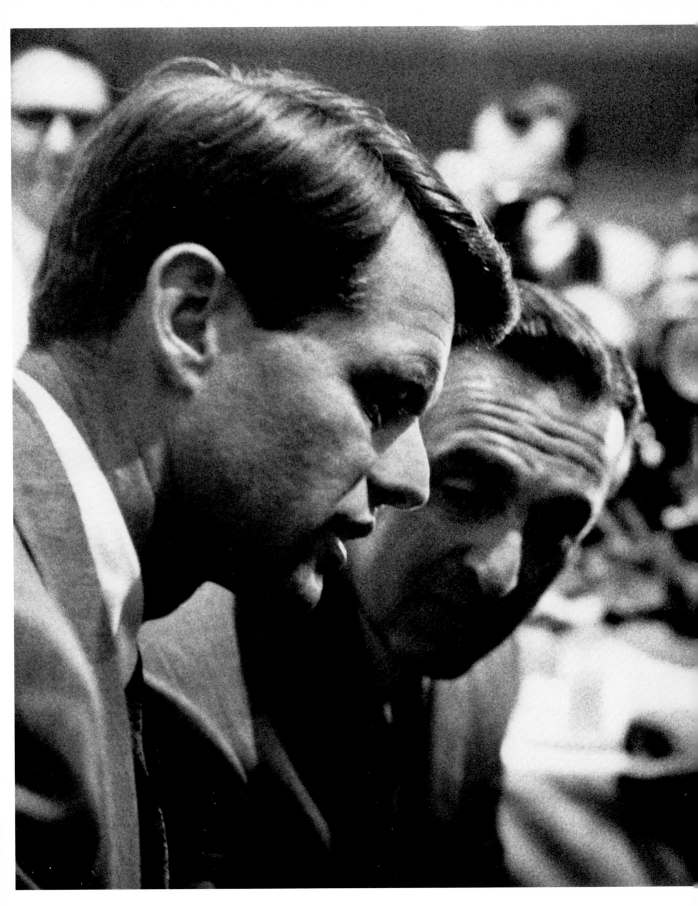

Previous pages: Suite 8315 in the Biltmore Hotel serves as the Kennedy nerve center. Bobby and Ted Kennedy join Press Secretary Pierre Salinger and their brother-in-law, Campaign Manager Steve Smith, in a strategy session.

Left: Prior to the presidential nomination on July 13, there were three steady days of state caucus meetings. Bobby and Jack confer with Senator Abraham Ribicoff during one of them.

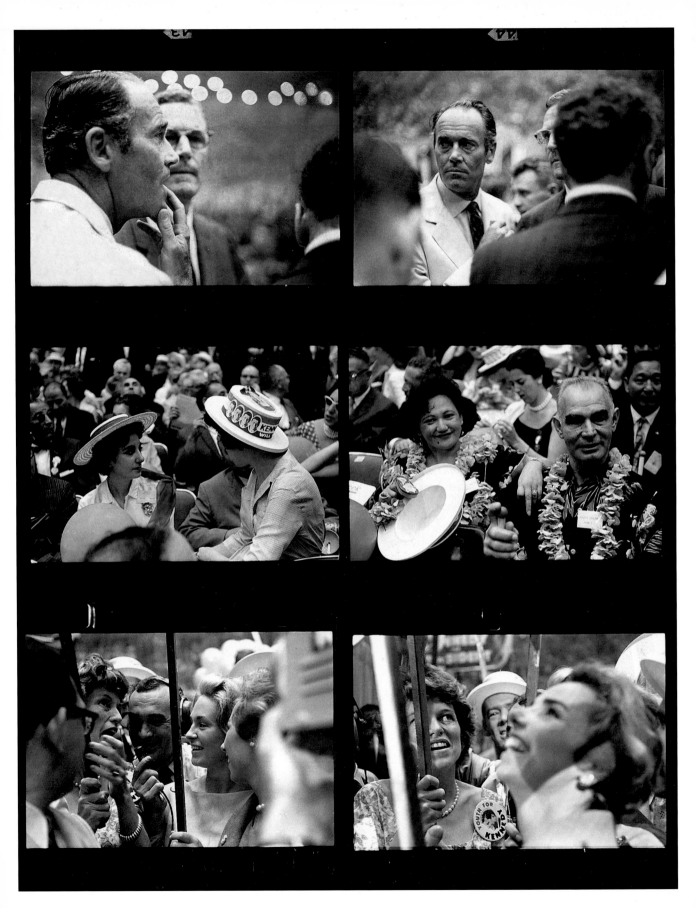

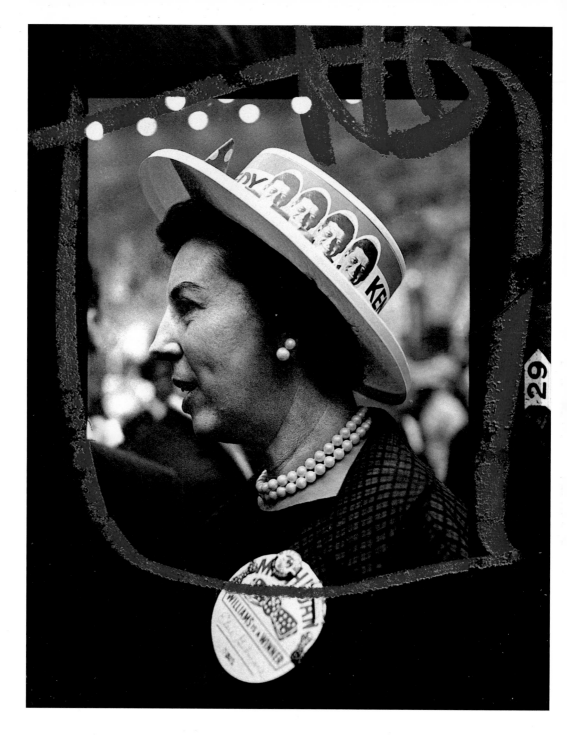

Left: An old-time liberal, actor Henry Fonda, helps direct the uproarious Adlai Stevenson demonstration on the convention floor. Elsewhere, conventioneers—including the Kennedy women— keep the energy high. *Above:* Like many Kennedy supporters, this Michigan delegate, pearls in place, has been swept up by the tide of change.

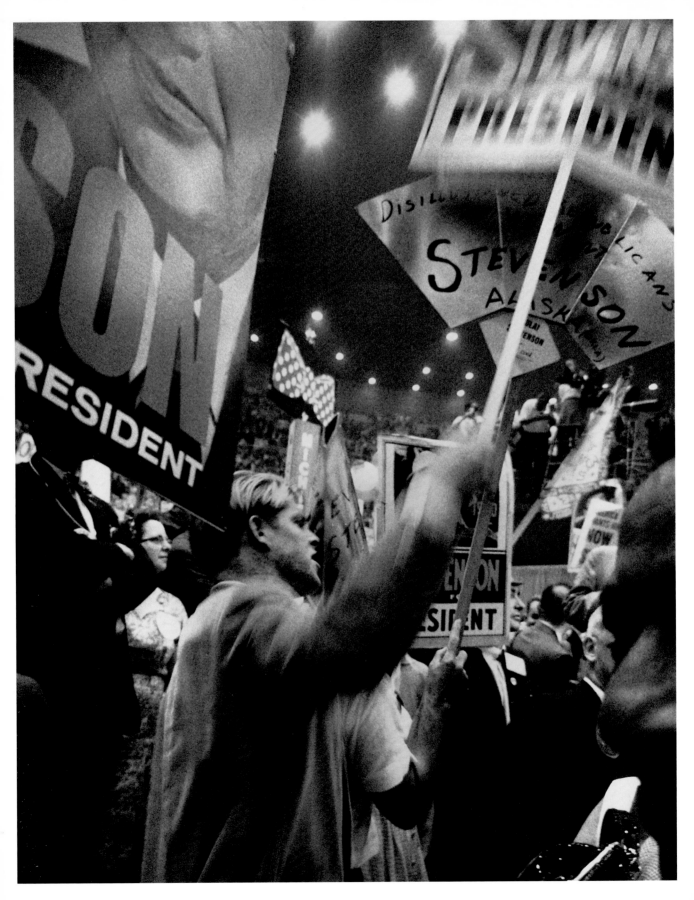

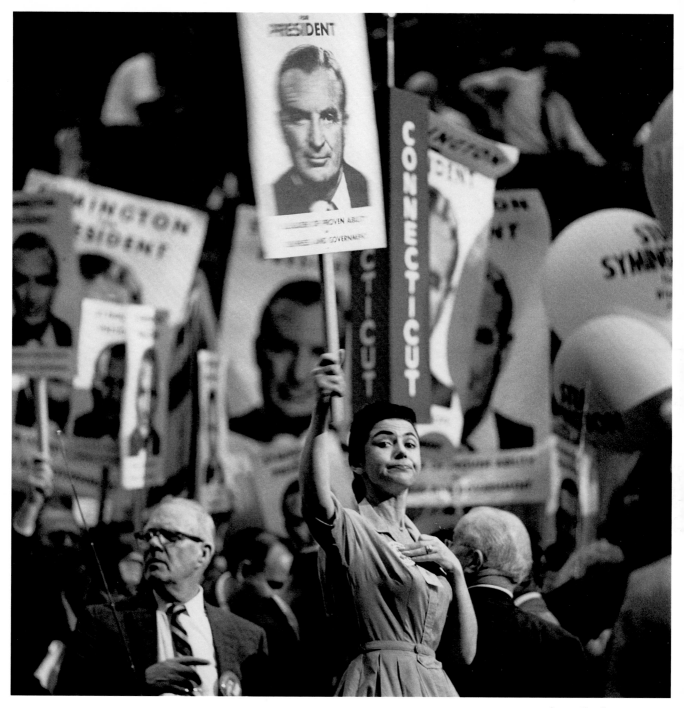

Convention floor demonstrations fail to loosen the Kennedy hold on the delegates. The rowdy Adlai Stevenson show was brought in from the outside and did not include many real delegates. The demonstration for Missouri Senator Stuart Symington was only a minor convention event.

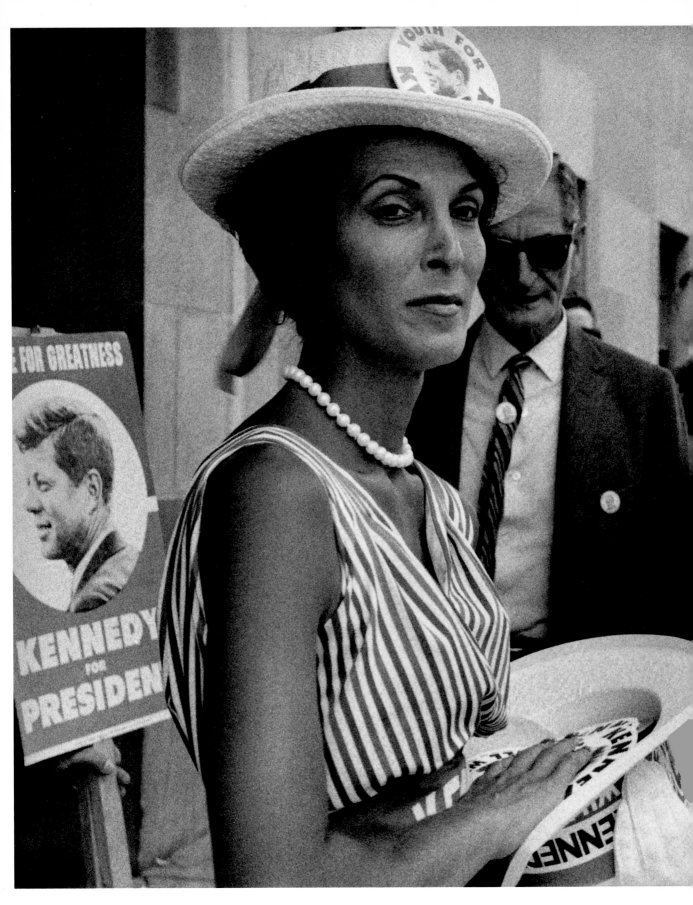

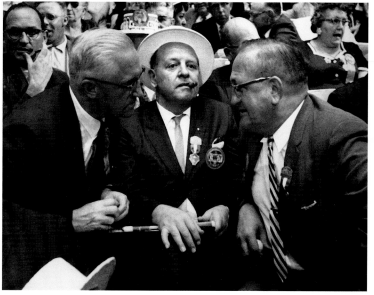

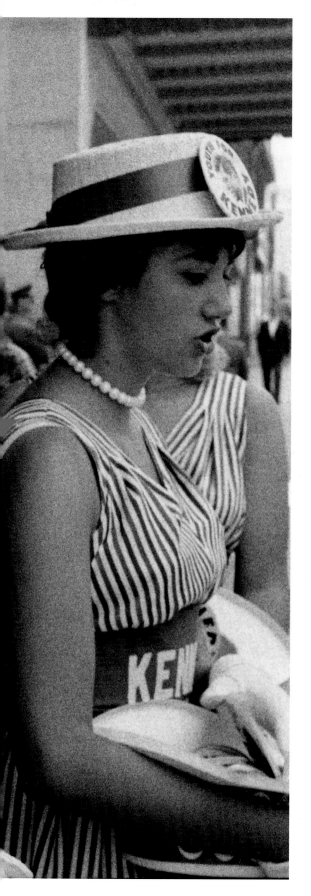

Left: Kennedy supporters, dressed for the event, stand in front of a placard made from a Jacques Lowe image.
Above: JFK's delegates run the gamut from fresh-faced young women to hardboiled veterans of the convention process.

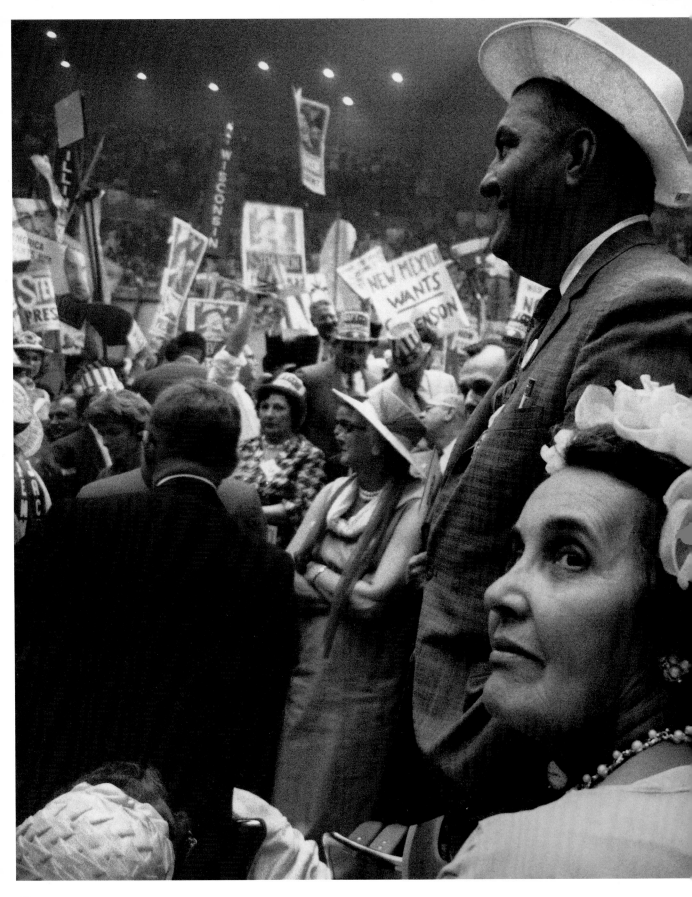

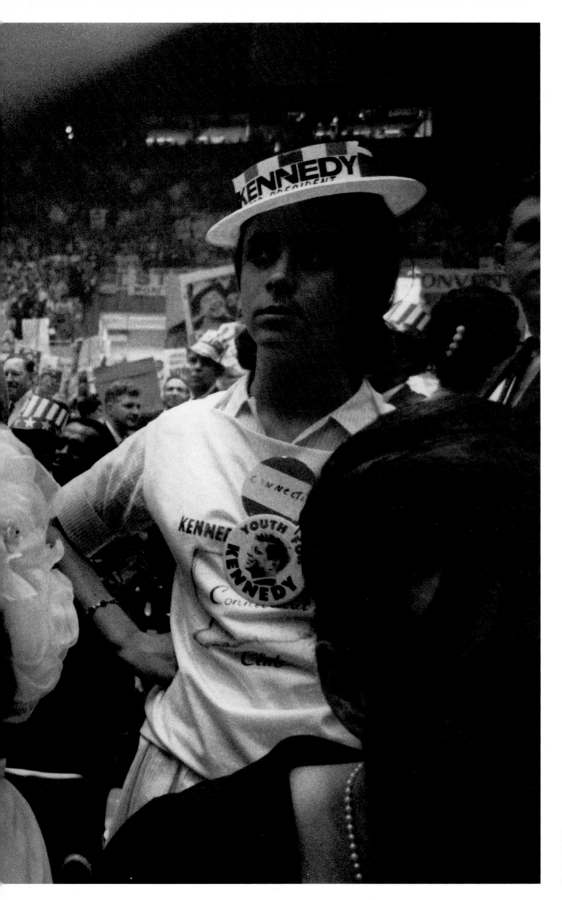

Delegates decked out
in goofy hats and
campaign garb wait for
speeches and votes.

129

Jack Kennedy already had Pennsylvania sewed up when he and Lyndon Johnson addressed the state's delegates, a convention ritual.

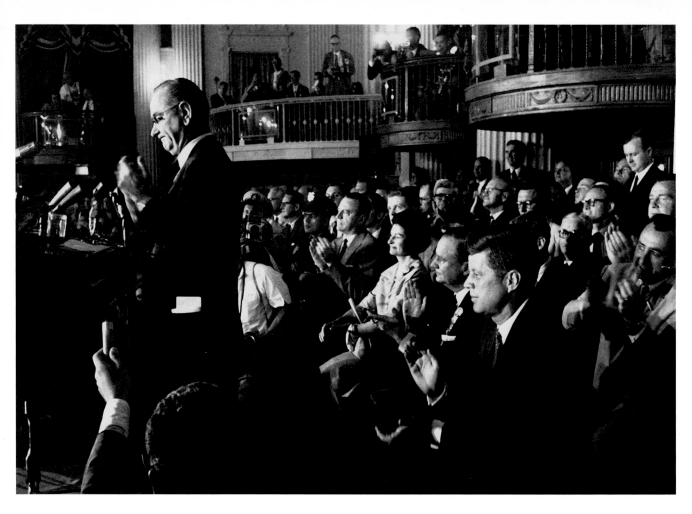

Above: Lyndon Johnson hoped to move the convention his way with a bold presentation to the delegation from his home state, Texas. Lady Bird Johnson sits behind her husband while Kennedy fidgets and takes notes. South Carolina Senator Fritz Hollings, a Kennedy friend, had persuaded Jack to respond to LBJ's challenge.
Right: Johnson gives a rousing, but heavy-handed, rundown of his Senate achievements. Kennedy would deftly counter that harangue by agreeing that LBJ accomplished much in the Senate—and should stay there.

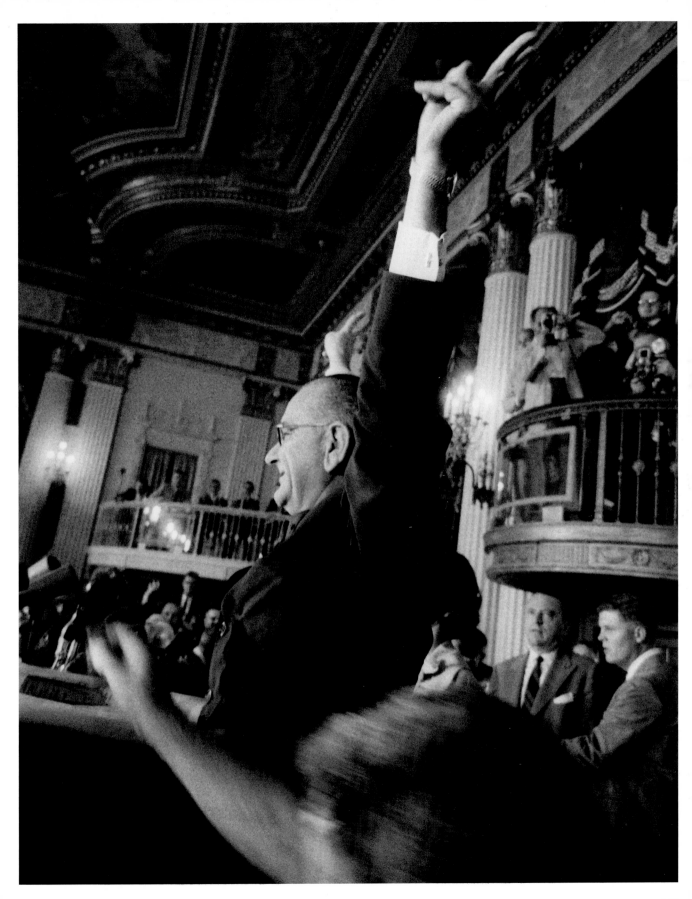

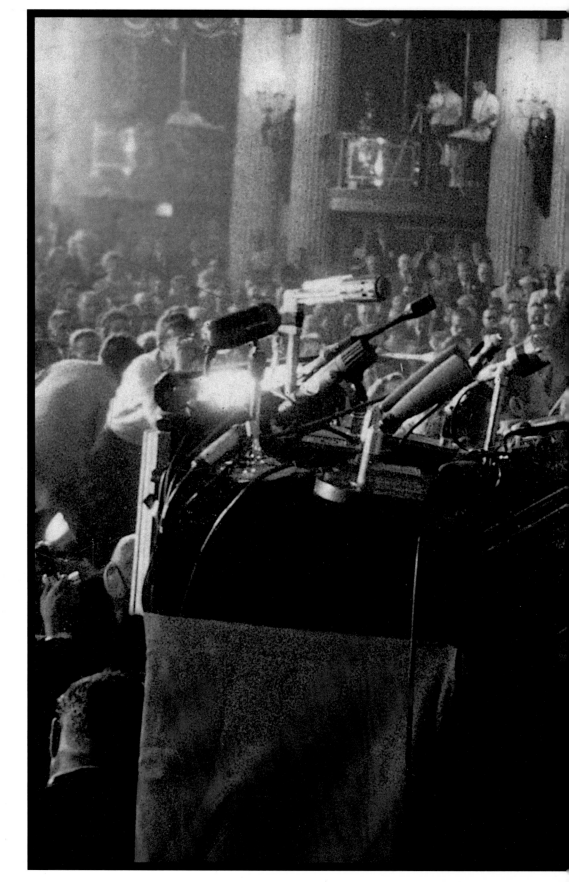

As Kennedy responds to LBJ in front of the Texas delegation, it became clear that younger men and women were taking over the political scene. To even many of the Johnson delegates, the change was exciting.

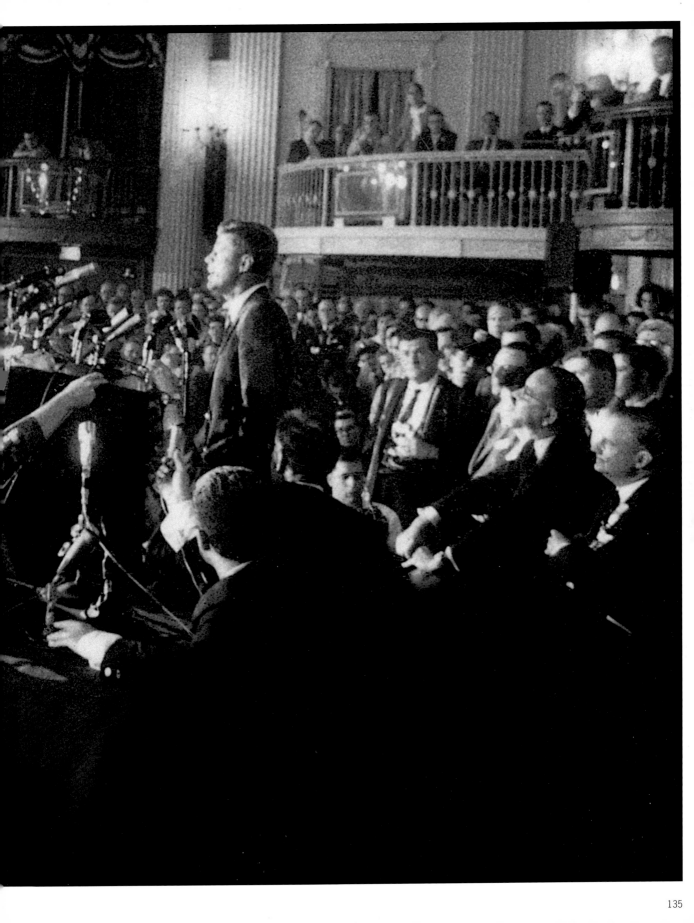

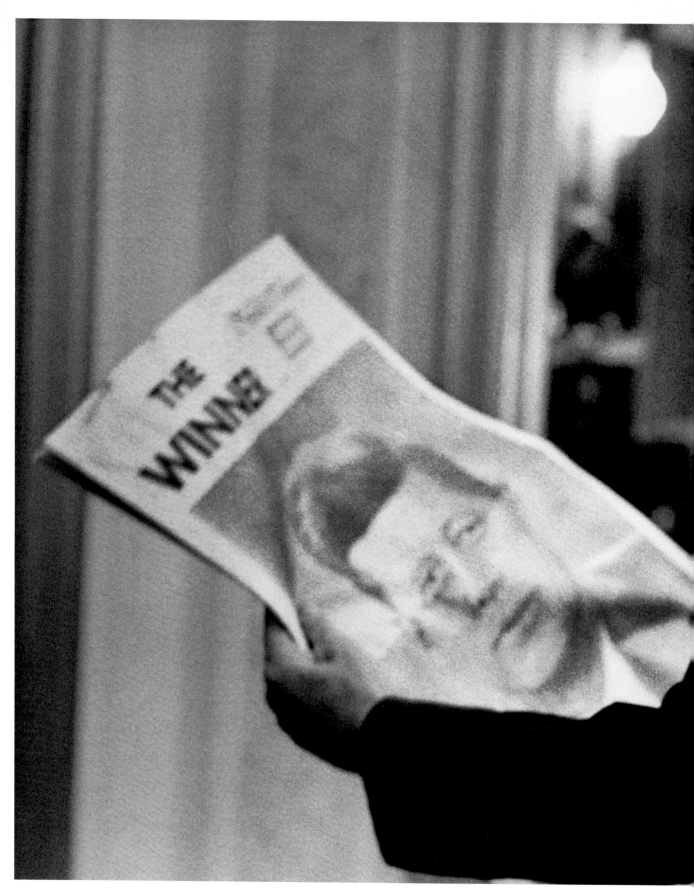

Though fully expected, the headline declaring triumph is a sweet one for JFK. Jack broke protocol when the vote came and sped in his motorcade to the convention hall to personally thank the delirious delegates.

Early in the morning after his nomination, Jack calls Lyndon Johnson from a suite at the Biltmore Hotel to seek a meeting two hours later. Kennedy intended to ask Johnson to be his running mate, fully expecting the Texan to decline. Senator Stuart Symington already had acknowledged his willingness to run as vice president. Lady Bird answered the phone call and woke her husband, who had stayed up most of the night.

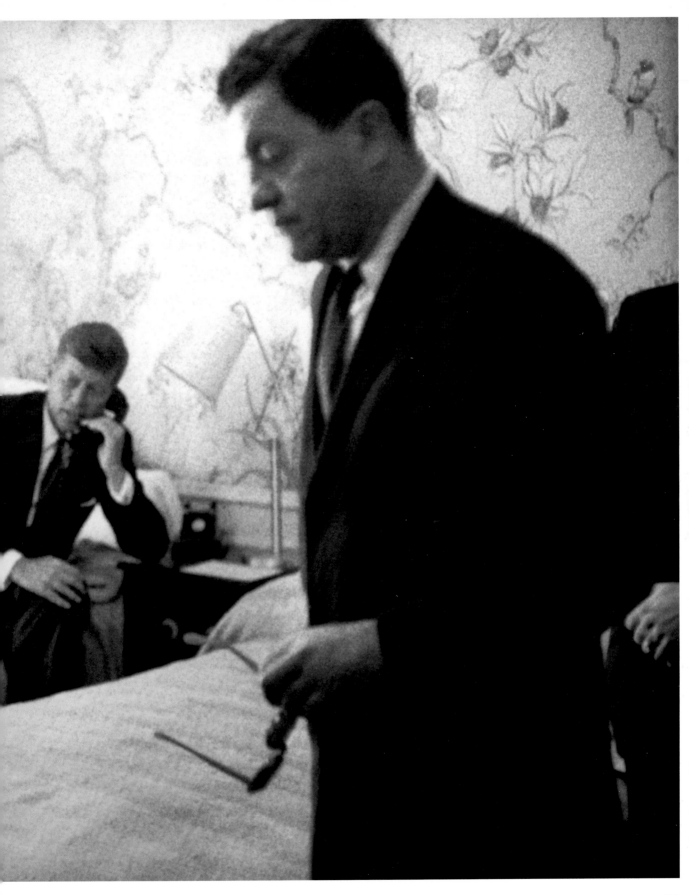

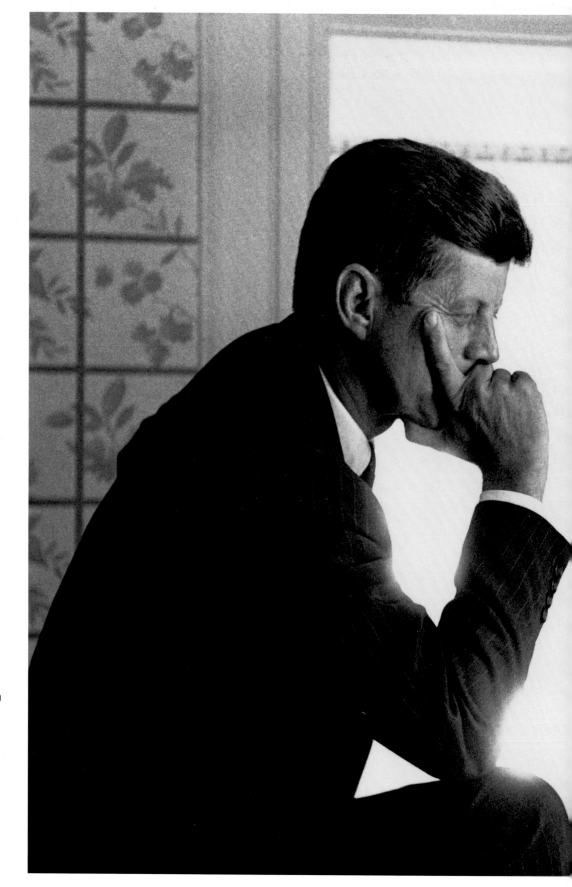

Kennedy told Jacques: "I asked Lyndon Johnson if he were available for the vice presidency. He told me that he was. He then suggested that I discuss the matter with various party leaders while he conferred with his own advisers." Kennedy neglected to mention that he was startled by Johnson's willingness.

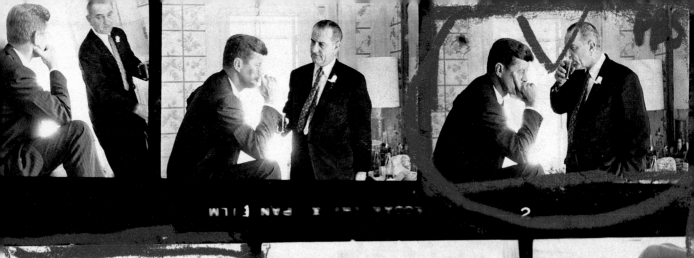

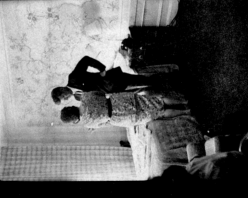

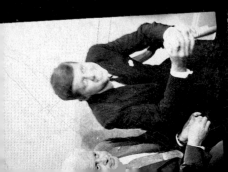

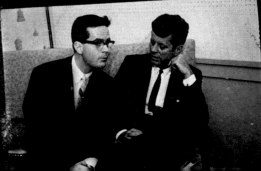

 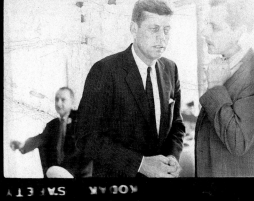

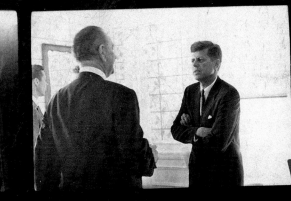 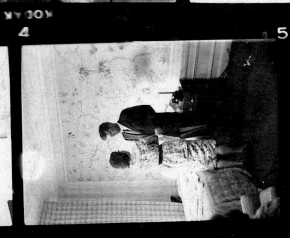

KODAK · SAFETY · FILM · A

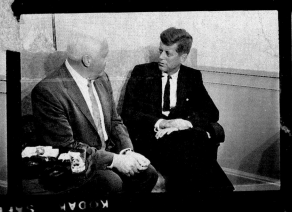

 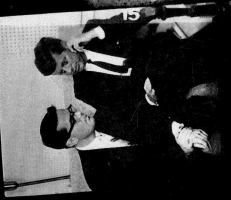

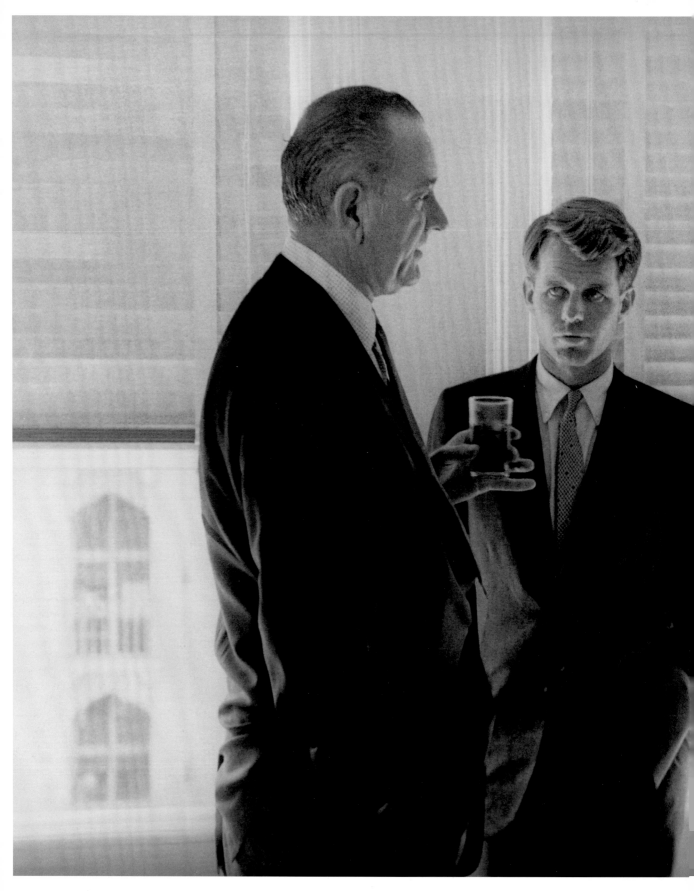

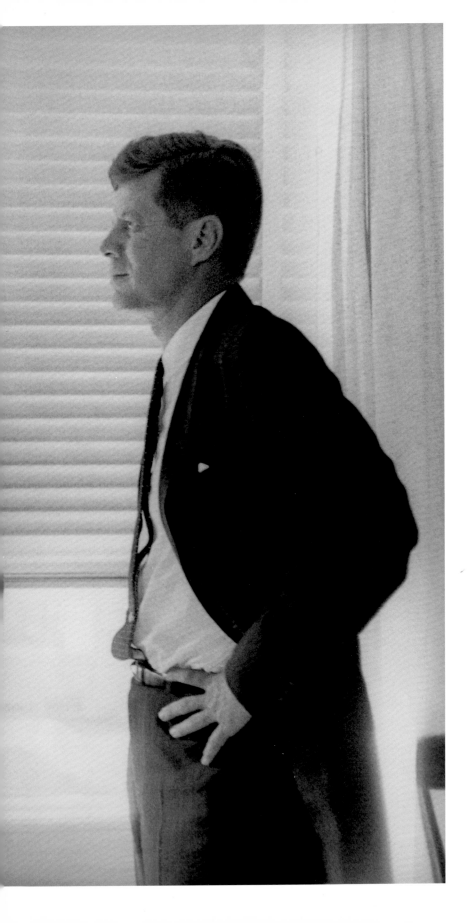

Previous pages: JFK
and LBJ meet, and then
spend most of the day,
July 14, consulting with
party leaders and aides.

Left: Meeting just after
LBJ agrees to run as vice
president, Bobby is
clearly wary. Bobby's
concerns grew so intense
that Jack later sent him
down to talk with LBJ,
who settled the matter
by stating: "If Jack wants
me for vice president,
I am willing to make
a fight for it." Like it or
not (Jack did, Bobby did
not) the Boston-Austin
axis was formed.

The Los Angeles
Coliseum, with seating
for 100,000, overflows
during Jack's acceptance
speech on Friday,
July 15. All five other
contenders had thrown
in with the new champion,
rallying the crowd with
calls for party unity.
Even Eleanor Roosevelt
abandoned her
misgivings about the
Kennedys and praised
the new standard-bearer.
The evening was
often described as
a Democratic love-in.
Pregnant Jackie had
gone back to Hyannis
Port and patriarch Joe
Kennedy had stayed out
of sight, watching the
acceptance speech in
New York with Henry
Luce, publisher of *Time*
and *Life* magazines.

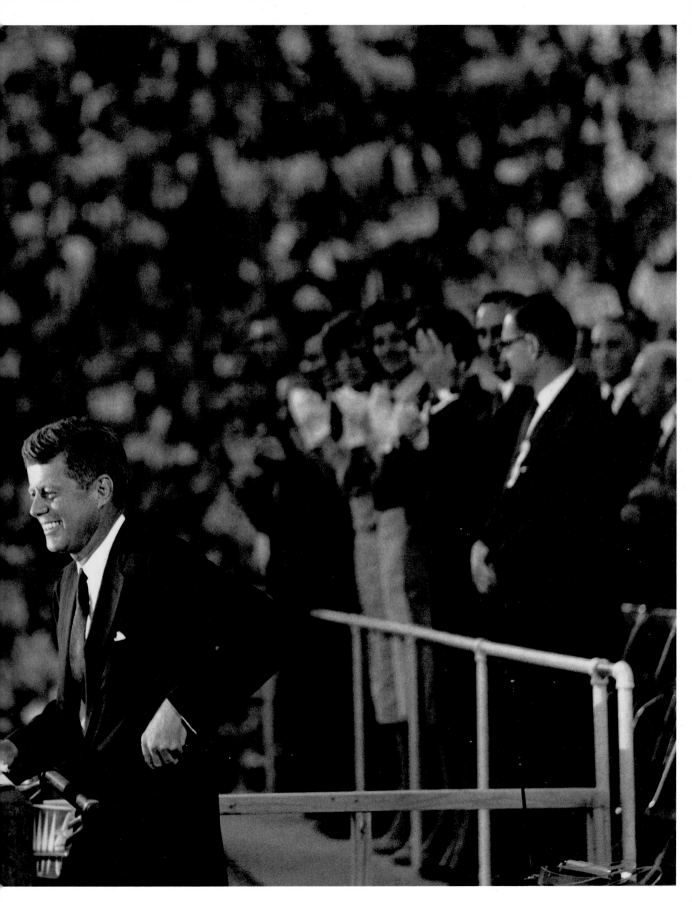

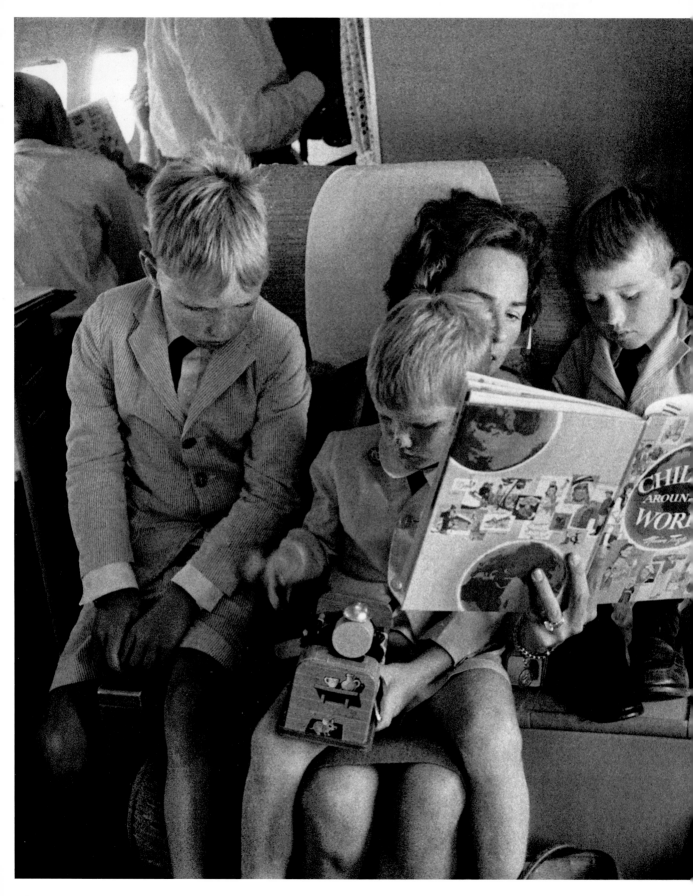

The *Caroline* proves too small for the team of family and advisers now headed to Hyannis Port to rest and plan campaign strategy. Aboard a chartered American Airlines jet dubbed "The Kennedy Special," Ethel reads to her brood. JFK chats with Bobby Jr.

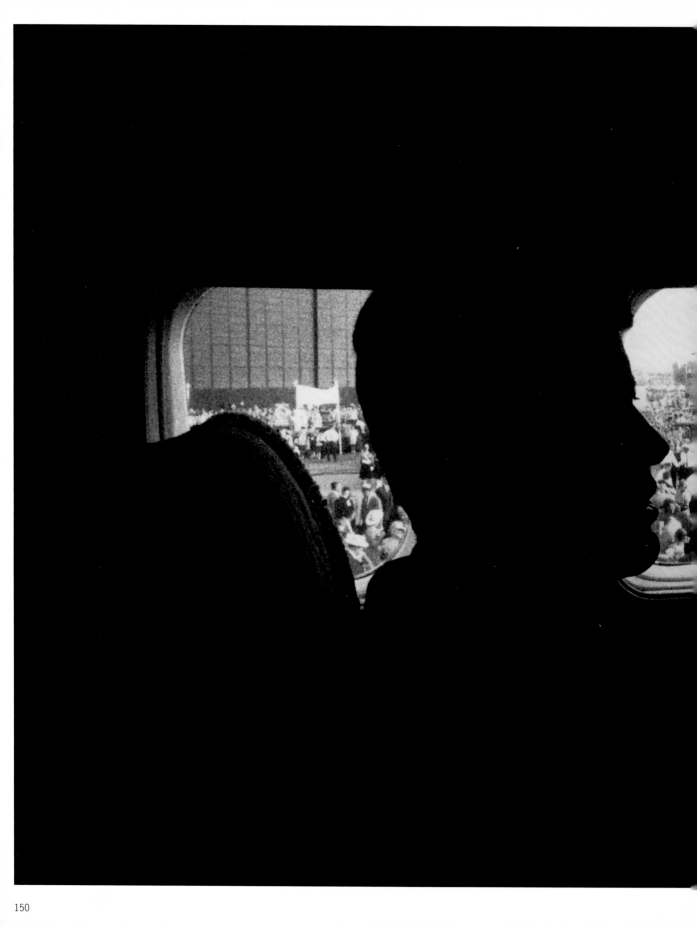

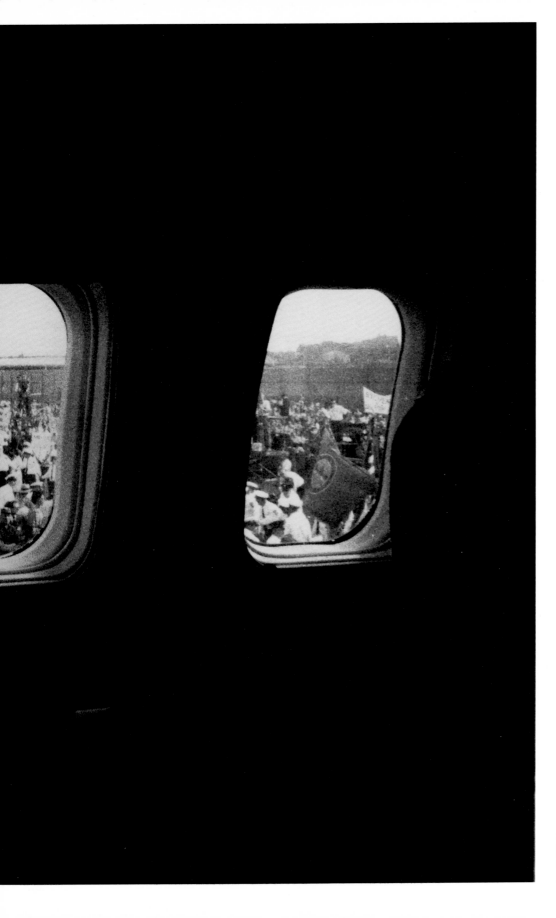

An estimated 15,000
people turn out to
welcome a triumphant
Jack back in Boston.

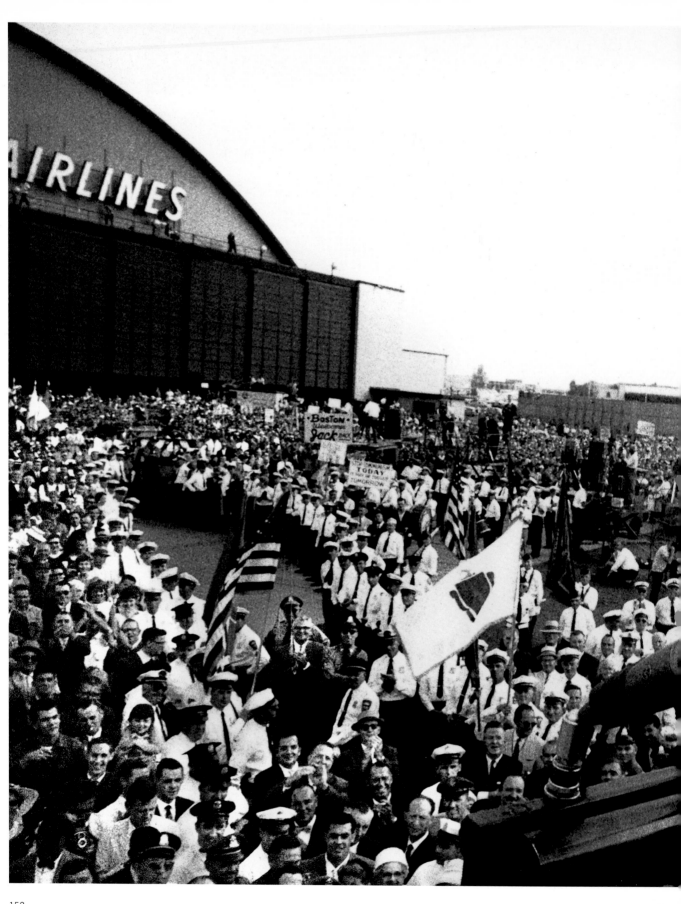

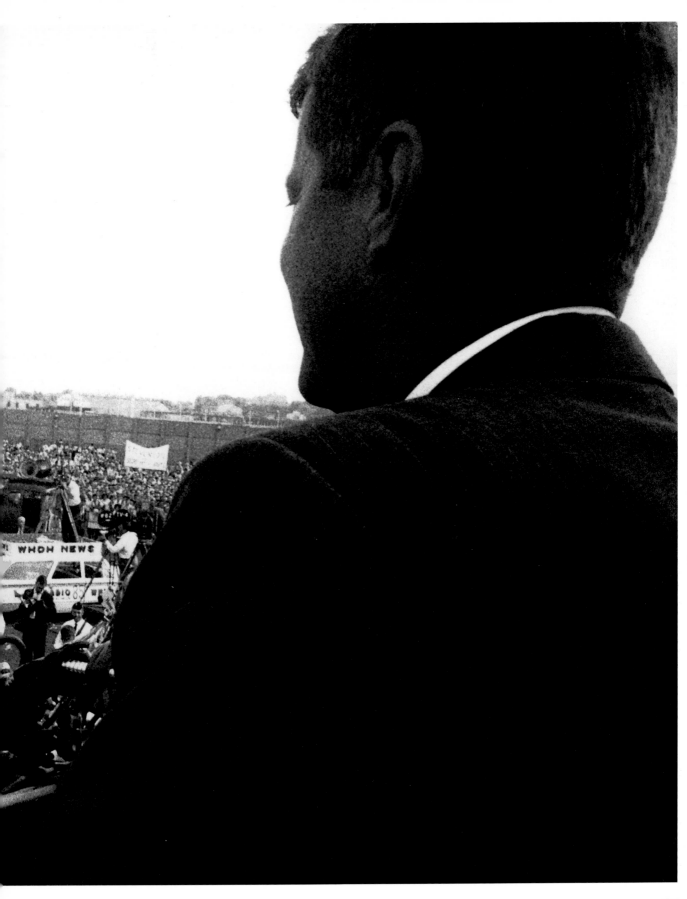

153

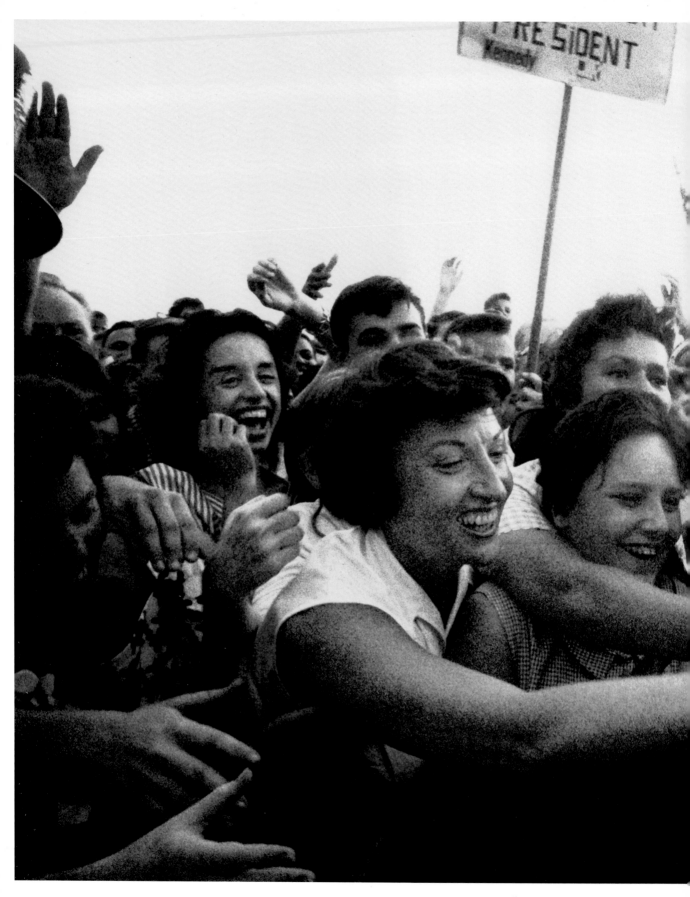

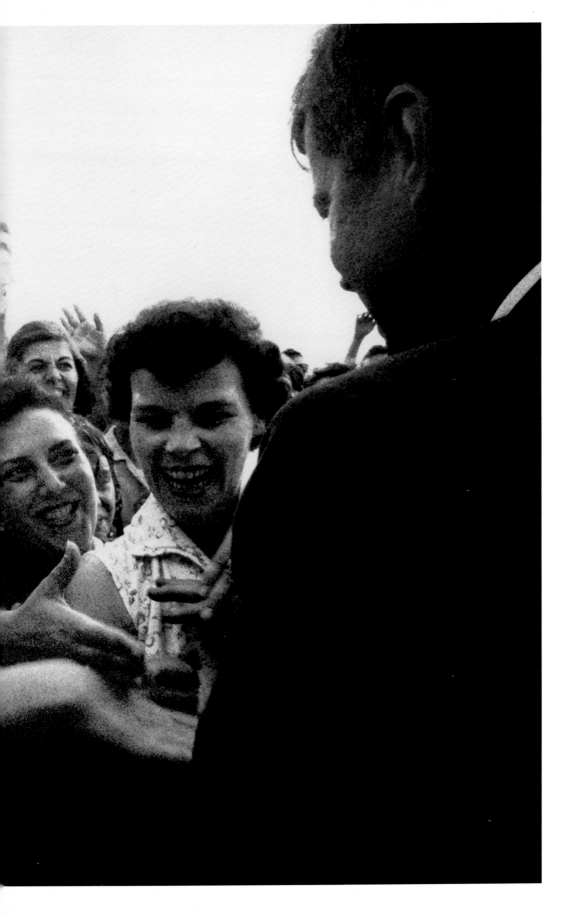

Previous pages: The effusive hometown reception following the Los Angeles convention was a good omen at the start of the campaign. However, Jack and his staff understood that the support was swelled by unprecedented television coverage at the 1960 Democratic National Convention.

Left: Already idolized by many American women, Jack Kennedy sparks even more of a frenzy as the presidential contender. This scene at the Boston Airport was a sign of what was to come: One look, one smile, one touch, and these women became walking cheerleaders for the charismatic young politician.

Summer Camp

Hyannis Port

Hyannis Port was base camp for the Kennedy clan, the place they flocked to over the years to recharge and plan anew. After the Democratic National Convention, they followed old instincts and gathered on Cape Cod to sun and swim and complete blueprints for the national campaign.

Jacques's pictures of the Kennedys in bathing suits and sports clothes, some culled from past respites at Hyannis Port and others from that critical summer after the convention, are among the most unusual in his collection. The close-ups of Jackie in a bathing suit on the beach were a first—and last—for her. As wife, mother, and first lady, she would keep her moments of recreation private.

Though the full impact of the prying public was not yet felt in that August of 1960, Jackie surely had a premonition of what was to come, and she was wary about exposing herself and her daughter to cameras other than Jacques's. The scenes of Jackie and Caroline, both burnished by wind and sun, pleased her, but they also revealed an intimacy she would now want kept within the family as the political storm approached.

Those few weeks after the convention were only a summer idyll on the surface, however casually the Kennedys staged family contests around tennis and touch football. Beneath the soothing vistas of sky and sea, against a backdrop of expansive green lawns, near-frantic preparations were underway for the campaign push. The family had a nation to consider—and conquer. Jack and Bobby crossed the lawn to each other's houses and lounged in the sun, but always with telephones in hand. The gears were grinding.

Lyndon Johnson came by to discuss his role in the campaign, meeting for hours with Jack before adjourning to a motel where he conferred with the Kennedy staff. A couple of reporters hid in the motel's bushes and overheard LBJ through the open windows declaring that he should be cast as a tall, tough Texan riding into American towns and cities with his guns drawn. "The people really like that image," he declared.

The eavesdropping reporters were so tickled by the declaration that they began to chortle; Johnson's secretary heard them and called the police. The reporters scurried out of sight over a berm just as LBJ began explaining the need for a press secretary who would transfer some of the Kennedy magic to him.

During the same summer, Adlai Stevenson was taken on a four-hour cruise in Nantucket Sound aboard the *Marlin*, the Kennedys' fifty-two-foot motor-yacht. Jack sought Stevenson's opinions on foreign and domestic policy. "I tell you that this country is lucky he was not nominated," Kennedy groused to a friend the next day. "Stevenson couldn't make up his mind about anything. Whatever I asked him, he told me he would have to get back to me or he wasn't sure."

By then, the outside world had discovered the sleepy streets of Hyannis Port and the importance of the Kennedy compound, which contained the homes of father Joe, Bobby, and Jack. For all old Joe's notoriety and money, few people previously paid much attention to the family's summer residence so, at first, only a white picket fence twined with roses separated it from the public street. That changed with the Los Angeles convention, however. Now tourists arrived in increasing numbers, cameras loaded and cocked in hopes of a glimpse of any Kennedy adult, child, or pet. With the gawkers came an eight-foot fence.

One story that circulated with sinister delight claimed that Jackie had been spotted on a worker's ladder left leaning against the fence. She had peered over the top at the cluster of tourists outside then, hidden by the fence on her way down, thumbed her nose at them.

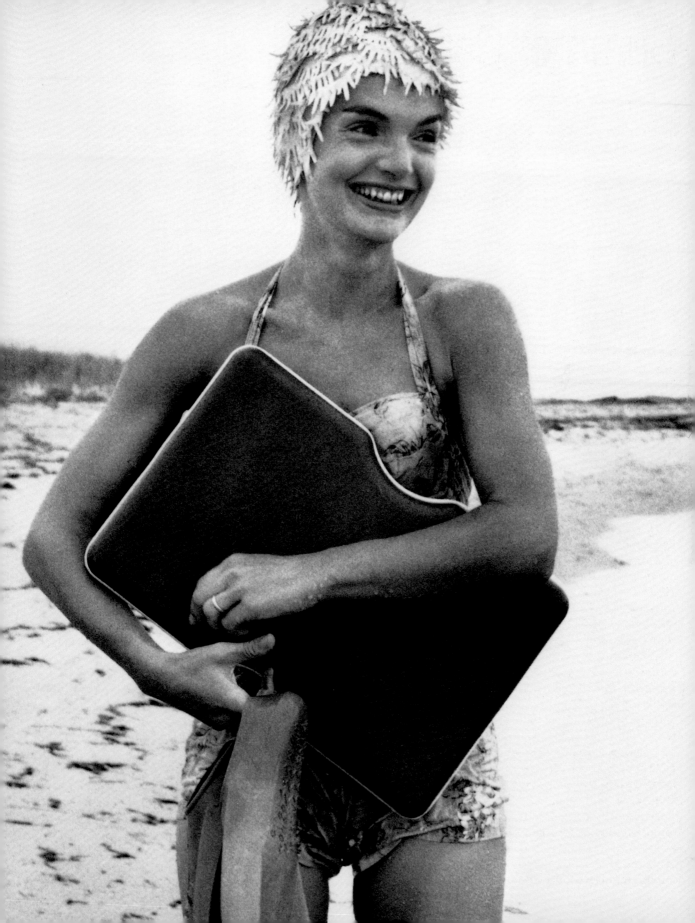

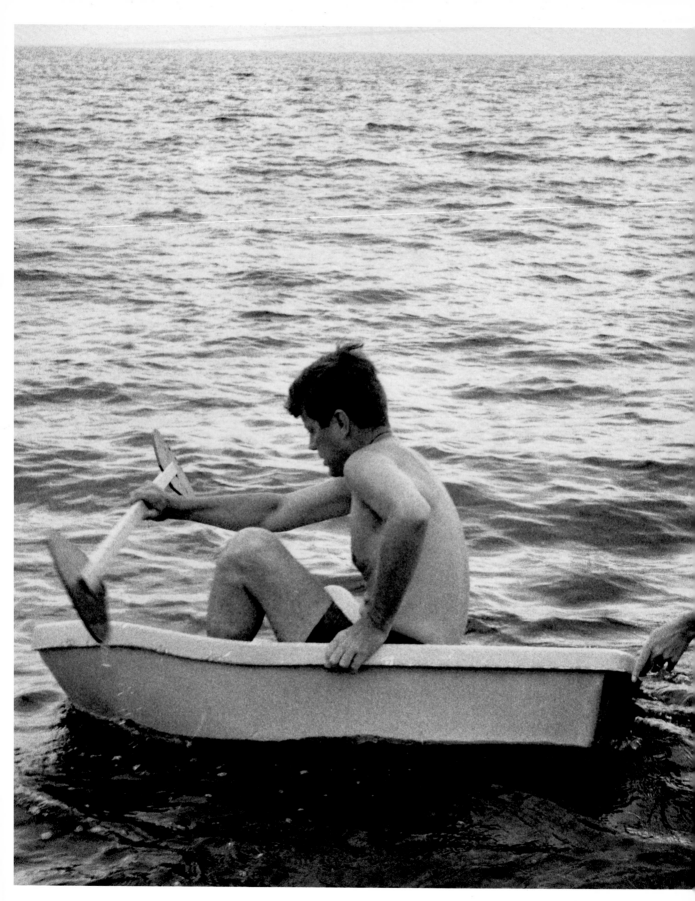

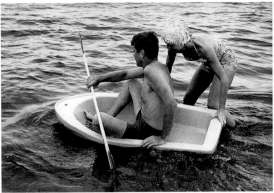

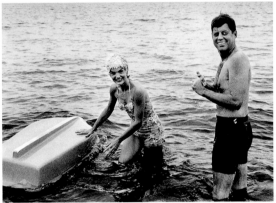

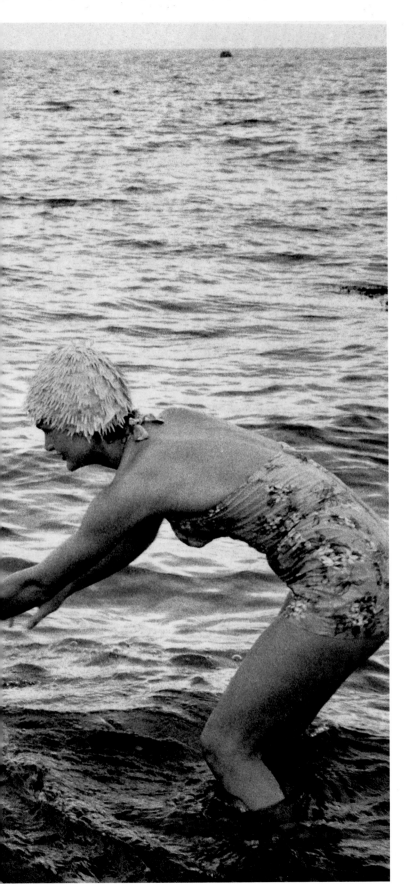

Previous page: Jackie was not always keen on touch football and other Kennedy pastimes, but she liked the water. Jackie became an excellent water skier during summer stays at Hyannis Port and Hammersmith Farm, her stepfather's home on Narragansett Bay, Rhode Island.

Left and above: Jackie generally preferred stately yachts to small craft, but Jacques catches a relaxed Mrs. Kennedy having fun with her husband in the children's dinghy.

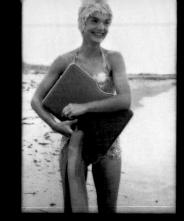
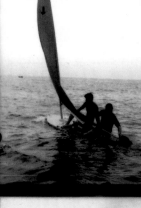
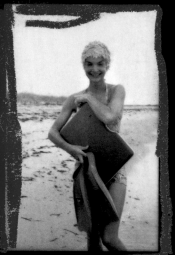
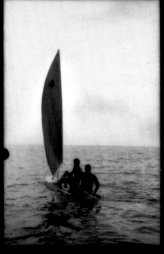
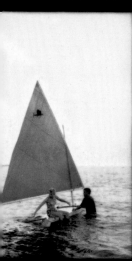
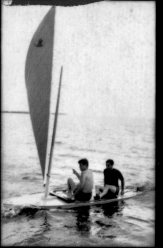

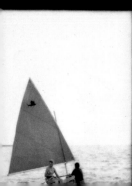
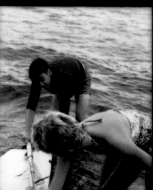
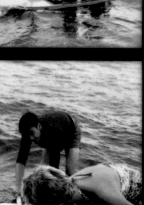
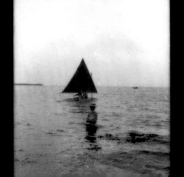

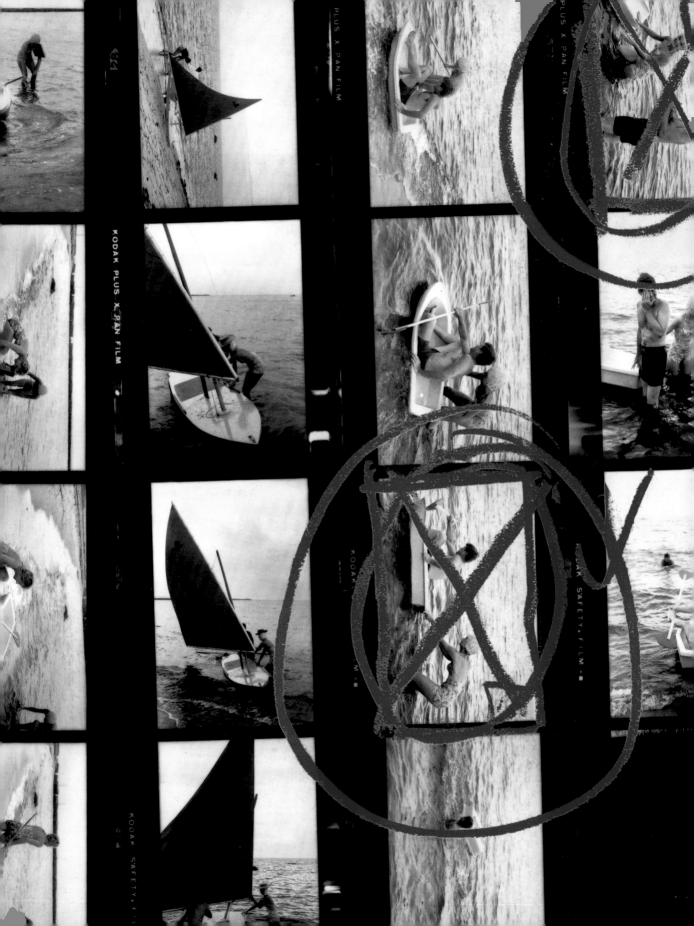

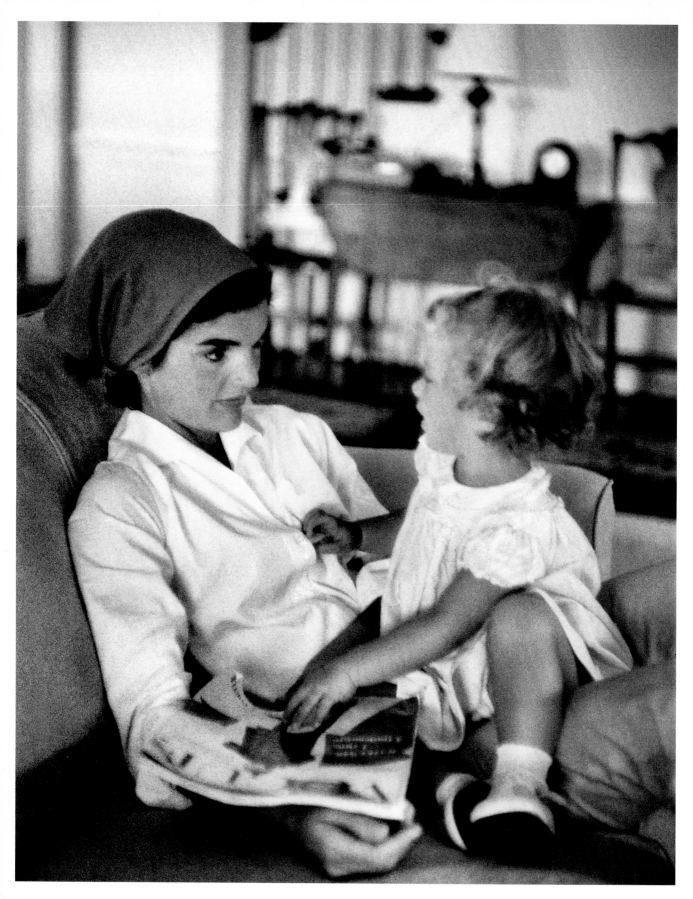

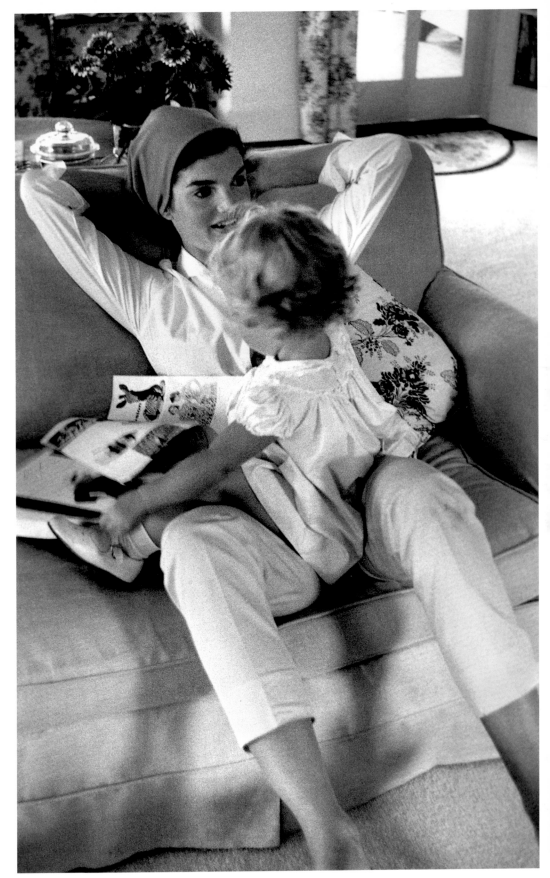

Previous pages: Hyannis Port was where Jack and Jackie could leave the rest of the world behind. Here they play with a children's boat, then test their skill with the Sailfish.

Left and right: Cape Cod's soft summer light proves ideal for Jacques and his cameras. He captures Jackie and Caroline playing and reading during one of the family's Hyannis Port escapes.

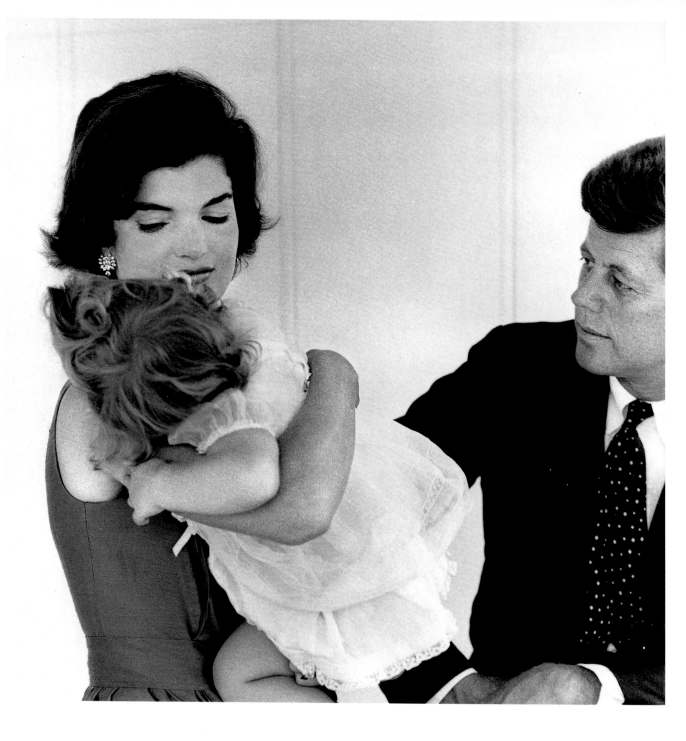

Photographers began
to call Jack, Jackie, and
Caroline the "famous
threesome." Jacques
Lowe had the inside track
for these family pictures.
Photographers on the
outside had virtually
no access at this time.

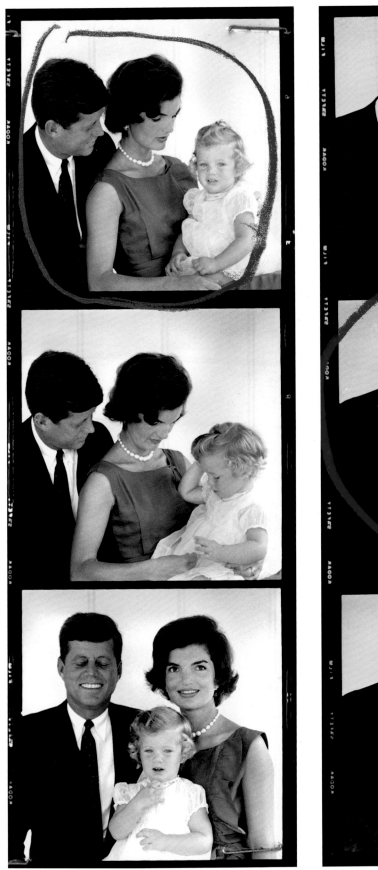
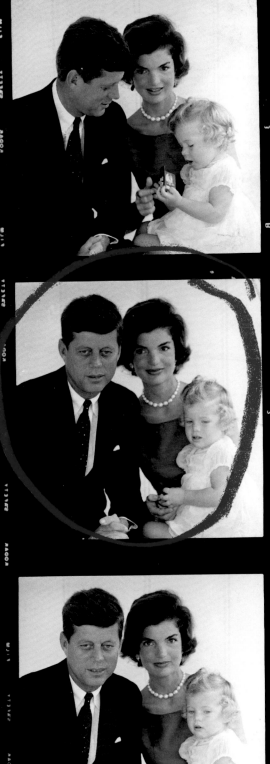

Two of Caroline's favorite
things were Jackie's pearls
and her book, *I Can Fly*.
Jack was generally
skeptical of photographs
showing public hugging
and kissing, but the
kiss from Caroline was
a special exception.

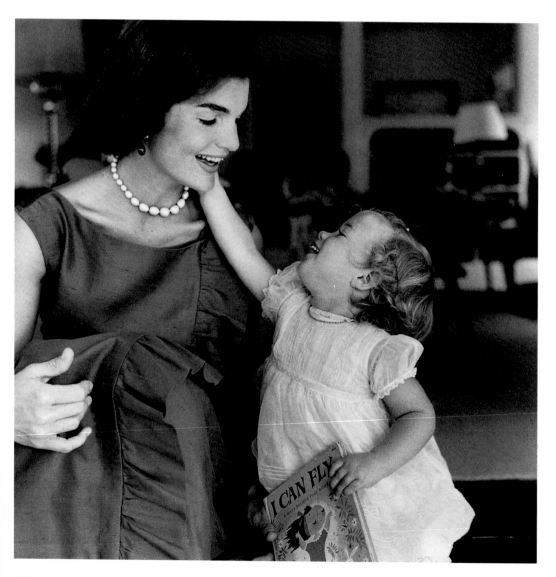

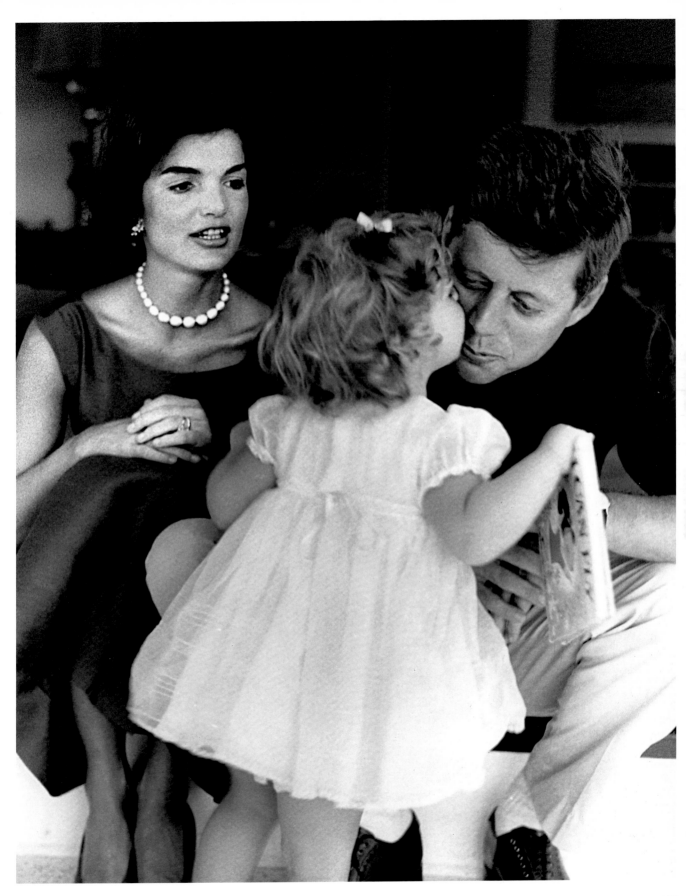

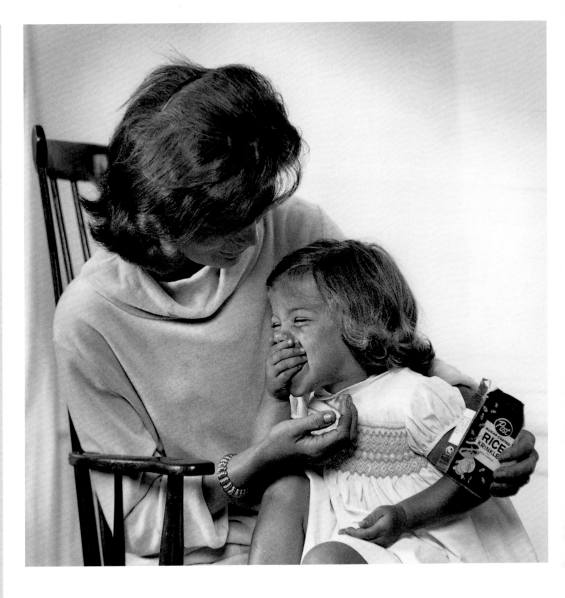

Few of Jacques's pictures have more appeal than these two of Jackie and Caroline at the Kennedy compound on Cape Cod. The mother and daughter appear beautiful, tanned, rested, and happy during that interlude before the outside world closed in.

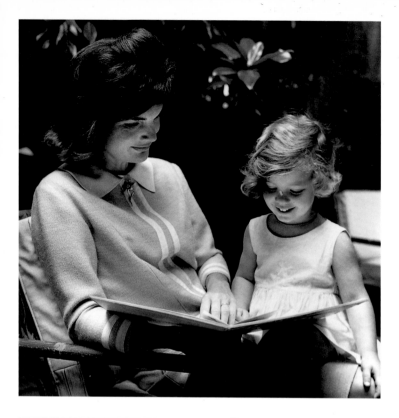

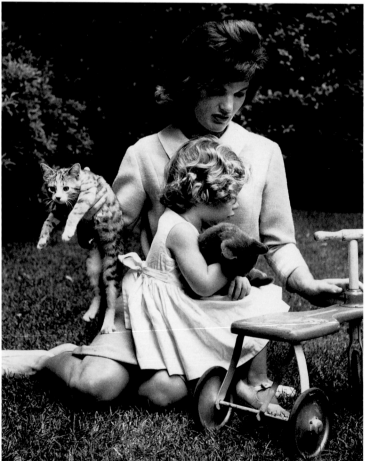

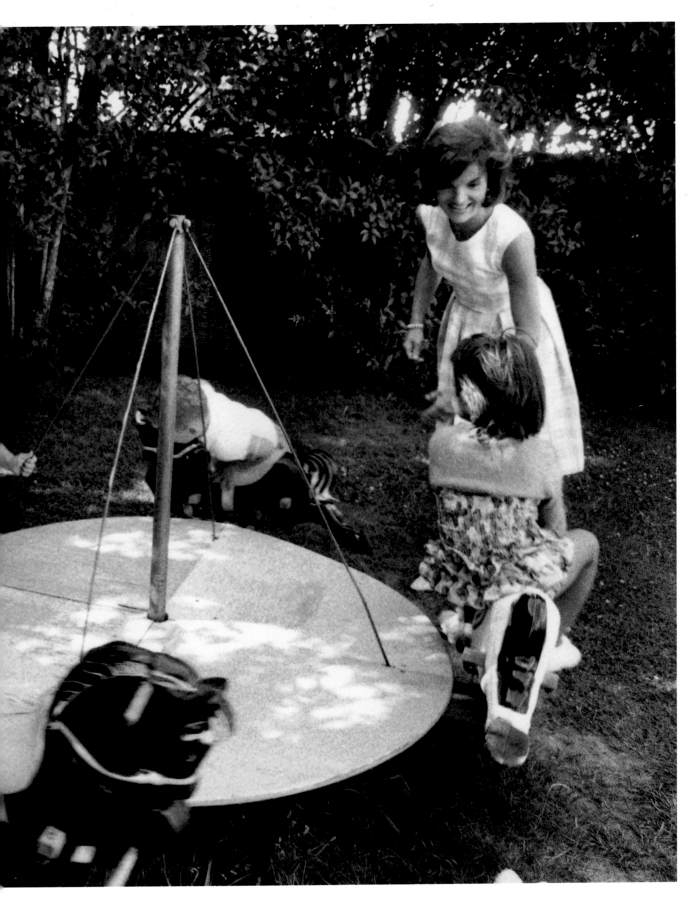

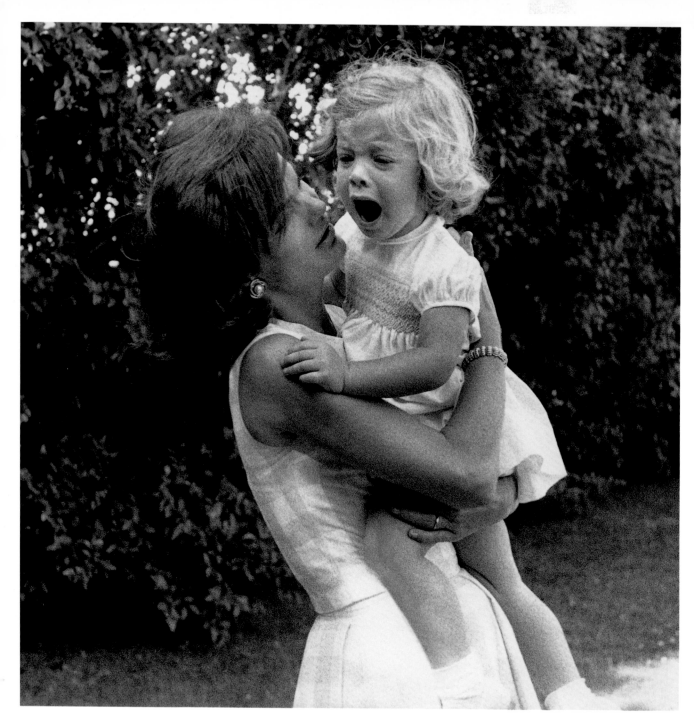

Previous pages: Caroline's
play includes her mother,
kittens, and friends.

Above: Caroline could
fuss, too, even when there
was a camera around.
Right: Her gymnastics—
walking a rail fence—
unfold at the Kennedy's
Hyannis Port compound.

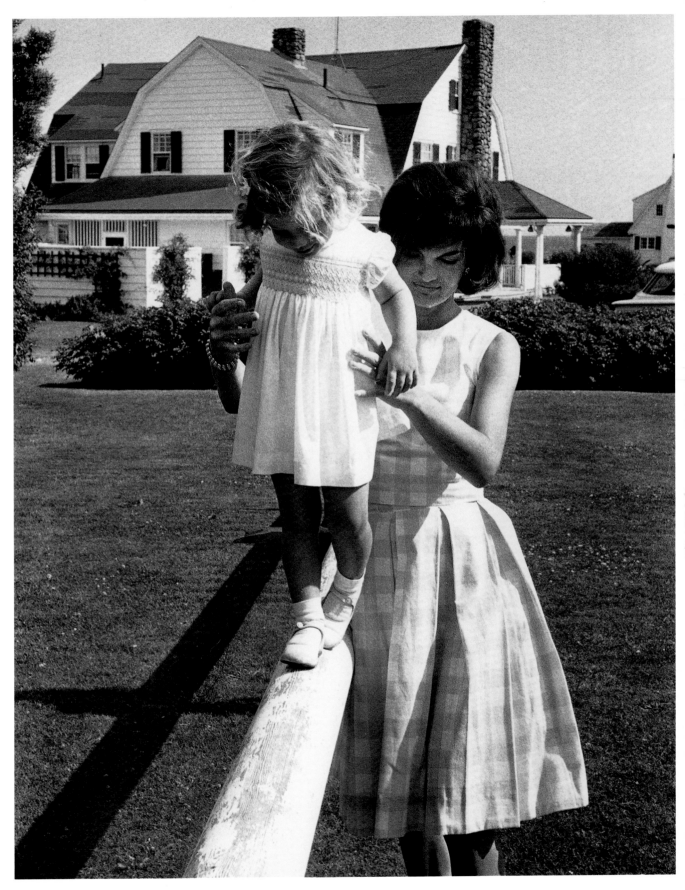

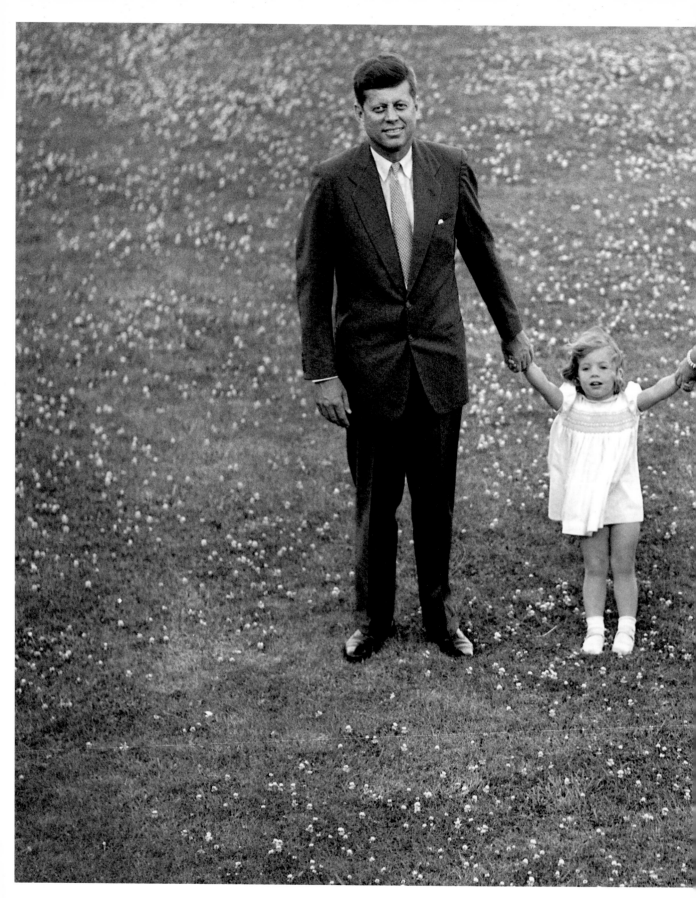

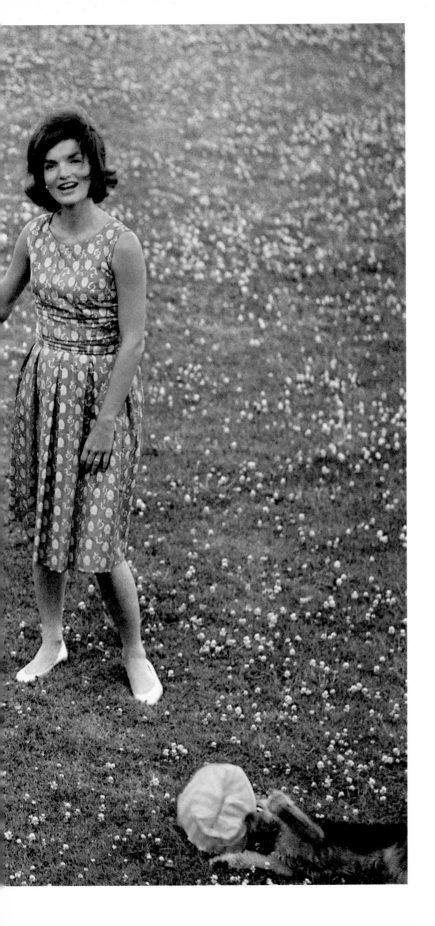

In a family photo at Cape Cod, Jack is dressed in his campaign uniform, apparently hurrying to an appearance.

Kennedy Women

Hyannis Port and Hickory Hill

The Kennedy women were a new national political phenomenon. They had undergone tryouts in Jack's campaigns for House and Senate where, solo and in pairs, they proved their energy and worth. Now, assembled en masse to kick off a countrywide push, they formed an exuberant and much-in-demand force like none before witnessed in a political campaign. Kennedy, at the end of the long political trail and only partly in jest, would say, "They won it for me."

In the summer of 1960, Jacques and his cameras found five of the seven women in Washington and Hyannis Port, all with children in tow, adding yet another dimension to this campaign. At the center was Jackie, whose soft beauty was tailor-made for a camera lens. Was there ever a bad picture taken of Jackie, editors asked, as hundreds of images passed through their hands and immediately into print. If there was a shot that wasn't good, a study of Jacques's contact sheets certainly doesn't reveal it. Nothing seemed to slake the thirst for photos of the candidate's wife.

Jackie's melancholy girlhood story just deepened her appeal. She was the daughter of Janet Lee, a woman from modest roots who craved the rich life, and a rakish father, "Black Jack" Bouvier, who came from wealth but could not keep it and consoled himself with drink. Jackie, rocked by their divorce, had found solace in culture and the arts.

"She is Jackie Kennedy, the cameo-faced wife of the presently running Democratic candidate," wrote *Life*'s Don Wilson. "Mrs. Kennedy, who dazzles the voters' eyes, is an amateur scholar of 18th-century European history. She speaks Spanish, French, and Italian fluently. Her interests run, as her husband puts it, 'to things of the spirit—art, literature.' When the senator lost the notes for a speech that he had planned to end with a quote from Tennyson's *Ulysses*, Jackie bailed him out by quickly reciting the appropriate lines."

Bobby's wife Ethel and their six children, meanwhile, formed an exploding constellation within the wider Kennedy galaxy. Ethel emerged as an earth mother who watched over Hickory Hill and her growing brood with one eye while assessing political scrimmages with the other. When she could, she helped with a zany abandon. Jacques's pictures of her children were a campaign plus by themselves.

The organization and business side of the Kennedy campaign fell to Stephen Smith, husband of Jean Kennedy. Smith, the son of a wealthy New York shipping family, came to Washington in 1959 to set up the apparatus in the Esso Building. At the same time, Eunice Kennedy Shriver's husband, Sargent, from an old Maryland family, emerged as one of the candidate's utility infielders, moving from place to place and event to event as needed.

Joan Kennedy, Teddy's bride, made a graceful addition to the female assault force. Her talent as a pianist added luster to the lineup.

Two Kennedy women were absent during Jacques's photo taking, but they, too, marched with this colorful, coiffed patrol. Pat Kennedy Lawford lived on the West Coast with actor-husband Peter Lawford, who would serve as an important Kennedy link to Hollywood money and celebrities, including Frank Sinatra, a fun-loving but risky asset because of his friendships with crime bosses. And the family matriarch, Rose Fitzgerald Kennedy, also played a role in the campaign.

Rose Kennedy was viewed as a saintly woman who reared her offspring while her husband Joe, a noted philanderer, busied himself with his commercial empire. Rose buried herself in her children and her religion, keeping her poise and guarding her silence even through the ambassador's famous affair with the silken Hollywood actress Gloria Swanson. Rose's mark was on her son's journey through war and through illness, the tests that she told people would make him a great president.

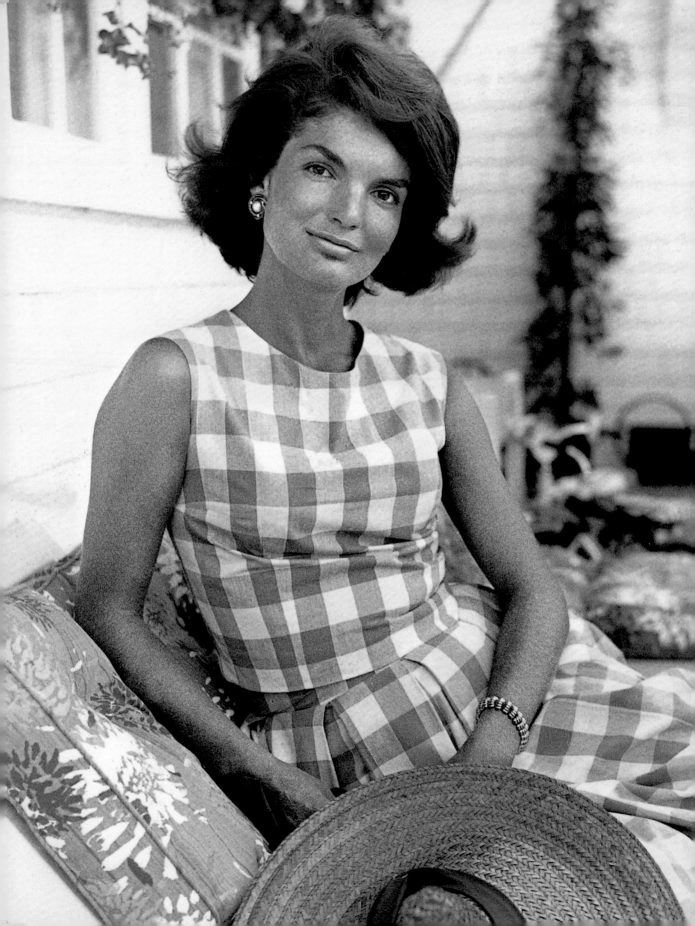

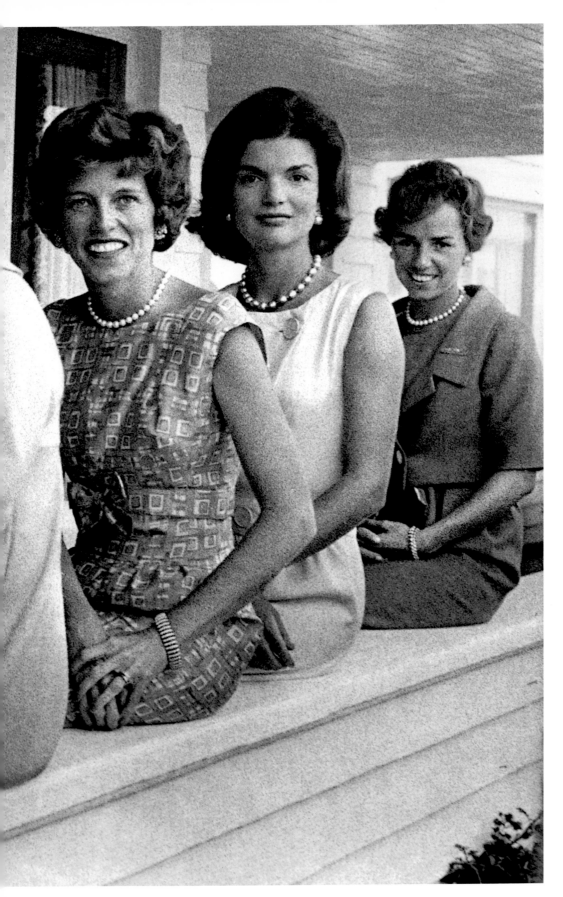

Previous page: A wistful Jackie sits on the patio of her home in Hyannis Port late in the summer of 1960.

Left: Joan Kennedy, Jean Kennedy Smith, Eunice Kennedy Shriver, Jackie, and Ethel Kennedy make up five-sevenths of the female powerhouse that would jump into the campaign. Patricia Lawford Kennedy and Kennedy matriarch Rose would round out the team.

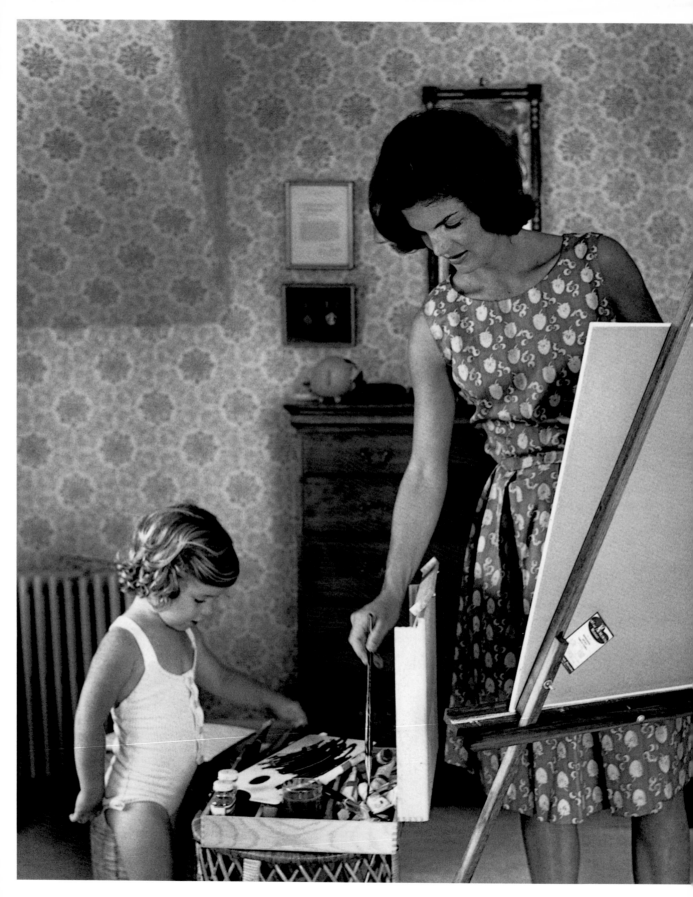

Jackie shares a love of art with her small daughter. Years earlier, Jackie had also persuaded Jack to emulate Winston Churchill and try painting as a calming therapy. Jackie's girlhood letters were often graced with sketches and watercolor cameos.

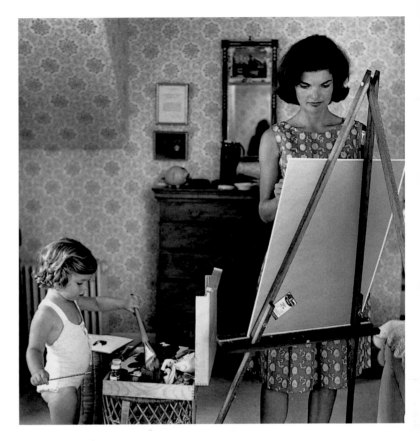

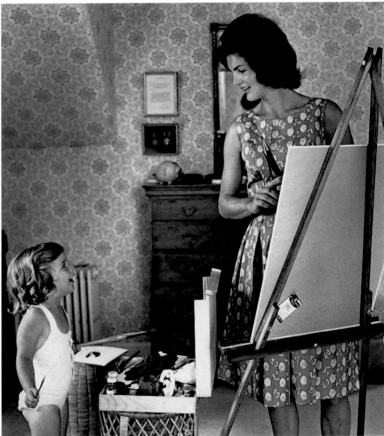

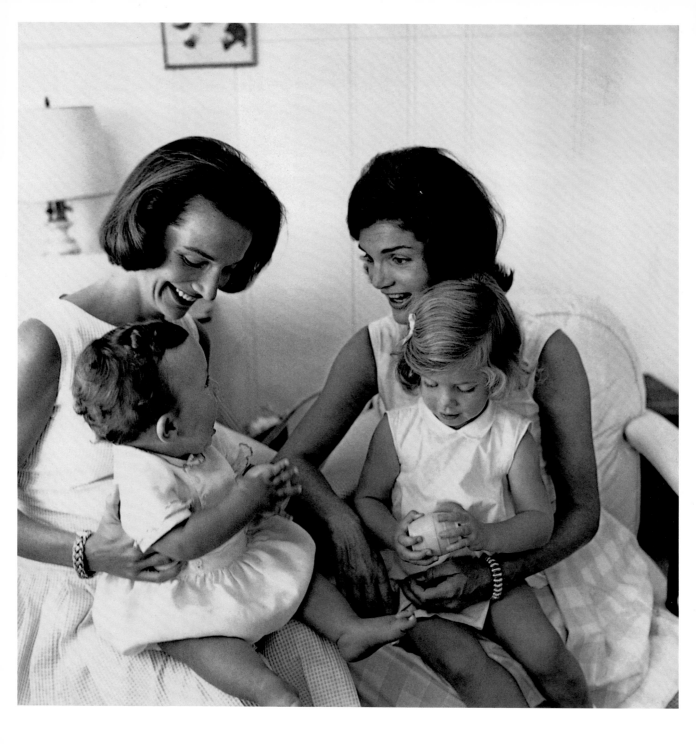

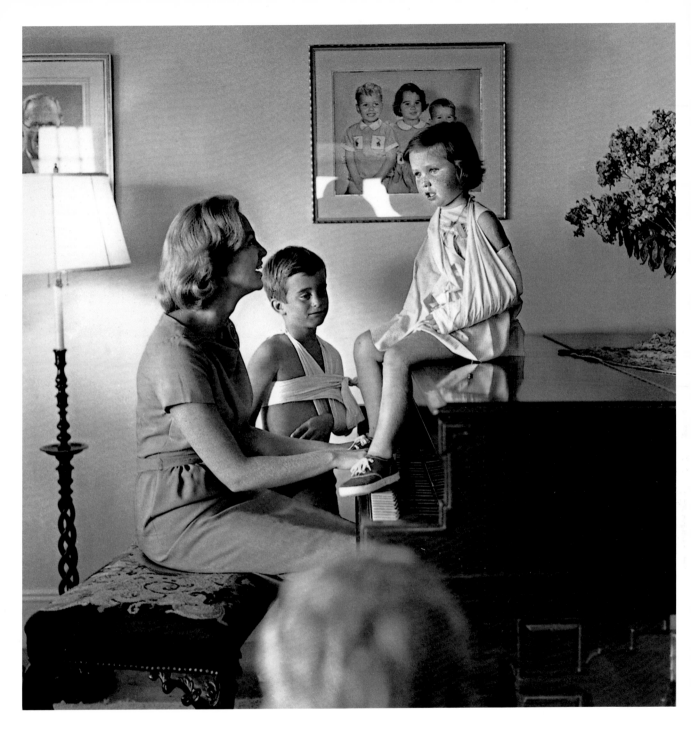

Left: Jackie and her sister, Lee Radziwill, play with their children, Caroline and Anthony. *Above:* Joan offers a piano serenade to a pair of banged-up Kennedy and Shriver kids.

Above: Lunchtime was no small undertaking for the growing Kennedy clan. *Right:* At Hickory Hill, Ethel reads to her children, who now number seven. The youngest, Mary Kerry, listens from her mother's lap.

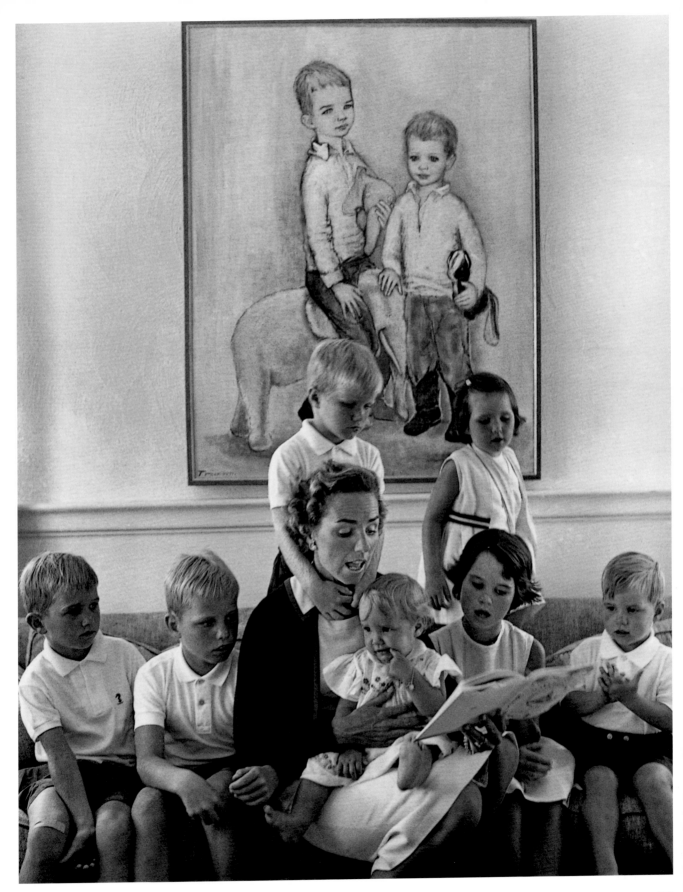

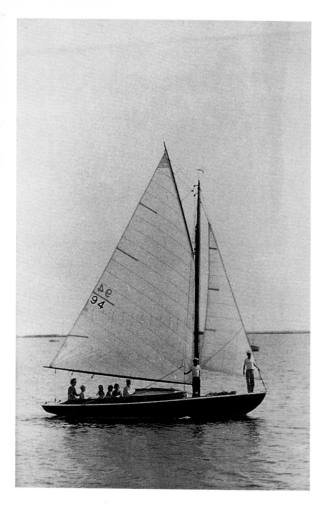

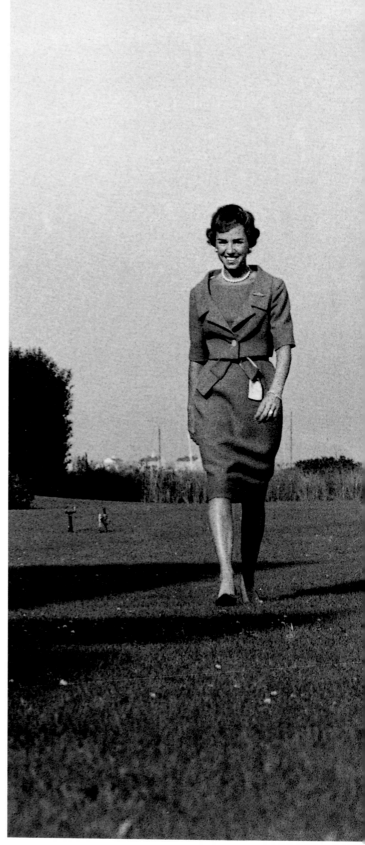

Above: Kennedys, big
and small, take a sail
in Nantucket Sound
aboard Jack's boat,
the *Victura*, before
the campaign begins.
Right: Ethel, Joan,
Jackie, Eunice, and
Jean, organized for the
presidential campaign,
march across the lawn
at Hyannis Port in the
summer of 1960.

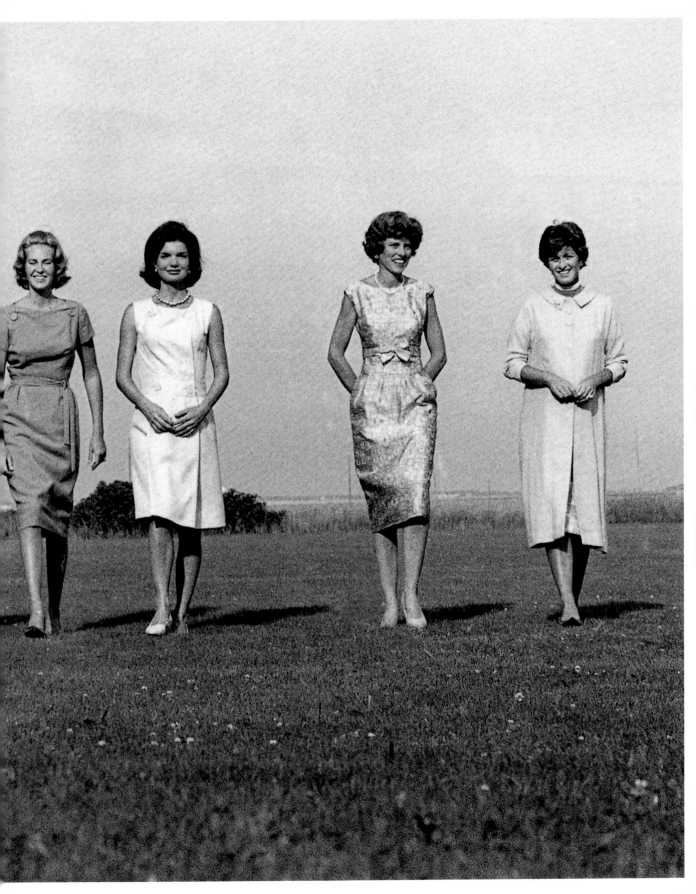

Presidential Campaign

Across the Country

"Look at their faces," Jack Kennedy used to say as he campaigned across the nation, staring into the throngs that clustered around him. "I can tell in their faces if they are with me." As Kennedy watched crowds, Jacques Lowe stared through his cameras, clicking, clicking, and clicking. He was in his element, capturing American faces caught in this new ritual of democracy.

The handsome Kennedy became an intoxicating pied piper for teenagers and even some of their fathers and mothers. The correspondents on the press buses, nudging through the human tides, began to catalogue what they termed as "leapers" and "screamers," those with limber legs who could sprint alongside Kennedy's car and demonstrate their affection with acrobatics and those who showed their support vocally.

Kennedy's hands were often scratched by the long fingernails of women desperate for a touch, women who dissolved into tears if he gave them a full handshake. At day's end, the candidate often had to soak his abrasions in hot water and apply balm. His cuffs were ripped off and his shirtsleeves so frequently shredded that staff members carried replacements.

Presidential candidates had never allowed the public so close as Jack did, and no one had ever worked so hard and so long—and reached so far into remote corners of the republic—in a bid for the nation's highest office. Kennedy had a tough slope to climb. Although fluctuating, polls gave Republican candidate Richard Nixon, who had stormed the country for eight years as Dwight Eisenhower's vice president, a comfortable lead. Yet, there was a sense that the Republican was vulnerable in this changing political environment. Nixon reeked of what had been. JFK was newly minted.

Kennedy's voice gave out often enough that a Boston therapist joined the cavalcade and taught the orator to use his whole diaphragm instead of just shouting. The candidate also took to carrying sugar cubes soaked in medication to sooth his vocal cords between stops.

Appearance was important and Jack worried about how to wave to distant construction workers standing on steel building frames or clustered at hillside excavations. "I can't do what Ike does and raise both arms," he explained. "I don't want to flop like Nixon. I don't want to use the clenched fist, which is labor's signal." He finally settled on an open-handed, stiff-wristed chop that soon became a familiar gesture.

Television demanded that he and Nixon debate face to face. In Chicago, in the first of four confrontations, Nixon was wan and ailing from a knee infection. Those who watched the encounter on television gave Kennedy the edge, but radio listeners thought Nixon won. It was a warning to Kennedy followers just how close this election would be. On the big issues of peace through strength and economic growth, the candidates agreed. That meant personal appeal and small actions could make the difference.

Before the Greater Houston Ministerial Association, Jack struck at the fear that threatened to keep a Roman Catholic from the Oval Office: "I believe in an America where the separation of church and state is absolute— where no Catholic prelate would tell the president how to act." Many in his audience nodded approval.

When Martin Luther King Jr. was arrested in mid-October at a restaurant sit-in in Atlanta, and King alone was sentenced on a technicality to four months hard labor then spirited off to a state penitentiary, JFK acted instantly. He telephoned King's wife, Coretta, from a Chicago hotel, expressed his concern, and offered his assistance. Nixon stayed quiet, fearful of a southern backlash. After Bobby called a Georgia judge and asked for help, King was released. Advantage: Kennedy.

Kennedy forged ahead, his strange army of handlers, pollsters, advance men, and journalists so tired that they sometimes forgot where they were. Kennedy's face showed the strain, too, but even in fatigue and battling the pain of a fragile back, he played star athlete. He clambered on the hoods and trunks of vehicles in his motorcades, flashing his wide grin at the adoration engulfing him.

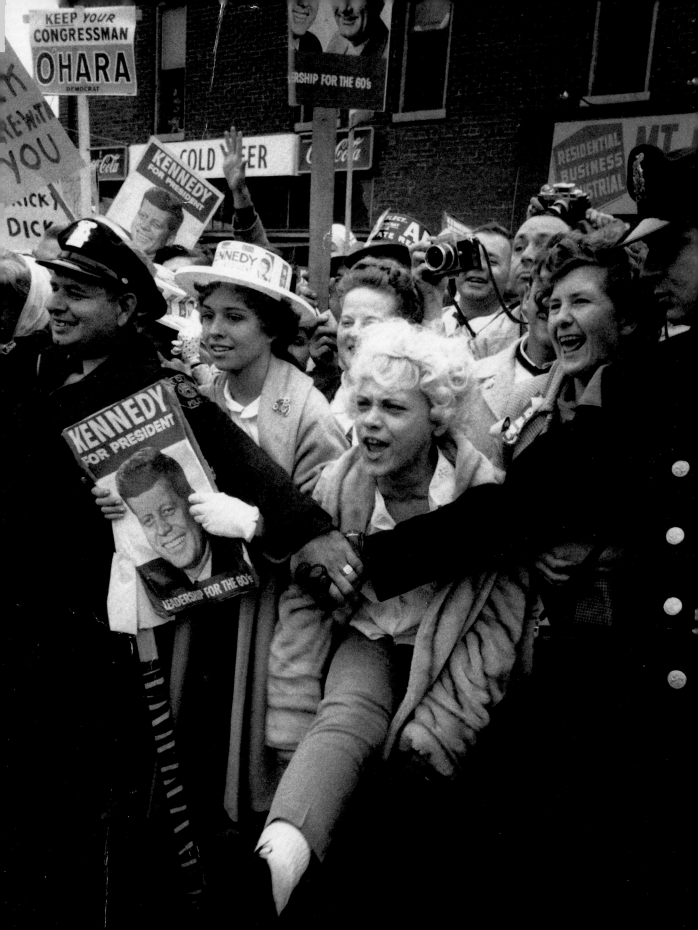

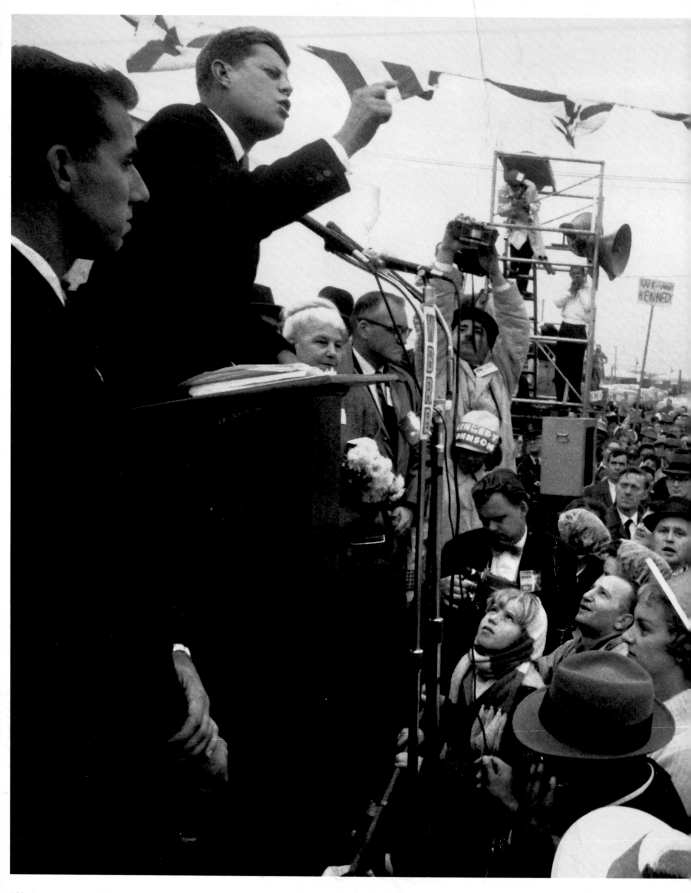

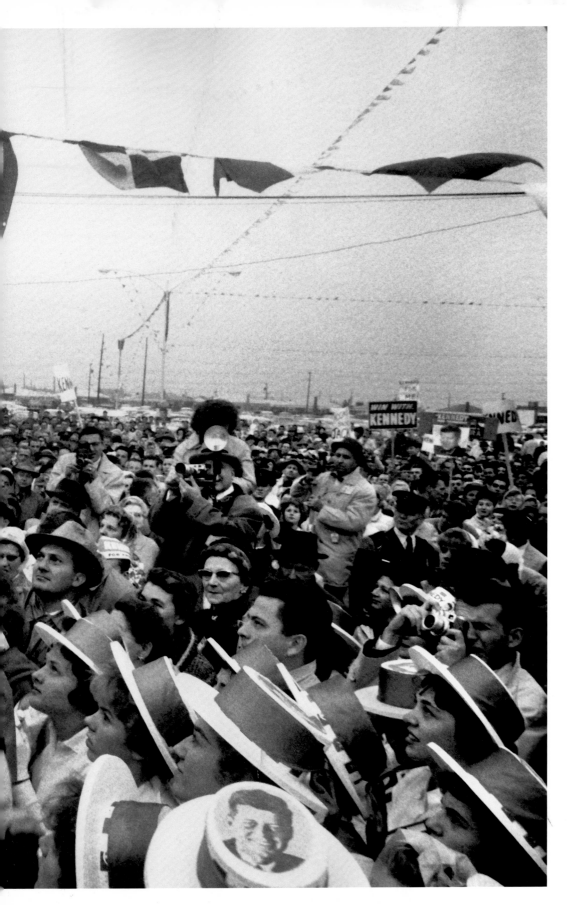

Previous page: Drawing enthusiastic Pittsburgh crowds, the campaign is off and running.

Left: Atop a platform hastily erected in a parking lot, Kennedy drums up support for his presidency.

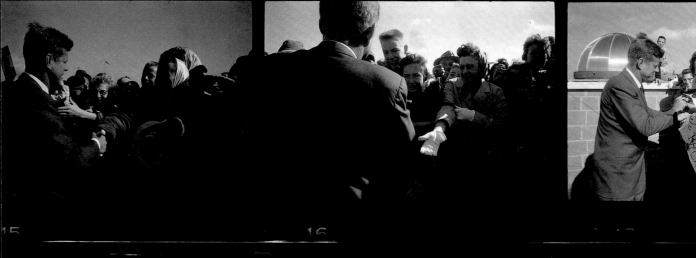

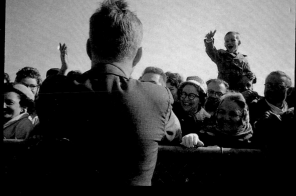

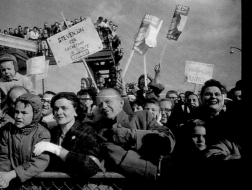

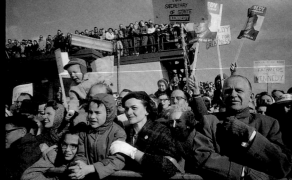

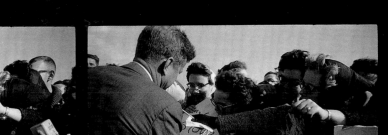
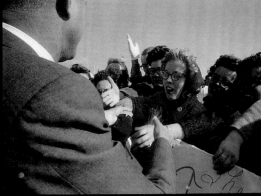

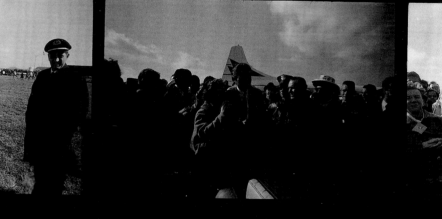
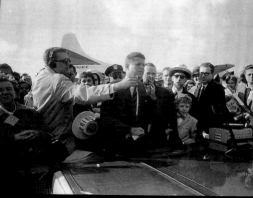
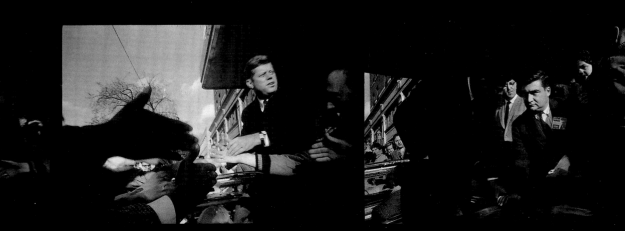

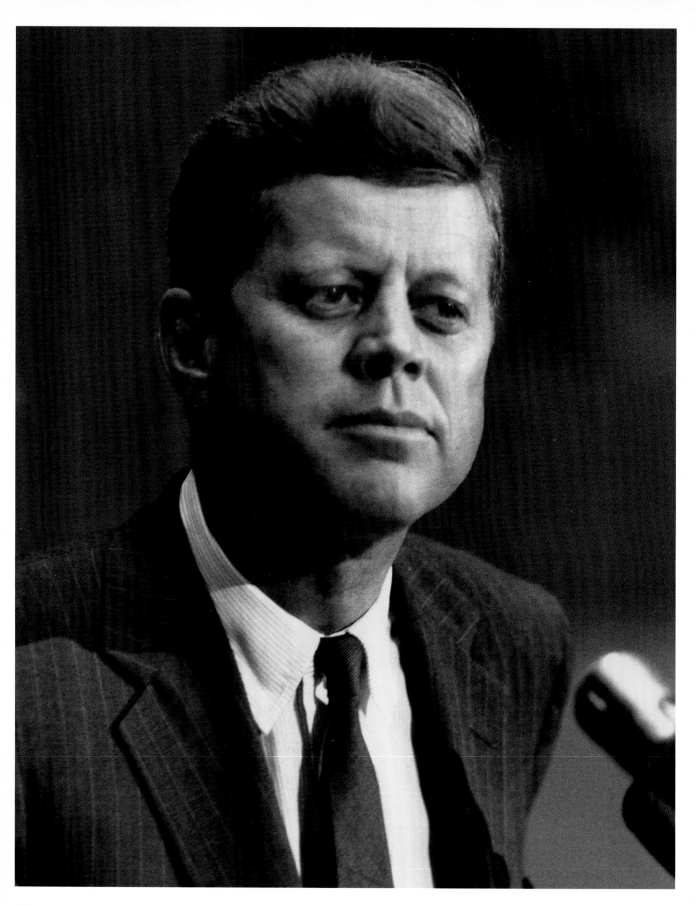

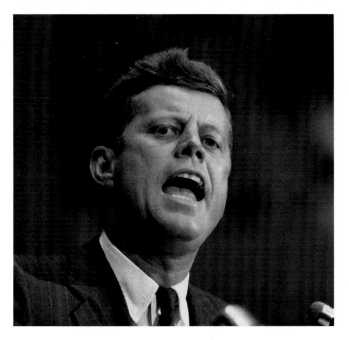

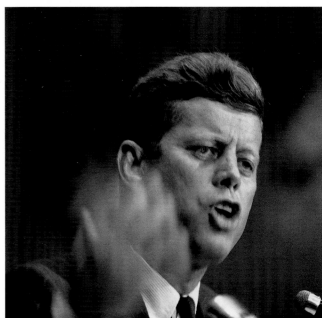

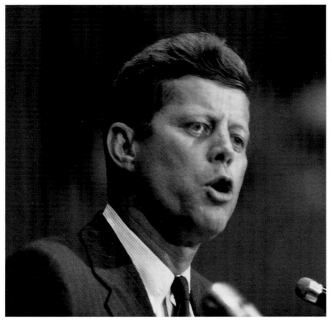

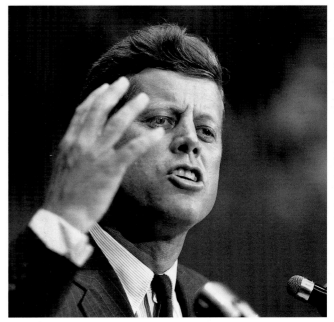

Previous pages: The airport stops become almost routine: autographs on posters, children hoisted on shoulders, and handshakes.

Left and above: Kennedy campaigns in Des Moines, Iowa, in early fall of 1960. America's heartland was skeptical of the young candidate, who is obviously irritated by a question from the crowd.

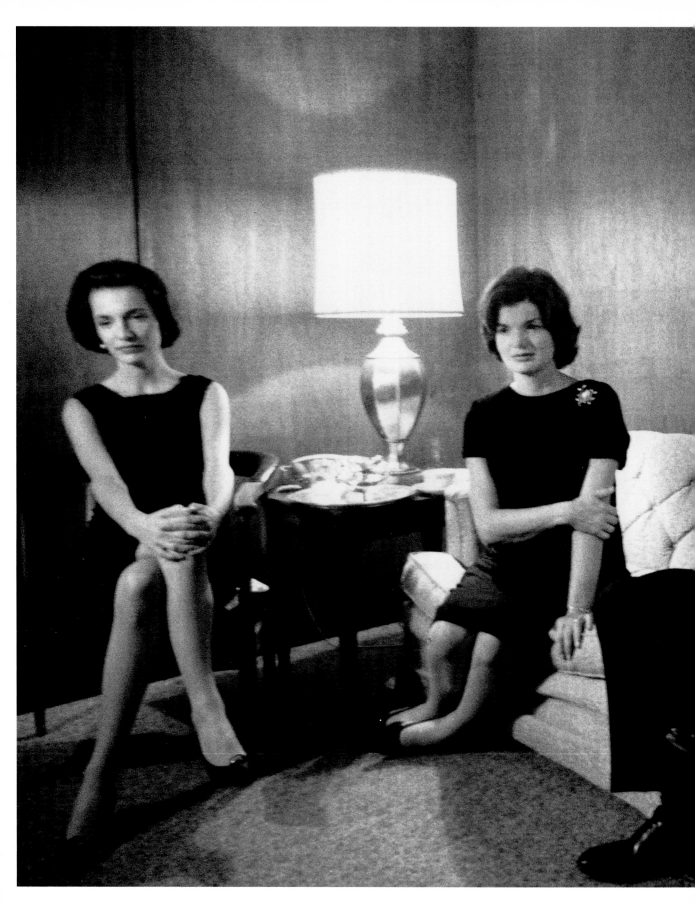

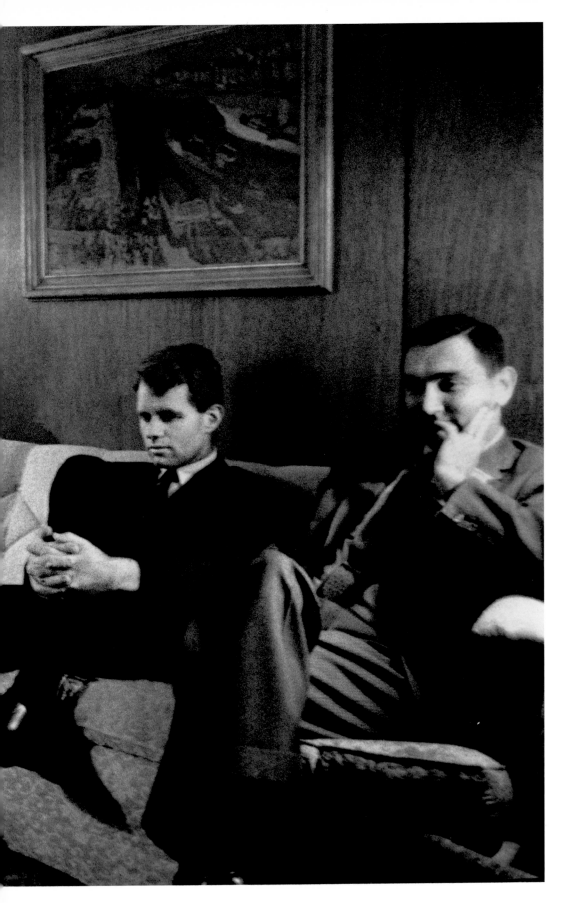

Lee Radziwill, Jackie,
Bobby, and campaign aide
Kenny O'Donnell watch
a Kennedy-Nixon debate.
The candidates squared
off in four debates.

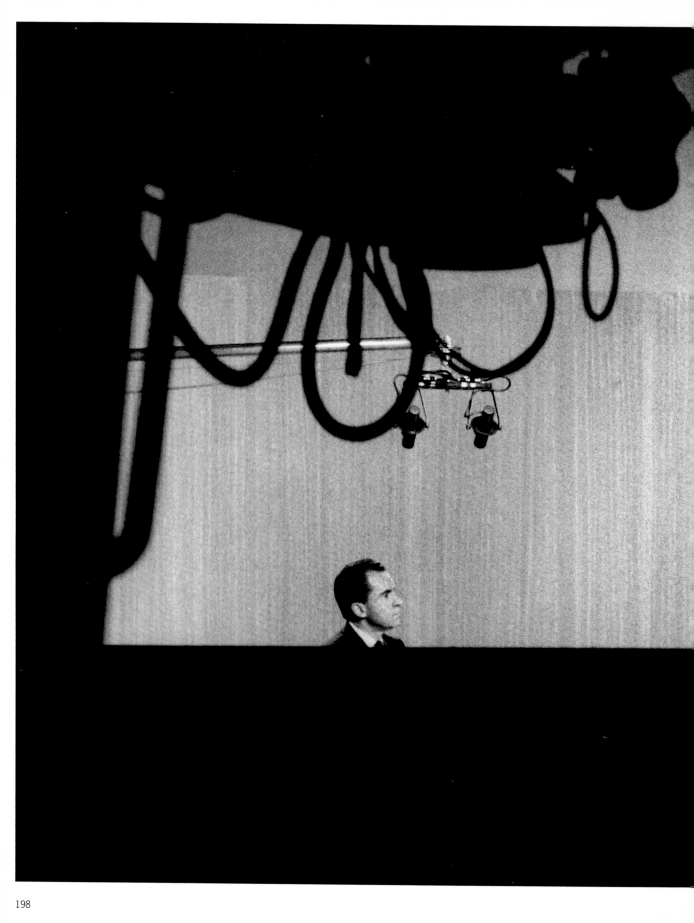

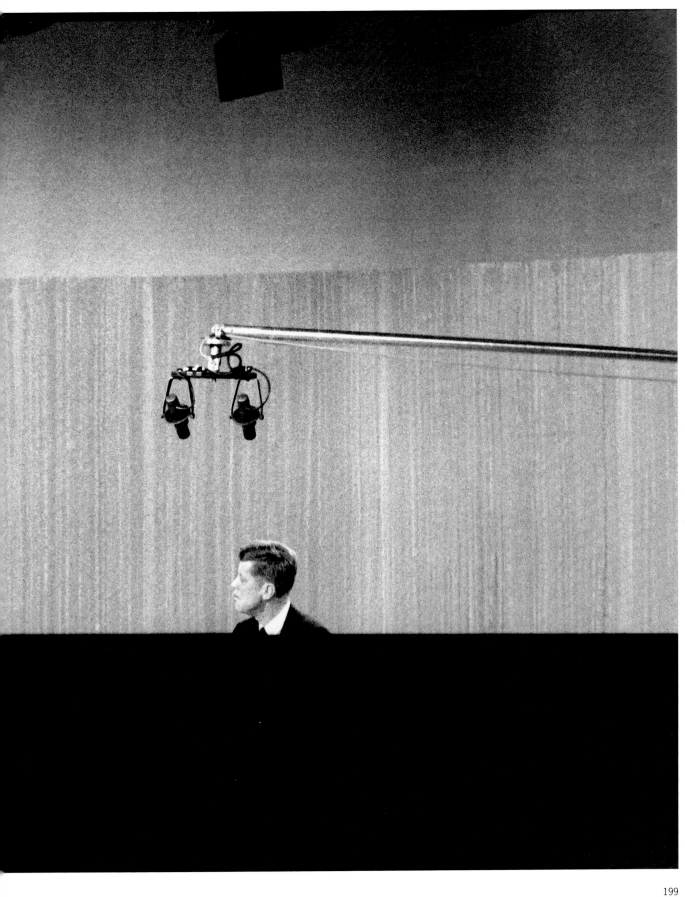

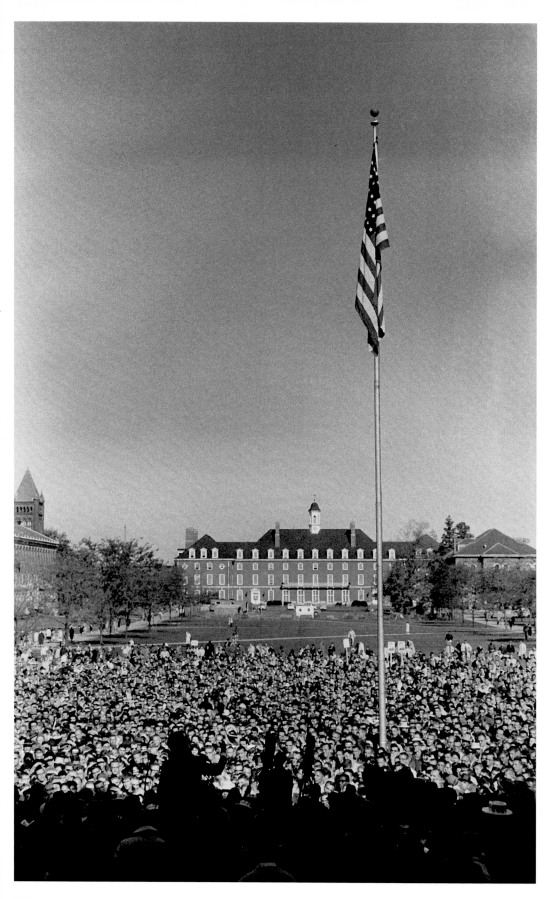

Previous pages:
Jacques Lowe catches debate action through an ABC studio window.

Left: Throngs gather around the flagpole at a college campus rally. *Right:* Campaign paraphernalia surrounds Kennedy during a speech in Houston, Texas.

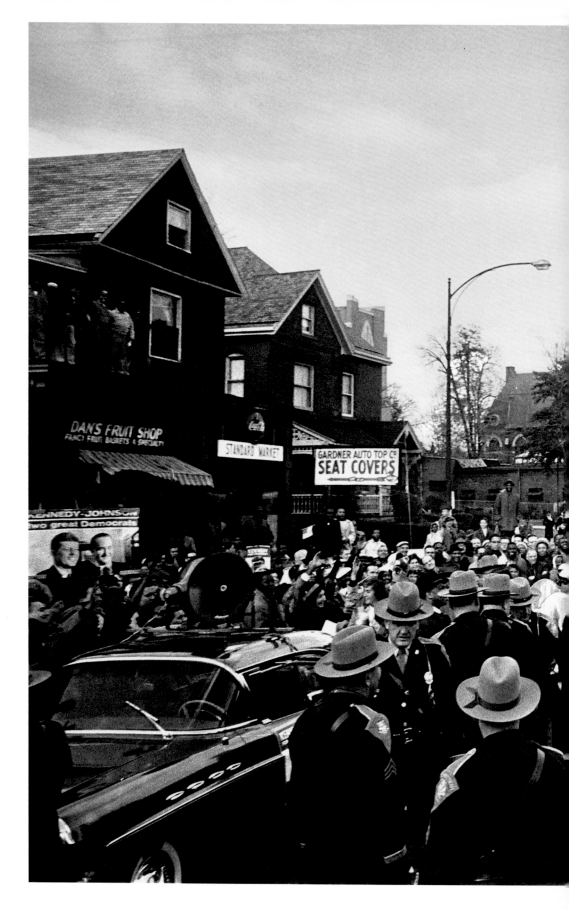

Kennedy, who refused to wear a hat even though they were still in style in 1960, may be laughing because of the "Vote Straight Republican" sign his motorcade has just passed. The campaign took JFK down the worn streets of one aging American community after another.

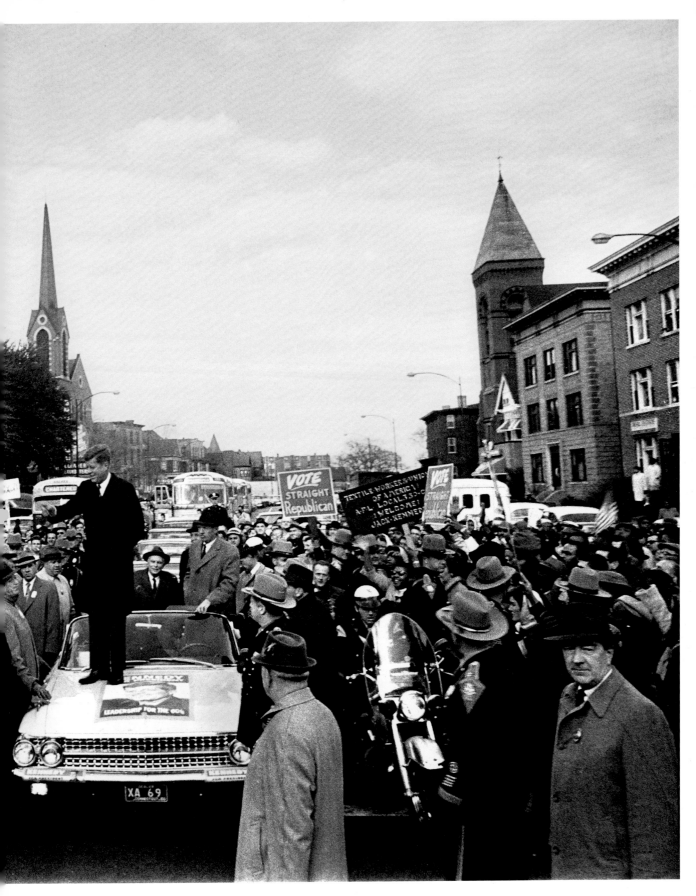

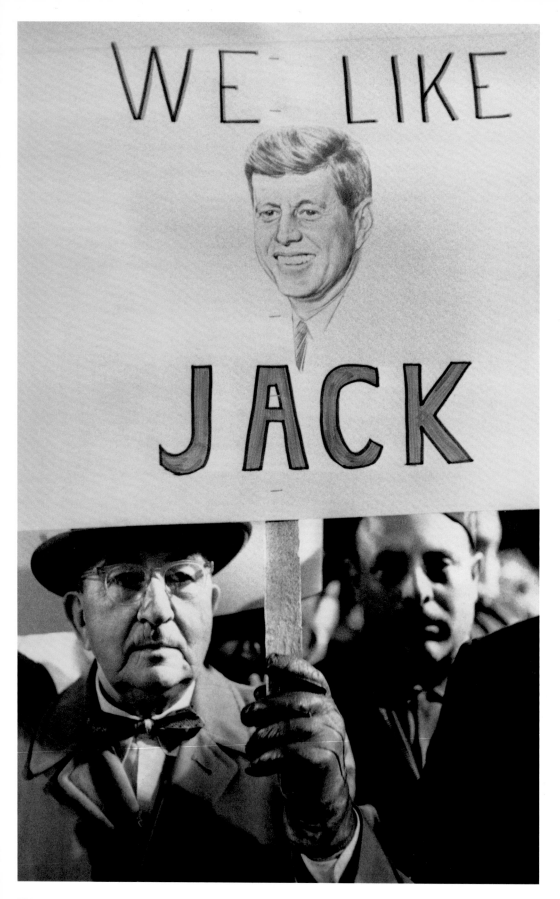

Attracting both old Americans and new Americans, Kennedy gets a show of support from Hamtramck, Michigan.

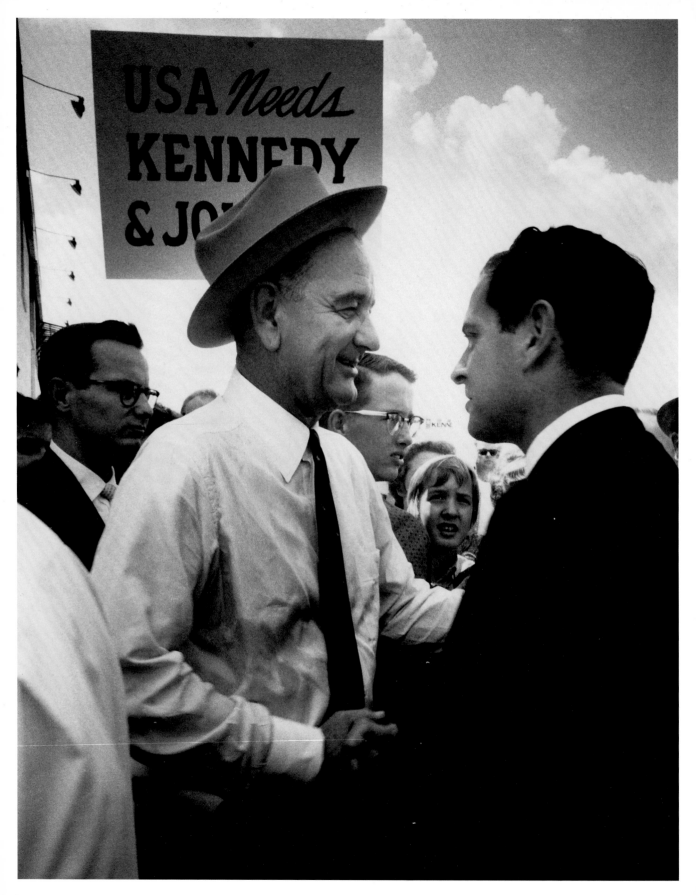

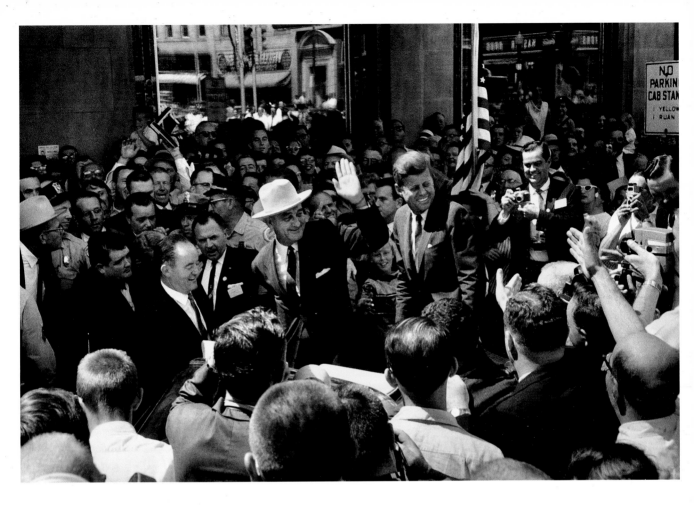

Left: Lyndon Johnson, with aide Bill Moyers at his back, does his own share of campaigning. The Texan does not share Kennedy's aversion for hats. *Above:* Minnesota Senator Hubert Humphrey joins Johnson and Kennedy at an Iowa rally early in the campaign.

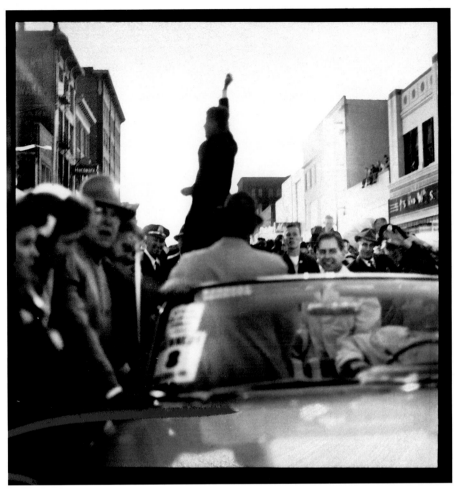

Left: Daytime, nighttime, anytime. The campaign rolls forward as light fades on the motorcade in Wilmette, Illinois. *Above:* Kennedy also carries his message to Mount Clemens, Michigan, on a gray day.

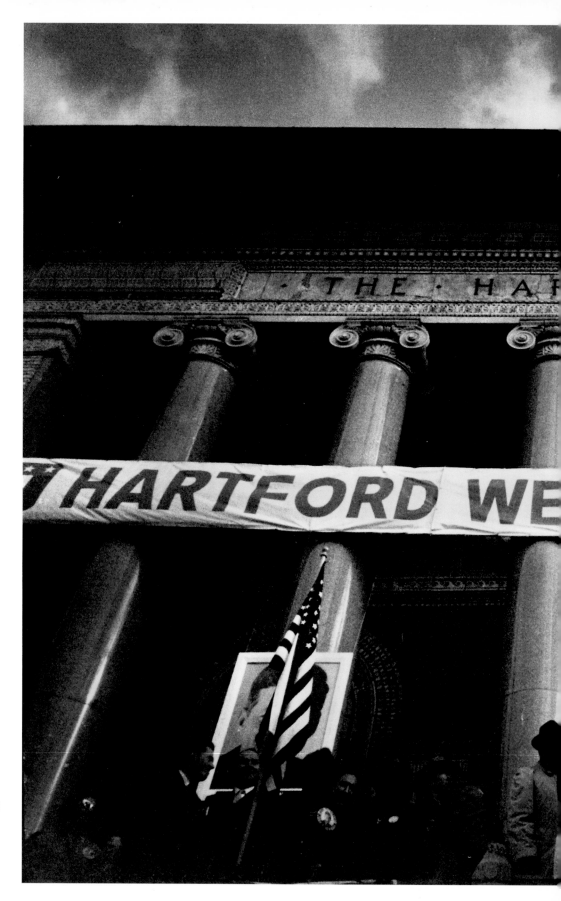

The Democratic state chairman in Connecticut, John Bailey, was one of Kennedy's earliest and most enthusiastic supporters. Bailey helped rig this extravaganza in Hartford. Kennedy later confided that his elevated perch at the rally amused him.

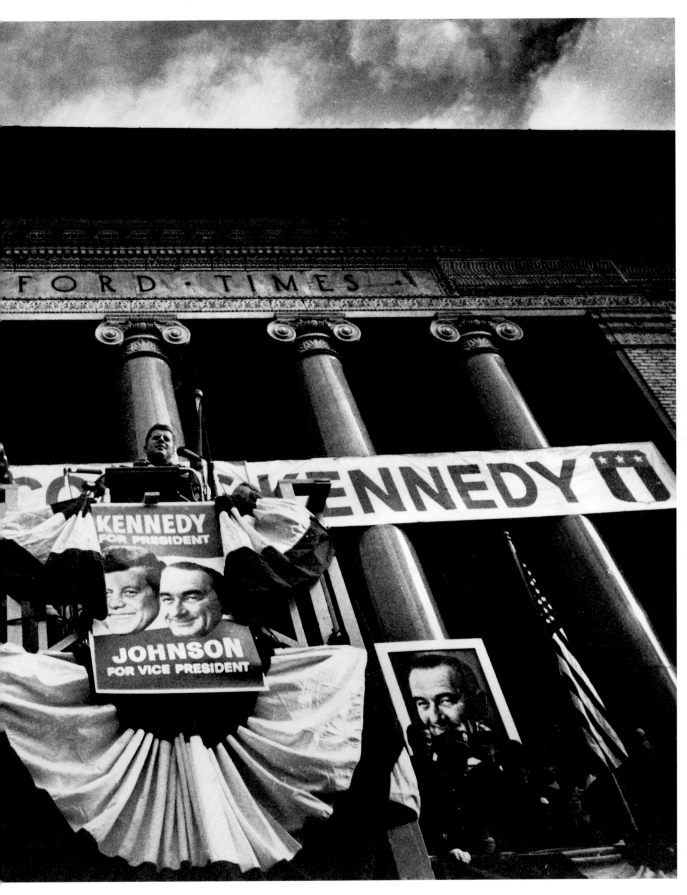

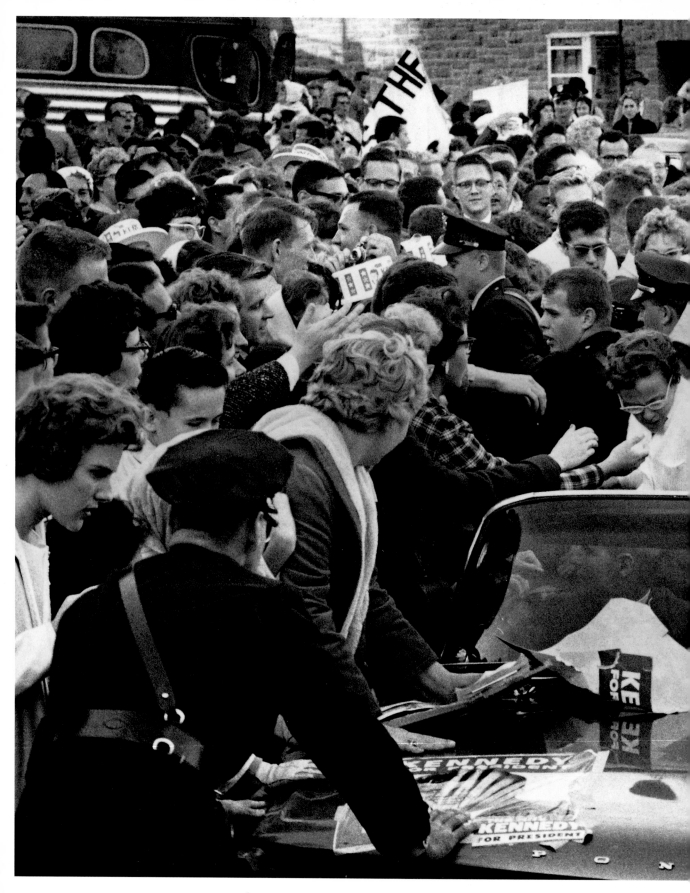

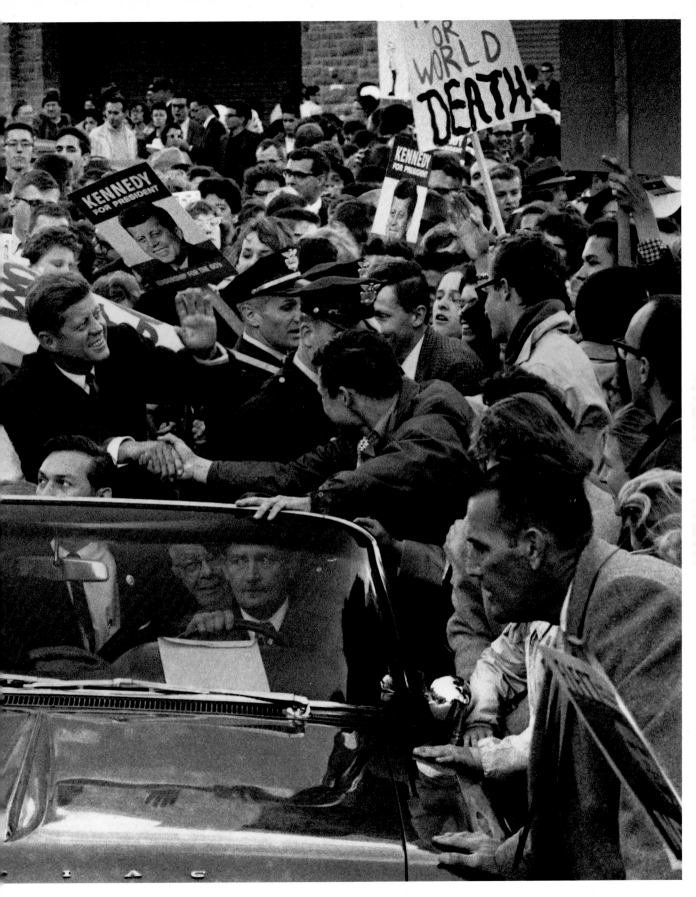

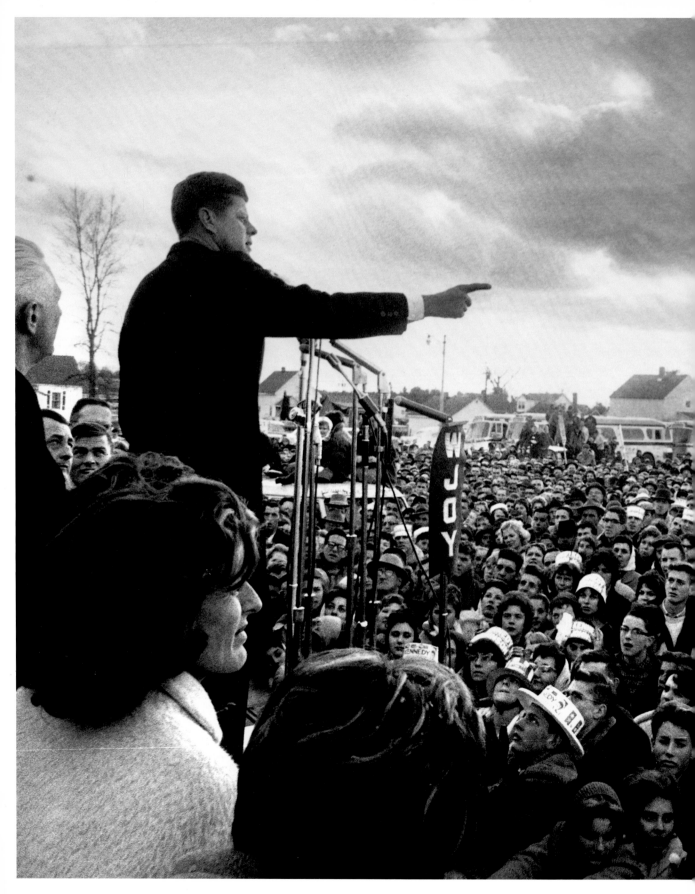

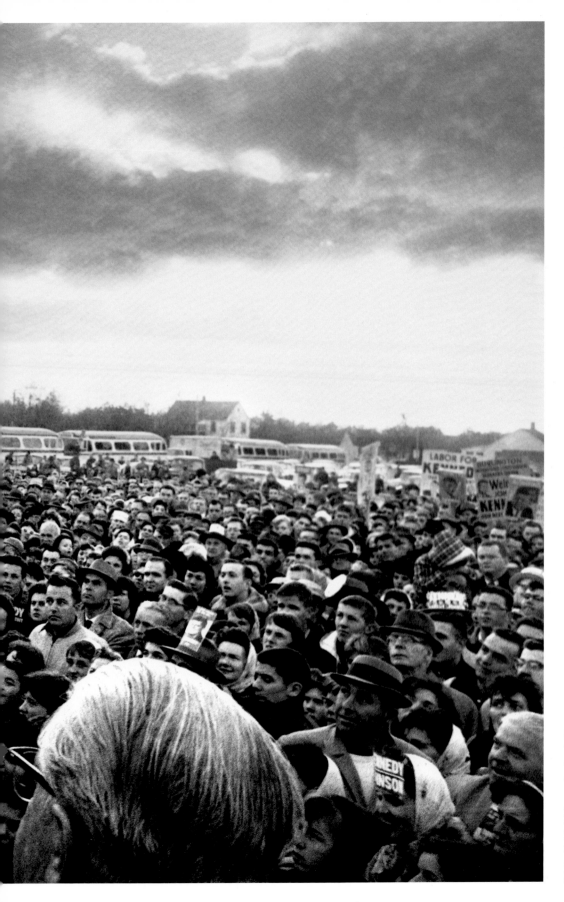

Previous pages: Kennedy loved and encouraged these campaign crushes, often to the consternation of his security detail.

Left: Jack's sister Patricia Kennedy Lawford, in the left foreground, stood in for the pregnant Jackie on some campaign swings, like this one in Kansas.

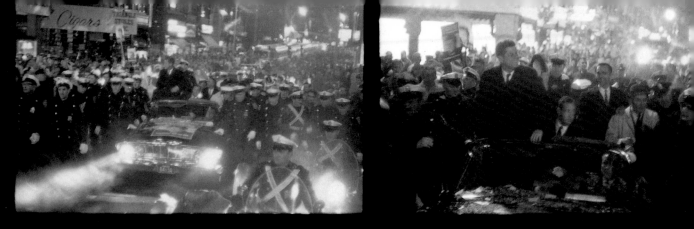

→ 32

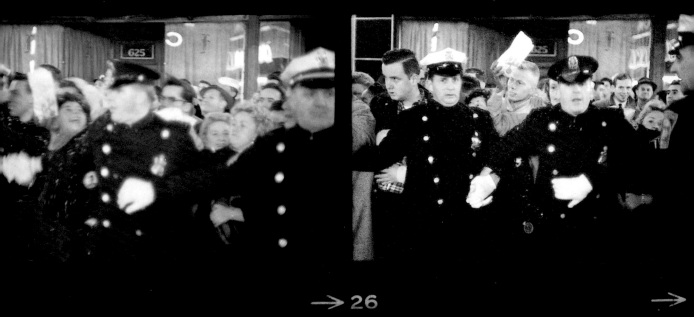

→ 26 →

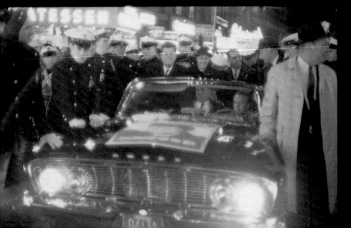

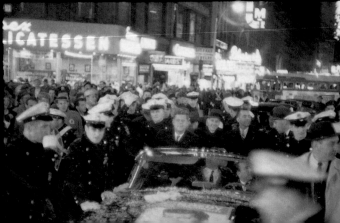

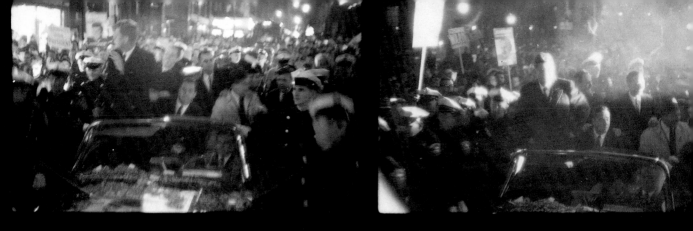

→ 34

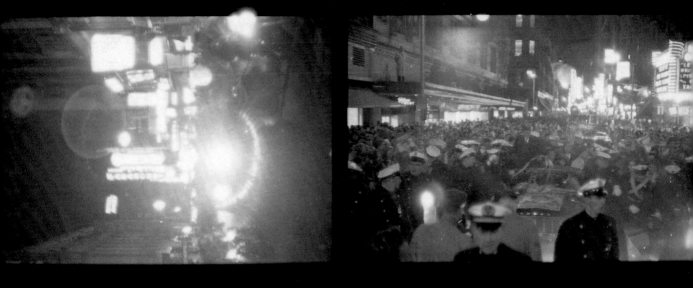

→ 28

→ 2

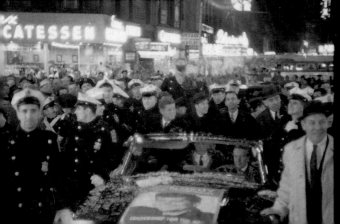

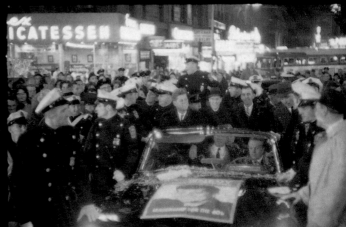

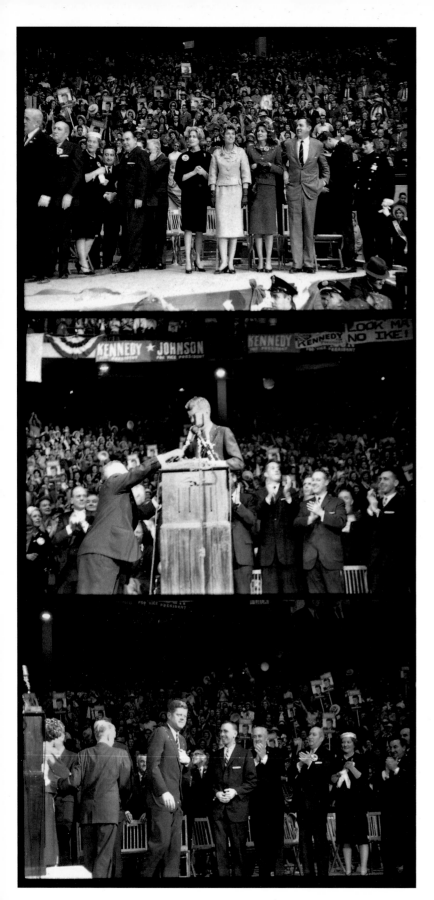

Previous pages: JFK receives a tumultuous welcome as he returns to hometown Boston on election eve.

Left and right: The campaign ends November 7, 1960, with a grand finale for native son Jack at Boston Gardens. The day after the huge and boisterous rally, Jack voted in Boston then flew to Hyannis Port to await the election returns.

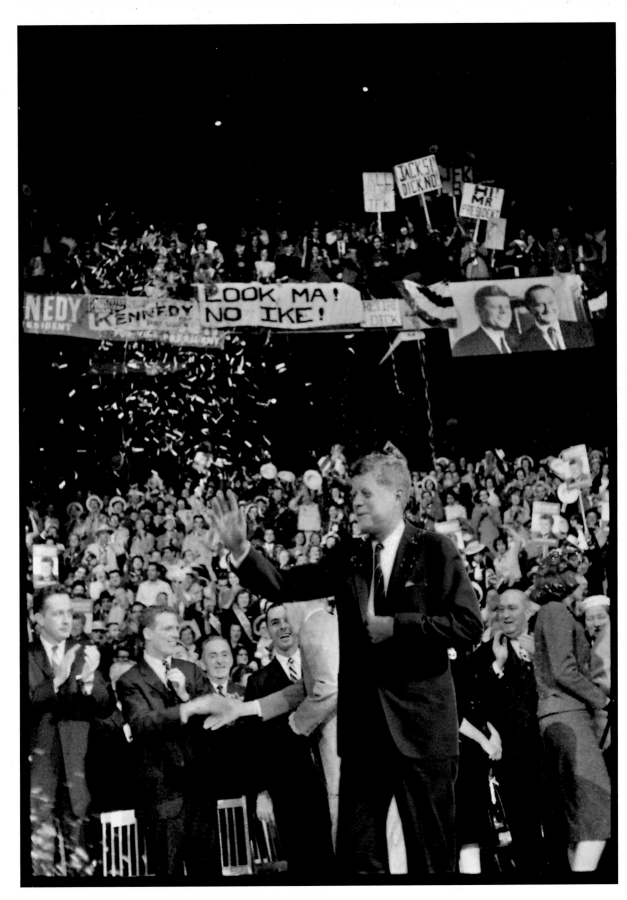

Election Eve
Hyannis Port

Footsore after a 229,000-mile odyssey, the Kennedys flocked home to Hyannis Port for the election. Despite some favorable polls, there was apprehension about the election results. But, assembled together, the Kennedys generated the old verve. Lights burned in all three of the Kennedy homes in the compound as the political drama unfolded through a long night.

Before heading to the family compound, Jack and Jackie voted at the West End Branch of the Boston Public Library, giving his Senate district address as their residence. By campaign standards it was a quiet event. Few people showed up at the airport to see them off on their short flight to Hyannis Port.

Bobby's modest home facing the water served as election headquarters. Furniture was moved from one of the children's bedrooms upstairs to make way for pollster Louis Harris, who would analyze returns as they came in by phone and ticker. Harris was already nervous. His sample precincts, so meticulously chosen to detect national trends, were shaky. His nervousness flowed downstairs where a phone bank sat in the sun porch. Ethel Kennedy's Steuben crystal had been cleared out of the dining room and a huge coffee urn took its place. It would see much use before morning.

The Kennedy crew kicked off their shoes and padded around in stocking feet, occasionally breaking the routine by darting onto the lawn to toss a football, roughhouse with the kids, or admire the latest scratch on Caroline's nose.

The election night gathering, though small, was infused with Kennedy flavor. Besides immediate family members, brother-in-law Peter Lawford offered a Hollywood touch while Jackie's artist friend who had worked on the campaign from its beginning, Bill Walton, also was on hand. Author Theodore White, gathering material for what would become a classic election book, *The Making of the President, 1960*, moved from room to room taking meticulous notes.

Kennedy was ahead by two million votes near midnight and early favor-seekers already were sending messages of congratulations. But these votes came from East Coast and urban voters. As the returns swept west into farm country, it would be tougher going.

The idled senator took catnaps and lounged, chewed on a sandwich and complained when there was no milk to accompany it. He conversed about D-Day with his friend, military historian Cornelius Ryan, author of *The Longest Day*, and asked for an appraisal of his amateur paintings from artist Walton, who pronounced Kennedy's canvases "fine primitives."

Jack's sense of humor bubbled up. He recalled how, during the campaign, he saw a man in black on a country road standing straight and stiff with a clothespin over his nose. In skyscraper territory, meanwhile, he often encountered great cheers of support at street level, only to look up at the corporate offices and see white-collar types making rude arm gestures.

Night moved into daylight as his election margin narrowed to 112,000 votes and Nixon refused to concede. "I don't blame him," said Kennedy. "I wouldn't." But when Illinois finally went for Kennedy under questionable, but skilled, manipulation by Chicago Mayor Richard Daley, victory was assured and Nixon acknowledged defeat. Kennedy studied the television face of his old foe in silence. He would later say, despite his dislike of the man, he felt a twinge of sorrow for him that night.

The Kennedy clan unwound with a chilly November walk on the beach then, at the urging of Jacques Lowe, they straggled into old Joe's house for a family portrait. Jacques and campaign aide Bill Haddad pleaded and pushed and had them nearly corralled when they discovered the very-pregnant Jackie was missing. She had run away for a few minutes from what she would later call "the longest night of my life" to take a lonely stroll near the water. The new president-elect went for her. When she walked in, the family burst into applause.

The Secret Service moved in and the Kennedys, combed and dressed, journeyed to the Hyannis National Guard Armory, where 250 journalists waited for their first chance to question the future President of the United States.

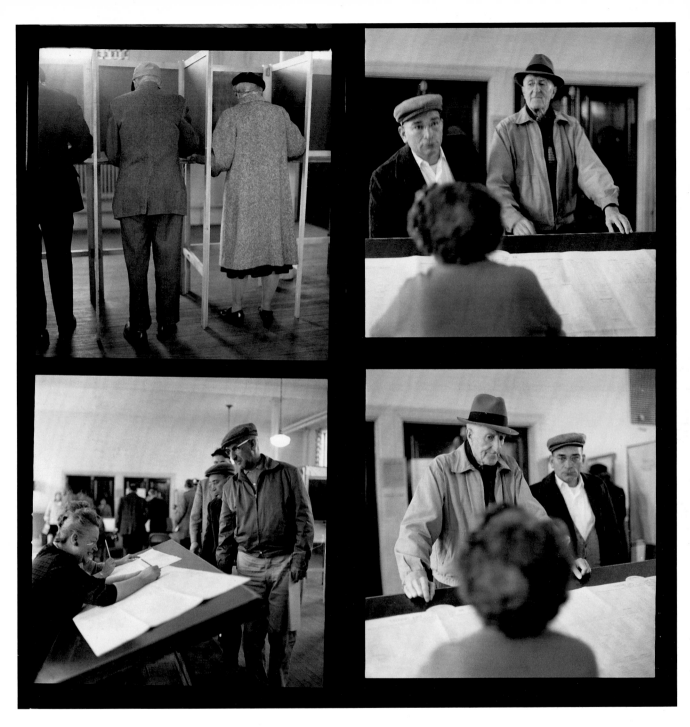

Previous page: Jack and Jackie's Hyannis Port home, lit up as night descended, was the focus of the nation's attention on election eve. But the real action unfolded next door in Bobby's home.

Left: Hidden by election booth curtains in Hyannis, Massachusetts, Bobby and Ethel cast their votes.
Above: Other Hyannis residents check in at their polling place to vote on November 8, 1960.

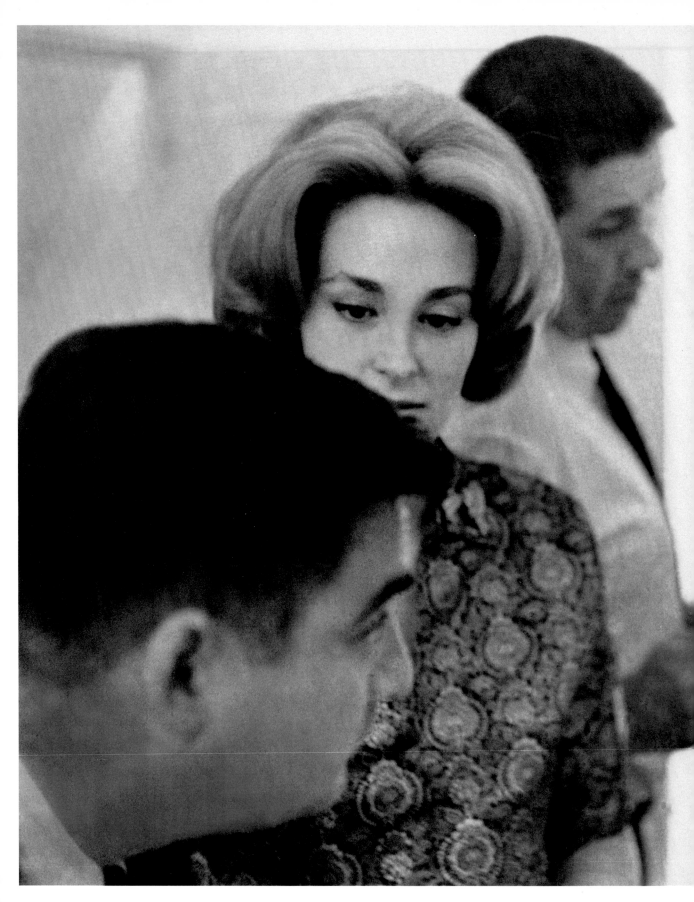

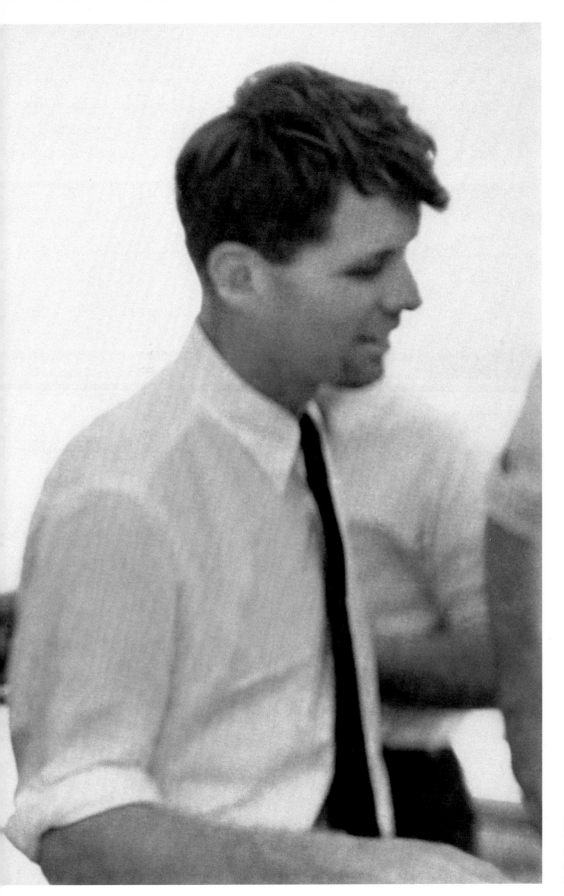

Pierre Salinger, Joan, an unidentified member of the Kennedy team, and Bobby wait for returns on election night.

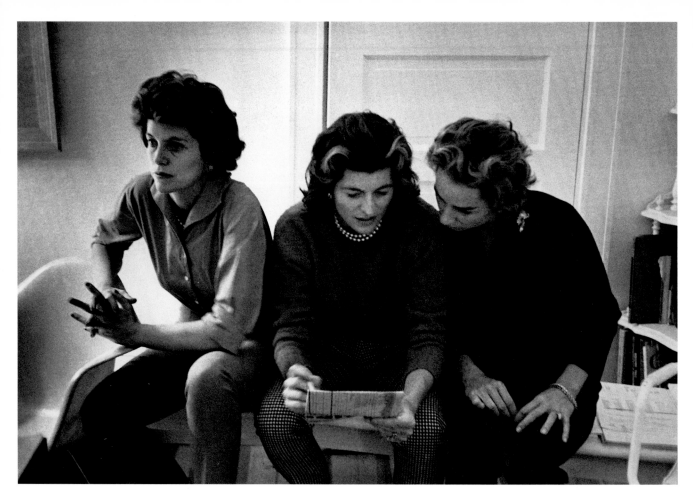

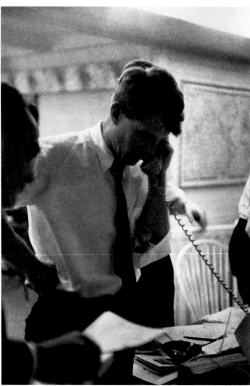

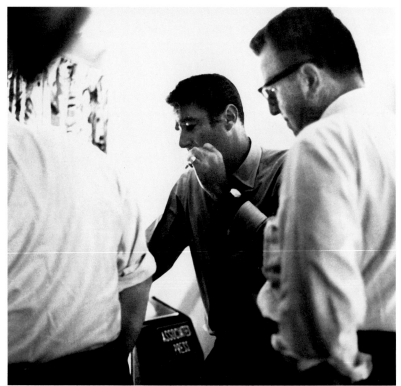

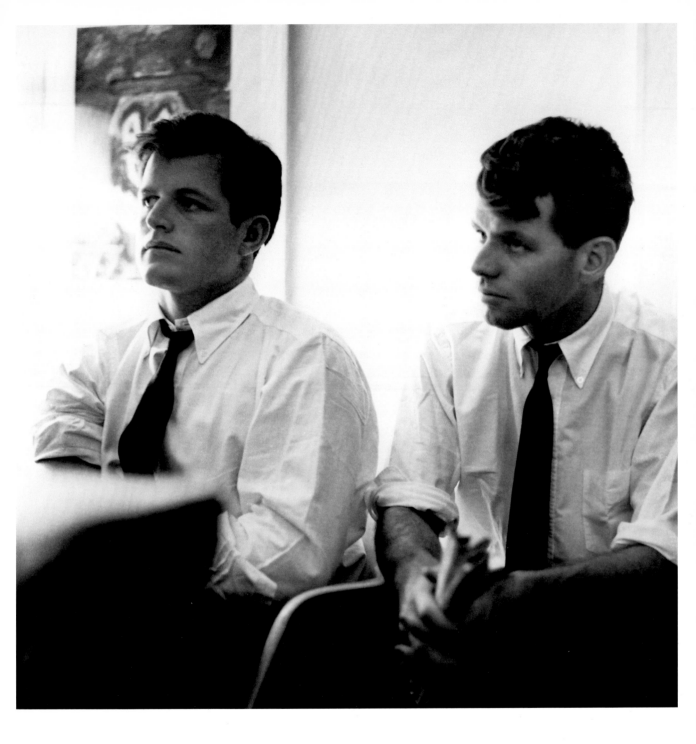

Left: Eunice Shriver, Pat Lawford, and Ethel Kennedy keep the vote vigil, while Bobby gets a field report, and Peter Lawford and campaign strategist Larry O'Brien check returns.
Above: The expressions on Ted and Bobby's faces show how rough the wait is. This photo was taken at 4 a.m. on November 9 as a TV monitor showed Jack's margin shrinking from two million votes to just a few hundred thousand.

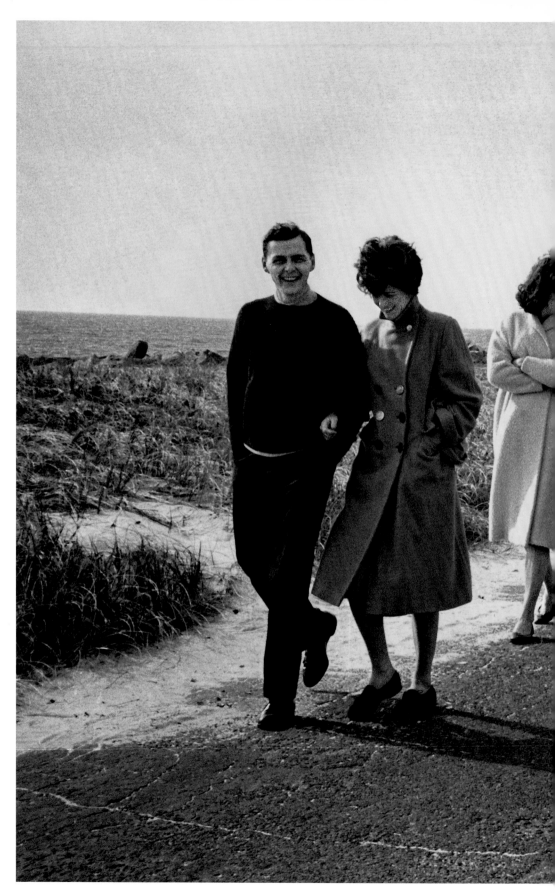

With the election results still uncertain, the Kennedy clan takes a morning stroll along the beach. Steve and Jean Smith lead the walkers, followed by Patricia Lawford, mother Rose, Ethel, Ted, Eunice Shriver, Bobby, and Jack's close friend Lem Billings.

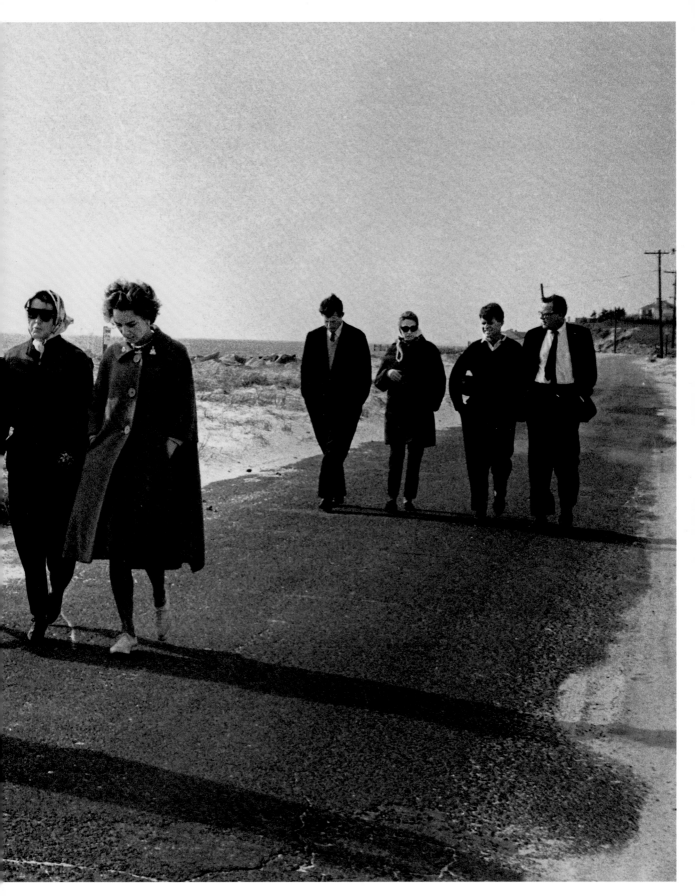

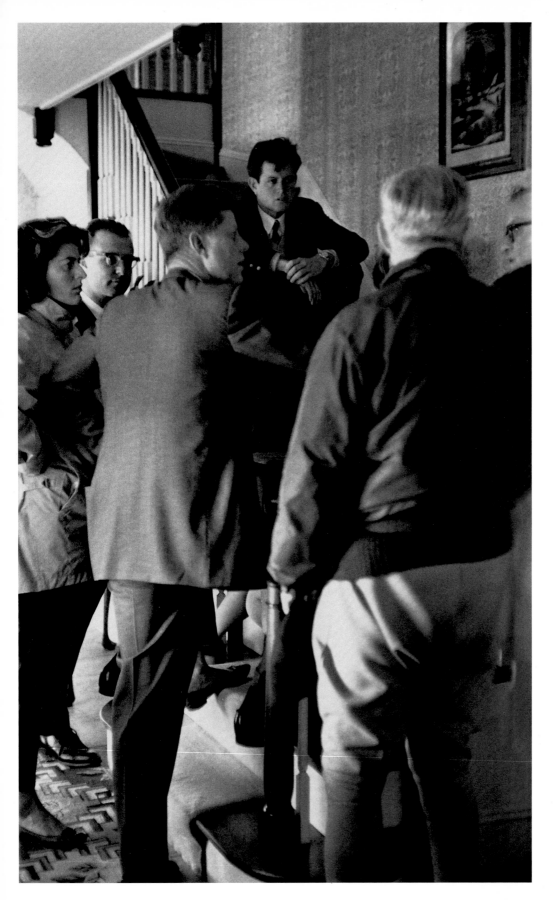

Left and right: The outcome is still unknown, and tense group discussions move from the stairway in old Joe's home to Bobby's porch.

Overleaf: Jack and Bobby, joined by Eunice and Ethel, mull the uncertain news. It is about 8 a.m. the day after the election. Richard Nixon has not conceded.

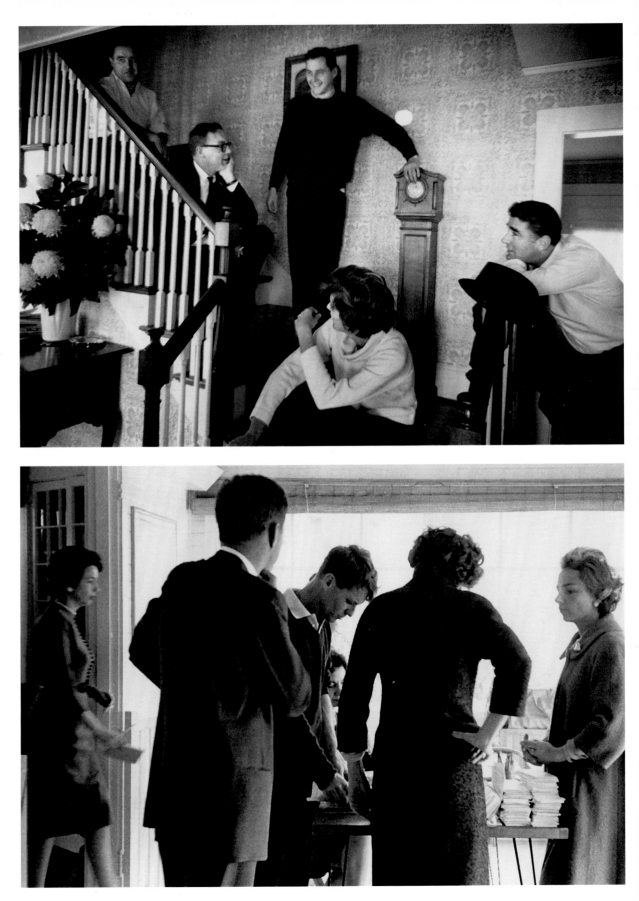

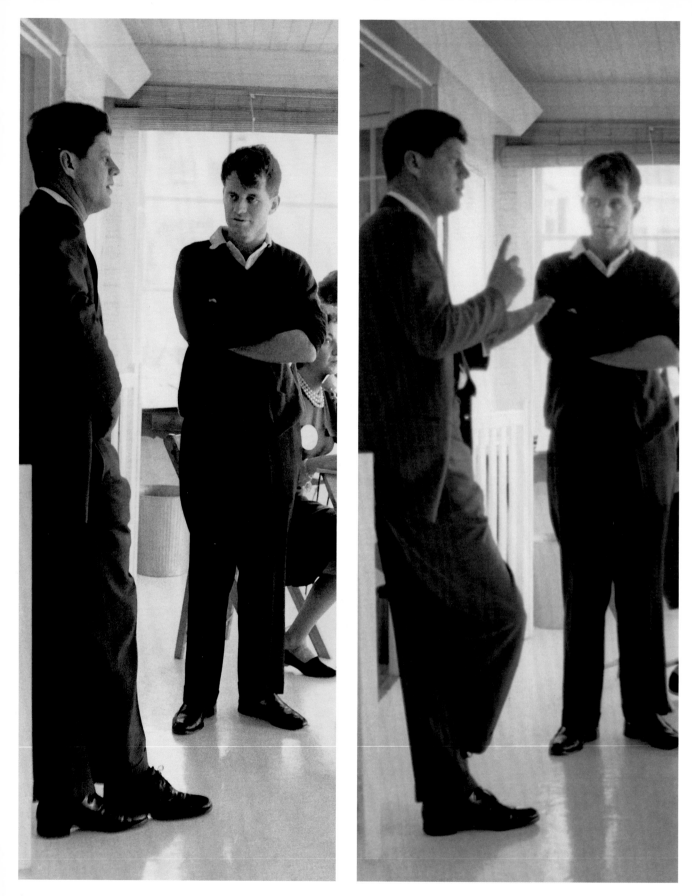

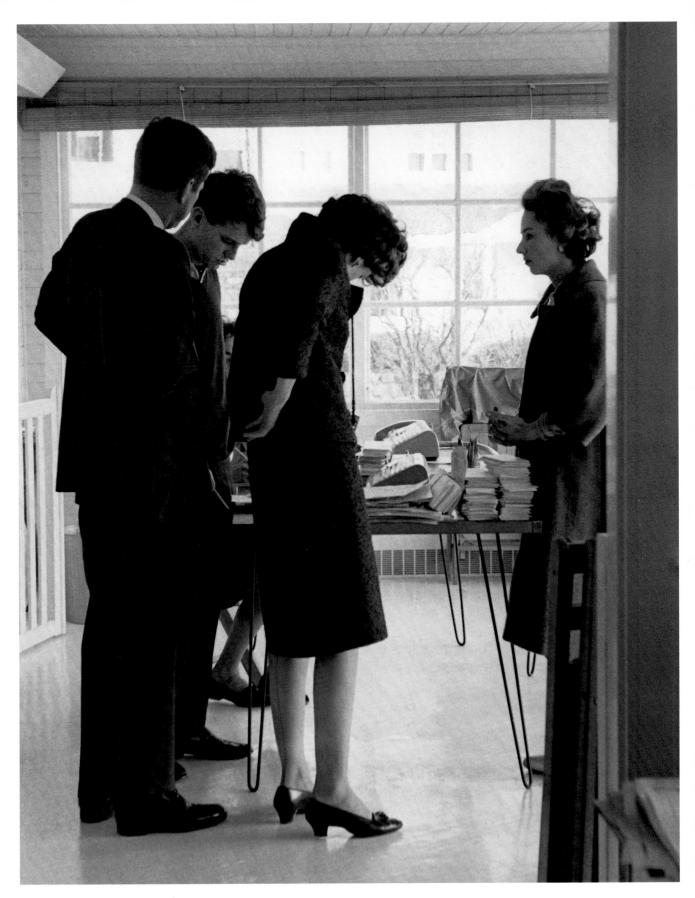

The critical hour approaches. Jacques took this picture about 11 a.m. when Jack's winning margin was a spare hundred thousand votes and Nixon still hadn't called. Waiting with Jack, from the left, are artist Bill Walton, Pierre Salinger, Ethel, Bobby, Bobby's secretary Angie Novello, and campaign aide Bill Haddad. The man on the staircase is not identified.

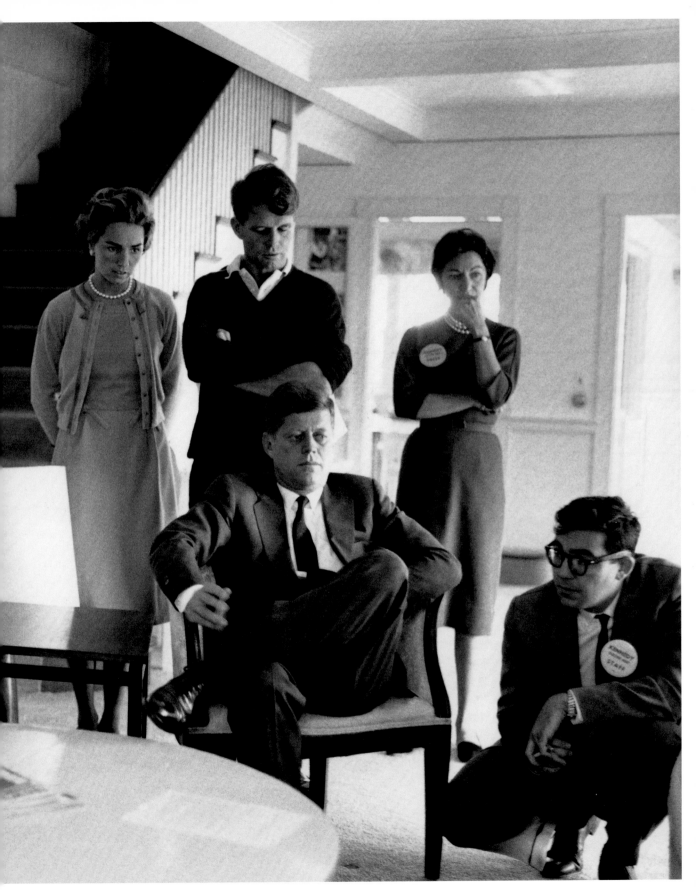

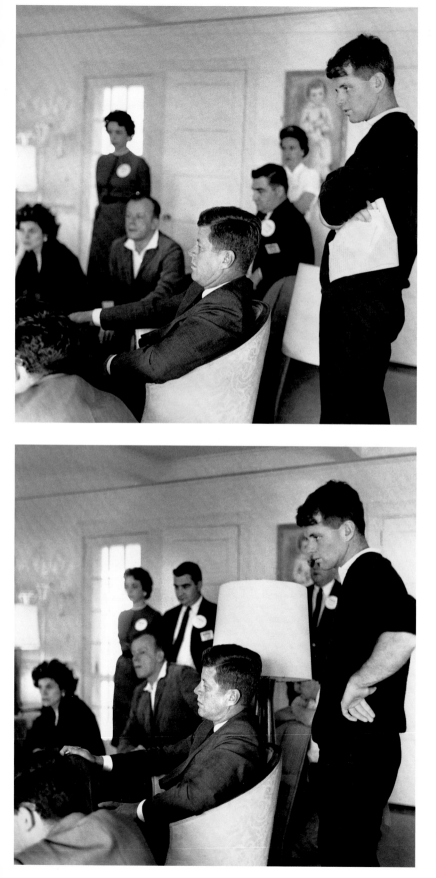

Kennedy sat before the television screen, fiddling with a pencil, for more than an hour near noon on the morning after the election, waiting to hear if the Nixon camp would challenge the results. Not long after, he learned that Nixon's concession would be broadcast and that a congratulatory message from former President Dwight Eisenhower was on its way.

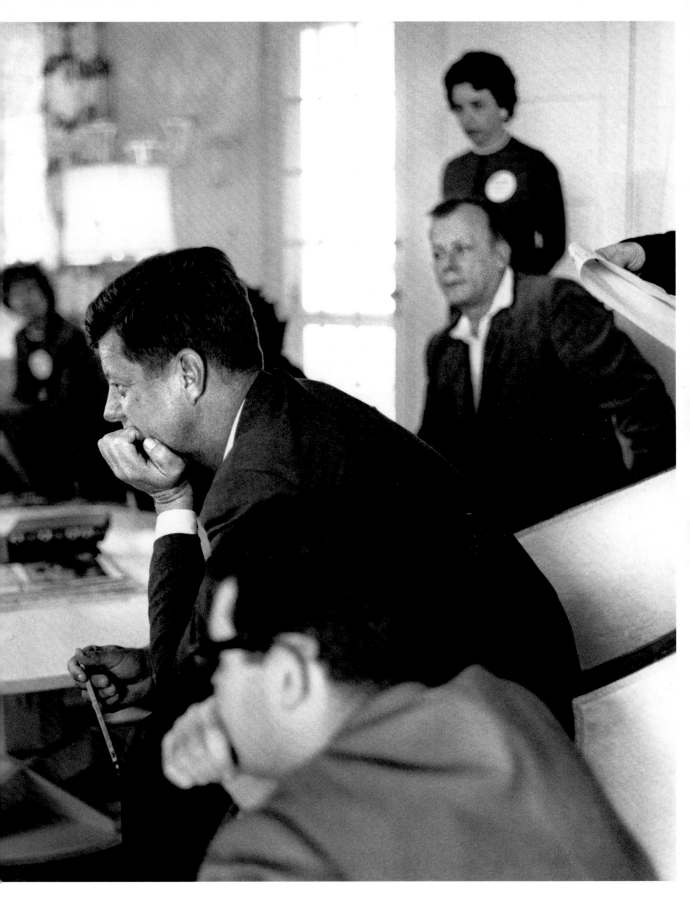

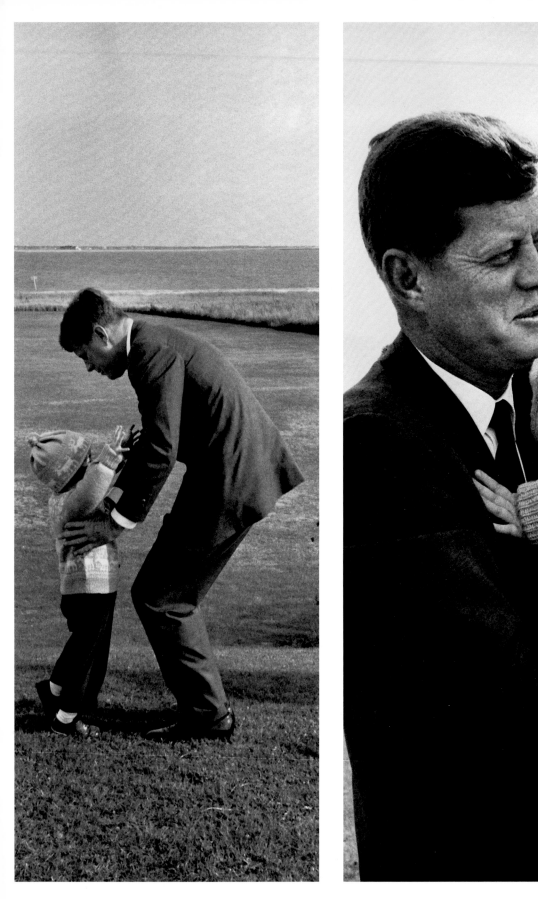

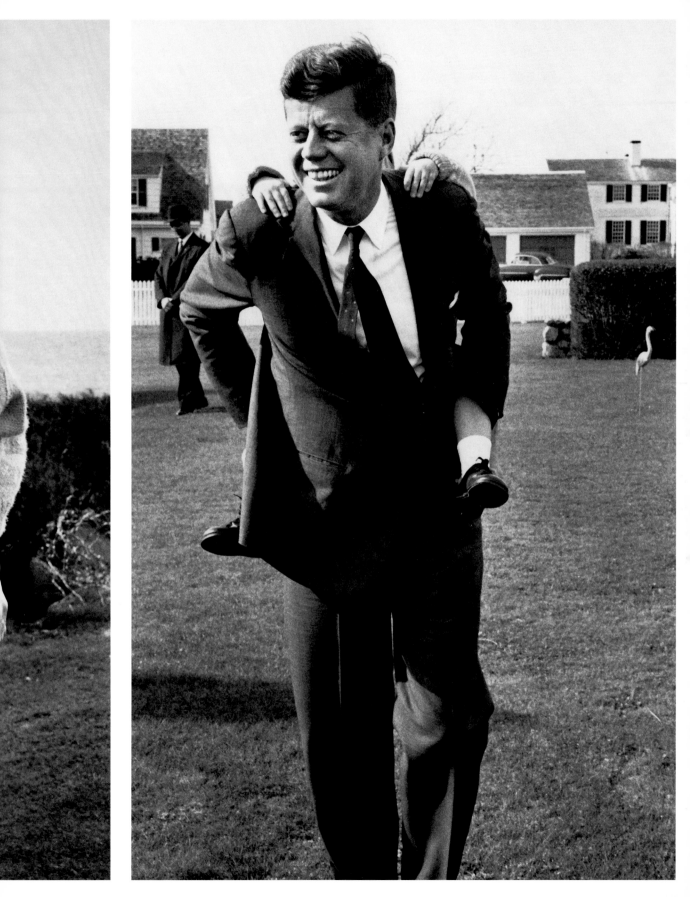

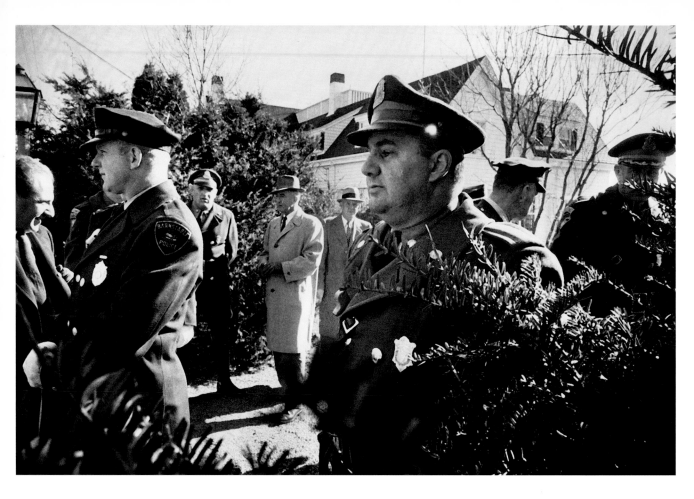

Previous pages: A happy President-elect Jack grabs playtime with his daughter, Caroline.

Above and right: A Secret Service security detail and extra police officers quickly materialize after Kennedy's election is confirmed. Jacques commented on how impressed he was: The agents showed up fully briefed on Kennedy and knew such detailed information as the names of family members and staff, as well as their jobs.

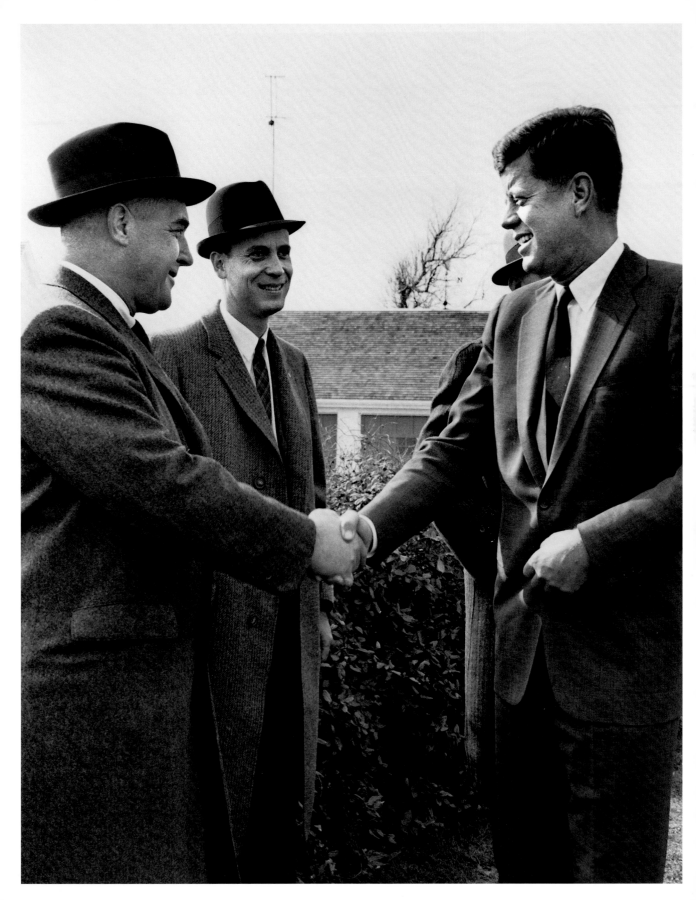

241

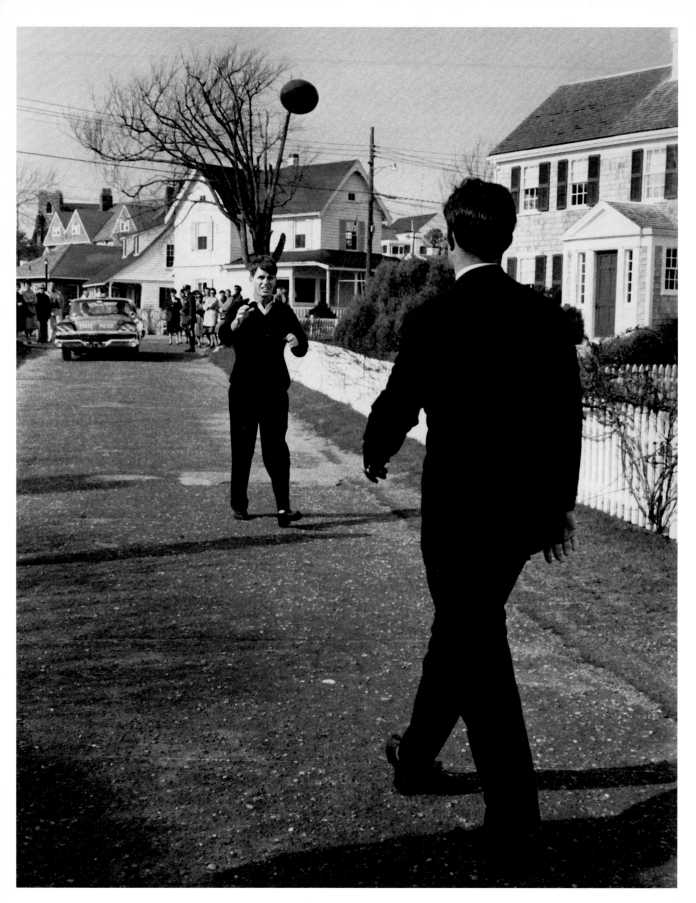

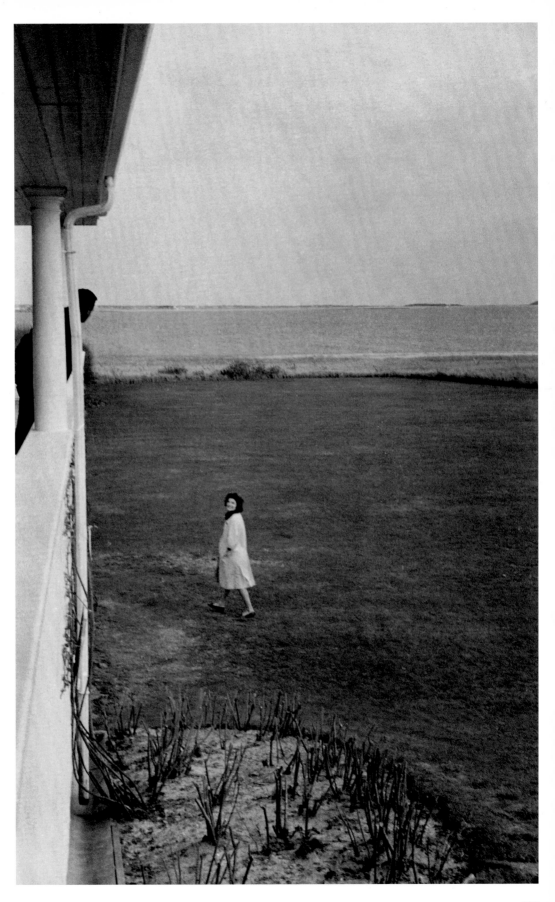

Left: Bobby and Ted unwind after the long, tense night by tossing a football on the compound road. Behind them, spectators gather in hopes of glimpsing the soon-to-be president. *Right:* Jackie, perhaps already apprehensive about what she has lost as well as gained, heads for a lonely stroll on the beach in a faded raincoat and flat beach shoes.

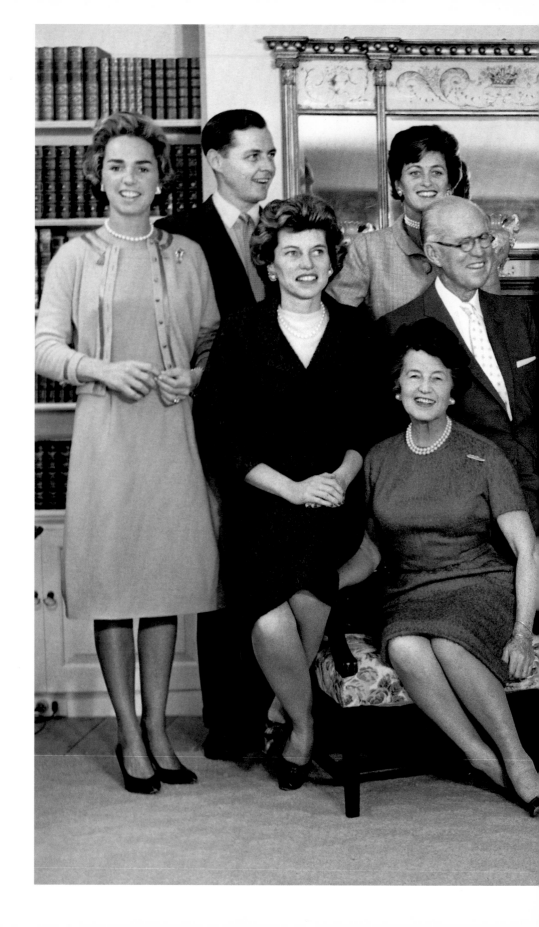

A triumphant Kennedy family, after much pleading and prodding by Jacques, assembles for the portrait that became, arguably, the most disseminated photo of the day. From left are Ethel, Steve Smith, Eunice, Rose, Jean, Joe, Jack, Jackie, Bobby, Ted, Patricia, Sargent Shriver, Joan, and Peter Lawford.

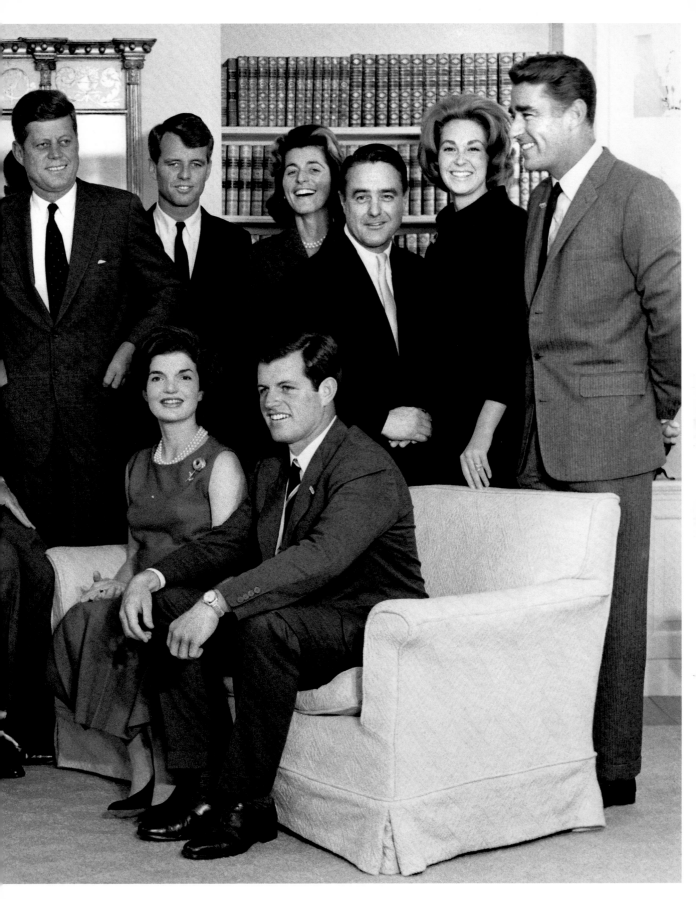

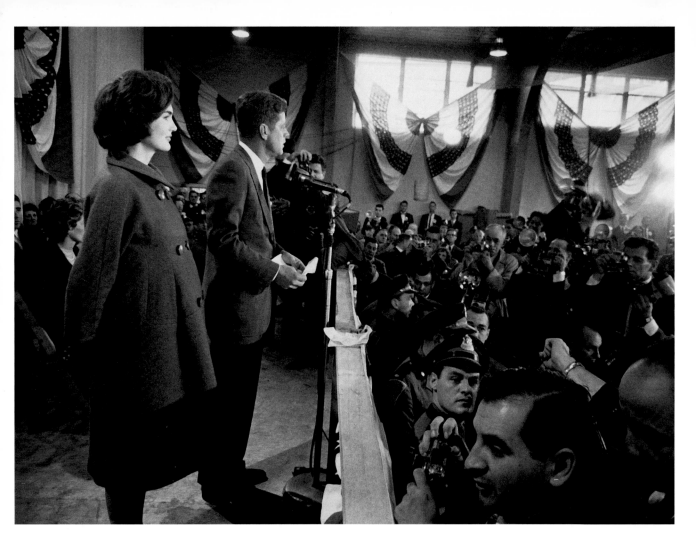

Above: Journalists waited all night in Hyannis Armory for their first look at the president-elect. "So now," said Kennedy, "my wife and I prepare for a new administration and a new baby."

Right: Noticing his father's absence as a victory motorcade formed, Jack dashed into the patriarch's house and insisted that Joe dress and accompany them.

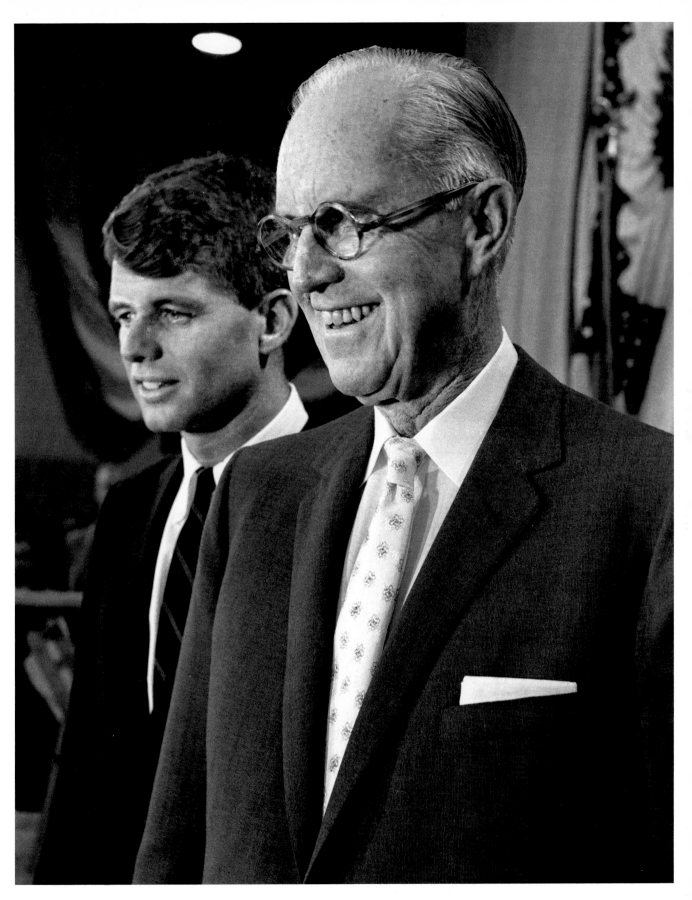

Inauguration
Washington, D.C.

What a party. Jack's inaugural pageantry—an evening gala followed by the swearing-in ceremony the next day—featured a blizzard, Bette Davis, Frank Sinatra, revelry in every hotel, composer Leonard Bernstein, actor Laurence Olivier, Harry and Bess Truman, a seven-hour parade, millions of dollars in designer dresses and diamonds on display, and old Joe Kennedy in a topper on the Capitol steps waiting for his son to become the thirty-fifth President of the United States. There was a God in the Irish heaven after all.

In a brief but revealing moment before the inauguration, Jack asked a friend to join him for a few minutes on the flight to Washington from Palm Beach, Florida, where he had been resting in the Kennedy family's beachside mansion. Jack had been working on his inaugural speech. Tossing a yellow legal pad filled with two pages of jagged script at the friend, he asked his opinion. "I want to say that the American Revolution still is going on, that this nation is still young and vital," he explained.

Vitality was on display that night as Kennedy's Secret Service detail literally lifted his limousine over snow banks so a gala staged by Sinatra would begin almost on schedule. The snow, rather than a problem, seemed to infuse the festivities with even more gaiety than usual. Many of the celebrants never went to bed. They just clumped back to their hotels at dawn, changed clothes, and headed through the deep snow on Capitol Hill to the swearing-in.

Early inauguration morning, Kennedy walked a few blocks to attend mass at tiny Holy Trinity Catholic Church. There was already a crush of press, and a few reporters crowded into the sanctuary behind him. The president-elect went to the front of the church and knelt alone, unaware that his mother, Rose Kennedy, sat in the shadows at the side. She stayed still, silently praying as she would later say, for her son and for the United States.

A preoccupied Jack still did not see her as he swept back down the aisle and outside. When she left the church, there were no taxis on the constricted streets. She walked to the White House.

As they took their places behind the inaugural stand, the Kennedy males judged one another in their top hats. Jack won easily while Bobby, it was agreed, looked like a trapped animal. He probably felt that way, as well.

At noon a cold wind whipped the Capitol plaza, but a dazzling sun glinted off the snow and heightened the vivid colors of the parka-clad crowd, which sensed history was in the making. Kennedy shed his overcoat when he took his oath, a demonstration of his vigor, but not as bold as many thought since the stand had heaters going full blast.

Kennedy had asked 86-year-old Robert Frost to read a poem at the inauguration. Frost, with his wispy white hair blowing in the wind and his breath condensing into clouds, stepped to the podium. He could not control the pages of his script in the wind so he recited *The Gift Outright* from memory. When a short in the microphone produced smoke, he remained unfazed, standing craggy, strong, and undaunted like the people he wrote about in his beloved New England.

When Kennedy spoke to the nation, he was no longer "Jack," or "the other son," as father Joe had once described him. He was the President of the United States, or "Mr. President" to all but a close few. He squared his shoulders, looked out at the upturned faces, chopped air with his arm as he had done throughout his climb to victory, and shouted his message into history: "Let the word go forth from this time and place, to friend and foe alike, that the torch has been passed to a new generation. . . .

"And so my fellow Americans, ask not what your country can do for you. Ask what you can do for your country."

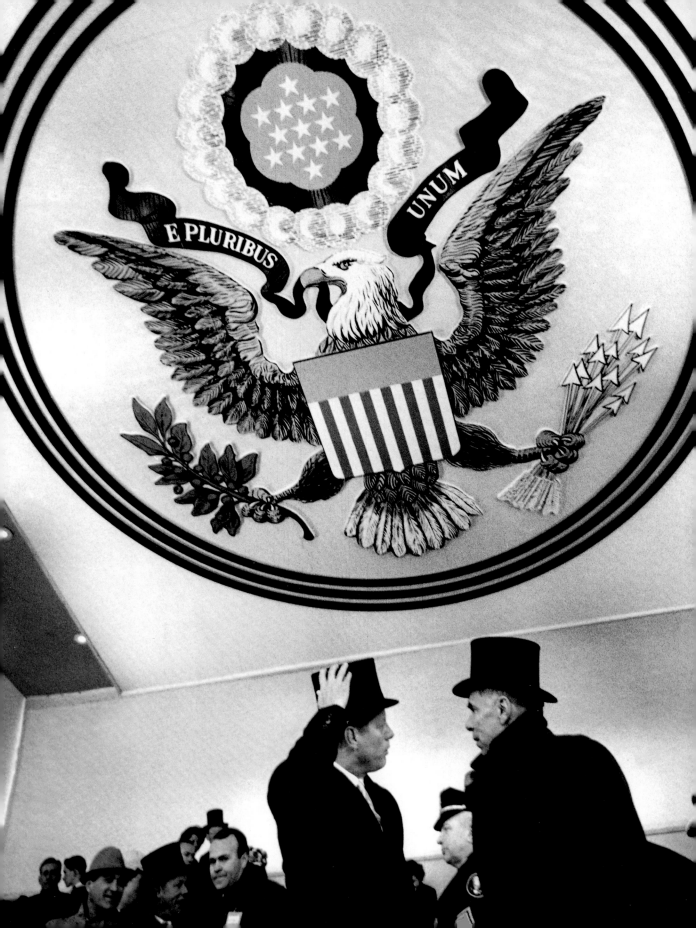

Previous page: Kennedy hangs onto his hat in the parade-reviewing stand in front of the White House. The parade, which followed the swearing-in, lasted nearly seven hours. Kennedy stayed for three of them.

Left: A roster of celebrities, including Leonard Bernstein, Bette Davis, Anthony Quinn, and Tony Curtis, get ready for the inaugural gala at the D.C. Armory. *Right:* The show was produced and directed by Frank Sinatra, caught by Jacques in a pensive mood.

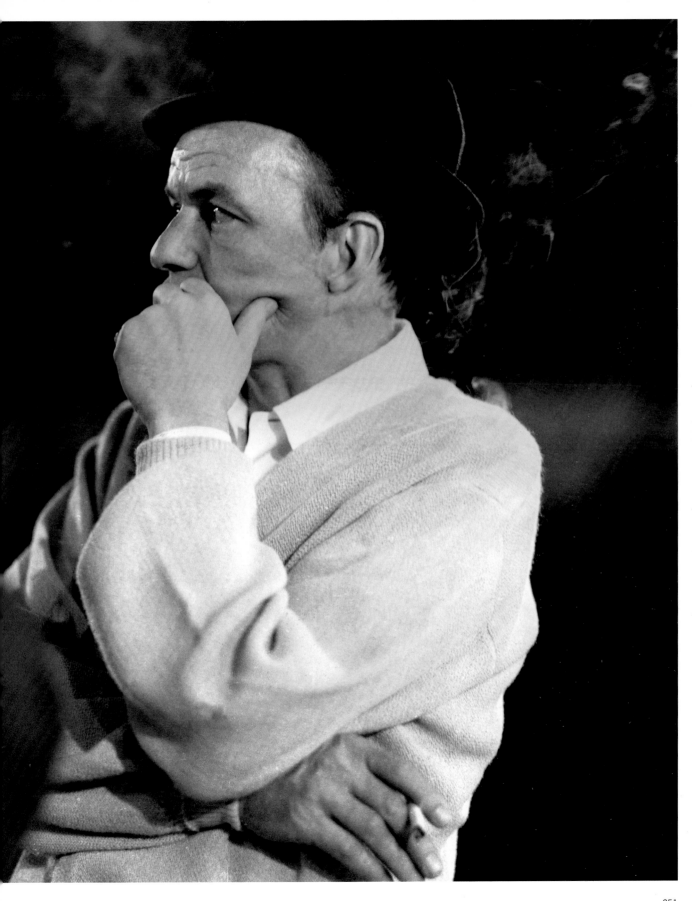

→3 →4

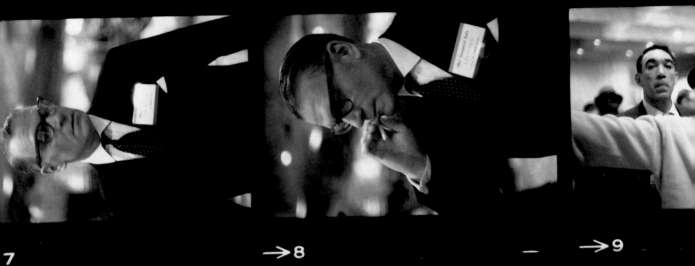

7 →8 →9

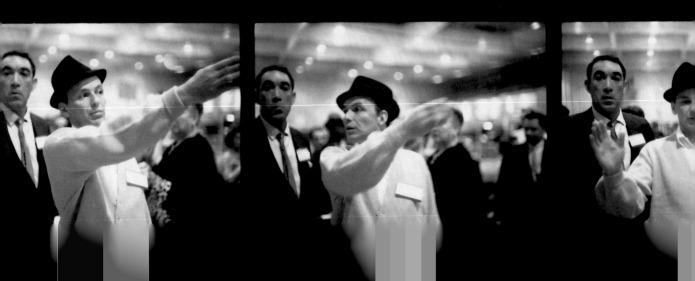

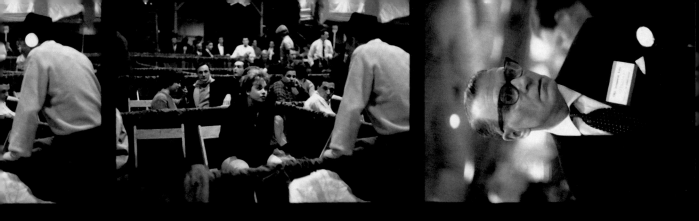

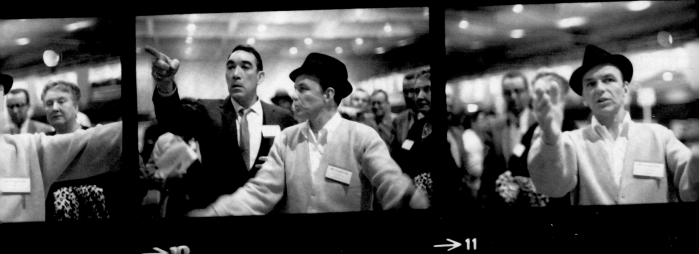

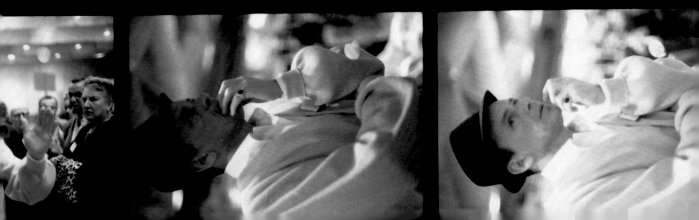

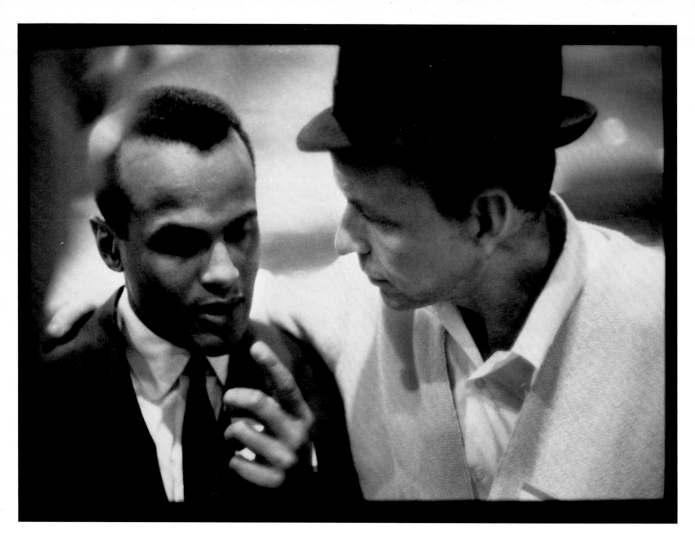

Previous pages:
A very much-in-charge
Frank Sinatra warms up
participants before the gala.

Above: Sinatra talks
with Harry Belafonte.
Right: Jimmy Durante proves
that age is no barrier.

Far right:
The stars get their
cues. Performers ready
to welcome the new
president include Tony
Curtis, Janet Leigh,
Gene Kelly, Laurence
Olivier, Fredric March,
and Ella Fitzgerald.

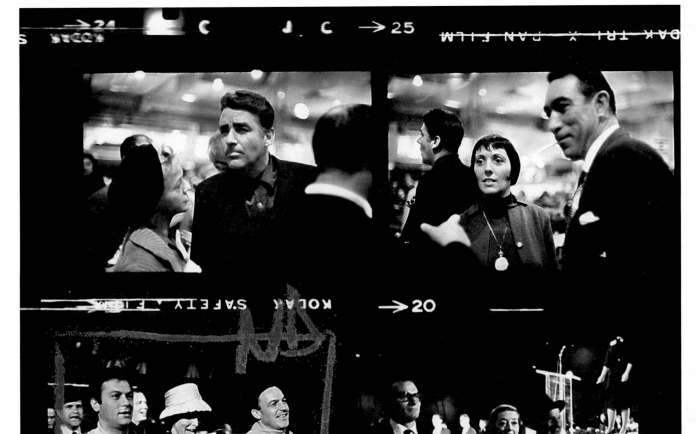

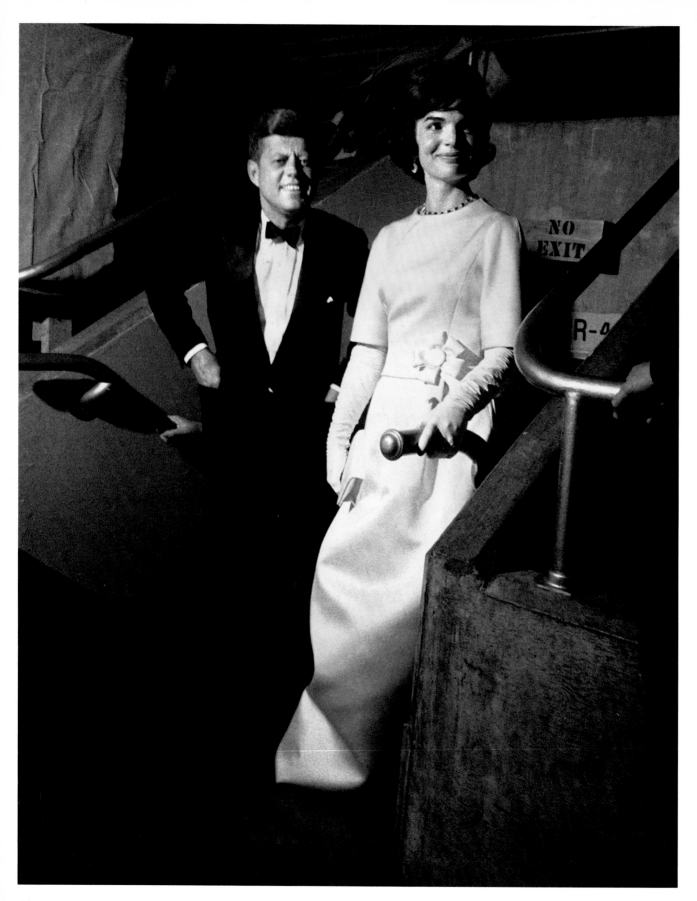

Left: Snow delayed the start of the inaugural gala by an hour, but when an elegant Jack and Jackie finally appeared, the hall erupted in cheers. They were the real stars of this show. *Right:* Other Kennedys wait for the beginning of the gala, which was Sinatra's idea—a gift to his friend, Jack.

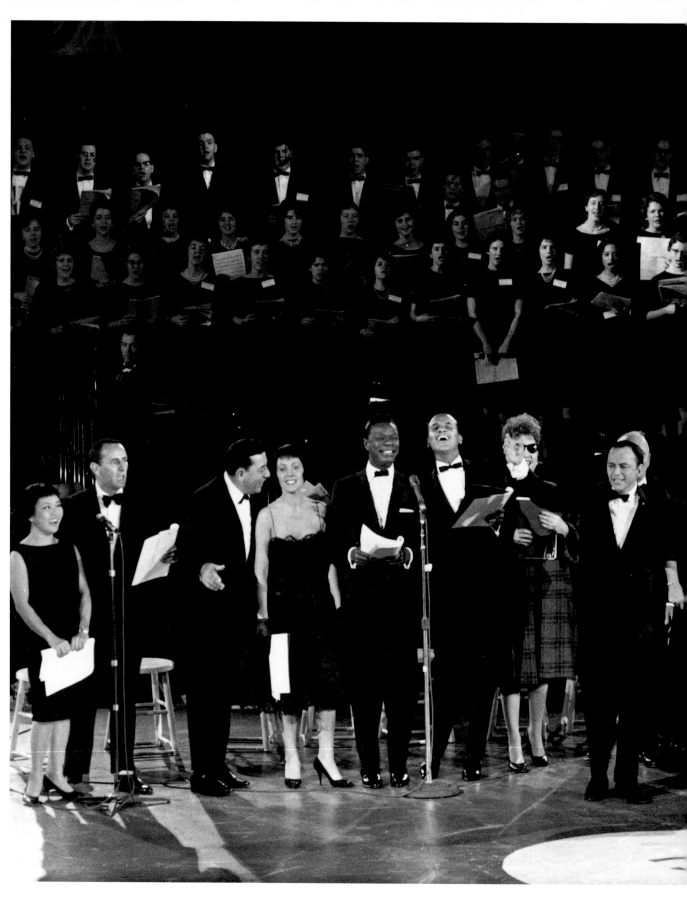

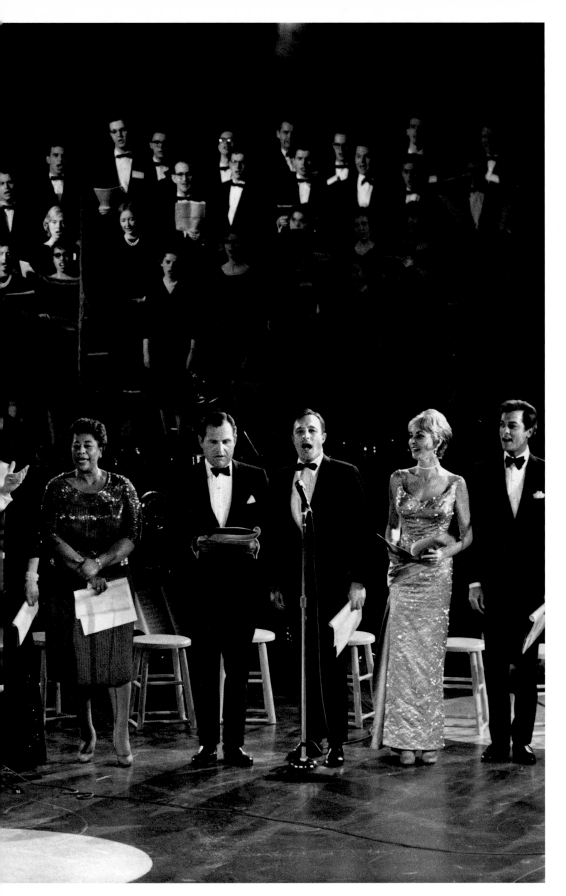

Celebrity performers line up at the gala finale. The show at the D.C. Armory went on well after midnight. Local historians agreed that the city had never glittered with so much star power.

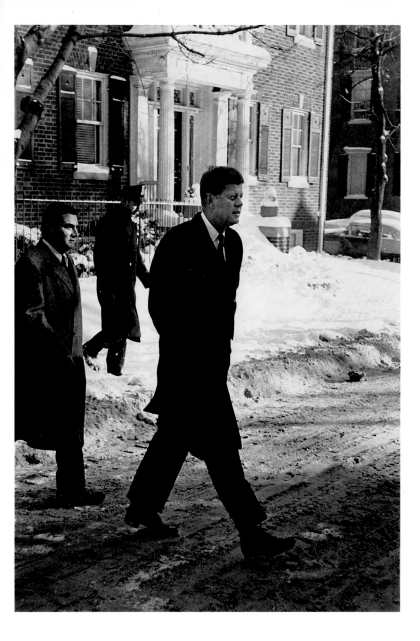

Above: Early on Inauguration Day, JFK walks through the snow to mass at nearby Holy Trinity Catholic Church. Pierre Salinger trudges behind. *Right:* After Jack changes into his formal wear, he and Jackie head for the White House where they will pick up Dwight and Mamie Eisenhower for the ride to the Capitol and the transfer of power.

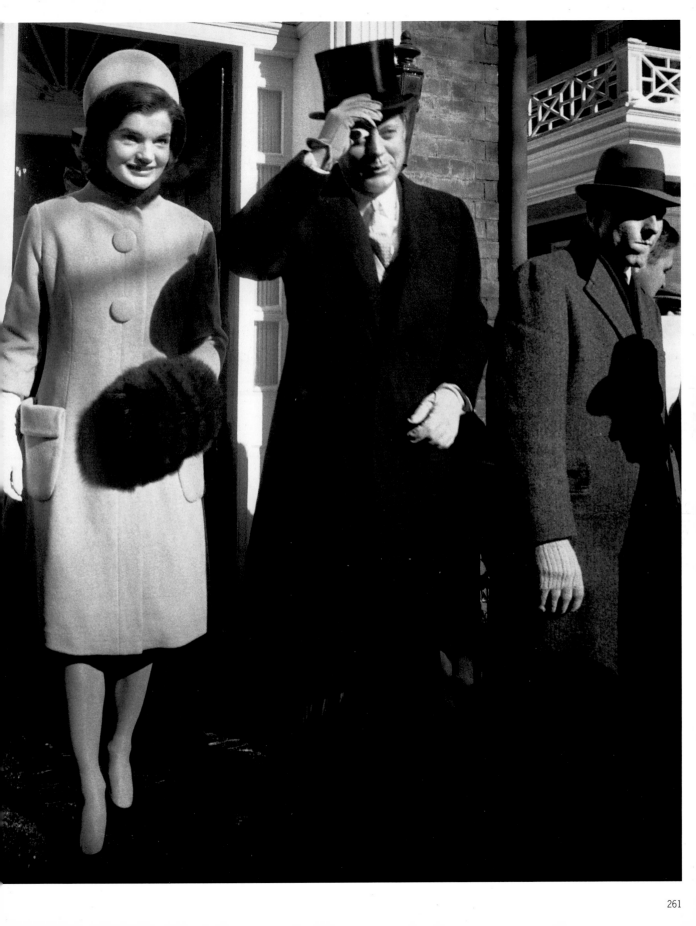

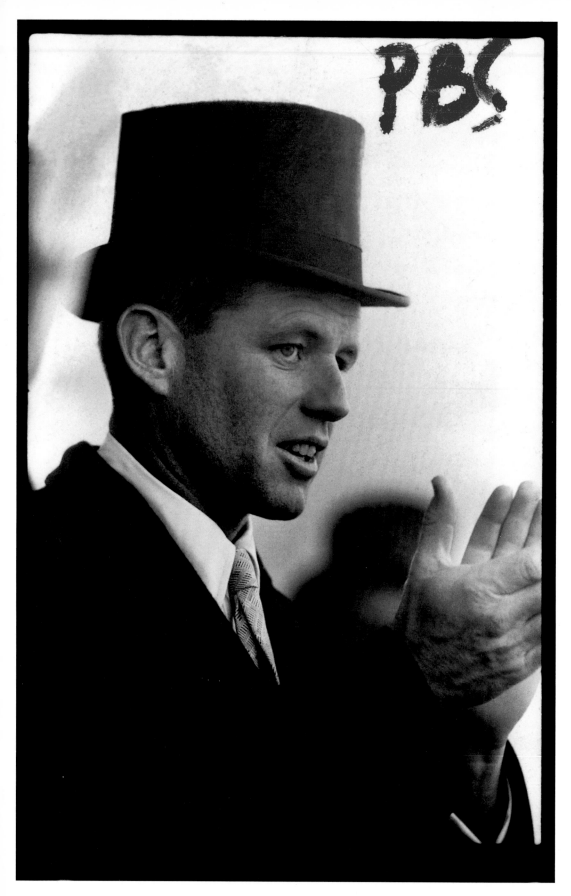

PBS

Left: The Public
Broadcasting System
selected a photo of
Bobby in a topper
for a PBS program.
Right: Lyndon and Lady
Bird Johnson assemble
with Jack, Joe, and
Rose Kennedy on
the inaugural stand.

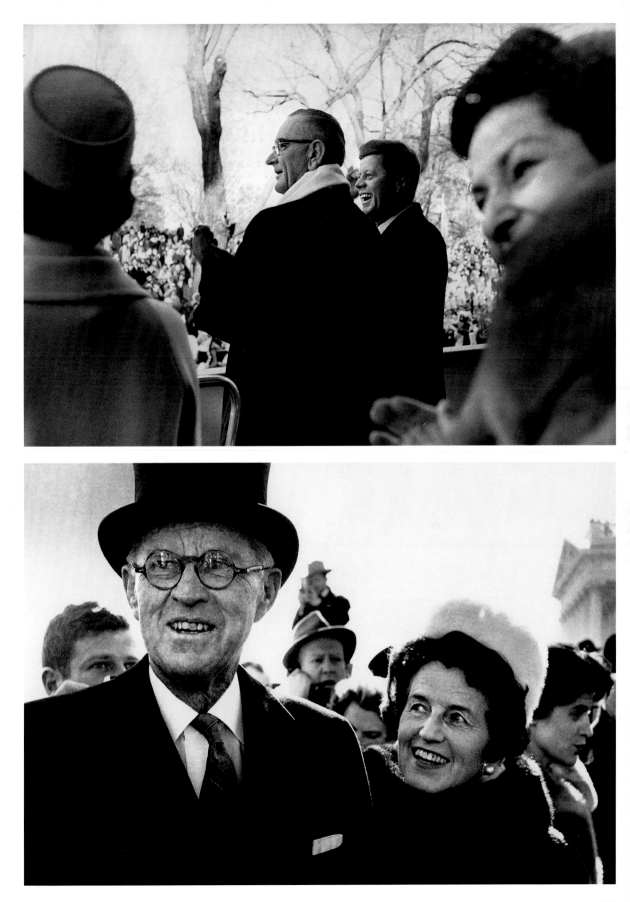

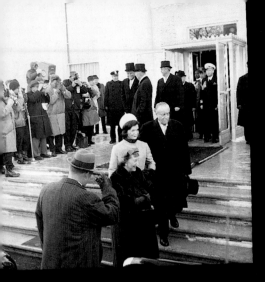

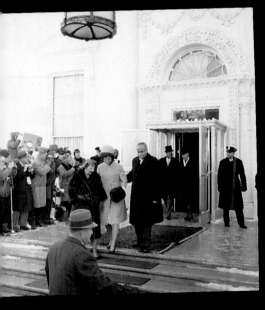
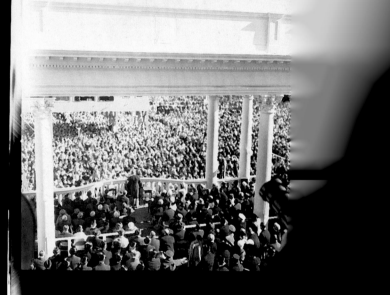
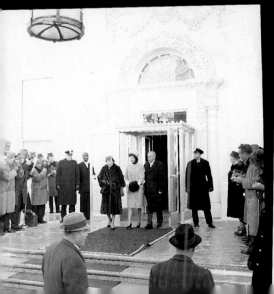

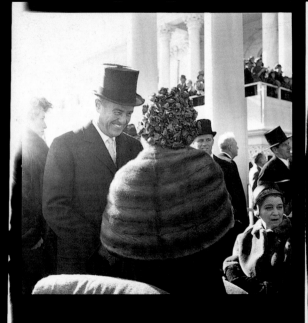

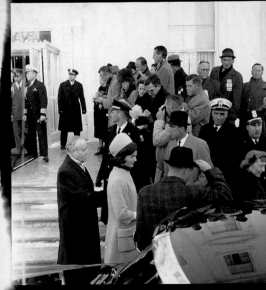

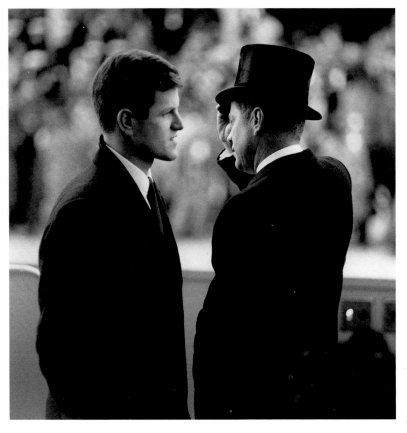

Previous pages: The Kennedys leave the White House with Dwight and Mamie Eisenhower for the trip to the Capitol, where they greet, among others, Adlai Stevenson and former President Harry Truman and his wife, Bess. *Left:* Harry Truman looks as tough as ever on Inauguration Day. Not once during his eight-year term did Eisenhower invite Truman back to Washington.

Above: Ted and Jack grab a minute alone amid the ebullient crowd.

Overleaf: After years of planning and struggle, JFK becomes the nation's thirty-fifth president. Earl Warren, chief justice of the Supreme Court, administers the oath of office. Elegance, draped with excitement, sets the tone for the inaugural hubbub.

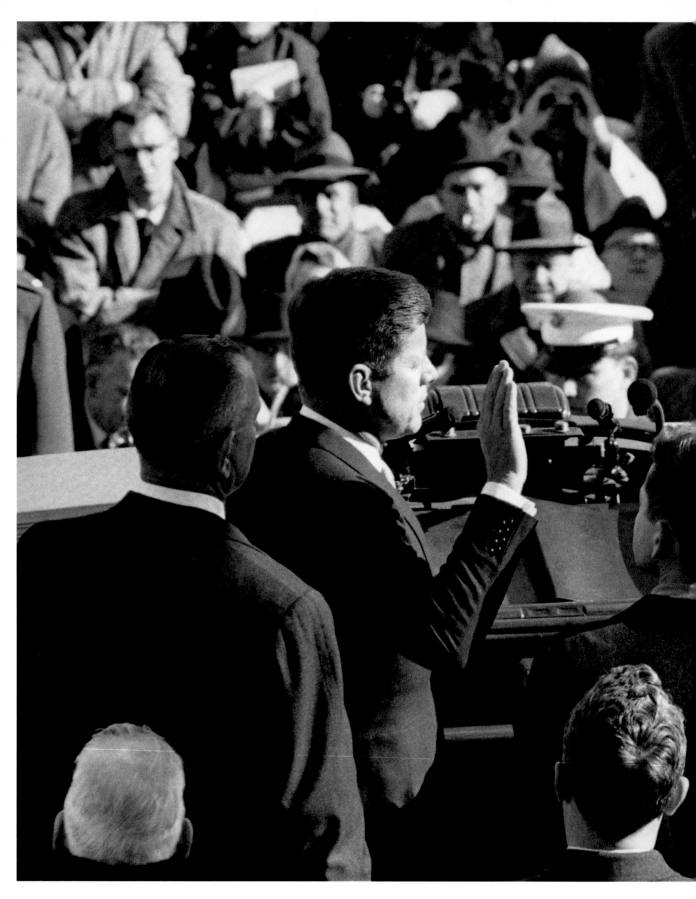

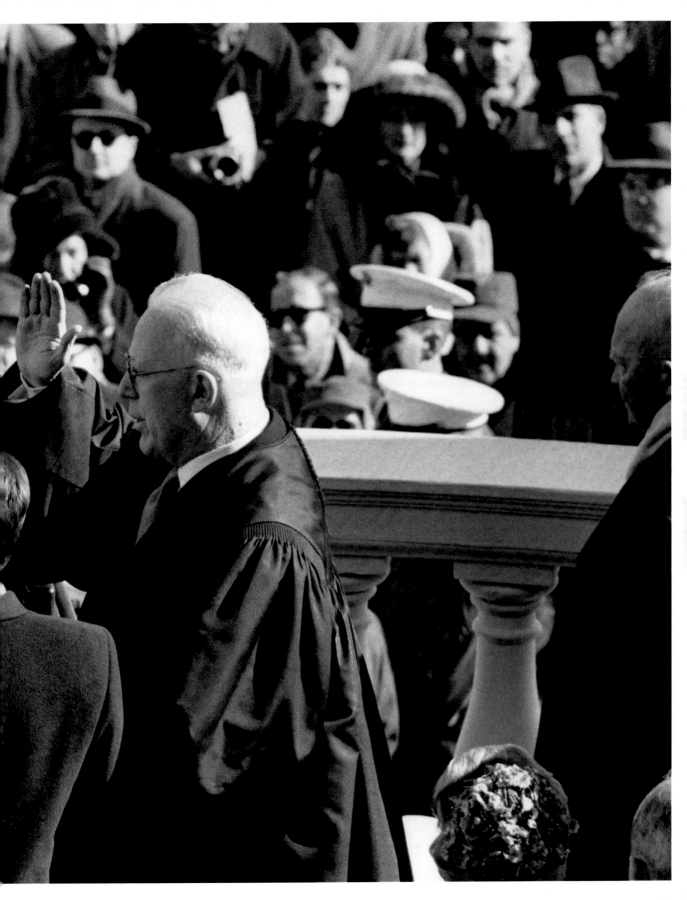

KODAK TRI X PAN

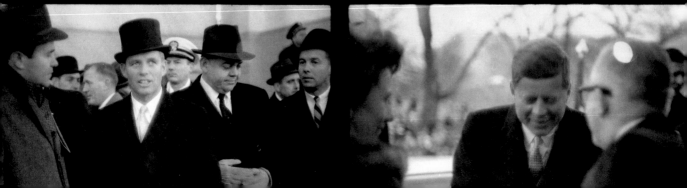

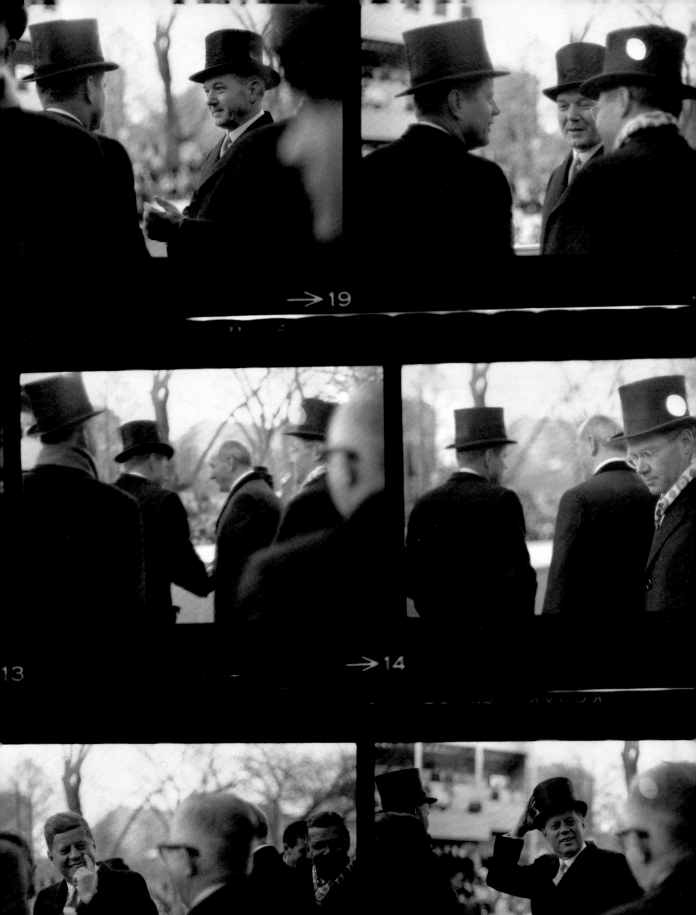

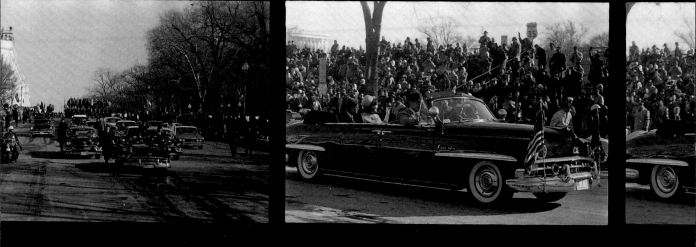

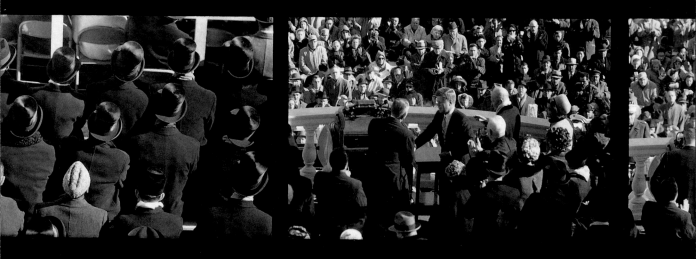

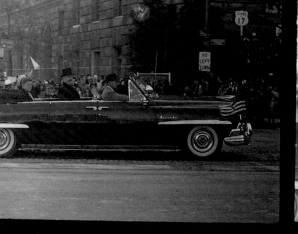

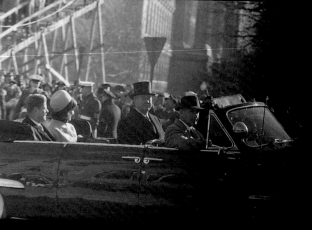

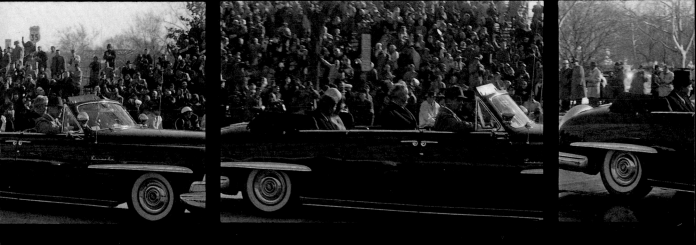

→19 →20

KODAK SAFETY FILM

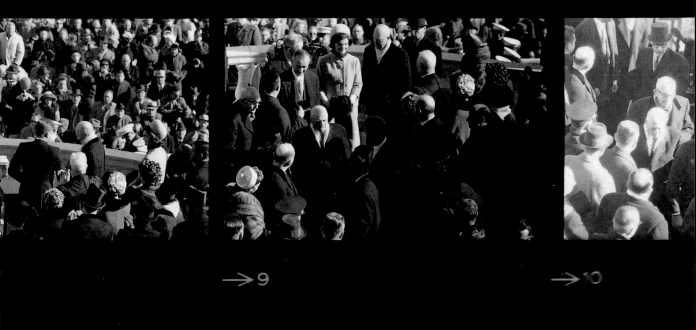

→9 →10

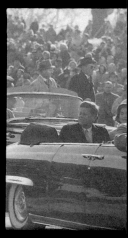

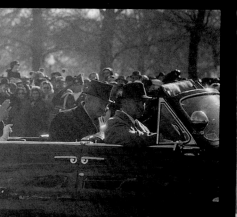

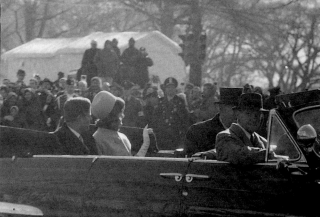

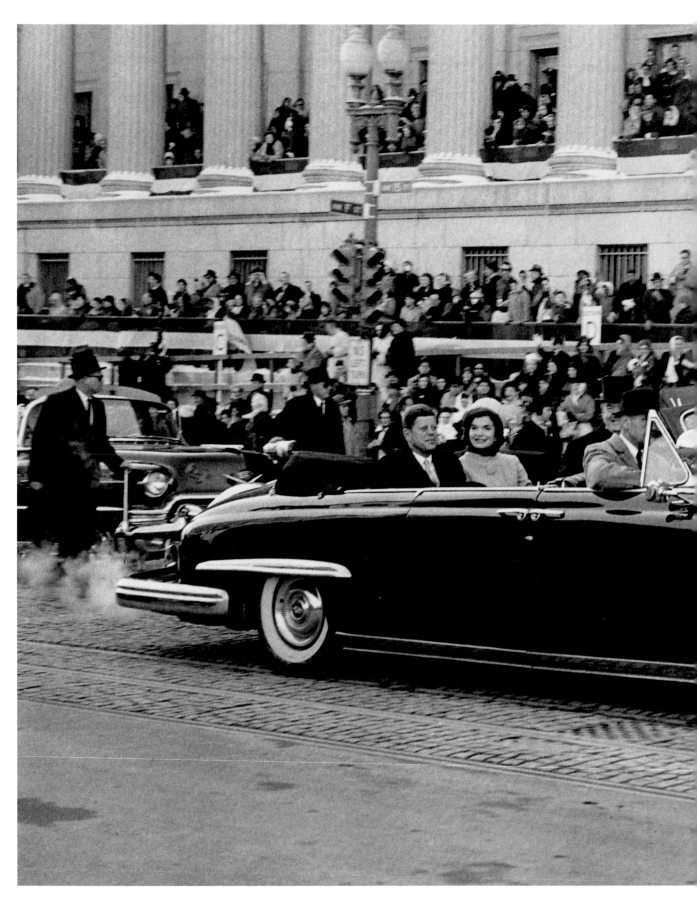

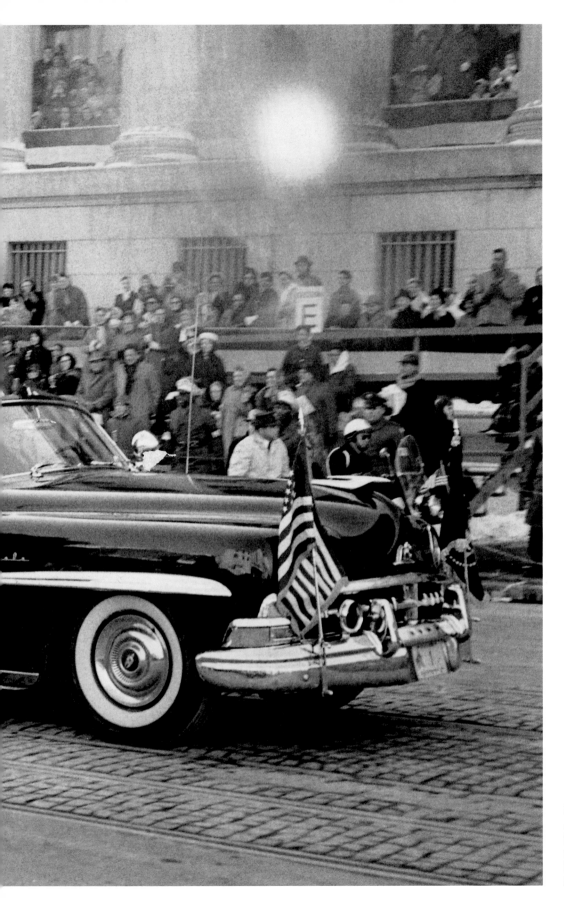

Previous pages and left:
Jack and Jackie, now
the country's president
and first lady, head
back down Pennsylvania
Avenue in an open car.

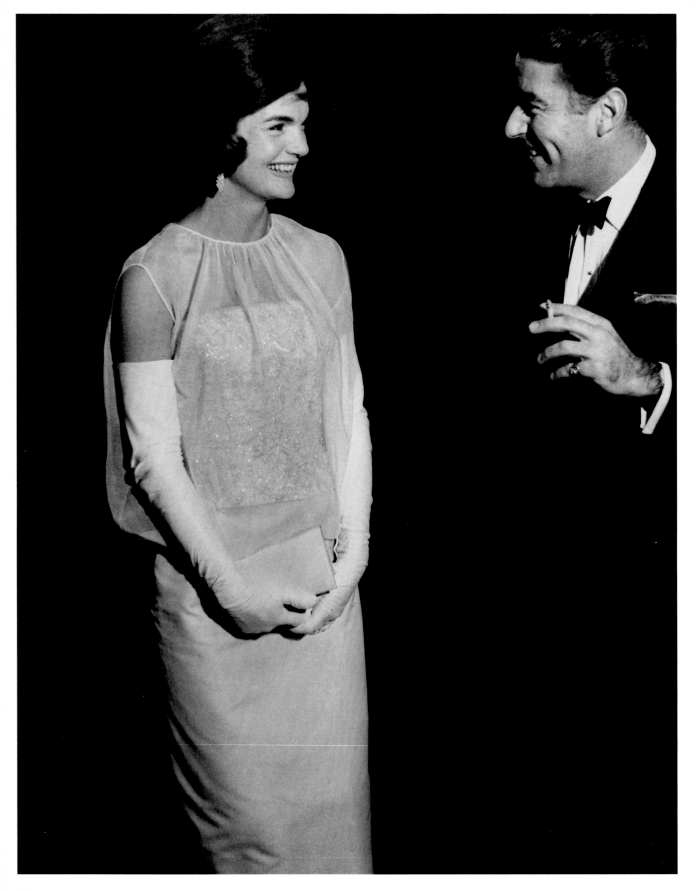

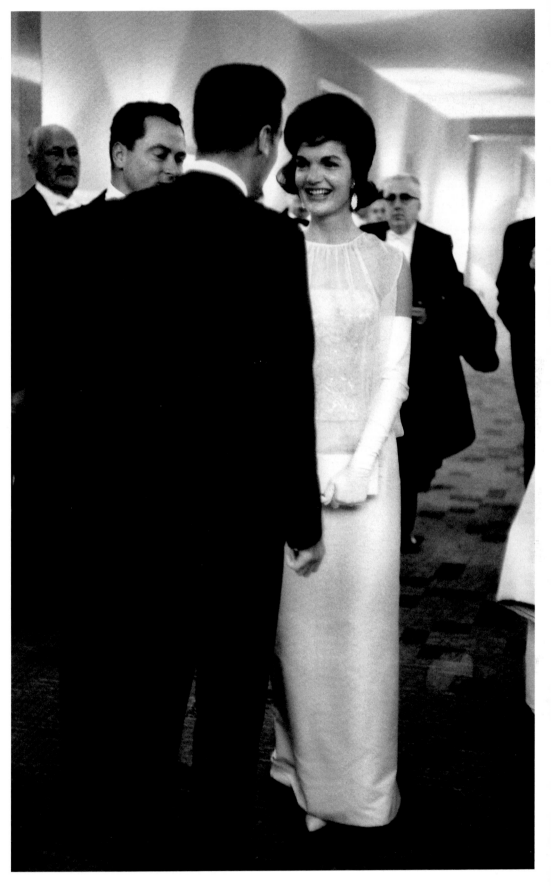

Left and right: After the swearing in and long inaugural parade, the Kennedys were expected to make appearances at five inaugural balls. The biggest fête took place at the D.C. Armory, where two-and-a-half acres of Kennedy fans waited, elbow-to-elbow, for the couple.

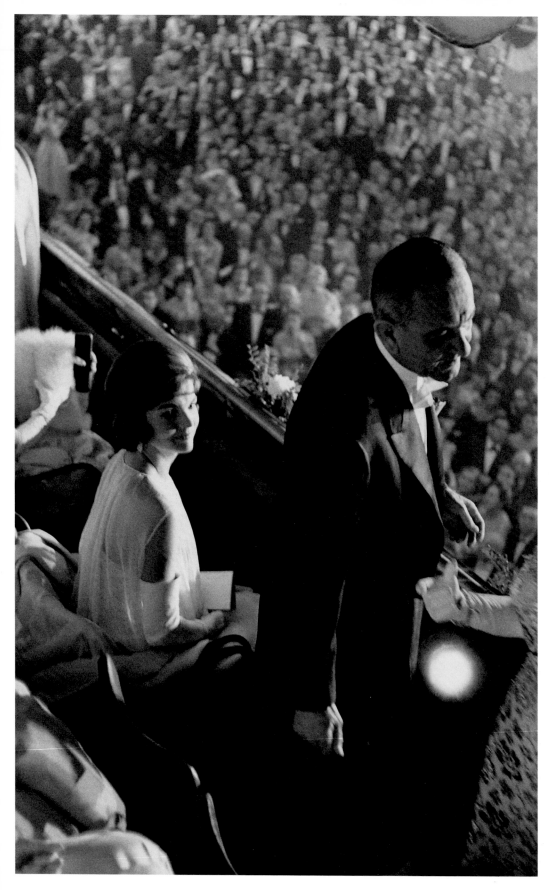

Left: Jackie and new Vice President Lyndon Johnson sit high above the adoring crowds at the premier inaugural ball at the D.C. Armory. *Right:* President John Kennedy signals to old friends he spots in the crowd. Jack and Jackie's entrance at the ball seemed at times more like an event for royalty than for the leaders of the greatest democracy on earth.

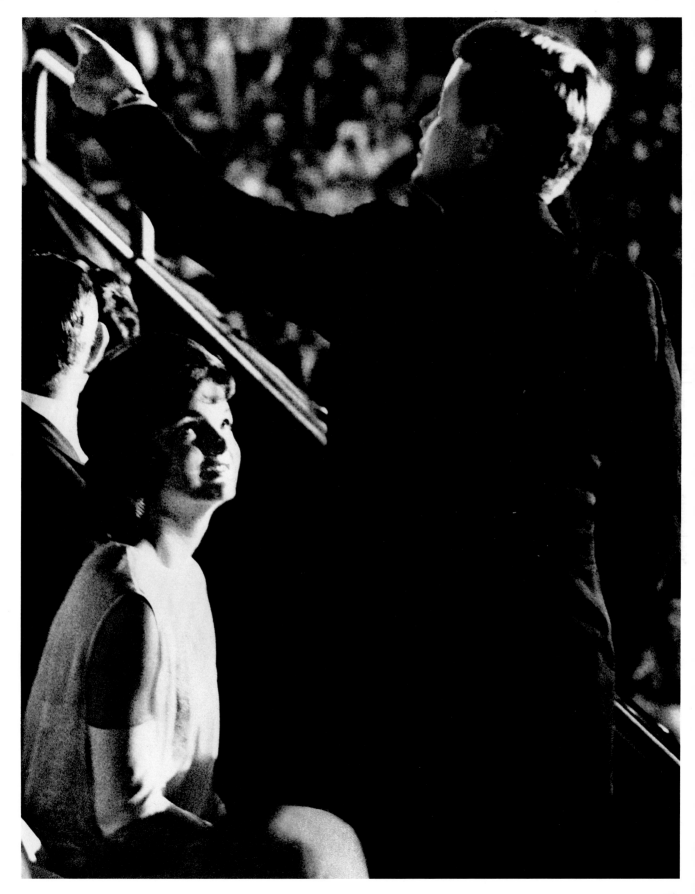

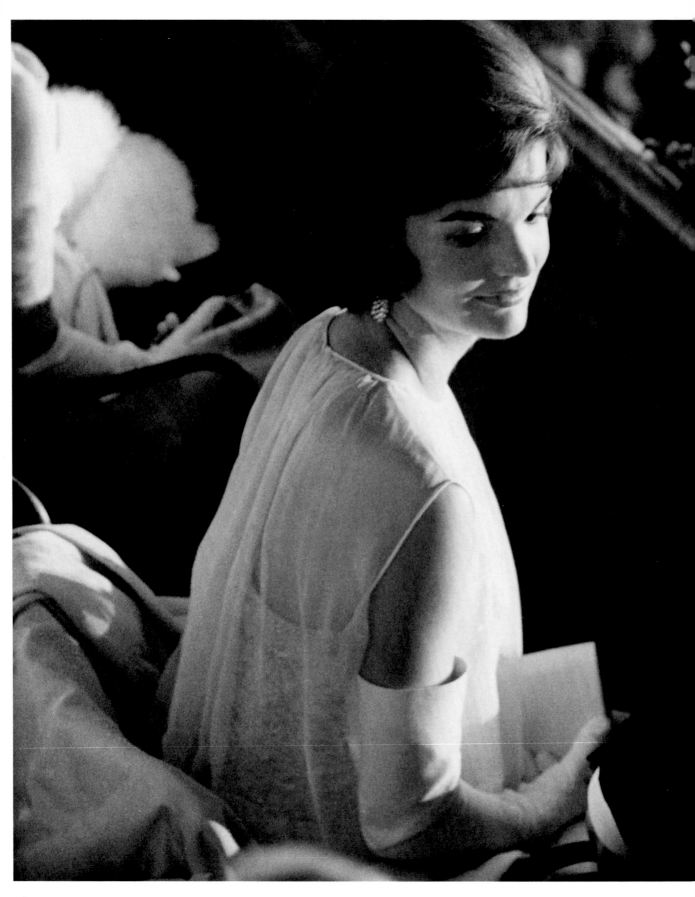

Left: Jackie's ephemeral beauty and ravishing gown created an exciting new focus for fashion writers. Jackie, who had given birth to John Jr. just weeks before, would only last through three of the five inaugural balls. Jack would attend them all, then wind up at a private party that was still going on when he left at 3:30 a.m. for his first night's sleep in the White House. *Above:* "I think this is an ideal way to spend an evening," Jack tells the huge audience at the inaugural ball. "You looking at us and we looking at you."

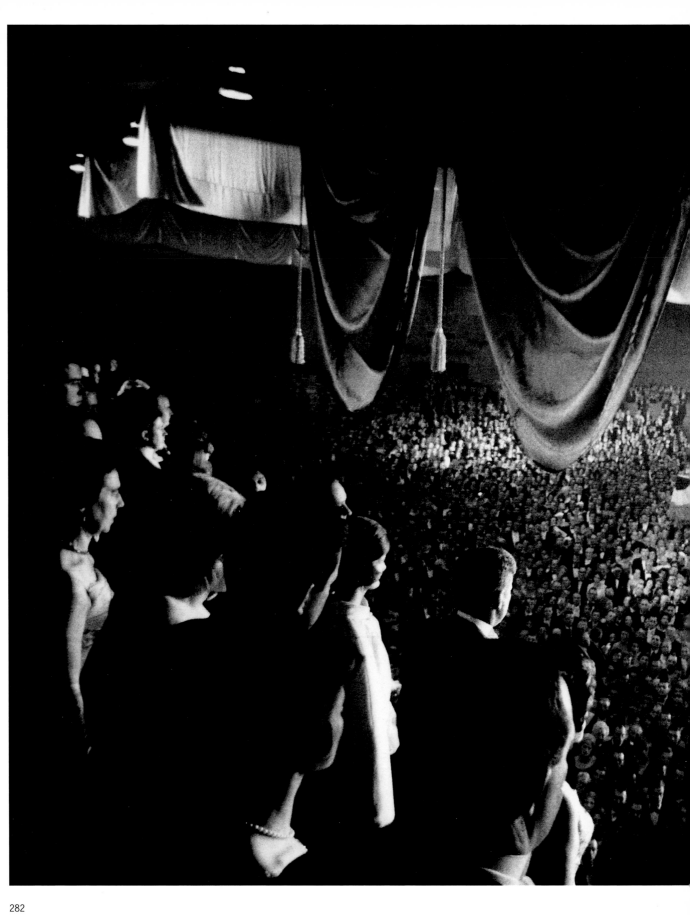

For many, the great inaugural ball topped anything they had known in terms of exuberance and expense. Designer dresses and tuxedos joined jewelry, furs, and cases of fine champagne. Washington was awash in limousines. It was the first stirring of what would become the modern-day Camelot.

283

Mr. President
Washington, D.C.

The inauguration was over. It was nearly 4 a.m. And for President John F. Kennedy, a first working day as chief executive of the world's most powerful nation was just a few hours away.

Kennedy had run a gantlet of five inaugural balls, shook hands with hundreds of jubilant attendees, and spoke to woozy audiences that would hush in reverence for the young crusader then roar back to action when he waved and walked toward the exit. A cadre of longtime friends, including Navy pal Paul Fay, kept close to his side.

The president had topped off his partying at syndicated columnist Joe Alsop's Georgetown home where power brokers, authors, journalists, and Hollywood cuties—another segment of the Kennedy ménage—crowded in for a look at the youthful victor. Jackie, still weak from the Cesarean-section birth of John F. Kennedy Jr. five weeks earlier, had long ago headed to her new Pennsylvania Avenue residence.

At the White House, Kennedy paused on the steps of the north portico, which glowed softly in the light reflecting off piles of snow. Wind whipped the tails of his tux as he gazed over the lawn and puffed one of the small cigars he relished. He stood alone but was crowded by history: thirty-two men preceded him through those doors. (George Washington never lived in the White House; Grover Cleveland was both the twenty-second and twenty-fourth president.)

JFK waved at a group of reporters struggling through the snow, called out something like, "Here goes," then stepped across the threshold of the most famous residence in the world and into the most important and powerful job on the planet. It seemed so effortless, an impression that would prove deceptive.

Later that morning, Kennedy lined up and welcomed his staff before retiring alone behind the shut door of the Oval Office. The story goes that one of the young aides had barely returned to his desk when the president buzzed. The aide rushed back to the Oval Office where a grinning Kennedy asked, "What the hell do I do now?"

The White House, at best, is a confused place, reflecting the idiosyncratic nature of political work, which defies graphs and charts and, instead, depends on human spirit and persuasion. Months earlier, faced with the serious business of running a country, Kennedy had observed, "There is no handbook for being president." Since he never personally knew Winston Churchill, Franklin Roosevelt, or other outstanding leaders from their era, he turned to books to understand how they exercised their authority.

The first days of a presidency are particularly chaotic, awash in ceremony and ritual meetings. Kennedy had former President Harry Truman and wife Bess come around. They had been cold-shouldered by Dwight Eisenhower for eight years. Chicago Mayor Richard Daley, to whom JFK owed so much during the election, was also one of the early visitors. Smiling, he pulled up the White House drive with all eleven of his offspring in tow.

The new president summoned his cabinet then gathered together his military chiefs and CIA Director Allan Dulles. He took a few minutes to talk to reporters, many of them acquaintances from the campaign and others old hands on the White House beat. The latter included the contentious Maine newswoman, May Craig, who always wore a hat at presidential press conferences.

This was a new world for Jacques Lowe. His movements had been free and easy when he was the lone family-photo man, often the only photographer around as Kennedy went through his political deliberations. Jacques now found himself herded with other photographers, constricted by security. He complained, then adjusted, as he rushed from room to room shooting pictures of that early carnival. Perhaps his most important picture in the beginning hours of the presidency was of Kennedy leaning over the table behind his desk, a cigar in hand, as he read. Kennedy, a speed-reader, could devour books, magazines, and memos at a prodigious velocity.

During presidential news conferences three certainties emerged: Kennedy almost always knew more than his questioners, he read the journalists' stories, and he let reporters know when he didn't like what they wrote.

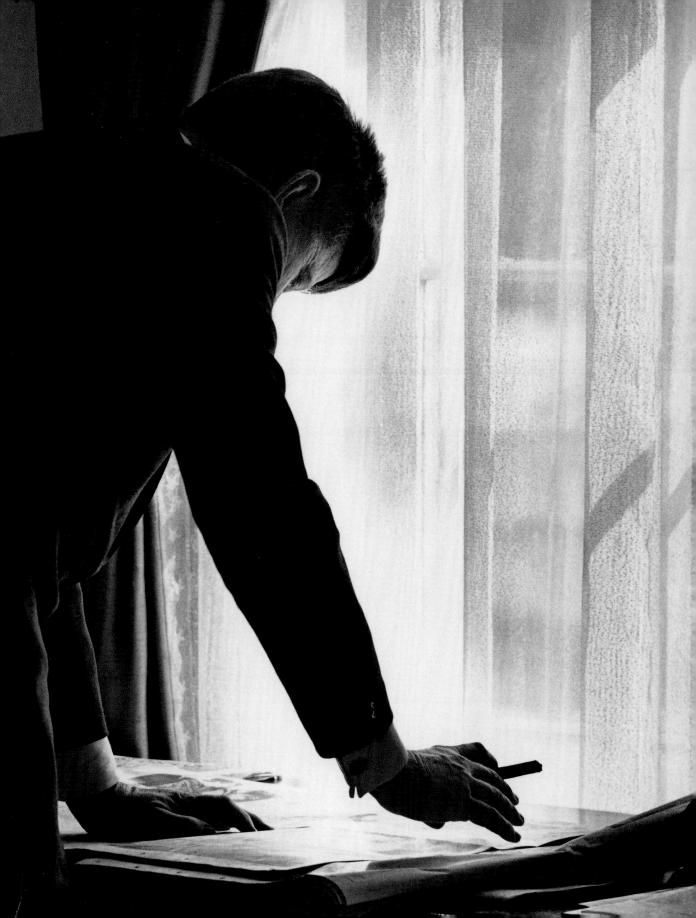

Previous page: This would become a familiar picture of JFK, behind his desk reading documents, memos, newspapers, and magazines left daily by his staff. Although he clutched a cigar, it was rarely lit.

Right: Kennedy listens to Treasury Secretary C. Douglas Dillon, a Republican who had served in the Eisenhower administration. Sitting behind Dillon in the Cabinet Room are Budget Director David Elliott Bell and Kennedy's assistant special counsel, Richard Goodwin.

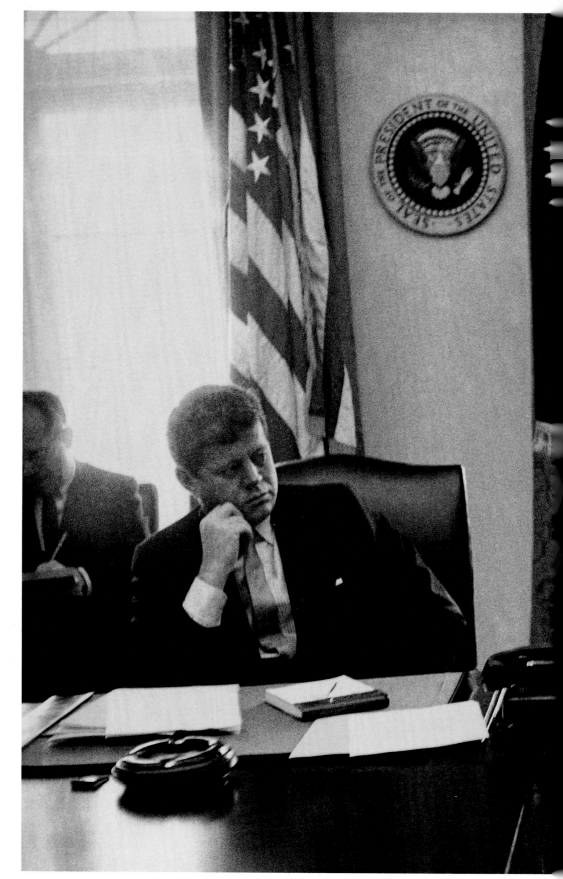

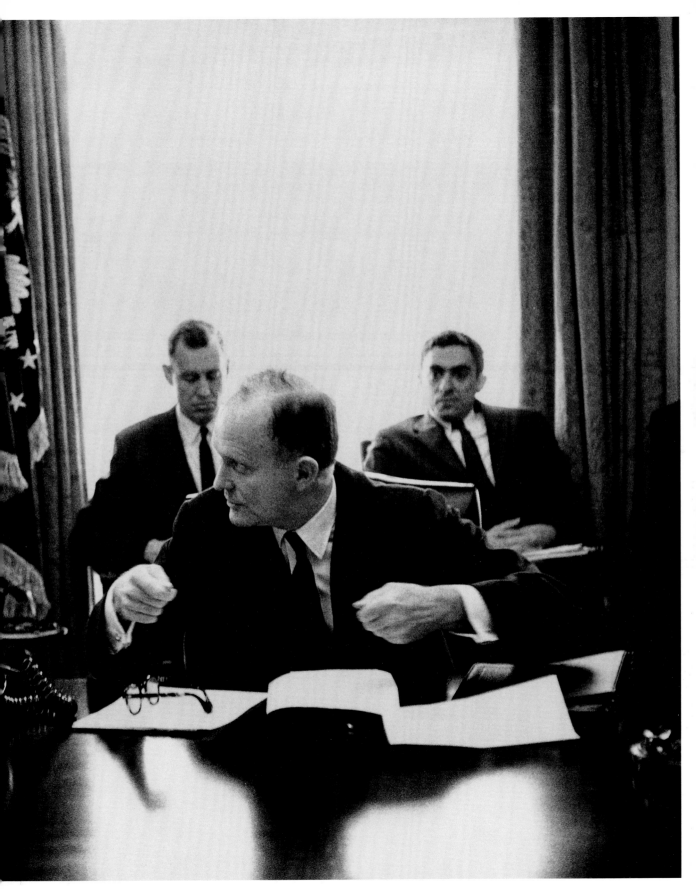

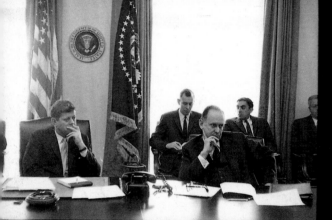

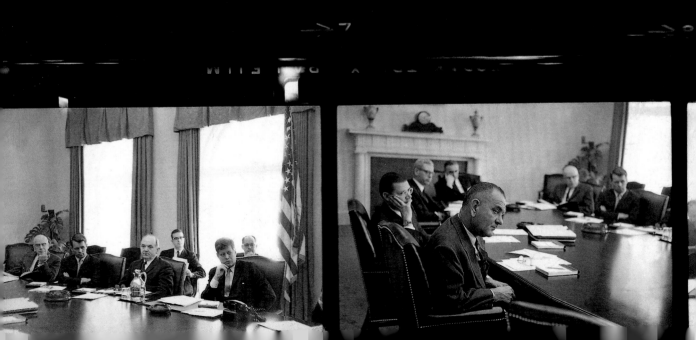

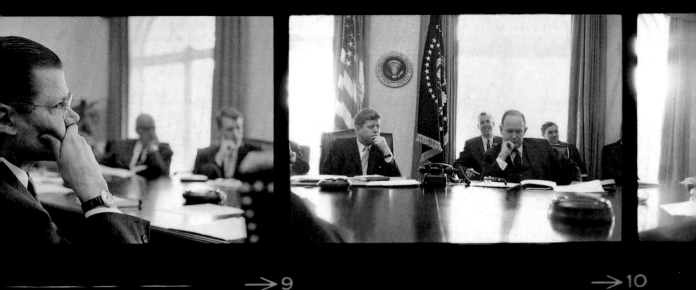

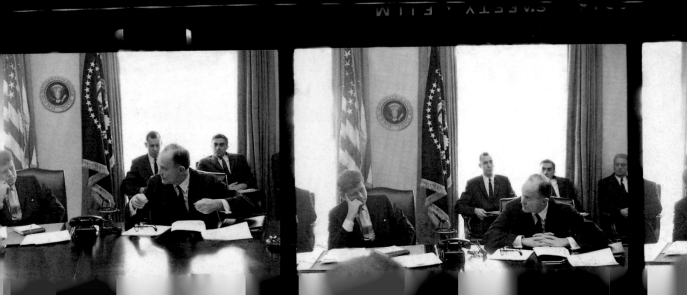

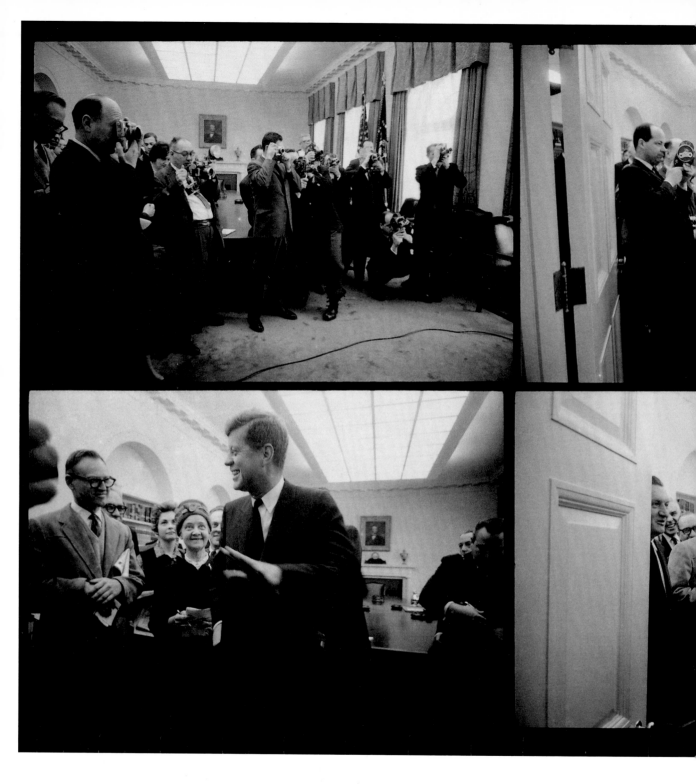

Previous pages: Jacques catches scenes from a cabinet meeting. Although he convened regularly with his cabinet, Kennedy generally preferred smaller meetings on specific issues.

Left: Kennedy greets journalists waiting at the door to the Cabinet Room, including veteran newspaper reporter May Craig, known for her hats. *Below:* In the crowd behind Craig, taking notes, is then-UPI reporter Helen Thomas, who was just beginning what would be a long trajectory covering the White House.

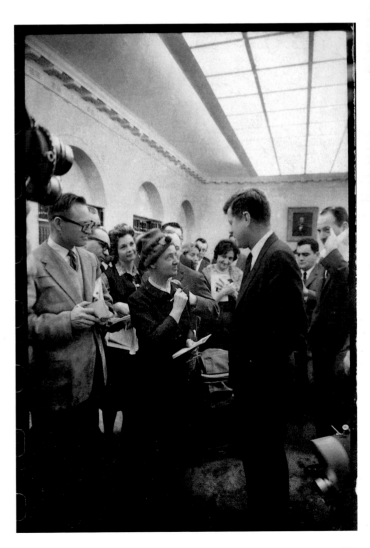

Members of the Joint Chiefs of Staff gather prior to a meeting with Kennedy. Admiral Arleigh Burke puffs on a pipe at the side of General Andy Goodpaster, the liaison for former-President Eisenhower. Marine General David Shoup chats with Army General George Decker, while General Lyman Lemnitzer, chairman of the Joint Chiefs of Staff, waits for the meeting to begin. Lemnitzer would later clash with Kennedy over U.S. action in Cuba.

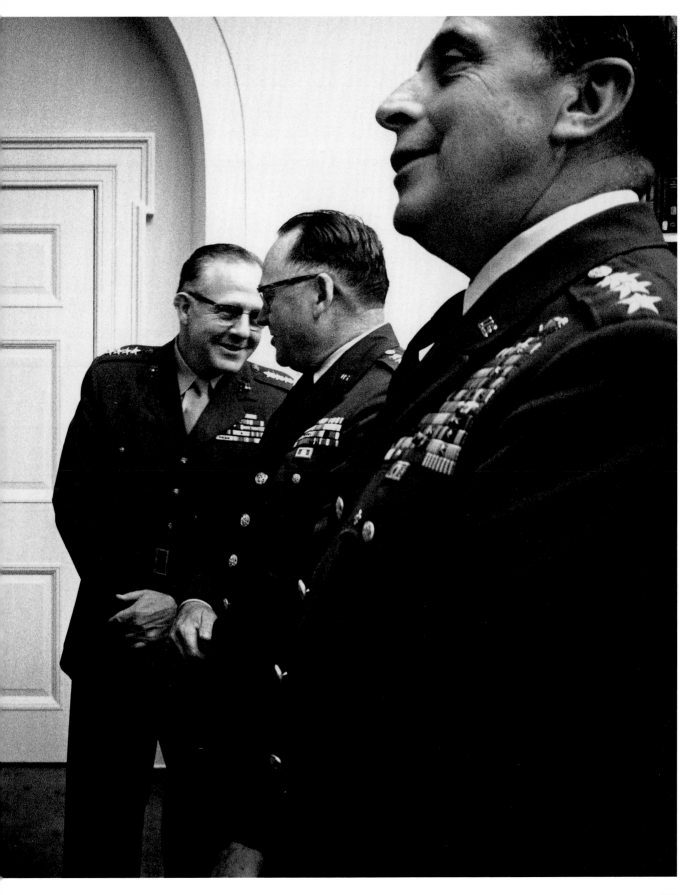

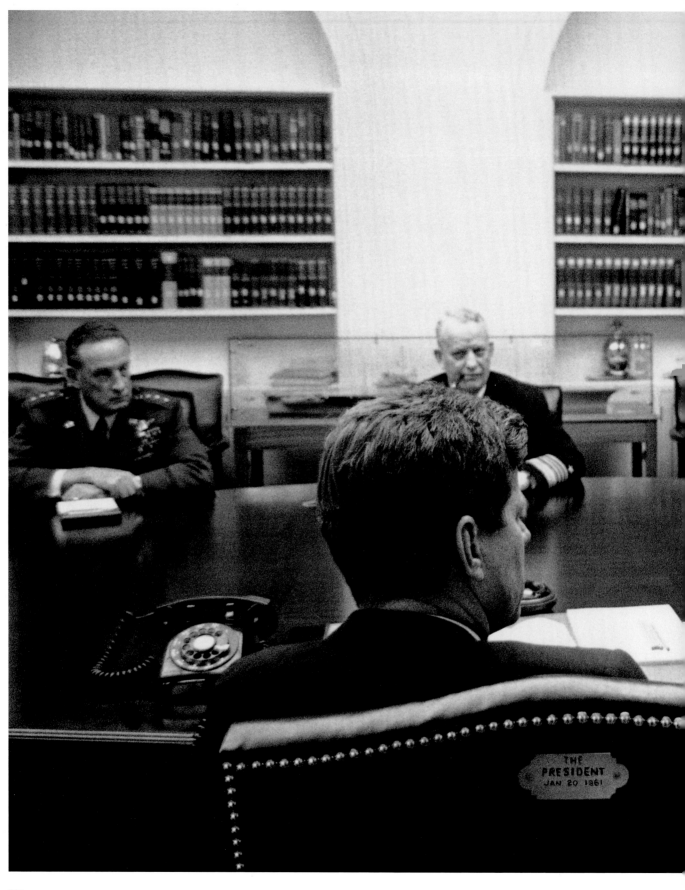

The label on the chair reads:

THE
PRESIDENT
JAN. 20 1961

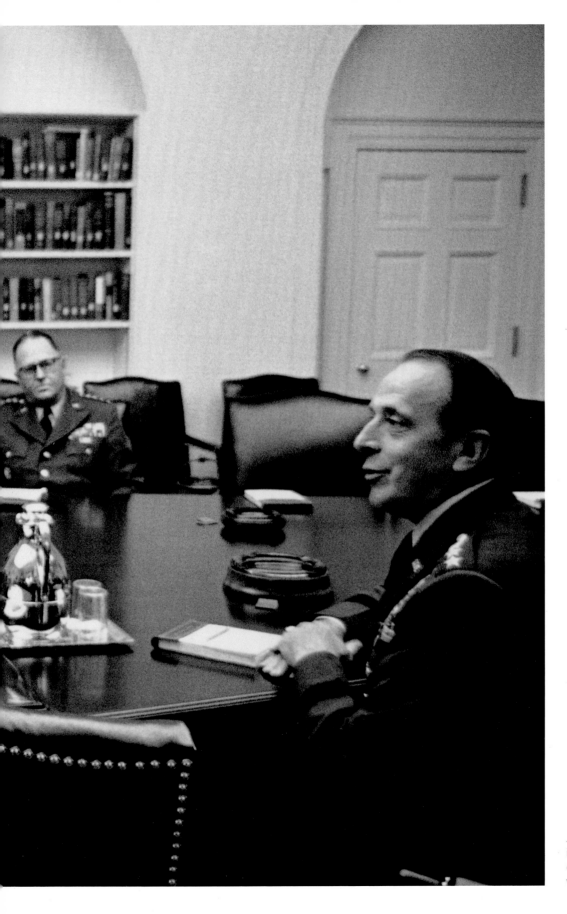

Just five days after his inauguration, Kennedy calls the first meeting with his military leaders.

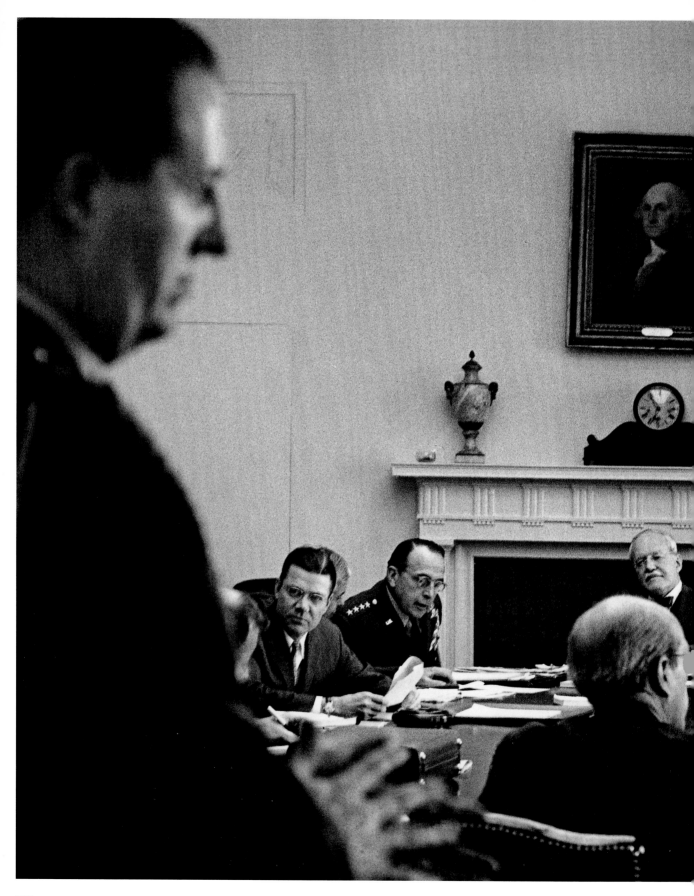

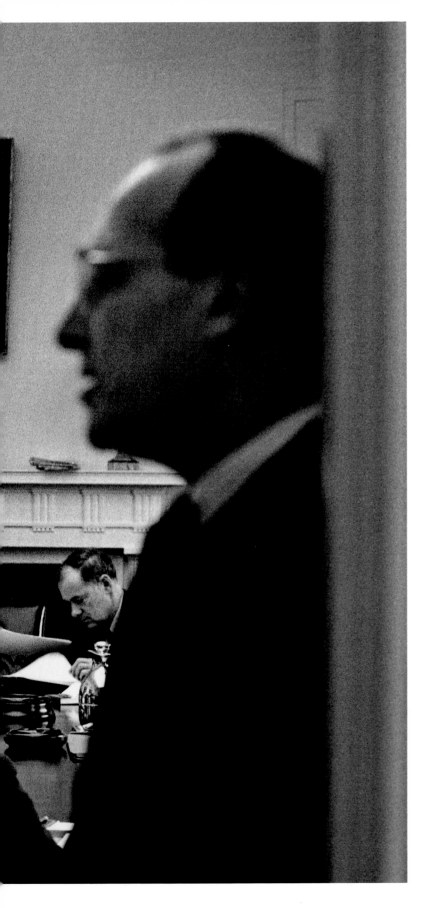

Left: Hopes ran high at a critical April 1961 meeting just a week before the invasion of Cuba at the Bay of Pigs. The plan would fail miserably. Meeting in the Cabinet Room, from left to right, are Army Major General Chester Clifton, standing; National Security adviser McGeorge Bundy (partially hidden); Secretary of Defense Robert McNamara; Chairman of the Joint Chiefs of Staff Lyman Lemnitzer; CIA Director Allen Dulles; CIA Deputy Director Richard Bissell, who was point man for the Bay of Pigs invasion; and Deputy National Security Adviser Walt Rostow, on the far right. The man in the center, with his back to the camera, is not identified.

Below: Kennedy talks to Secretary of State Dean Rusk and CIA Deputy Director Richard Bissell. In the bottom frame, Secretary of Defense Robert McNamara makes a point even after the meeting has broken up.

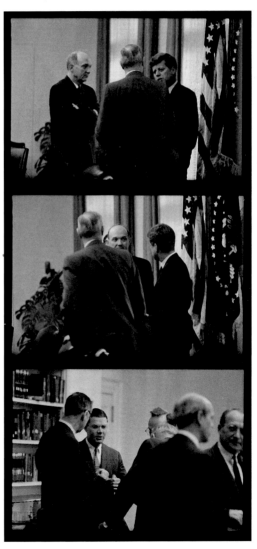

His Brother's Counsel

Washington, D.C.

Bobby Kennedy moved into the stately offices of the attorney general in the Justice Department as soon as Jack was in the White House. Within days, children's artwork decorated the walls of the office and a football from Hickory Hill was at the ready. Bobby and his eager young staff got their juices flowing by passing the ball within their cavernous workplace.

It had not been an easy transition for Bobby. When Jack was selecting a cabinet in the weeks following the election, public speculation about Bobby taking over the Justice Department was rife—and acid. Southerners feared "overzealous" pursuit of new civil rights regulations. Republicans shouted "nepotism." And labor was antsy about the prospect of more rackets probes.

Bobby hesitated. He considered whether he should, instead, strike out on his own and run for political office, teach, or perhaps even enter journalism. "Bobby's the best man I can get," the president said, "but that family criticism is the most sensitive there is. We'll see."

For Joe Kennedy, there were no ifs. "Bobby should be attorney general," the father snorted. "If a person in this life can count his true friends on one hand, he is lucky. I tell all my kids to stick with the family."

Jack tried humor to soften public doubts. Why not, he joked, let a young lawyer get a little government experience before entering private practice? When pressed on when he'd decide, Jack said he just might announce his choice by stepping out the door of his Georgetown home in the middle of the night and whispering, "It's Bobby."

It was December before Bobby finally made up his mind. He walked around the frozen capital for the better part of a day, dropped in to talk to Bill Rogers, the retiring attorney general, then lunched with his friend, Supreme Court Justice William O. Douglas. The older men advised him against taking the job. The next day, he called his brother to say he was withdrawing from consideration.

John F. Kennedy, in many ways a creation of his younger brother, was alarmed and refused to accept that answer. The two ate breakfast together the following morning. For seventy minutes they talked, reminisced, laughed, and then grew excited at the prospects before them. Bobby changed his mind.

Once on the job, Bobby would become the president's point man in the escalating civil rights struggle across the country. After the Bay of Pigs disaster in Cuba, Jack asked Bobby to conduct a post-mortem to determine what went wrong with the operation. And Bobby inherited J. Edgar Hoover, the egotistical head of the Federal Bureau of Investigation, believed by many to have overstepped his authority. For his part, the younger Kennedy believed Hoover spent too much time and energy searching for communists and not enough fighting big-time criminals and enforcing civil rights.

The Kennedy brothers talked almost hourly by phone. Bobby served as Jack's sounding board on virtually everything, and the world learned that the attorney general's office connected straight to the White House. Bobby's unchecked influence was duly noted, both because of his official status and because of his filial intimacy with the president.

An Oval Office visitor one morning found the president on the phone with, as the chief executive explained, "the second most powerful man in the free world." After a bit more conversation, Jack broke into a grin and said: "Bobby wants to know who Number One is."

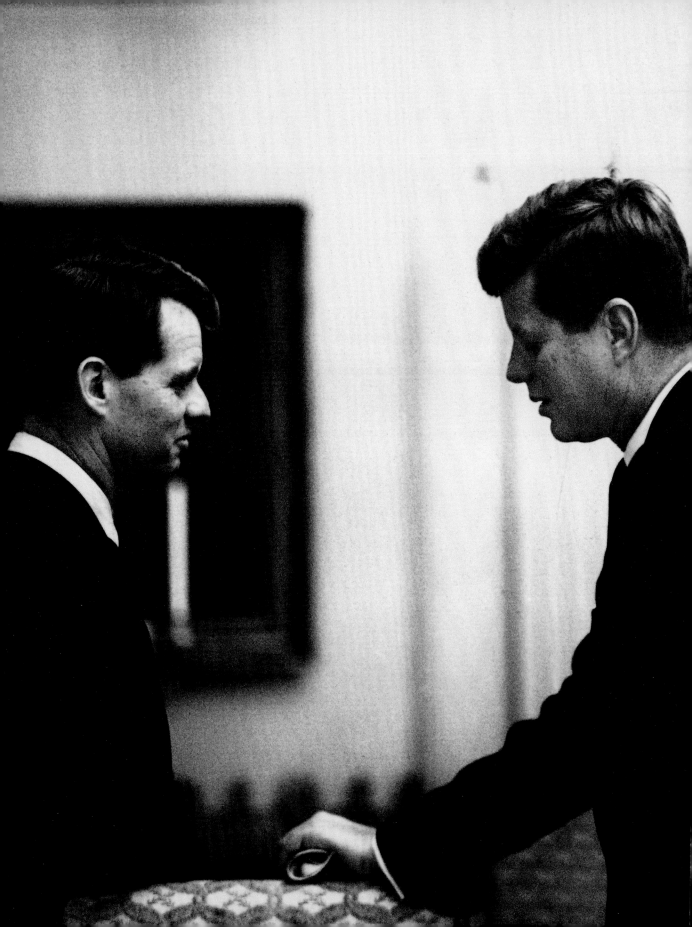

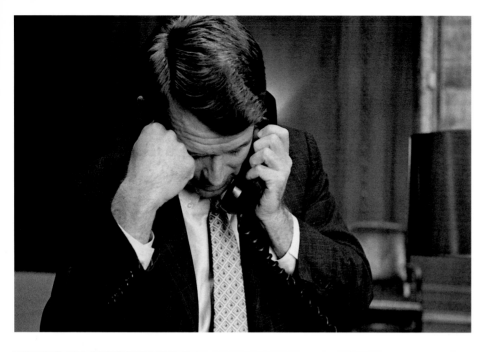

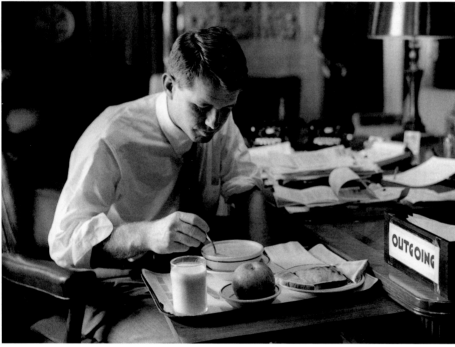

Previous page: U.S. Attorney General Robert Kennedy and President John F. Kennedy, the most powerful duo in the world, confer in the spring of 1961.

Above left: The telephone is Bobby's constant companion.

Lower left: The attorney general lunches at his desk to save time.

Above: The attorney general's office is softened by a preponderance of children's drawings, plants, a football or two, and, often, his monstrous dog Brumus.

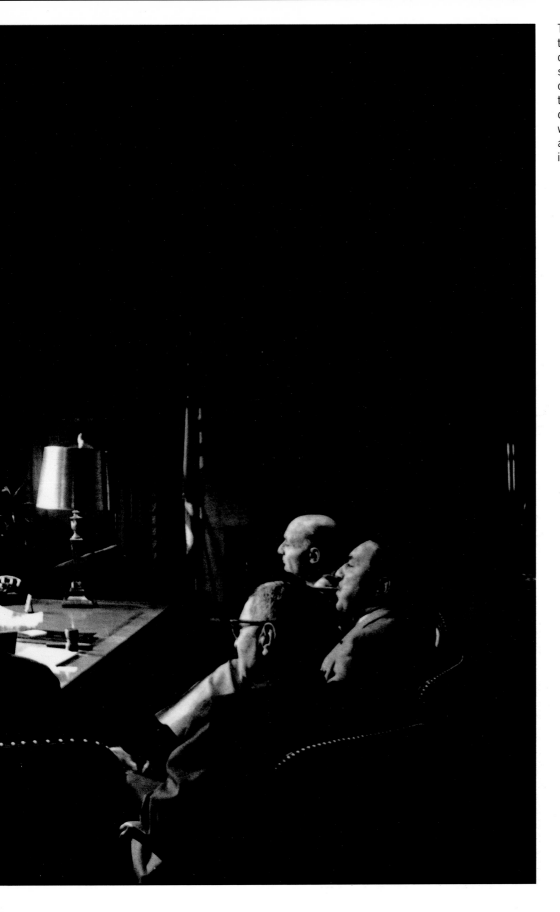

There were jokes that the cavernous office of the attorney general swallowed its new occupant. But it did not take long for Bobby to demonstrate that he was a major force, a partner with his brother in running the country.

The Kennedy brothers treated FBI Director J. Edgar Hoover warily. Hoover had carved out an empire within the Justice Department and was so powerful that no president dared replace him. The Kennedys, concerned that his files contained scandalous family details, considered retiring him but decided it was too risky.

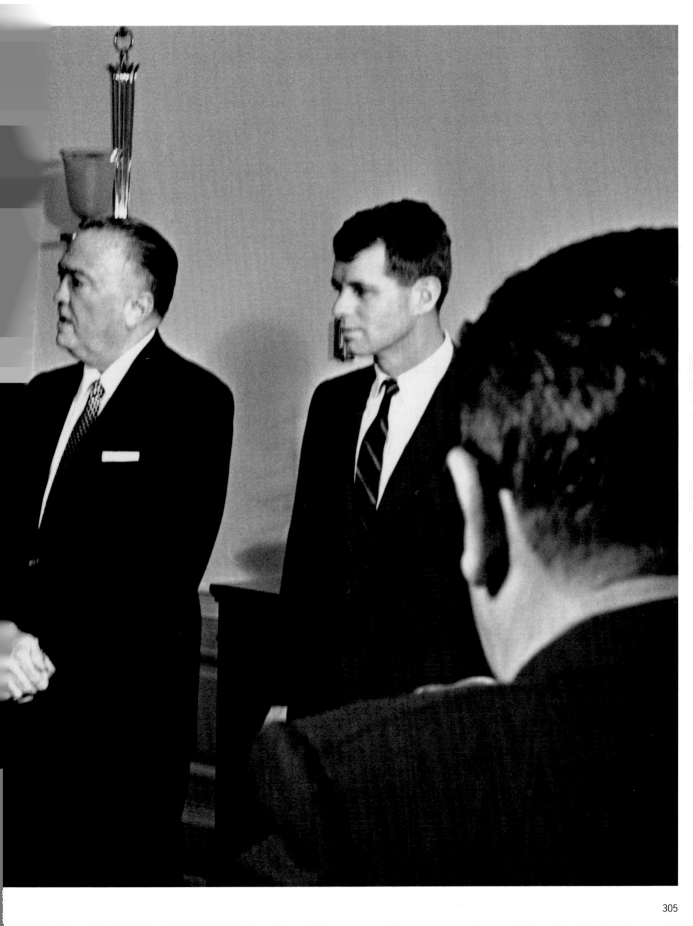

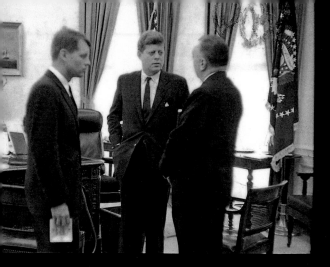

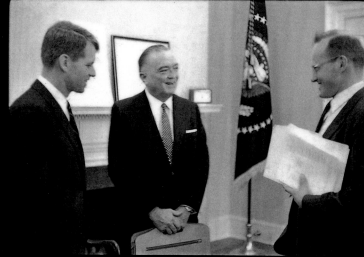

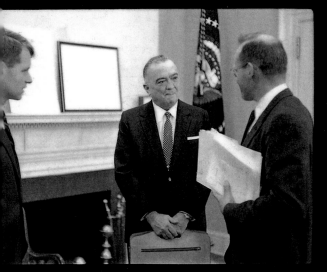

→3

→4

→8

→9

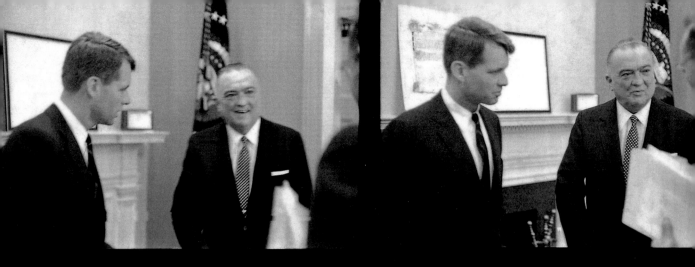

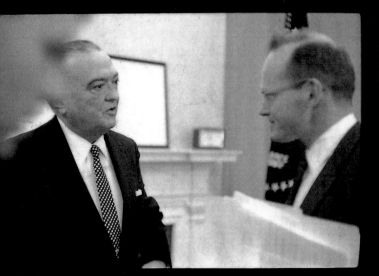

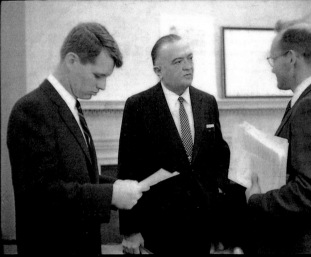

→5

→10

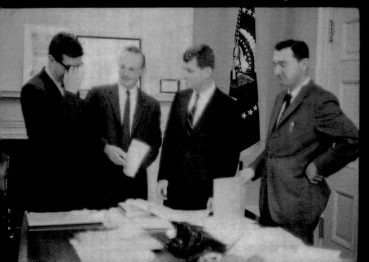

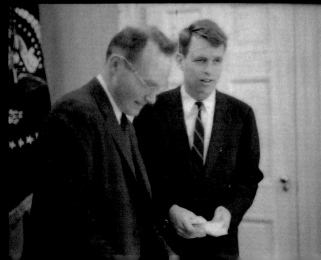

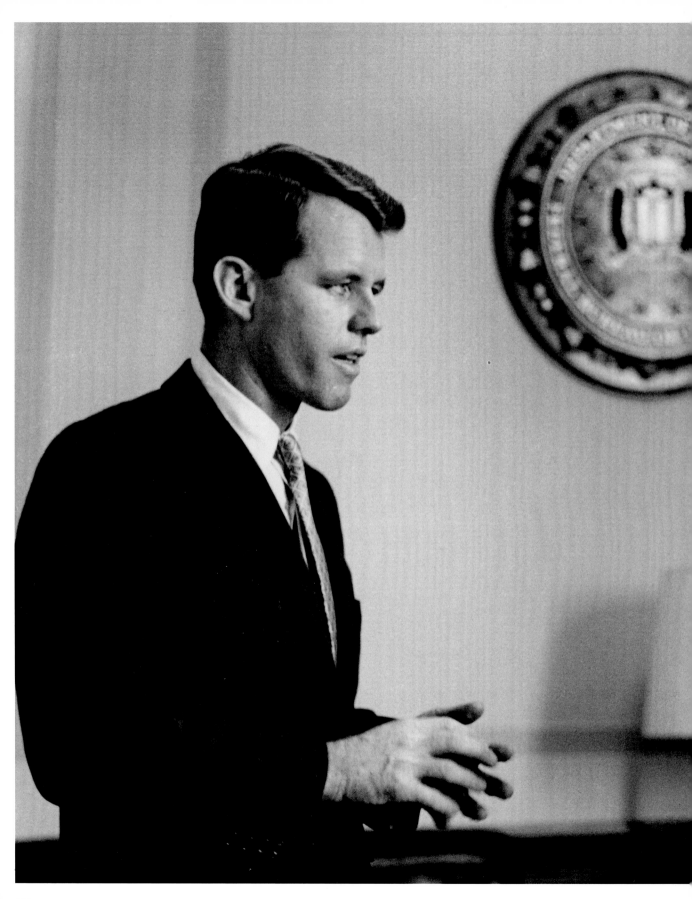

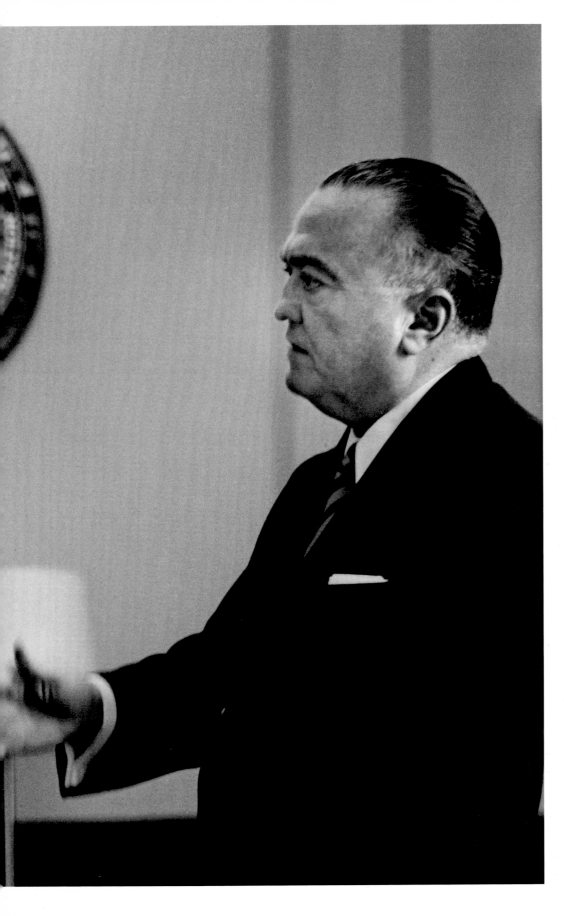

Previous pages: Bobby gives Hoover a tour of the White House, stopping along the way to greet Kennedy staffers McGeorge Bundy, Ted Sorensen, and Kenny O'Donnell.

Left: Suspicion marks this meeting between Bobby and J. Edgar Hoover in the FBI office. Bobby wanted the FBI to pursue more civil rights violations and to intensify the war against crime syndicates. The attorney general believed Hoover was too preoccupied with hunting down communists in the United States.

Oval Office
Washington, D.C.

The Oval Office took on mythical proportions under Kennedy. It had been part of the White House since 1909 when President William Howard Taft ordered its construction (prompting ribald remarks about how it was shaped like the 300-pound Taft). But it wasn't until Kennedy that "Oval Office" joined the journalists' vernacular. Television cameras, in particular, discovered the glamour and drama of that work place.

Jack and Jackie redecorated the office in muted white and blue then added a model ship and nautical paintings. In a government warehouse, Jackie tracked down the desk made from the oak timbers of the ship HMS *Resolute*, which was recovered by U.S. whalers from the frozen wastes of the Arctic. Britain's Queen Victoria had presented it as a gift to President Rutherford B. Hayes in 1880, but in recent years the desk had languished in storage. Under Jack, a history buff, the desk returned to the Oval Office where Caroline and John Jr. found its hinged front panel made an ideal cubbyhole for their play—and a marvelous prop for the photographers.

The Oval Office was not off limits to the Kennedy children. Caroline and John, who had quickly discovered secretary Evelyn Lincoln's candy dish, dragged stuffed animals and dolls under the president's desk. Their father never tossed them out. If a meeting was serious, and most were, he merely paused, explained the importance of his visitors, and let the youngsters wander off before he began his worldly discussions.

The room became the world's crossroads. Dignitaries like British Prime Minister Harold Macmillan often pulled up a chair with the president before a crackling fire or strolled the South Lawn, which had been originally planted by Thomas Jefferson. Vice President Lyndon Johnson was also a frequent visitor, pointedly invited by the president, who knew some of his family and White House staffers were dismissive of the Texan. This was a difficult time for the super-kinetic Johnson and it showed in Jacques's pictures.

While the president's office exuded an atmosphere of great power, a glance out its windows told a homier story: Children romped with dogs while gardeners worked in the Rose Garden (newly designed by Kennedy friend Rachel "Bunny" Mellon). Kennedy became fond of passing through the garden when he took visitors on a short tour.

Jackie, meanwhile, was busy transforming the rest of the White House into what she described as a "living museum." Her touch was magical. Before many months, this graceful and more authentic White House became a powerful part of the emerging New Frontier image that had carried this couple into power.

Jack was a phone man and it was during serious calls that Jacques caught some of his most dramatic and emotional images. Kennedy was usually so intent on his conversation that the photographer went unnoticed.

One sequence of photos reveals a rare bandage on the president's temple, a curiosity scrutinized by the press. Kennedy told reporters that he had hit his head on a cabinet while bending down to pick up one of the children's toys. More credible information later suggested he had hit a wall during an exuberant conga line at a private party he hosted for friends. The growing legend of the Kennedy White House had many and varied facets.

THE PRESIDENT'S APPOINTMENTS
TUESDAY, FEBRUARY 14, 1961

8:45 — Legislative Leaders and Cabinet Members will breakfast
with the President (list attached)

10:30 — Senator Albert Gore, Tennessee
Senator Estes Kefauver, Tennessee

11:00 — (Mr. Douglass Cater) Off Record

11:30 — (Cong. Emanuel Celler, N. Y., Chairman, House
Judiciary Committee) Off Record

1:00 — W. H. Luncheon — Prime Minister Viggo Kampmann of Denmark

2:45 — The Vice President

3:30 — (Sen. John O. Pastore, Rhode Island) Off Record

4:00 — Members of the Mexico-United States Interparliamentary
Group will call on the President. They have just returned
from Mexico and will present plaque to the President from
the President of Mexico (list attached)

4:30 — Hon. G. Mennen Williams, Assistant Secretary of State for
African Affairs — to call on the President before departing
for his African trip

8:07 — (Depart W. H. for Dinner at Joseph Alsop's Home) Off Record
(Business Suit)

Previous page: The president's schedule for Valentine's Day in 1961 sits propped on his desk. Kennedy was rather casual about scheduled obligations before he got to the White House, but as president he felt compelled to be more punctual. He often complained about being shackled to his White House itinerary sheet.

Right: President Kennedy gets word from United Nations Ambassador Adlai Stevenson that Patrice Lumumba, prime minister of the newly independent Republic of Congo, has been assassinated.

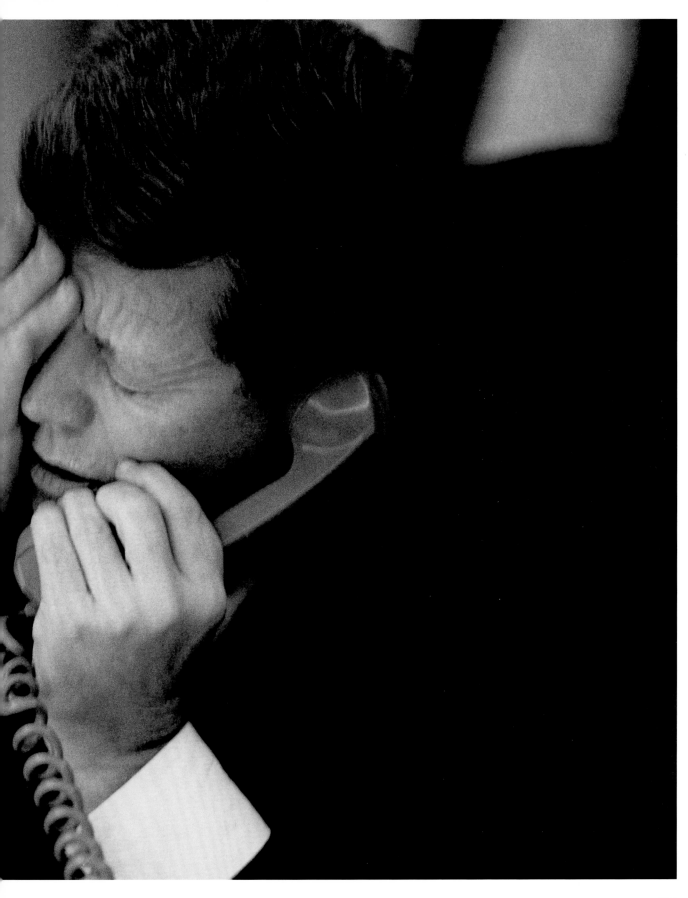

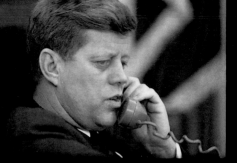
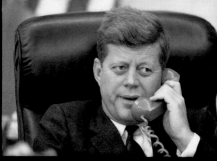

KODAK TRI X PAN F

ETY ▸ FILM

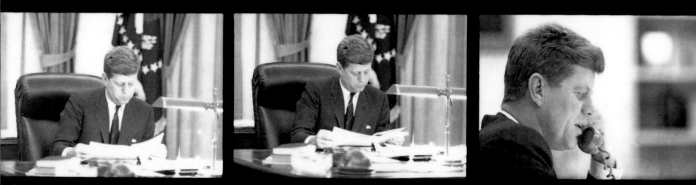

KODAK SAFETY ▸ FILM

M

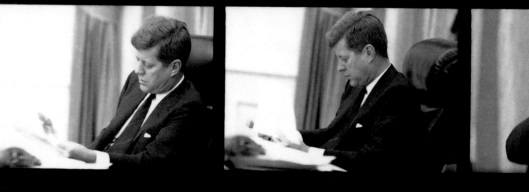
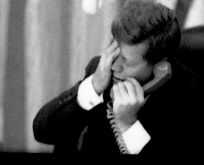

KODAK TRI X PAN FILM

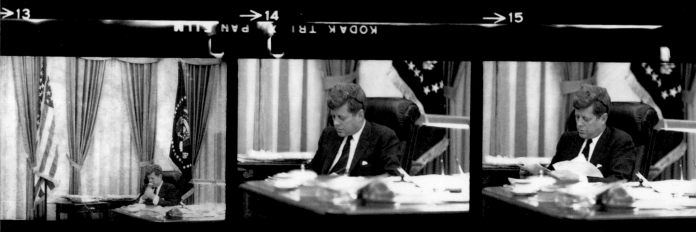

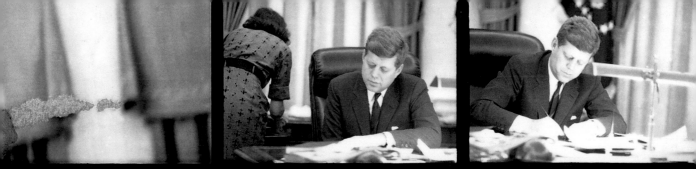

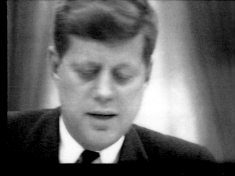

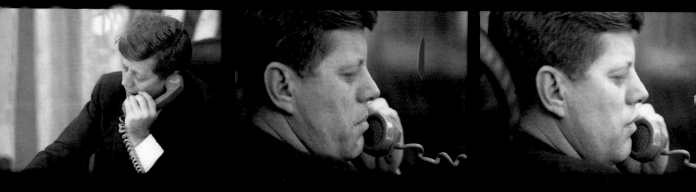

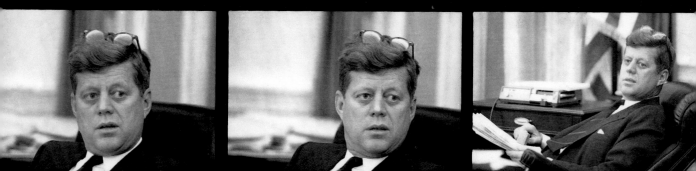

Previous pages: Jacques's photo of JFK learning about Lumumba's death on February 12, 1962, was part of a sequence that caught the president running through a range of reactions.

Left: This photo of Jack is an echo of Theodore Roosevelt, who often picked up a book between appointments, believing that even a few minutes of idle time should be wisely spent in reading. The first view greeting visitors often was the president's back as he finished perusing a memo or news item spread out on what became known as his "reading table." Standing also eased his back problems.

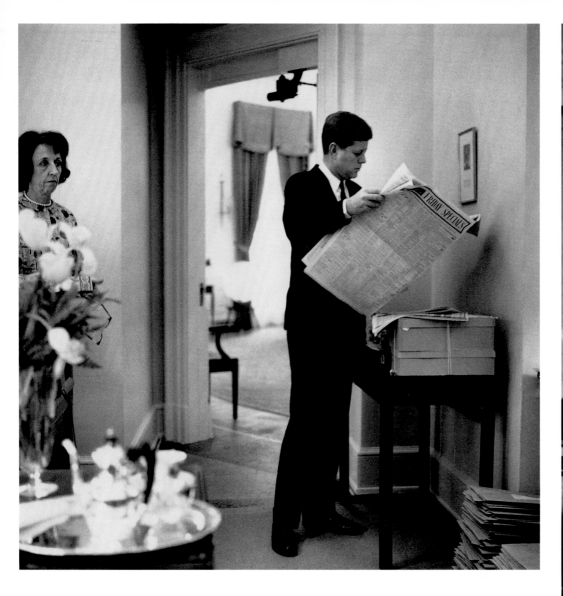

Above: Kennedy was a news addict who would grab a newspaper wherever he found it, including, in this case, secretary Evelyn Lincoln's office.
Right: Jacques again catches Jack on the phone, although in a more upbeat mood than usual during his first months on the job. At one point in the summer of 1961 Kennedy gruffly jested, "I am going to give this damned job to Nixon."

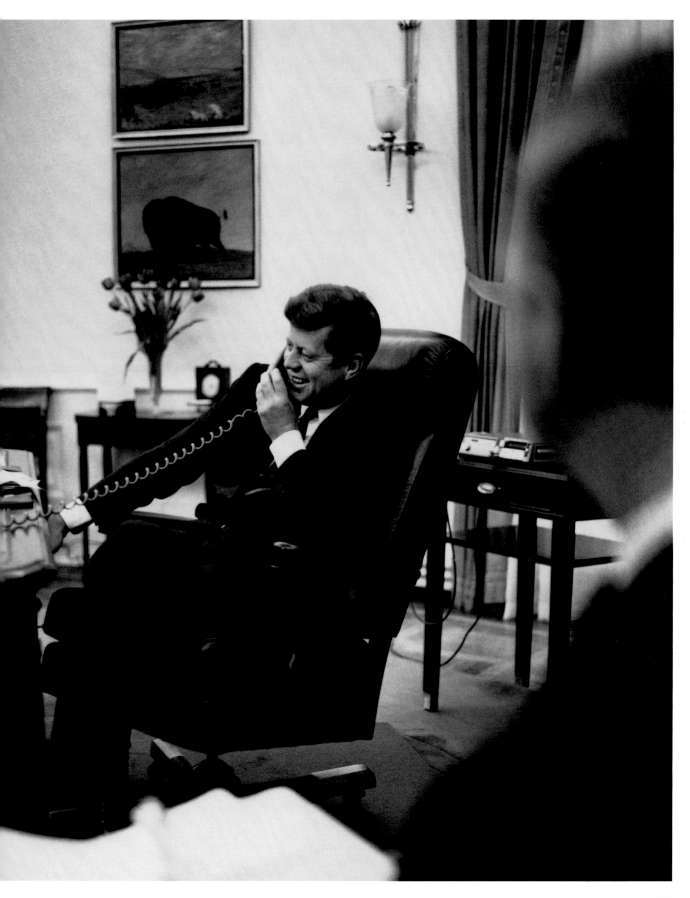

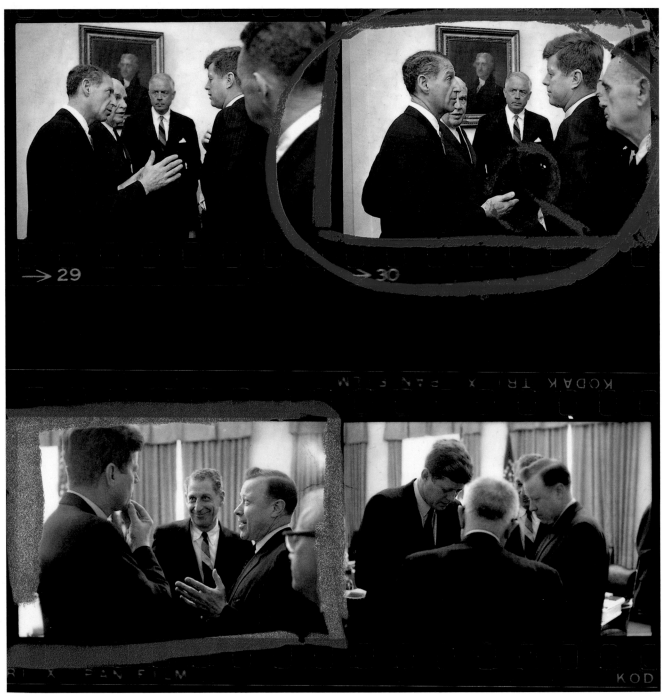

Above: Inland Steel President Joseph L. Block meets with Kennedy during the steel crisis in April 1962, as IBM president and Kennedy friend Tom Watson, in the center, looks on. Steel manufacturers had raised prices, and Kennedy feared the move would fuel inflation. Inland Steel, however, held its prices steady, and its competitors were pressured into rescinding their hikes. In the bottom frames, Kennedy discusses the steel problem with Walter Reuther, president of the United Autoworkers Union and an important force in the Democratic Party. *Right:* Labor Secretary Arthur Goldberg makes a point to Kennedy, on one side of him, and union leader George Meany, president of the AFL-CIO, on the other. Years earlier, Goldberg worked with the Kennedys during the Senate labor racketeering investigation.

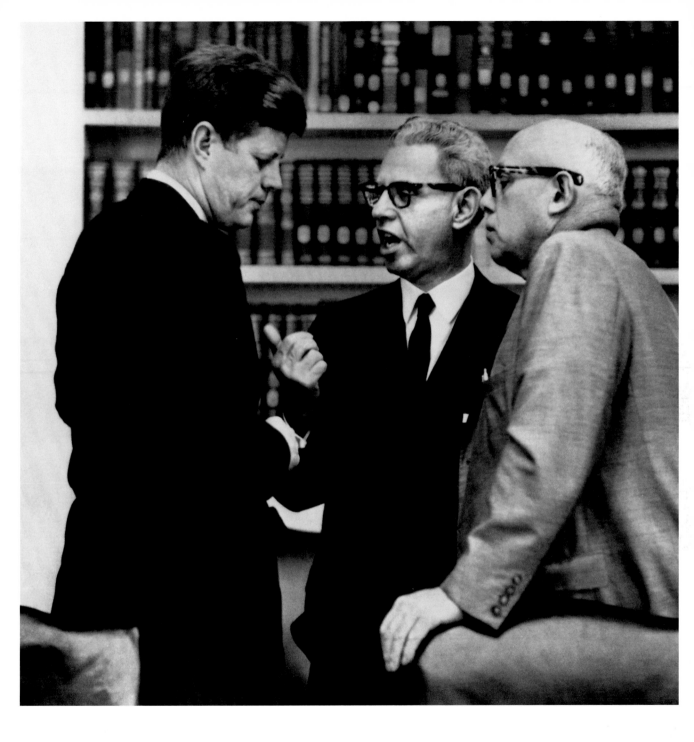

Caroline comes calling with her doll in tow. Jacques shot these pictures outside the Oval Office, where secretaries and aides were accustomed to appearances by the first daughter. Staffers played with Caroline, listened to her requests, and then gently guided her on her way.

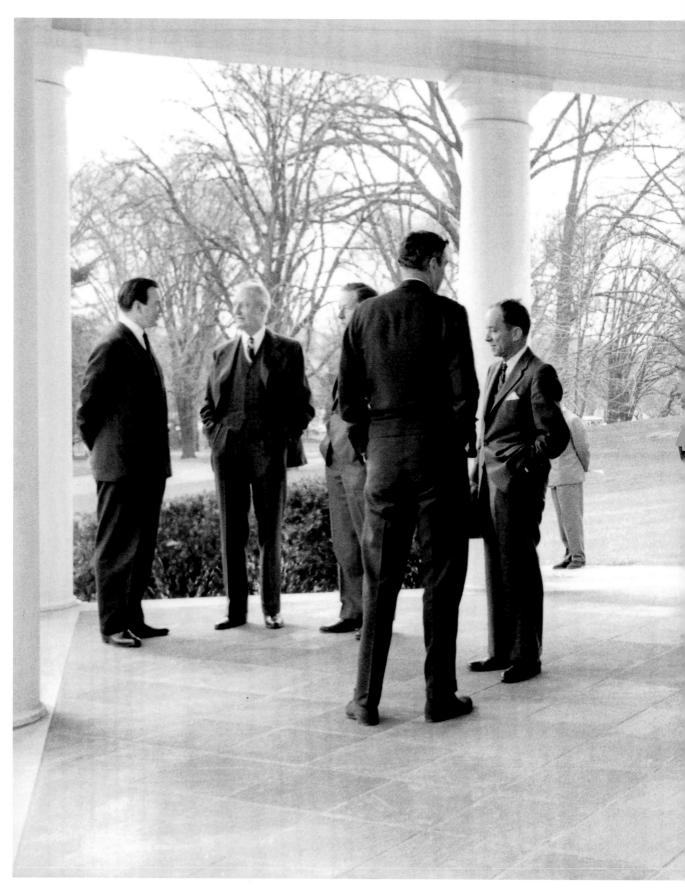

British and U.S. delegations linger on the porch outside the Oval Office in February 1961 as Kennedy meets with British Prime Minister Harold Macmillan.

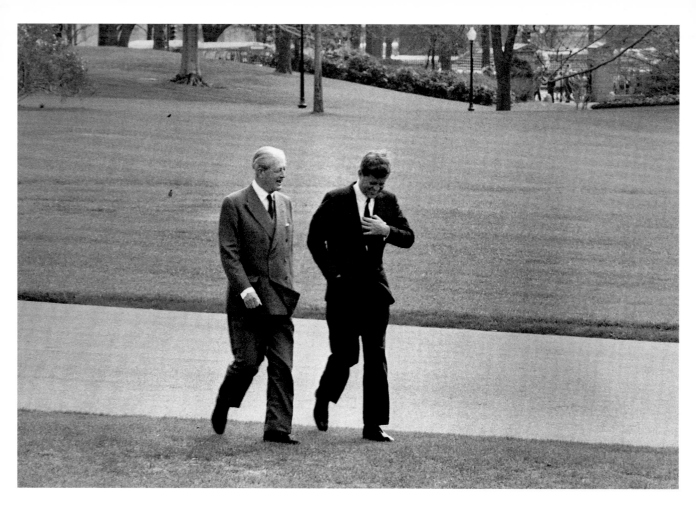

During their summit in early 1961, Macmillan and Kennedy took a private stroll on the South Lawn of the White House. The President enjoyed Macmillan's dry wit and calm British manner. Jack also loved to explain his plans to rehabilitate the Rose Garden and South Lawn, which was designed to show bursts of color throughout the year.

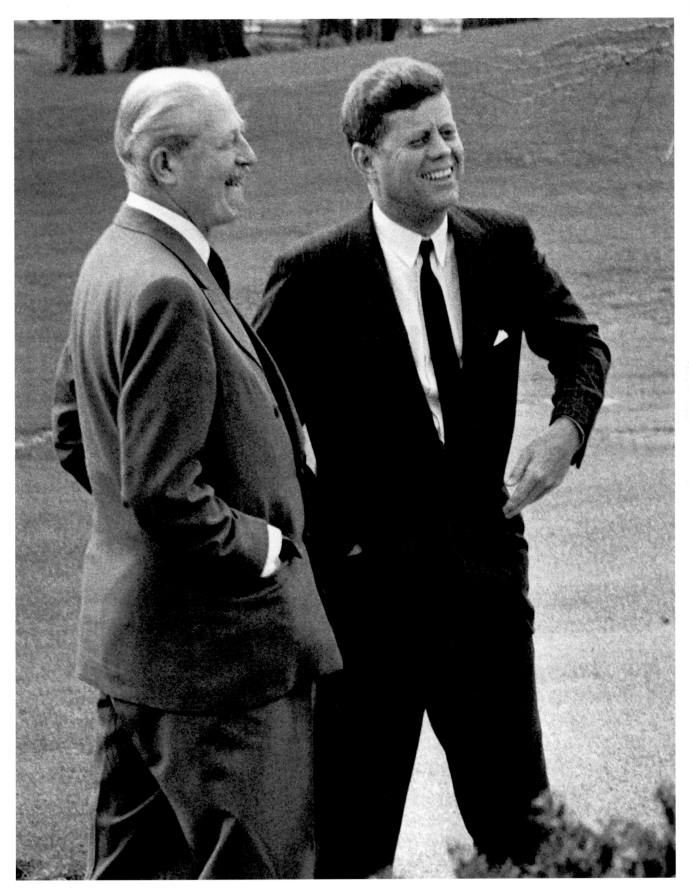

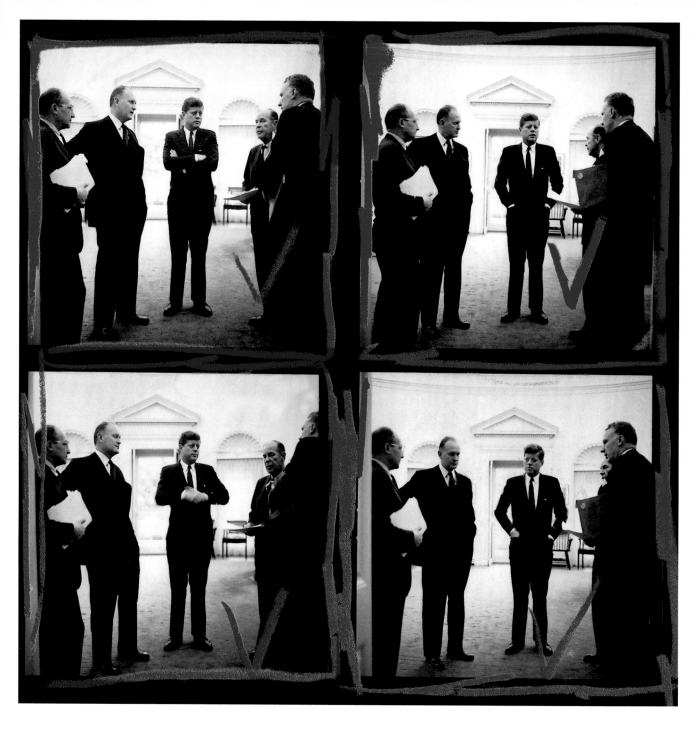

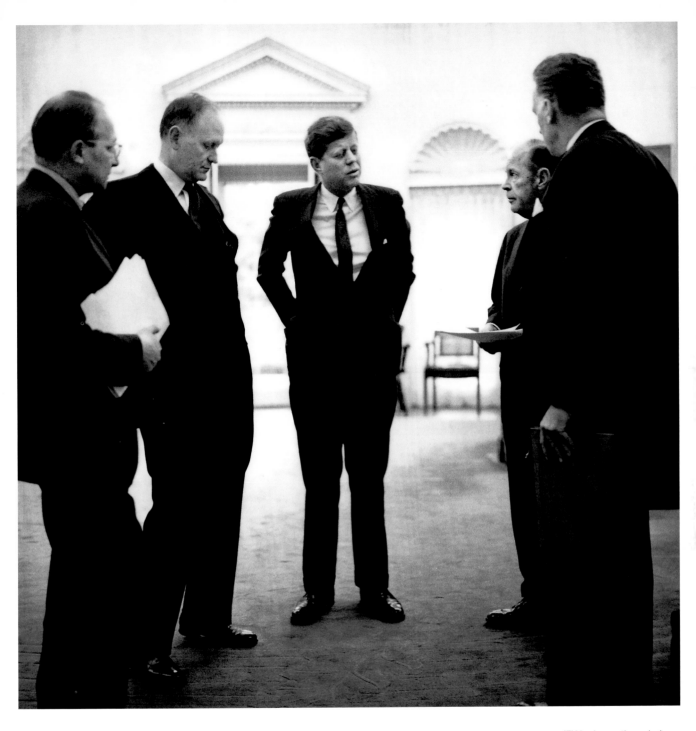

JFK looks restless during this sequence of pictures from spring 1961. The president is meeting with, from left, National Security adviser Walt Rostow, Treasury Secretary Douglas Dillon, an unidentified staff member, and Undersecretary of State George Ball.

Below: Jacques caught one of many private meetings between Kennedy and Vice President Lyndon Johnson in the Oval Office. Kennedy understood Johnson's volcanic nature and how hard it was for him to be idled so near to power. Despite Kennedy's efforts to keep LBJ busy and informed, the vice president constantly complained in private about his lack of stature.

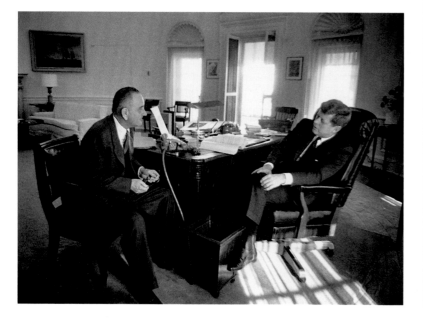

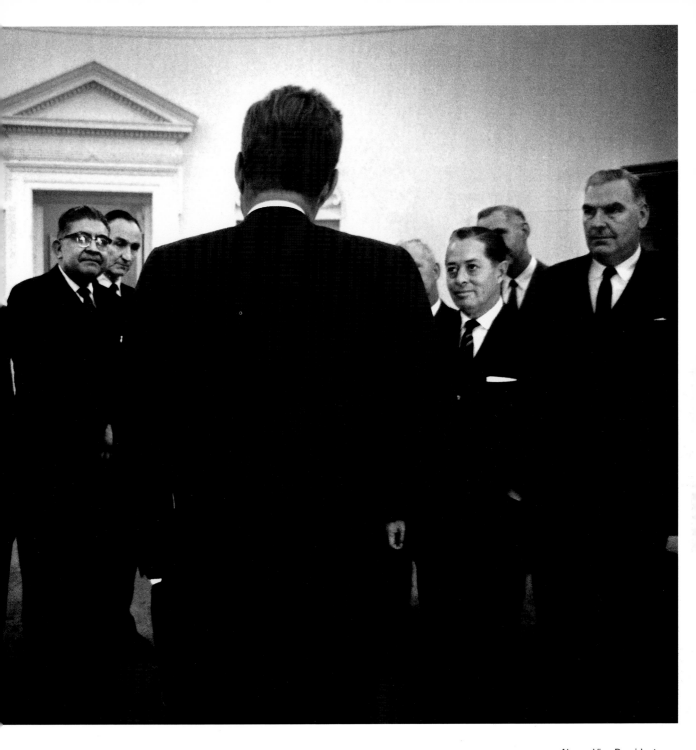

Above: Vice President Johnson looks pained as Kennedy talks with a Congressional delegation early in his term. Kennedy did not fare well with Congress. His important ideas did not become law until Johnson took over the presidency.

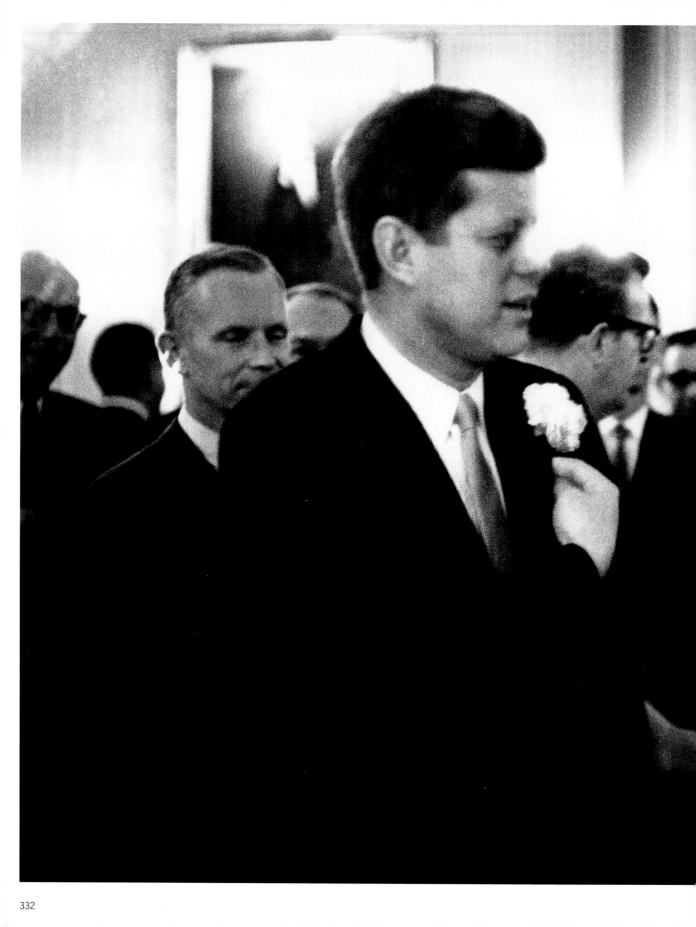

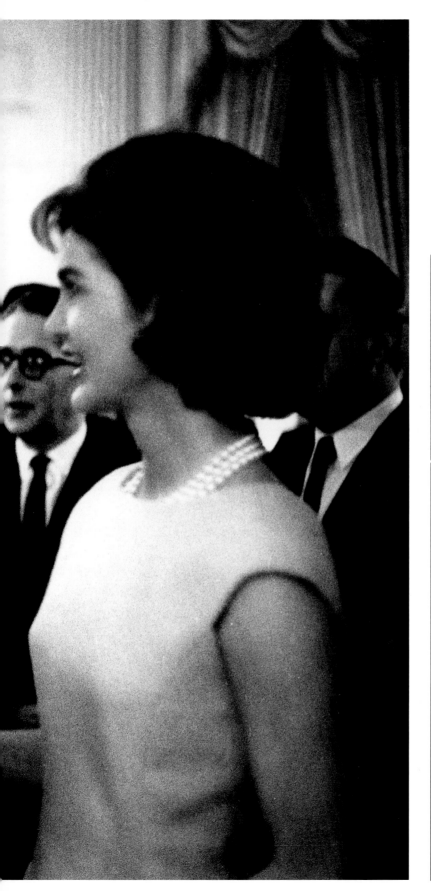

Jack and Jackie host a St. Patrick's Day party in the White House for members of Congress in 1961. Jackie could be a formidable social force. Many of the guests said afterward that their biggest thrill was meeting the first lady, not the new president.

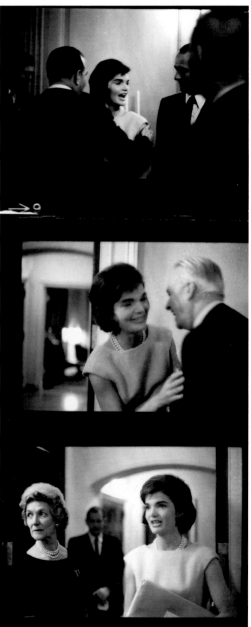

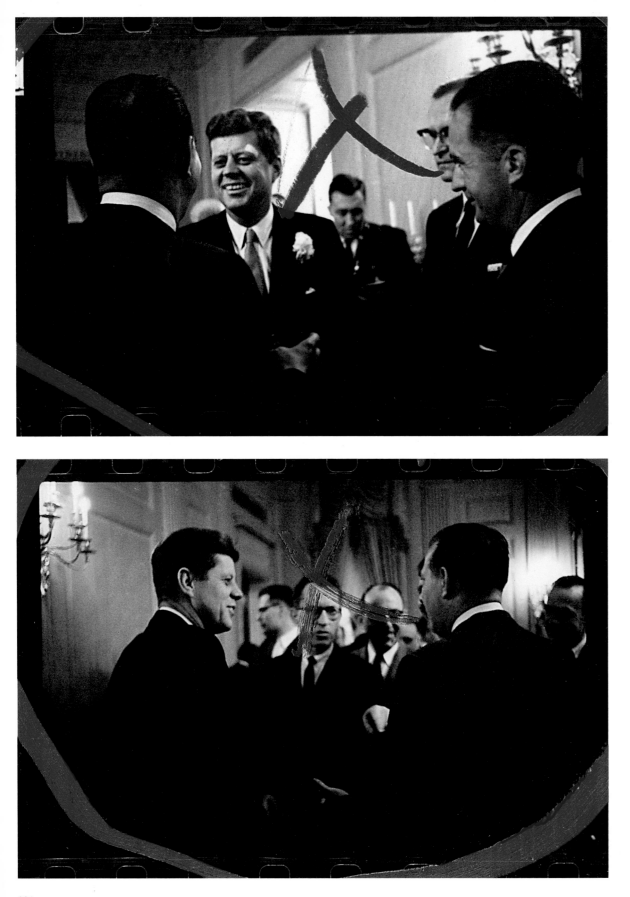

In the spring of 1961, Jack displays the mysterious bandage that created a minor buzz. He claimed he bumped his head picking up his children's toys, but credible sources said it was a party-related wound.

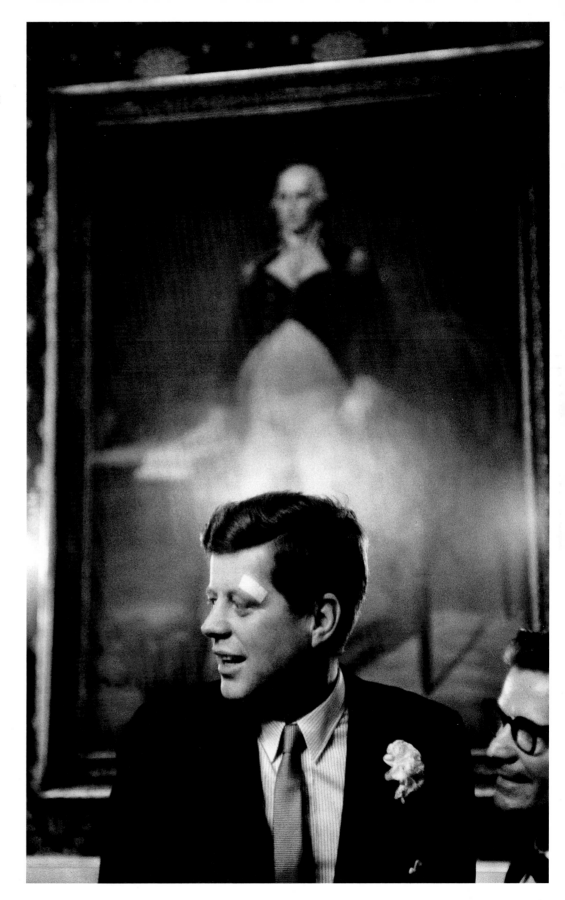

Bobby at Home
Hickory Hill and Hyannis Port

Jacques Lowe hit a photographer's mother lode in Bobby and Ethel Kennedy and their tribe, which swelled to seven children while Jack was in the White House. Even their homes in McLean, Virginia, and Hyannis Port, Massachusetts, were lens-friendly.

During family scrimmages the kids, and their father, too, grappled like a bunch of ruffians, mud smeared, torn, and wounded at times. Shouts and guffaws were generally the order of the day, although now and then tears had to be dried. These children were coached almost from infancy in complicated touch football maneuvers, few of which really worked, but they needed no instructions for the gleeful pileups that followed plays and, in many ways, were as popular as touchdowns.

Bobby's household swung from one extreme to the other. Cleaned up for bed or church, these rowdy youngsters beamed cherubic smiles, their hair slicked down (at least for a few minutes). When Jacques first visited Hickory Hill, the Virginia estate, he walked into the middle of a raucous pillow fight. Dinner followed.

Ethel loved photographs of her brood together and, by mid-summer, she was already planning the family Christmas card. Surviving images show the kids at prayer or in patriotic poses with salutes and their hands over their hearts. These images, too, would form part of this new Camelot.

Jacques watched this as an insider, pulled into the quiet moments that preceded the human storms and then lingering after the calm returned—or, at least, as much calm as ever materialized. "There was true love in Bobby," Jacques would later write, "and his children responded to that love." That wonderful treasure was smashed years later with Bobby's assassination.

Hickory Hill's rolling lawn saw as many animals as children, perhaps even more. Big dogs, smelly but lovable, joined frogs, snakes, birds, and rabbits as mascots in residence.

Guests, too, were welcome. Celebrities and famous achievers were constantly at hand, joining the roiling scene.

Astronaut John Glenn was spotted amid the family scrum. Sir Edmund Hillary, the first man to conquer Mt. Everest, showed up and found himself being scaled by the children for no other reason than "he was there." Hollywood's Frank Sinatra and Judy Garland turned up as guests.

One night General Max Taylor, chairman of the Joint Chiefs of Staff, was recruited to chase an errant bunny across the yard. His superior knowledge of field tactics served him well: the escapee was captured. Stuffy newspaper columnist Joe Alsop was crowned with a cowboy hat on one outing and even seemed to appreciate the irony. Humorist Art Buchwald, almost always in the whirl, was affectionately known as "Uncle Artie."

At one exuberant gathering, distinguished Harvard historian Arthur Schlesinger Jr. was so heated by the festivities that he leaped fully clothed into the swimming pool, a move imitated by a cascade of other well-fueled guests. Pulitzer Prize-winning journalist Clark Mollenhoff climbed into a tree with a bottle of champagne to survey the party below. It wasn't long before the word had spread that Hickory Hill and Cape Cod in the summer were the fun centers of the new government.

But there was more. Bobby had set off on a learning crusade. He was not the most diligent student in his younger years but now, immersed in an environment where experts and intellectuals were welcomed for their ideas, he decided he needed knowledge. Leadership required more than the street smarts he mastered during the campaign.

Bobby set up study groups at Hickory Hill at which historians, economists, and philosophers were invited to dine and discuss issues that the neophyte administration was just starting to tackle. History books, philosophy tomes, and biographies began to pile up on the attorney general's desk. Some he read, most he sampled. Still, he was determined to enrich his intellect. Learning, improving, pushing beyond the present had always been family traits, bragged father Joe. Bobby was making his move.

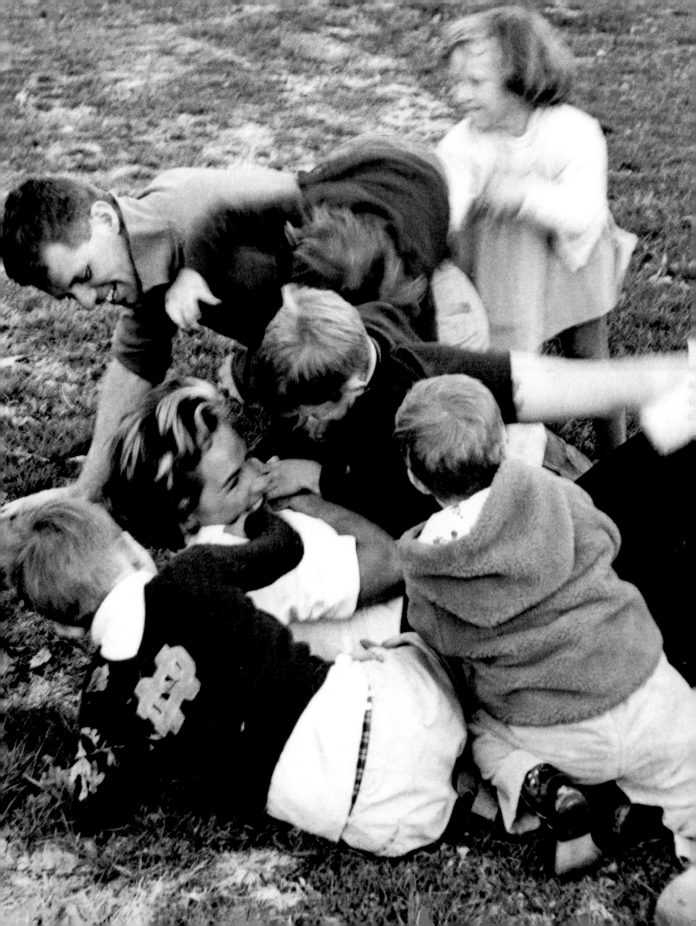

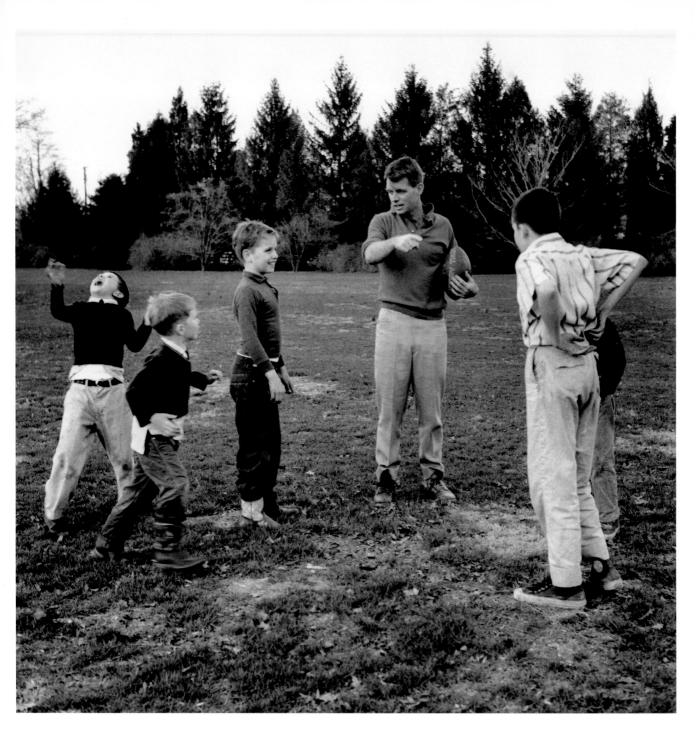

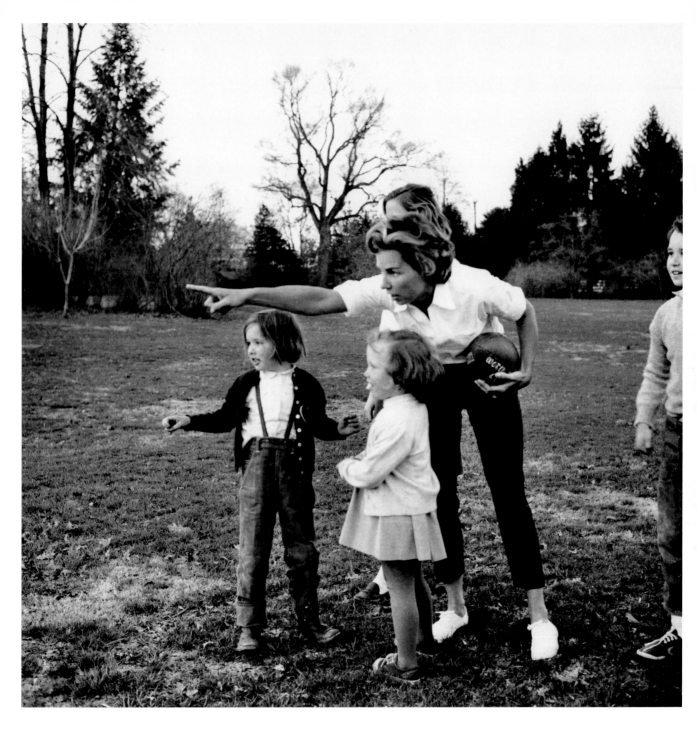

Previous page:
This football pileup
with Bobby and Ethel
was more about
hugs and love than
competition. Still, there
were rules, rallying
cheers, and inspirational
speeches.

Left and above: Team
captains issue instructions
that will be poorly understood
and generally ignored.

Overleaf: Action is the
keyword at Hickory Hill.
Jacques and his children
were sometimes pulled

into the Kennedy play,
although the photographer,
intrigued by this utterly
unusual (to him) way of
life, always arrived at the
scrimmages with his
cameras. The home team
called their football squad
the Kennedy Tigers.

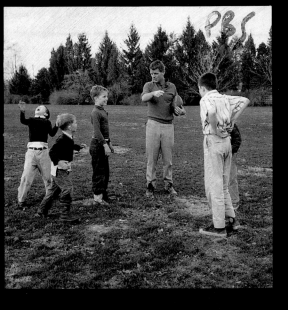

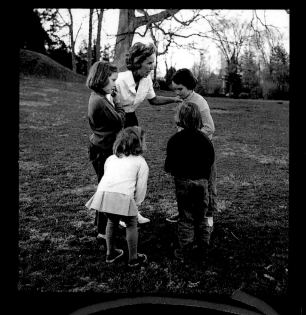

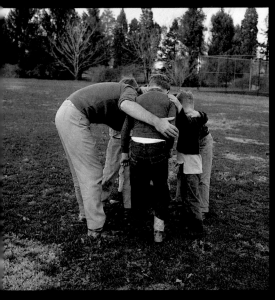

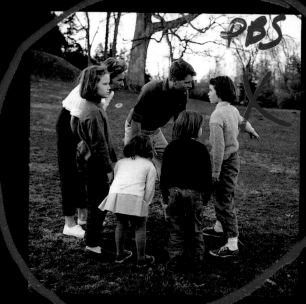

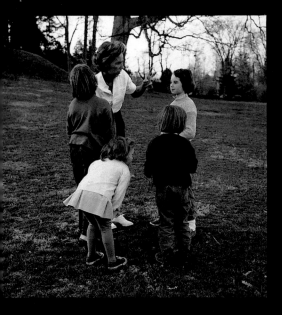

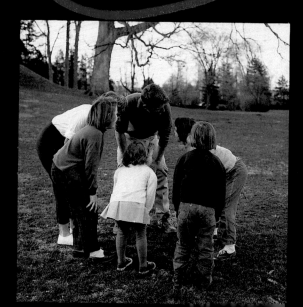

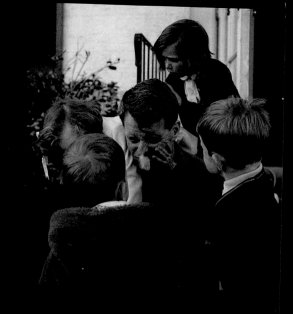
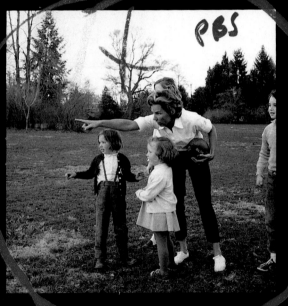

PBS

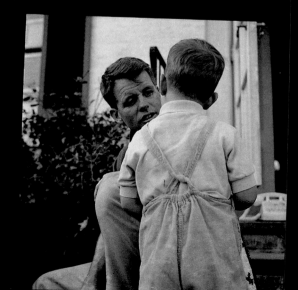

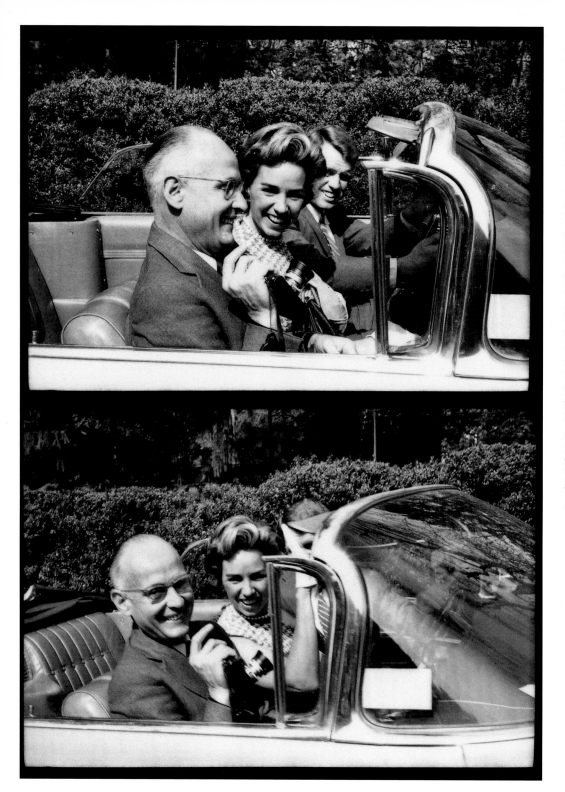

Previous pages: Ethel gives chase to Bobby on the touch football field. Jacques's photo inadvertently epitomizes the Kennedy administration's New Frontier: a blur of action headed somewhere, but rarely in a straight line.

Left: There was a convertible or two in every Kennedy household and guests were expected to partake of fresh air and thrill riding with a Kennedy at the wheel. Bobby and Ethel give internationally renowned photographer Henri Cartier-Bresson a ride to their Hyannis Port compound.

Right: Bobby comforts Caroline, not a regular in the family scrums, on the same day that the Kennedys outfit Joe Alsop, one of Washington's preeminent columnists, with an LBJ campaign hat. The stuffy Alsop seems to relish the attention, although maybe not the hat.

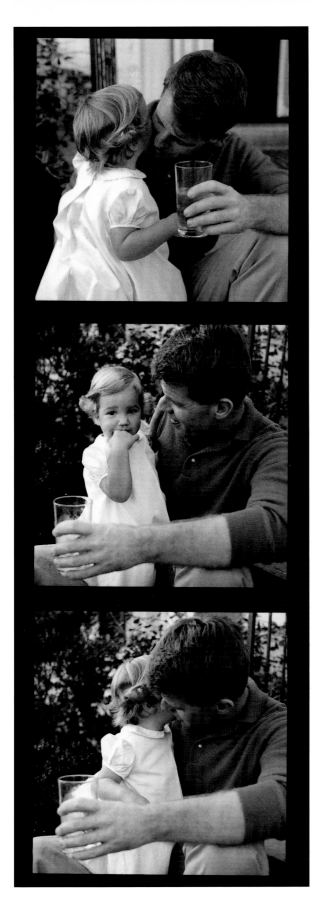

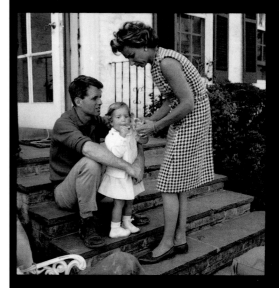

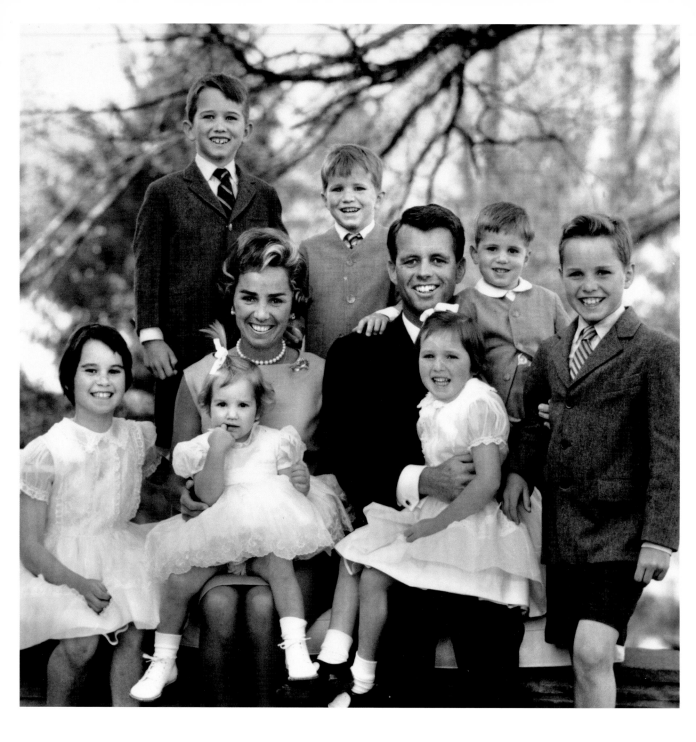

346

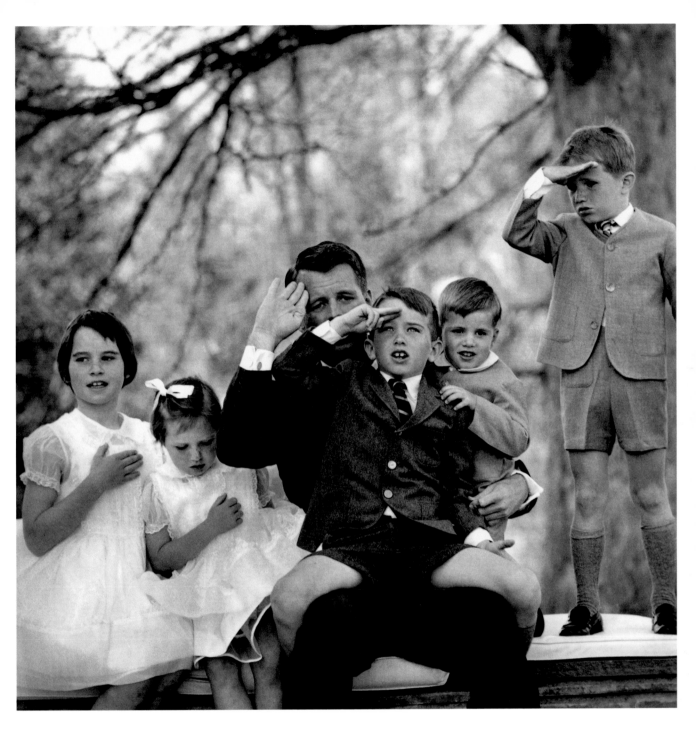

Left: Ethel Kennedy loved family portraits. These were taken in the summer of 1961. On the left, Kathleen, Bobby Jr., Mary Kerry, Ethel, David, Bobby, Courtney, Michael, and Joe smile for a formal sitting.

Above: In honor of a school vacation, the children have been granted permission to accompany their father to the office. To mark the momentous decision, they strike a patriotic pose with the attorney general.

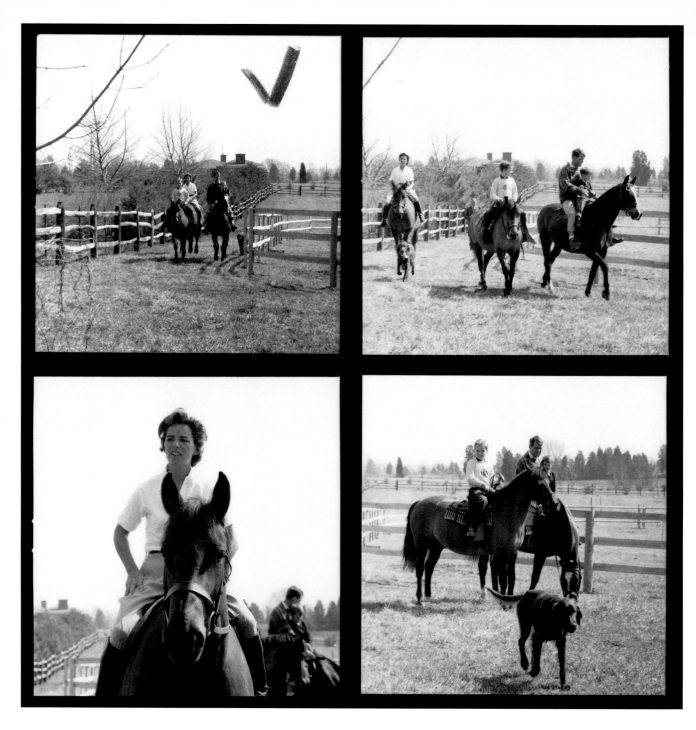

Above: Horses went
hand-in-hand with Hickory
Hill. Jacques captured
Bobby and Ethel helping
their children get
a feel for riding.
Right: As the children
saddle up behind the
family's imposing house,
Ethel tightens a saddle
for Kathleen.

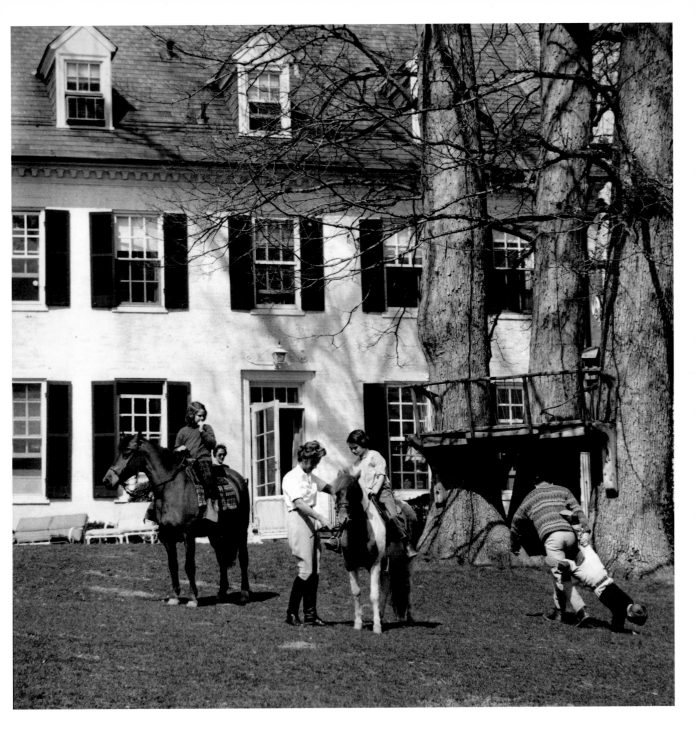

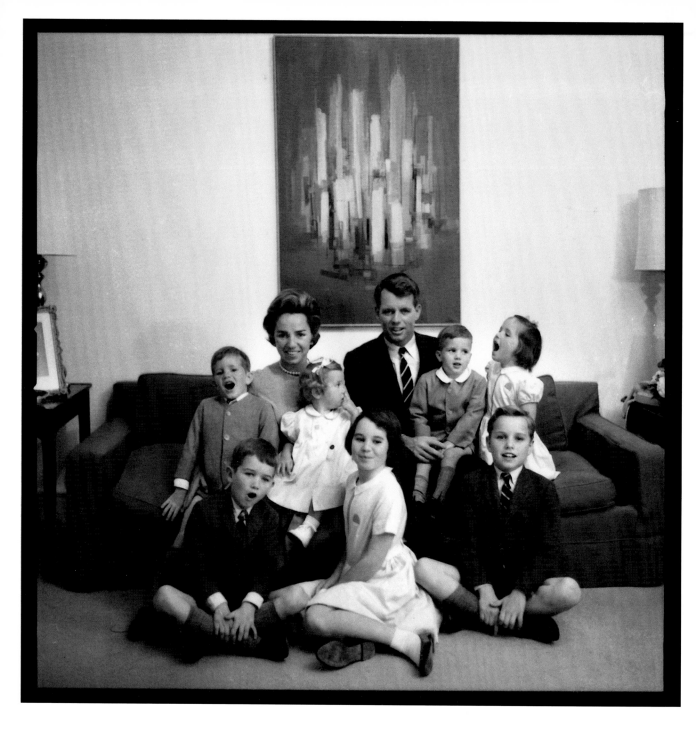

In the summer of 1961,
Jacques takes another
round of formal sittings
with Ethel and Bobby's
growing brood.

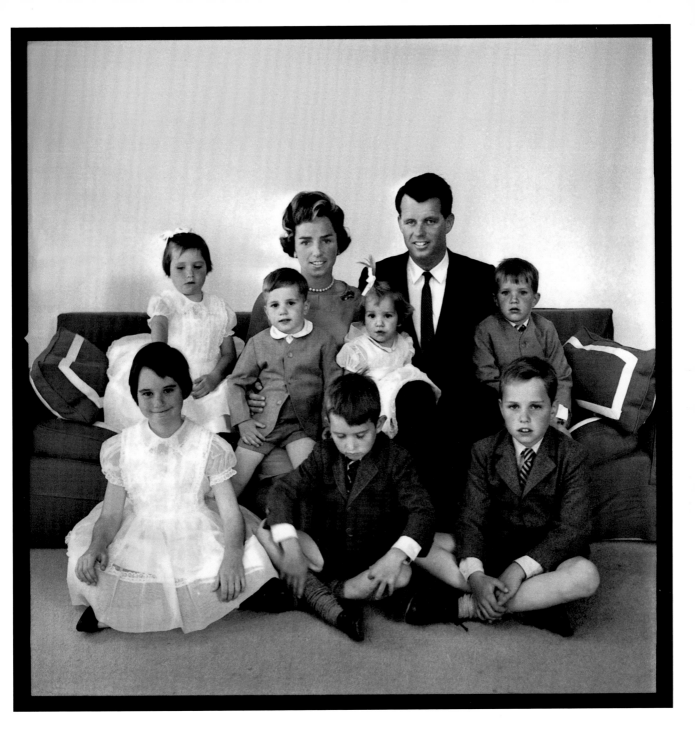

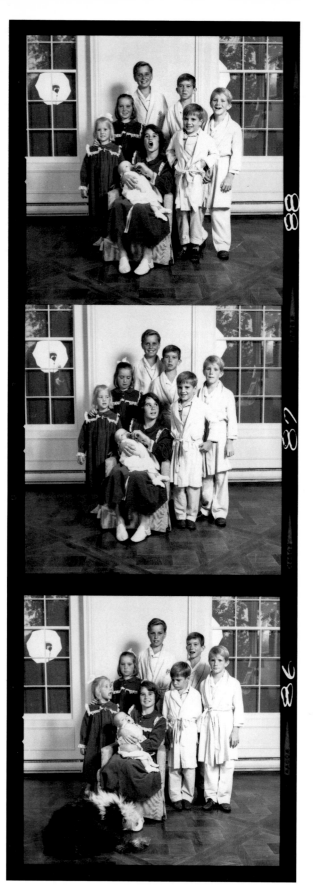

Carols, kids, and Christmas at Hickory Hill. A new baby, Christopher, joins the household. Even Jacques Lowe, expert photographer that he was, had trouble getting members of this crew to coordinate their holiday expressions.

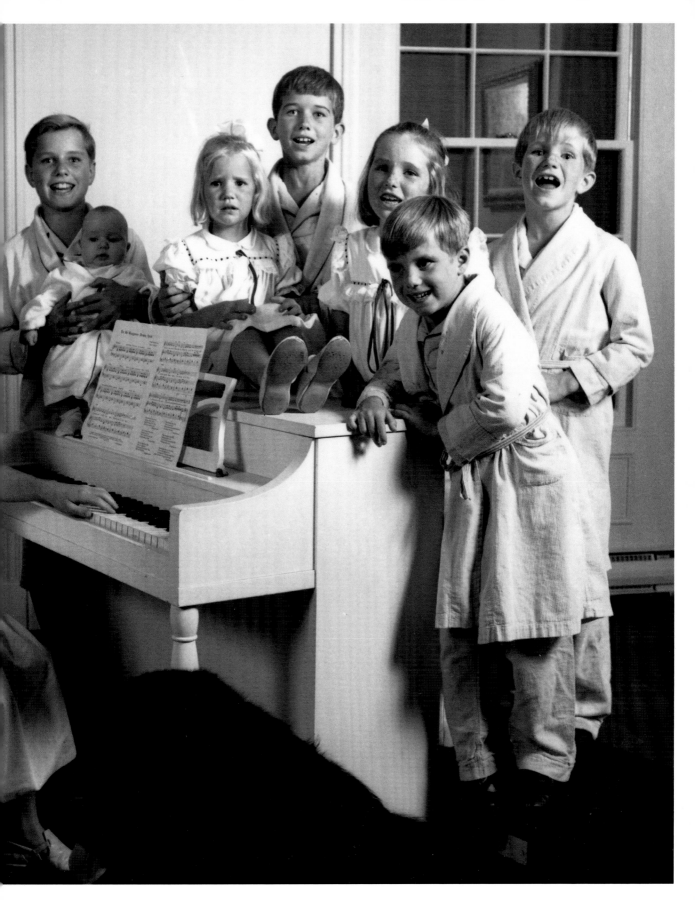

The Heir

Boston and Hyannis Port

With Jack in the White House and Bobby ensconced at the Justice Department, the Kennedy family's gaze turned to 29-year-old Ted, newly married to stunning Joan Bennett. Ted was the clan member perfectly positioned for the next power play, and he seemed to have the finely tuned and appealing political personality of his late brother, Joe Jr.

Exuberant (some would say reckless), Ted was the youngest and most handsome of the brothers. He was also the one found in the thick of family undertakings. He had plunged into Jack's campaign, serving as supervisor of the Rocky Mountain states. Before long, stories filtered back of his bronco-riding attempt and his ski jumping. These urban cowboy reports generally elicited a grin from Jack, although occasionally he cautioned his younger sibling to stick to business.

Ted got such a Rocky Mountain high that he announced he might move to Denver after his brother became president. But, as it turned out, political ambitions outran his need for adrenaline rushes. Still, he always cherished the grandeur of big sky country.

Ted had created his own center of excitement at the presidential inauguration. As host aboard one of the buses hauling VIPs to the inaugural gala, Ted danced and sang a couple of old Irish ballads, reminiscent of his grandfather, legendary Boston Mayor John Francis "Honey Fitz" Fitzgerald, a man as gifted at song and blarney as he was at garnering votes in that contentious city.

Author, ambassador, and lady-about-the-world, Clare Booth Luce, found herself exposed to Ted's charm on that wonderfully snarled night. She declared him "handsome as a Greek God" and destined "for great things." Not only was she right, but she knew father Joe was stirring again. The Kennedy patriarch was always trying to foreshorten the future by hurrying political events.

Ted was naturally ambitious. But he was also as disinterested in business as the other Kennedys. So he surveyed the political landscape and, with considerable encouragement from his father, thought he might go out and reclaim the Senate seat vacated by Jack in Massachusetts.

While Bobby and the president had reservations, the political experts around Jack were openly opposed. Then Joe Kennedy spoke: "You boys have what you want now, and everyone else helped you work to get it. Now it is Ted's turn." Another story making the rounds had it that the father simply laid down the law. "I spent a lot of money for that Senate seat. It belongs to the family," he reportedly said. Naked power on the march, had anyone forgotten.

Ted ran his campaign with verve and a lot of help from his Washington siblings. He buried his opponent, Edward J. McCormack, a favorite nephew of House Speaker John McCormack, by a humiliating 69 percent of the vote.

In another era not so completely intoxicated with Jack and Jackie in the White House, there would have been more serious outcries over the dynastic ambitions of the Kennedys. Did they want the world? Indeed, there was already talk that when Jack finished his two terms, Bobby would be in position for a go at the presidency.

Ted and Joan moved to Washington and took on the familiar trappings of the Kennedys. They had homes in Georgetown and on Cape Cod and they began to produce adorable children. Jacques Lowe enthusiastically turned his cameras on their family picnics, horseback riding, and splashes in the Hyannis Port surf. Jacques wondered if the Kennedys would be a full life's assignment.

This time, however, the Kennedy template for glamour and power would disintegrate. The beautiful couple would divorce and other scandals would plague the senator. Some would suggest that adversity had forged Ted into a better man, although his life would never be fully tranquil again. But Jacques's pictures had caught a golden moment, one more part of the Kennedy saga.

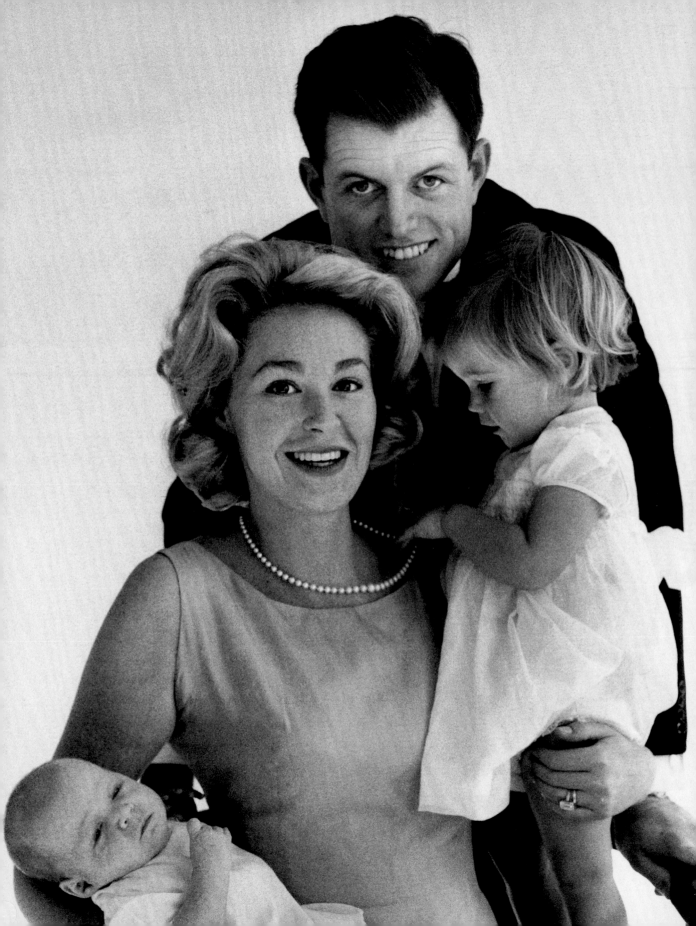

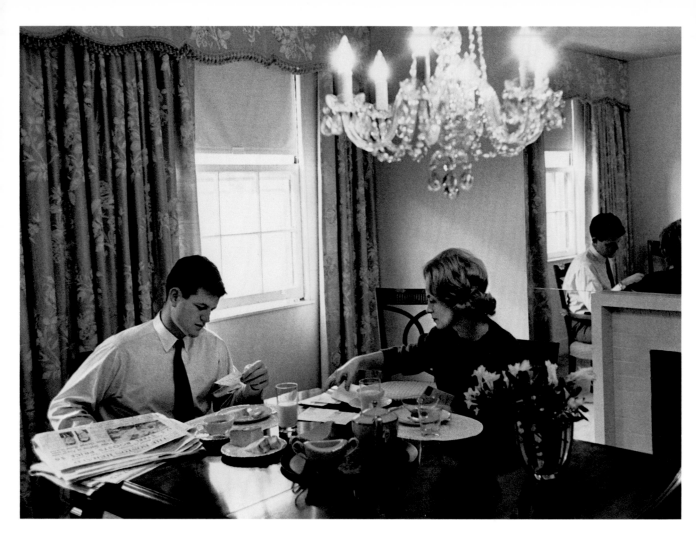

Previous page: The ultimate Kennedy family, judged by many writers to be the most beautiful people of their time. Jacques Lowe began a study of the third Kennedy family in the summer of 1961. This picture of baby Ted Jr., Joan, Ted, and Kara was taken in Boston when Ted was assistant district attorney.

Above: Ted and Joan, minus the children, have breakfast at their home in Boston.
Right: Jacques catches Ted and Joan in the doorway of their Boston home as the youngest Kennedy brother leaves for work. This picture looks much like the one taken of Senator Kennedy and Jackie in their Georgetown home.

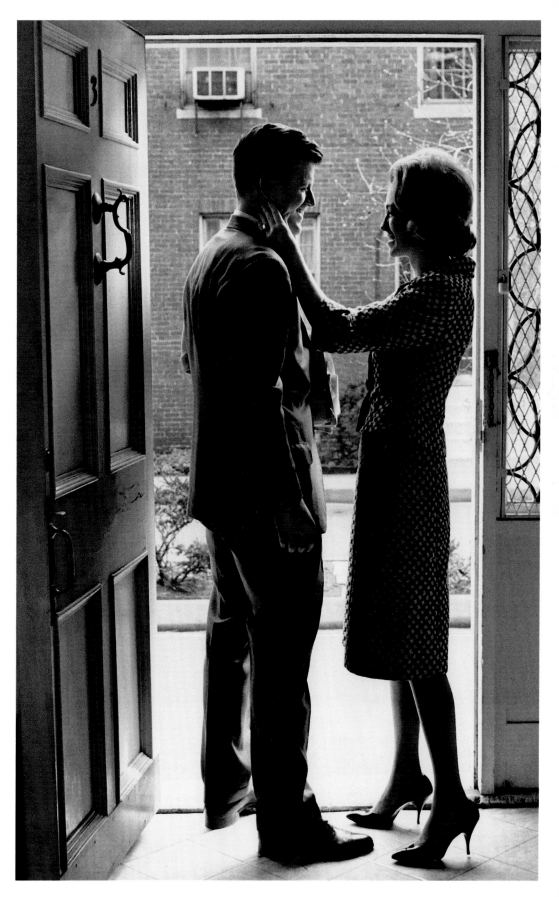

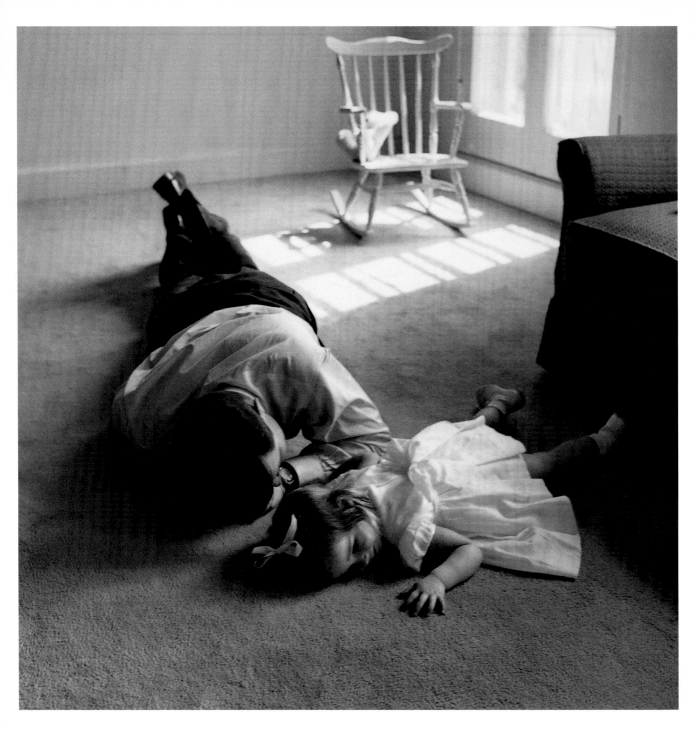

Above: Ted gets down on
the carpet of the family's
home to play with Kara.
Right: Jacques catches
the action of Ted, Joan,
and their son and daughter
during happy days.

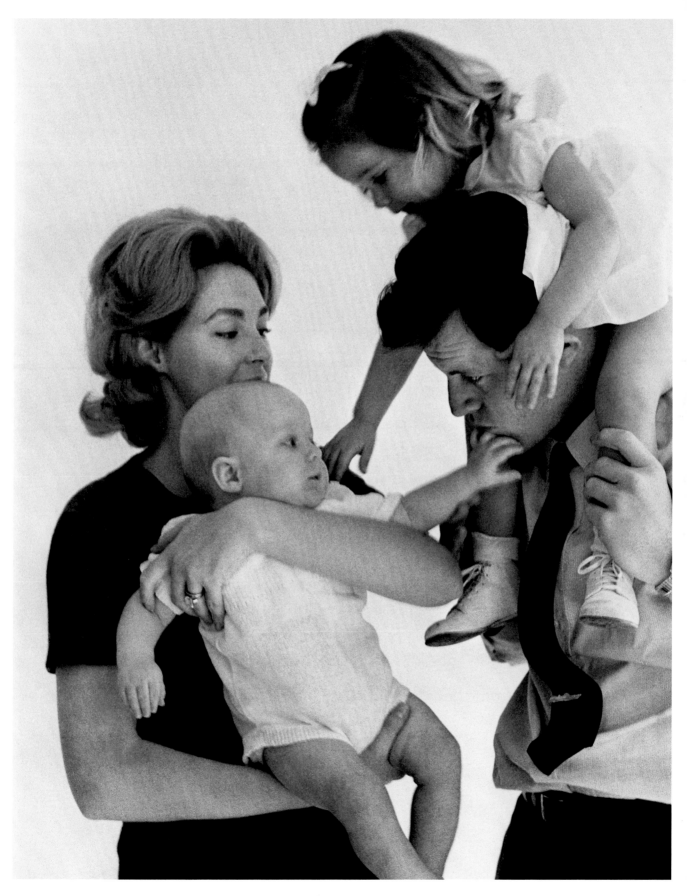

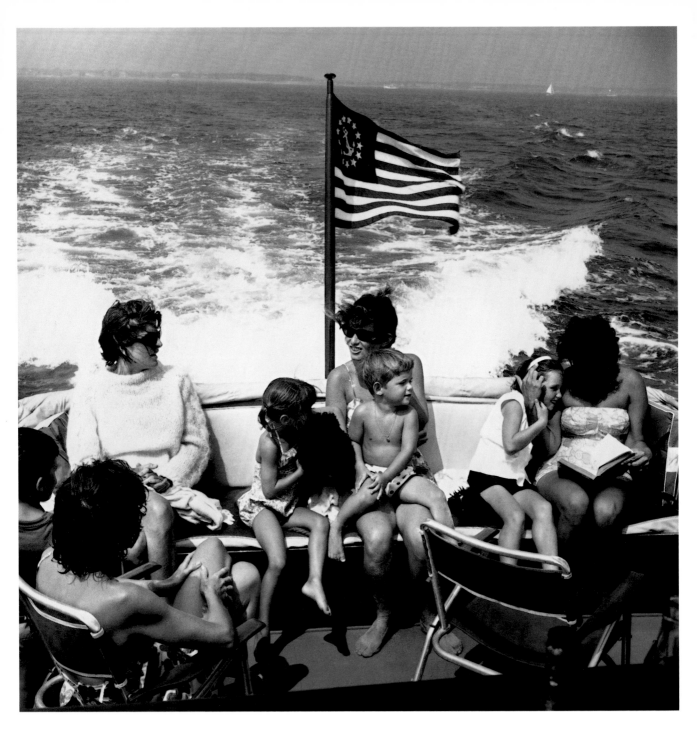

Above: Some of the
Kennedy women take their
children on a boat outing
in Nantucket Sound.
Right: Joan, her children
draped all over her, lets
the camera catch her
in a joyous moment.

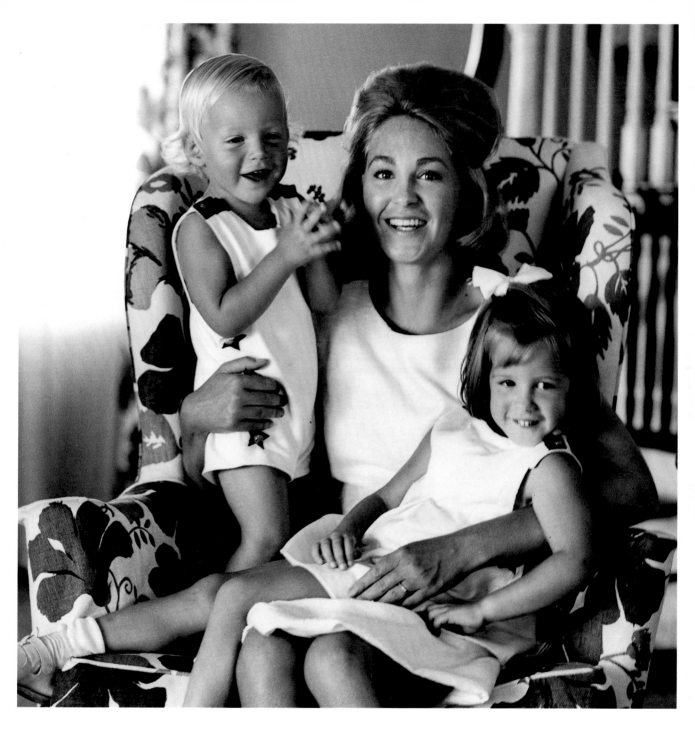

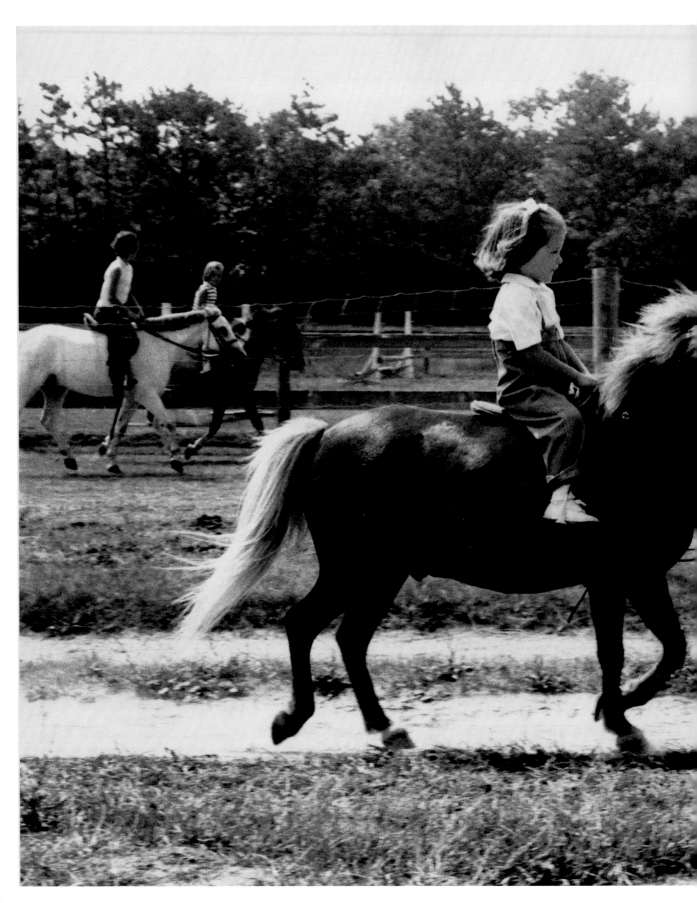

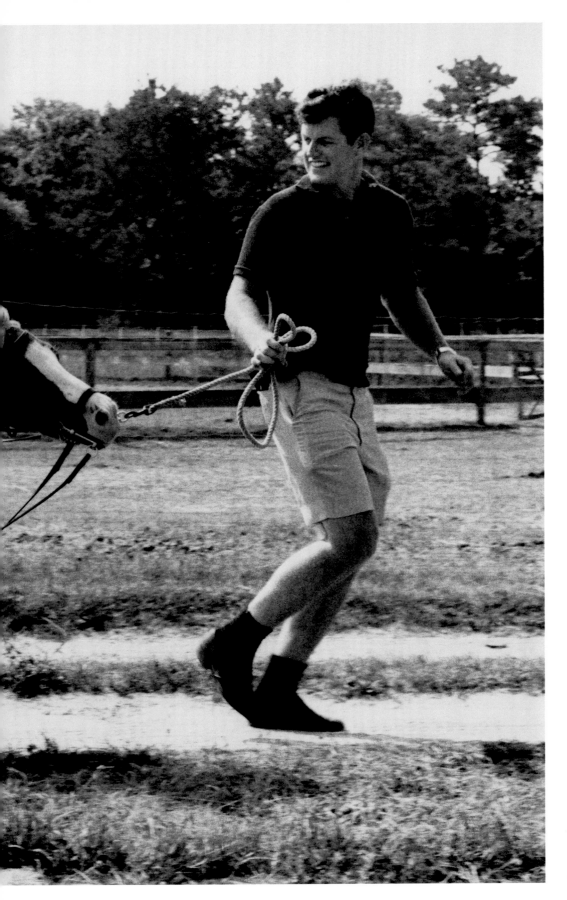

Ted gives daughter Kara a little assistance during her riding lessons on Cape Cod in 1962.

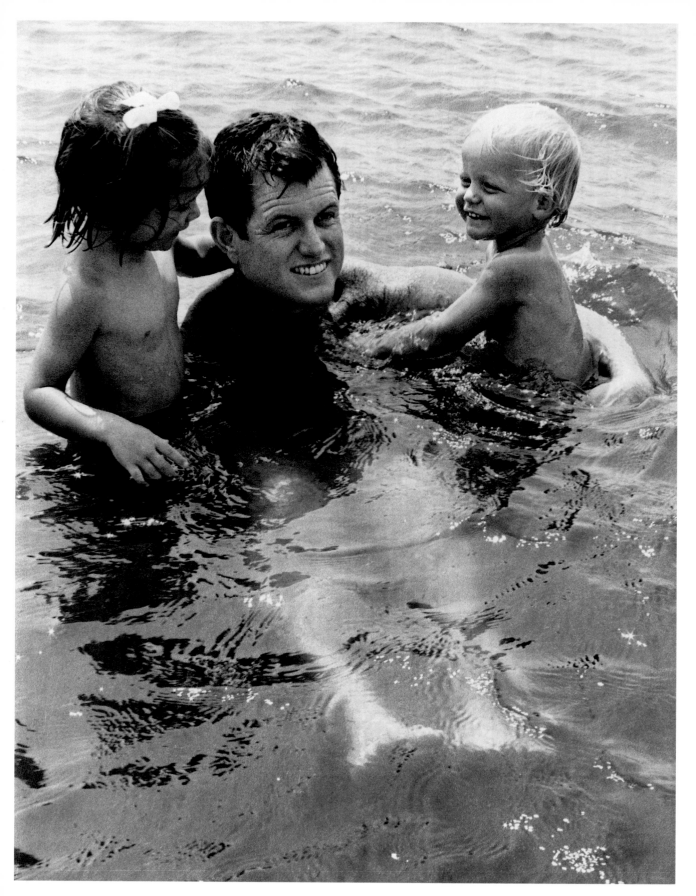

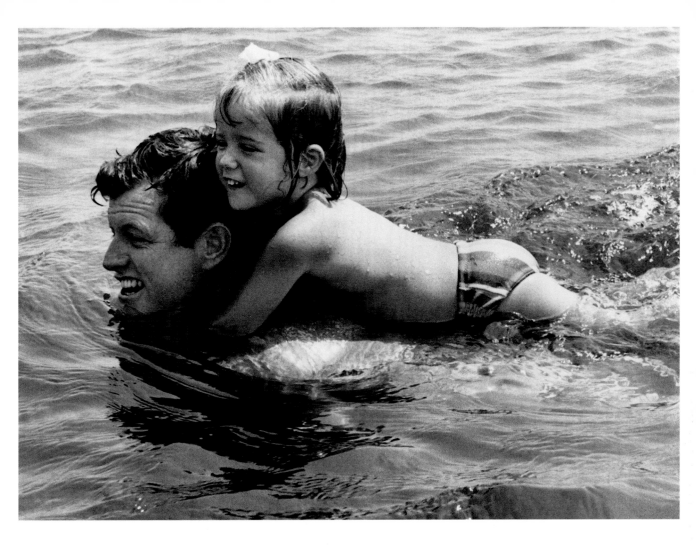

Like his brothers, Ted also loved the water. Kara and Ted Jr. get a water workout with their father on Nantucket Sound, just off the Kennedys' Hyannis Port compound, during the summer of 1962.

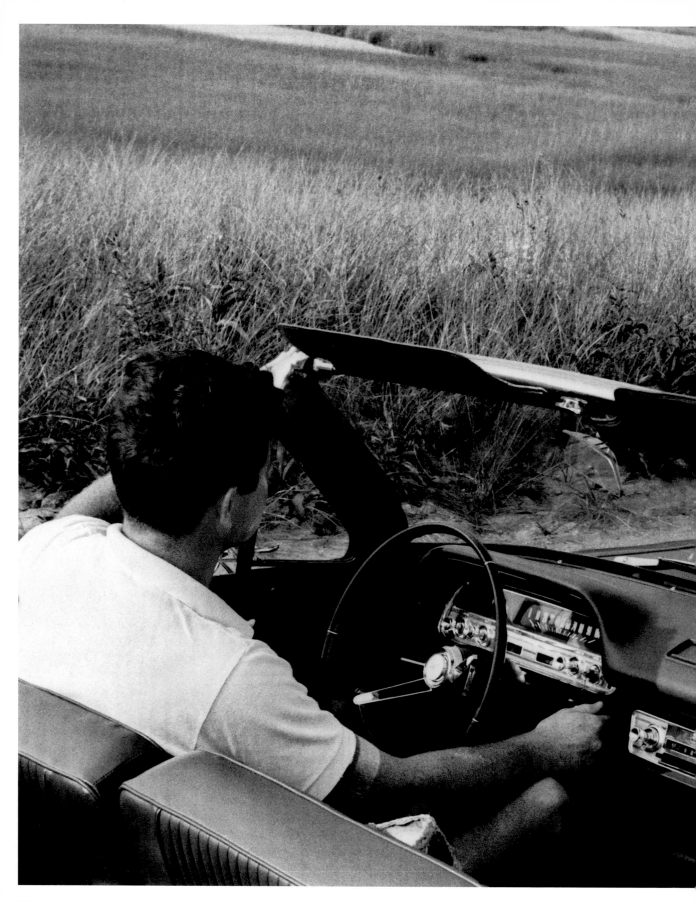

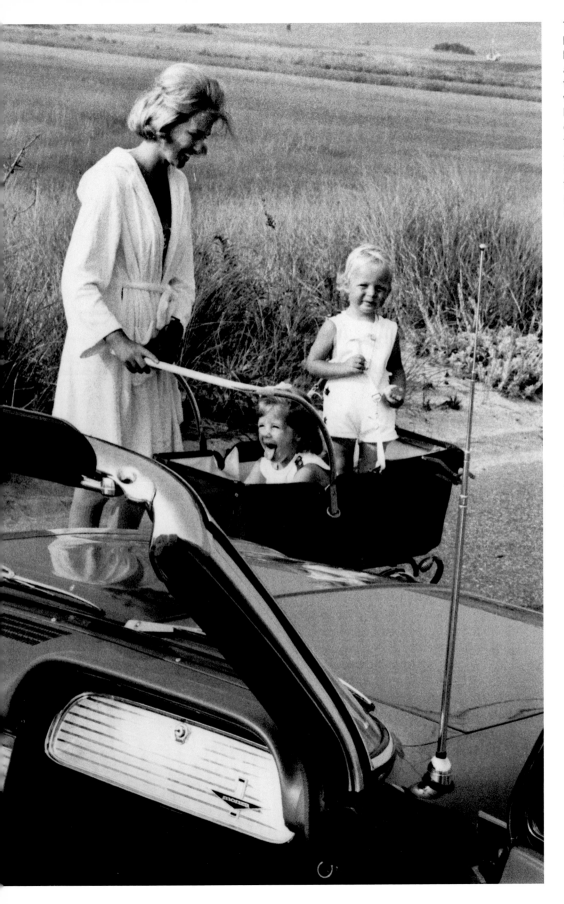

Ted and Joan's home in Hyannis Port was not in the Kennedy compound, although it is often referred to as if it were. Their house was actually on Squaw Island, down the road and over a causeway from the family compound. Here, Ted drives one of the trademark Kennedy convertibles on the road home when he encounters Joan and the kids out for a walk.

French Leave

Paris

The May morning in 1961 was rainy and cool and a small crowd of French dignitaries and American journalists milled and muttered at Paris's Orly Airport. A gigantic scarlet carpet was unrolled and haughty French President Charles de Gaulle, all six feet and seven inches of him, took up his place at the carpet's end, his nose unusually elevated at the thought of talks with the young and inexperienced U.S. president.

Then came a bit of magic. The rain stopped, the sun appeared, elegant Jackie gave a short speech in French, and John Kennedy talked humbly and briefly. De Gaulle melted just a little. He would soften more as time went on.

The motorcade through the French capital was overwhelming, with hundreds of thousands of normally undemonstrative Parisians out cheering this young American couple. The world took notice of Kennedy's entry into the international scene, of the new style of the leader from the United States. And Jacques Lowe was there with his cameras.

Paris was supposed to be a sideshow on the way to the Vienna Summit with Soviet boss Nikita Khrushchev. The Cold War was at its peak. The Soviets and their client states had four million men under arms. They possessed a formidable arsenal of nuclear weapons and the rocketry to deliver them. European leaders, particularly de Gaulle, were not at all convinced the United States would come to their rescue should the Soviet forces roll west into Europe. Already the Soviets were putting the clamps on access to West Berlin, that island of freedom buried in communist East Germany.

This heavy cloud of concern lay over Paris when the Kennedys arrived. But no member of the media had calculated the impact that would be made by stylish Jack and Jackie, nor had the world realized the underlying seriousness and purpose of Kennedy. His eloquence and Jackie's French connection made the trip a groundbreaking one.

When Kennedy climbed into his limousine, a French policeman with a huge smile, said, "Mon dieu, he's really an all-American boy." Kennedy sidekick Dave Powers responded with his own style of friendship forging. As the motorcade edged through the cheering, waving crowd, Powers shouted, "Comment allez-vous, pal."

Before it ended, Kennedy charmed the world when he humorously introduced himself to a luncheon audience as "the man who accompanied Jacqueline Kennedy to Paris, and I have enjoyed it."

In hindsight, Jackie's staff and some journalists concluded that it was in Paris where she came to terms with her new role as first lady. Jackie was not at first happy with life in the White House. After a few days in residence she told one friend it was like living in a hotel, there was no family privacy. A Secret Service agent lurked behind every door, down every corridor. In Paris she saw the possibility of establishing her image as one of grace and beauty.

By design, the motorcade into Paris traveled down the famed Boulevard St Michel—or Boul Mich for short—the cobblestone avenue slicing the university district, where Jackie once roamed as a student. Those with her saw the first lady's excitement mount as the trip progressed. In the Quai d'Orsay she slept in the Chambre de la Reine, bathed in a silver mosaic tub, and gazed at a ceiling swarming with Napoleonic cherubs. Once during the short stay she even escaped her security detail. Alone in a limousine, she returned to the neighborhood of the Sorbonne, possessed by her memories.

Jacques Lowe rustled up white tie and tails for formal receptions and, despite the French strictures against photographers (and with the help of Kennedy), managed to find his special spots and capture the magnificence of the visit.

The highlight came at the final dinner in the Hall of Mirrors at the Palace of Versailles. There, America's first couple wandered through corridors filled with the echoes of kings, queens, and failed empires, then watched in awe as the French turned on the great fountains of Versailles for the first time since World War II.

Previous page: Jackie takes center stage in Paris. French President Charles de Gaulle may have been imperious, and he certainly was stern when he talked to JFK about the Cold War, but Mrs. Kennedy delighted him. Beside the first lady is Mrs. Michele Petiet, wife of the chief of French protocol.

Above: An estimated million people jammed the streets in hopes of catching a glimpse of the young American couple in their motorcade from Orly Airport to the center of Paris. *Right:* French pageantry was at its best for the 1961 visit.

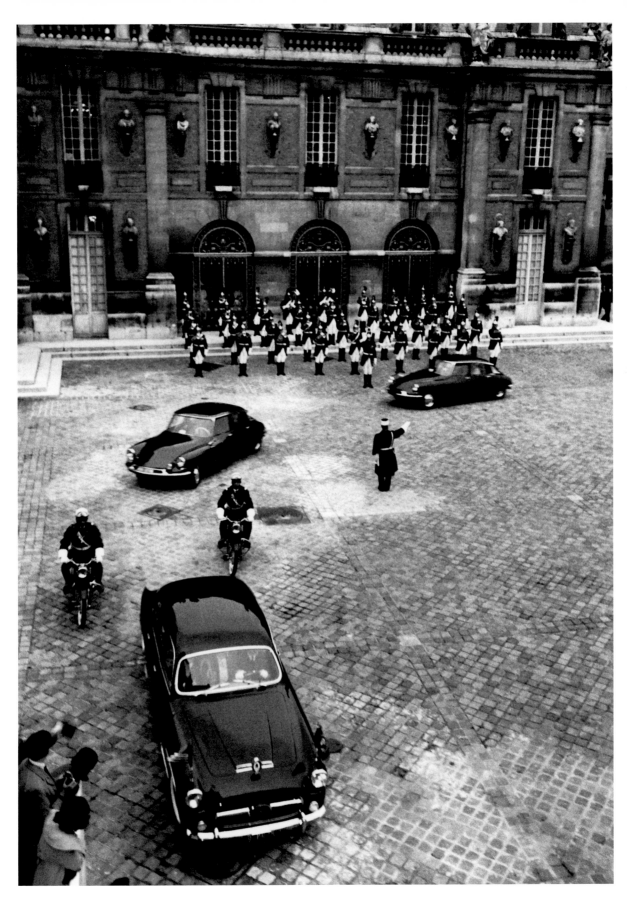

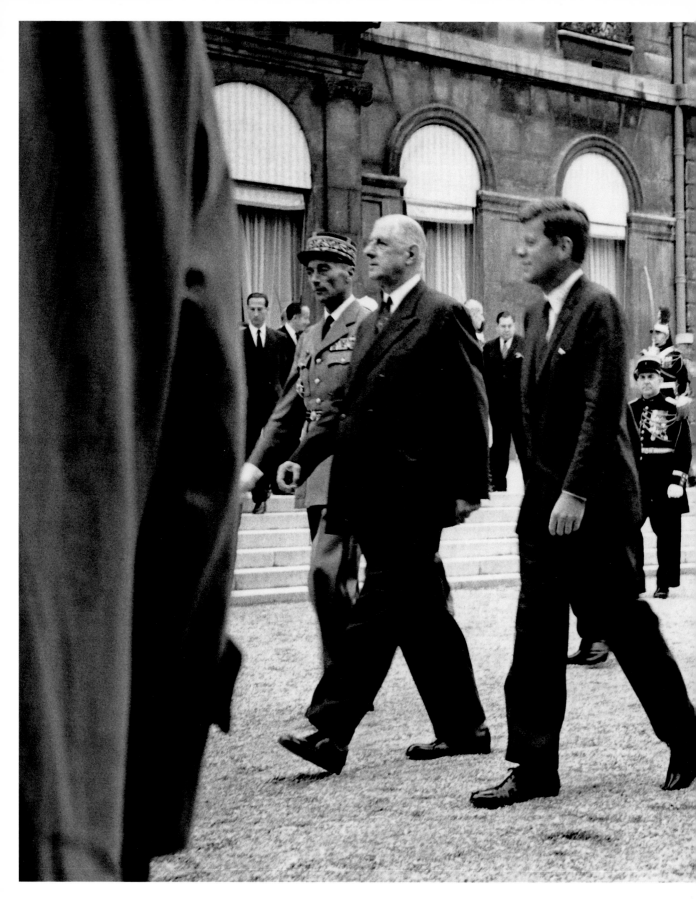

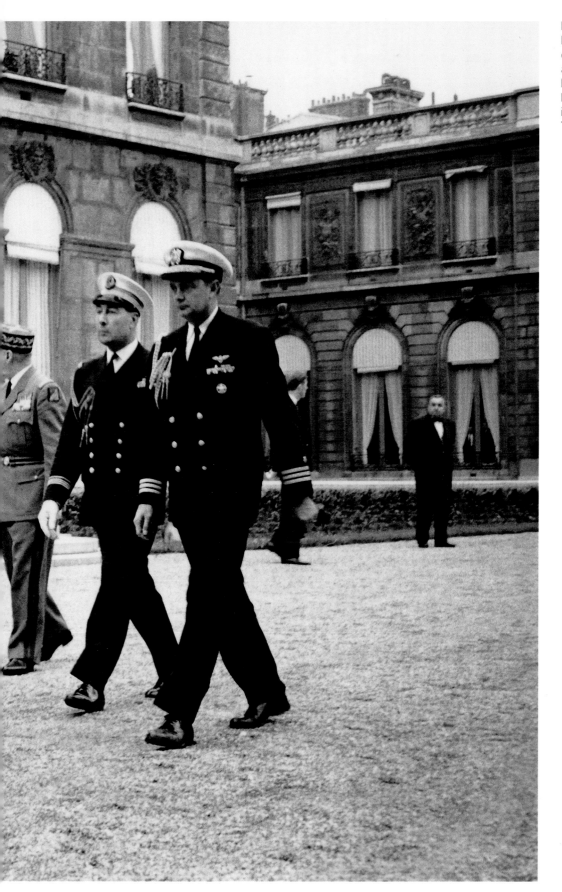

President Kennedy and President de Gaulle head off for serious meetings, although both men seem bemused by the moment. Directly behind Kennedy is his naval aide, Captain Tazewell Shepard Jr.

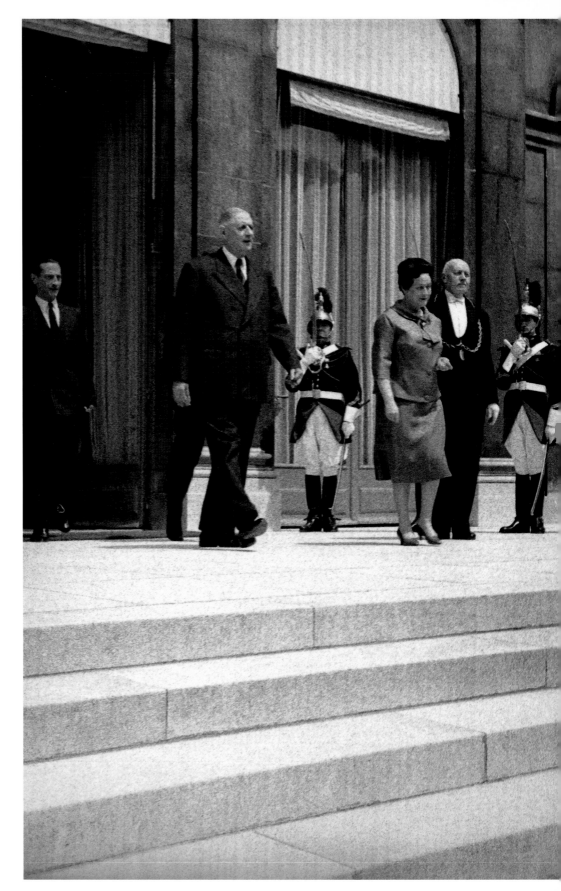

President Charles de Gaulle, to the surprise of some, stands at the ready to greet Mrs. Kennedy upon her arrival. Most of Jacques's pictures of Jackie and the French president together show an uncharacteristically mellow de Gaulle. Jackie is credited with brightening the Frenchman's disposition.

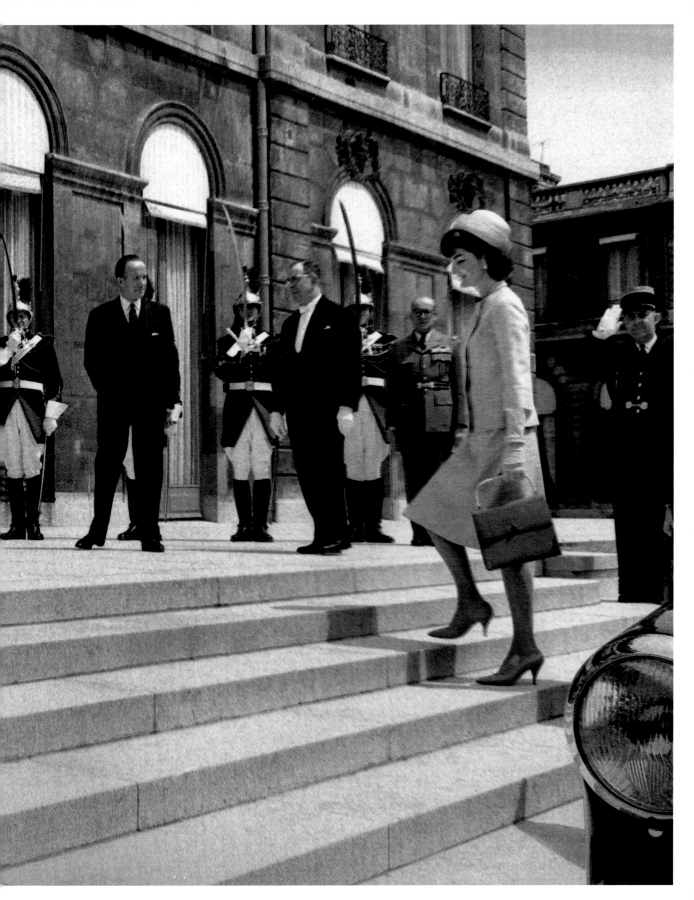

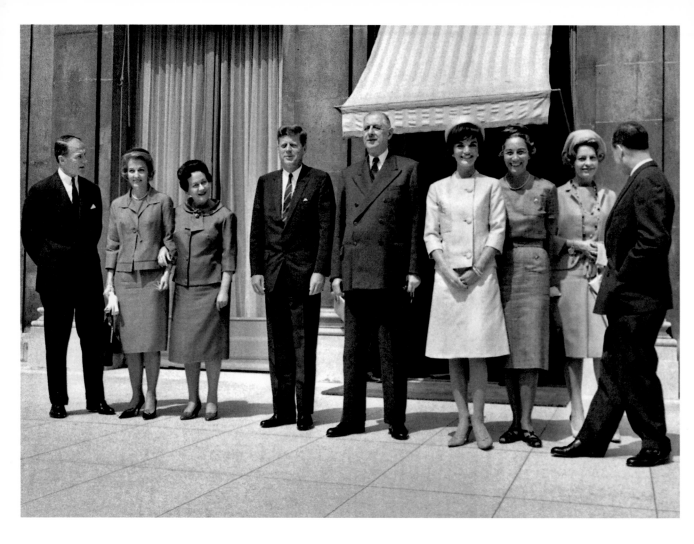

The Americans were
amused and dazzled by
the formalities at French
ceremonies, which
included the presence
of the elite, and
magnificently uniformed,
Garde Republicaine.
Jackie's orchestrated
changes of clothing for
each appearance not
only were intensely
catalogued by the fashion-
conscious French press,
but they were credited
with spawning a new
interest in fashion in the
United States.

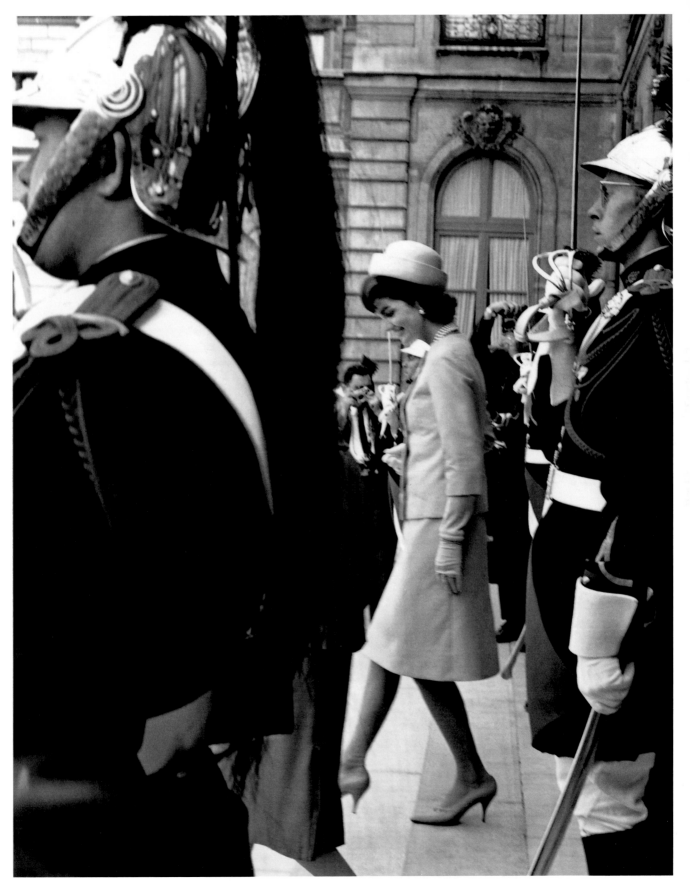

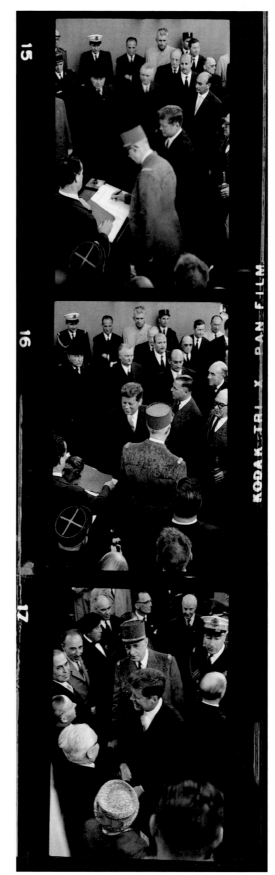

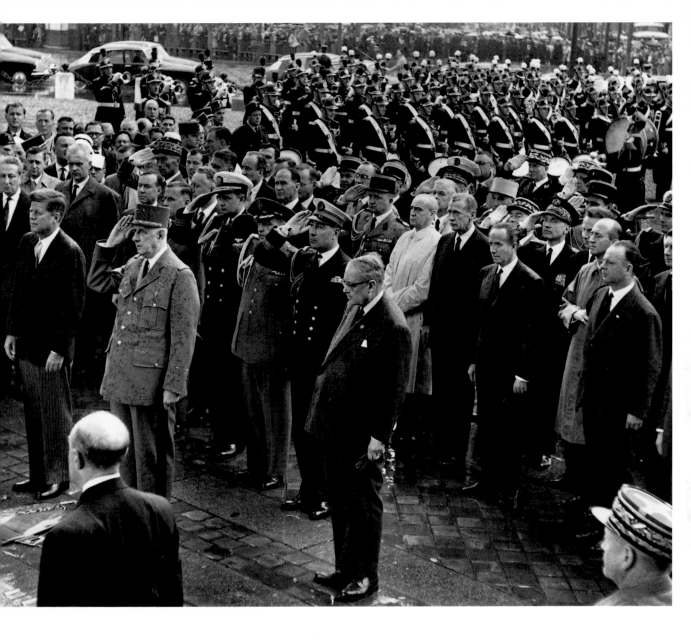

On his first day in Paris, President Kennedy slipped into a morning coat and joined President de Gaulle, in military uniform, at the Arc de Triomphe. Surrounded by dignitaries from both nations, the U.S. president laid a wreath and symbolically lit the eternal flame beneath the arch to honor France's war dead. Kennedy and de Gaulle then signed the official register.

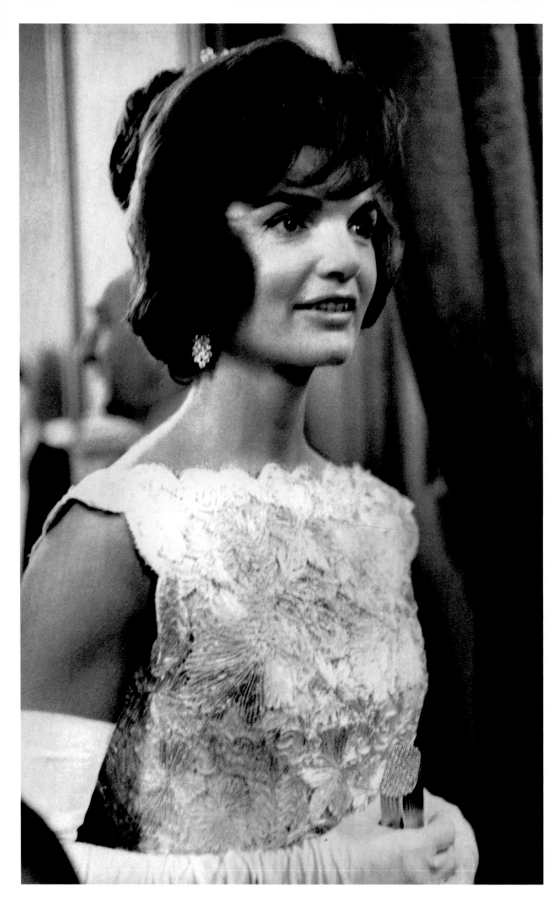

Left: Jackie dresses in an elegant sheath for the white-tie reception and dinner at the Elysée Palace, which was viewed by Parisian society as the premier event of the season. People fought bitterly for invitations: Some 150 people attended the dinner, but there was a receiving line for 1,500.
Right: The centerpiece is hoisted into place prior to the reception.

Overleaf: The swirl of the great reception with de Gaulle steering Kennedy among the invited guests, which included Jackie's sister, Lee Radziwill; Eunice Kennedy Shriver; and Rose Kennedy.

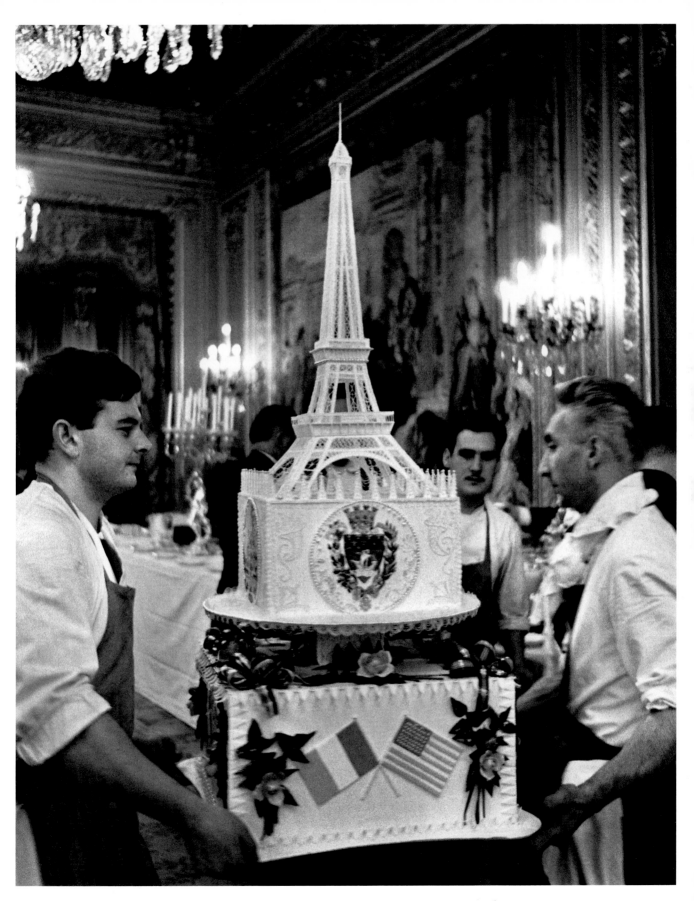

27

28

21

22

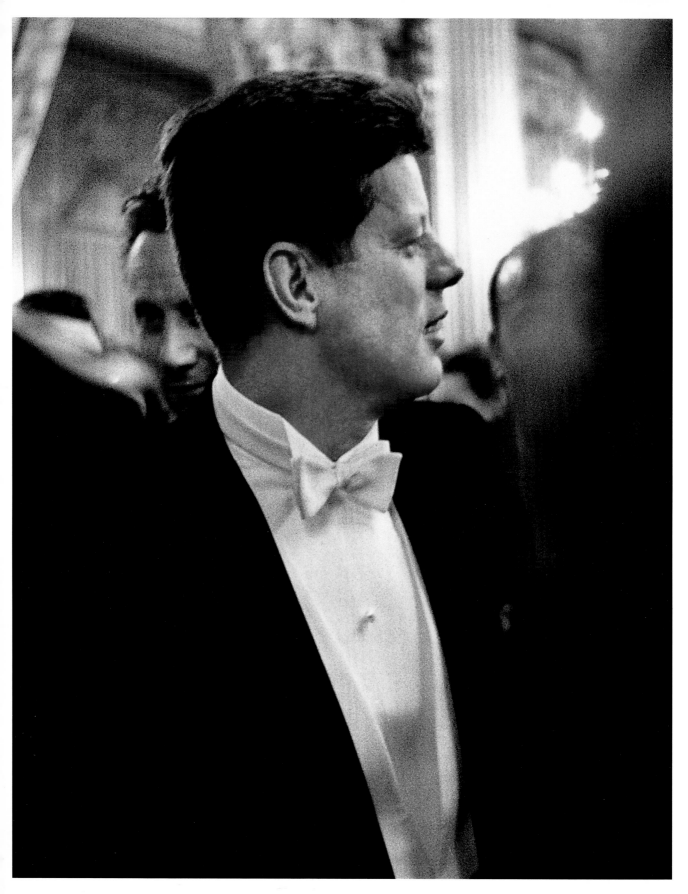

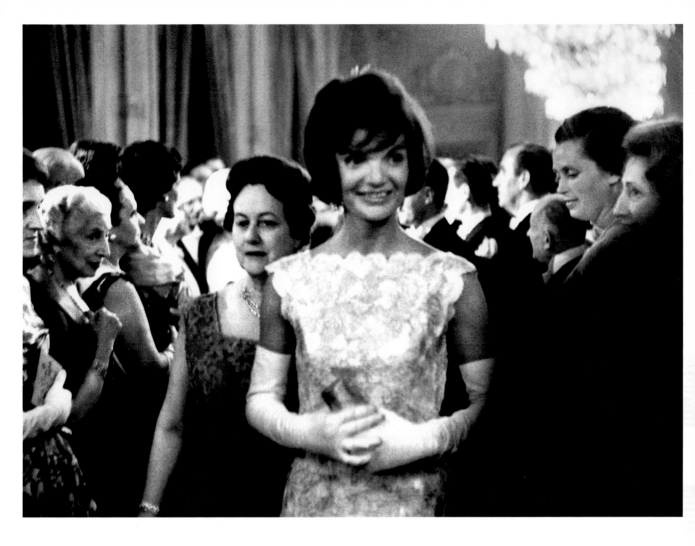

Left: Jacques selected a picture of a dashing Jack Kennedy at the reception for use in one of the photographer's earlier books.
Above: Yvonne de Gaulle, the French president's wife, guides Jackie among glittery guests at the reception. When the French women were introduced to the U.S. first lady, they beamed and sometimes curtsied, bowed, or shook hands, but few could resist grabbing another glance at the young American as she passed. By Parisian standards, both Jack and Jackie were simply dressed, which was part of their appeal.

Vienna Summit

Vienna

Today it's difficult for some Americans to understand how dangerous the world was during the long summer of 1961. The Soviet Union and the United States had dozens of nuclear missiles aimed at each other. The politburo, the gang that ran the Soviet empire, was viewed by many as killers and drunks given to dangerous miscalculations. Soviet boss Nikita Khrushchev had declared his country's right to foment "wars of liberation" around the globe. To Kennedy, that statement was ominous.

Beneath the exhilaration of political victory and the celebrations that followed, Kennedy had deep concern about preserving world peace. He had experienced war in the Pacific as a combatant and had traveled as a news correspondent to post-war Berlin, where he saw terrible devastation and smelled the rotting bodies in the rubble.

As soon as he assumed the presidency, he put out feelers for a face-to-face meeting with Khrushchev. JFK held out the belief that he and his adversary together could find areas of accommodation and lessen the Cold War tension. It was not to be just yet, although Khrushchev was ready for a summit to test the young challenger.

Even before the cheers died down in France, Kennedy had slipped away to the U.S. embassy in Paris for a somber chore: a briefing by his Soviet advisers. It was only a short hop to Vienna, the summit site. That once glorious city of music and art was still struggling back from the dead hand of Soviet occupation following the war.

The first sights in Austria were depressing to Kennedy. Barbed wire still stretched down streets. Security patrols of unsmiling troopers led wire-muzzled police dogs through the city. It was rainy, gray, and grim. Yet magnificent buildings like the Vienna Opera House stood intact and there were even moments when pleasure was displayed. Jacques Lowe was on hand.

One state dinner took place at the historic Schönbrunn Palace. Khrushchev, with an unusually bright smile, edged his chair closer to Jackie. Like France's Charles de Gaulle, he seemed quite captivated by the American first lady. The Vienna Boys Choir performed for the Kennedys, innocent and fresh voices rising in famed St. Stephen's Gothic cathedral. And equestrian Jackie got a special show from the Lipizzaner stallions. But the real event was buried behind the thick stone walls of official buildings. It was conducted by the two most powerful personalities in the world, each looking for a weakness in the other.

Khrushchev and Kennedy met for eleven hours, ate two lunches together, and took an hour's walk alone with interpreters through a spring wood heavy with the scent of blooming mock-orange bushes. As important as anything to Kennedy was his study of Khrushchev the man. JFK believed the nature of this adversary would affect U.S. strategy as much as any formal declarations of Soviet policy.

At every chance, he scrutinized the Soviet leader. Later, he described him as intelligent and cunning, but uninformed on America, perhaps deliberately. At one point in their encounter, Kennedy tapped two star-shaped medals pinned to Khrushchev's clunky gray suit. What were they, Kennedy asked. Lenin Peace Medals, the Russian replied. "I hope you keep them," said the American, with half a smile.

But the man facing him, Kennedy concluded, was no buffoon. Rather, he was a man who struck with animal vitality. "You're an old country, we're a young country," jibed Khrushchev. "If you will look across the table," responded the 45-year-old Kennedy, "you'll see that we're not so old."

There was no happy ending to this confrontation. Kennedy lingered after the scheduled meeting time to talk more, but Khrushchev was in a sour mood and determined to sign a peace treaty with communist East Germany later in the year, leaving the future of West Berlin uncertain. "In that case, " rasped Kennedy, "it is going to be a cold winter."

The new president would say later it was "the hardest work in the world." As he headed home, he had no illusions about what lay ahead.

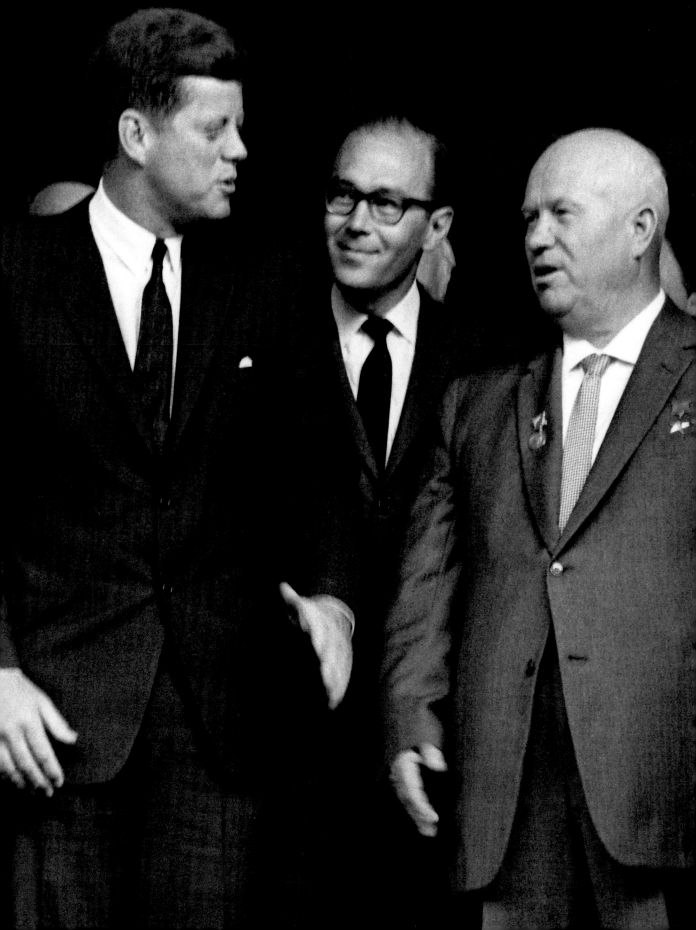

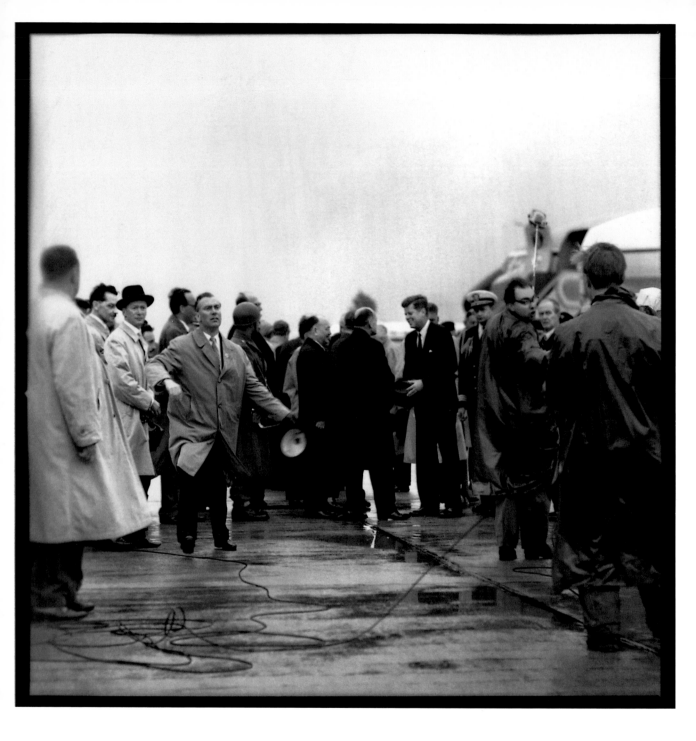

Previous page: Separated by a translator, President John Kennedy and Soviet Premier Nikita Khrushchev meet in the residence of U.S. Ambassador H. Freeman Matthews in Vienna. Photographers shouted for a handshake.

The two powerful men later complied.

Above: Austrian and U.S. officials greet Kennedy at the Vienna airport in June of 1961.
Right: Scenes at the U.S. ambassador's residence when Kennedy and Khrushchev came together include the lower-left shot of Kennedy with Soviet Foreign Minister Andrei Gromyko, to his right. The bottom frame on the right shows U.S. Secretary of State Dean Rusk.

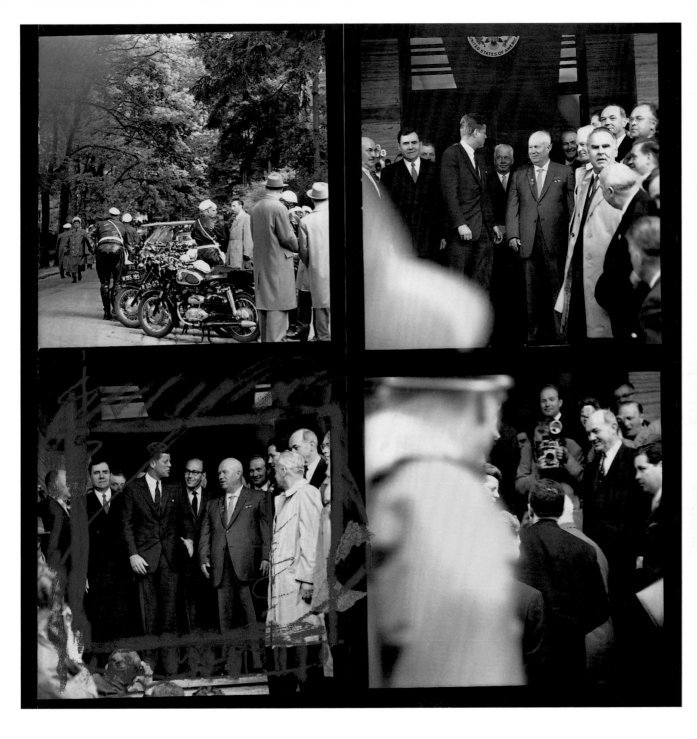

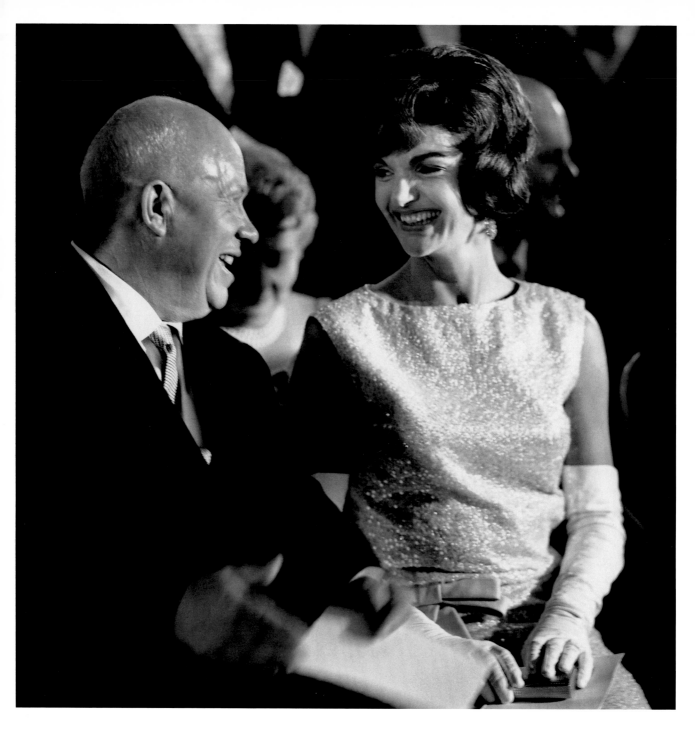

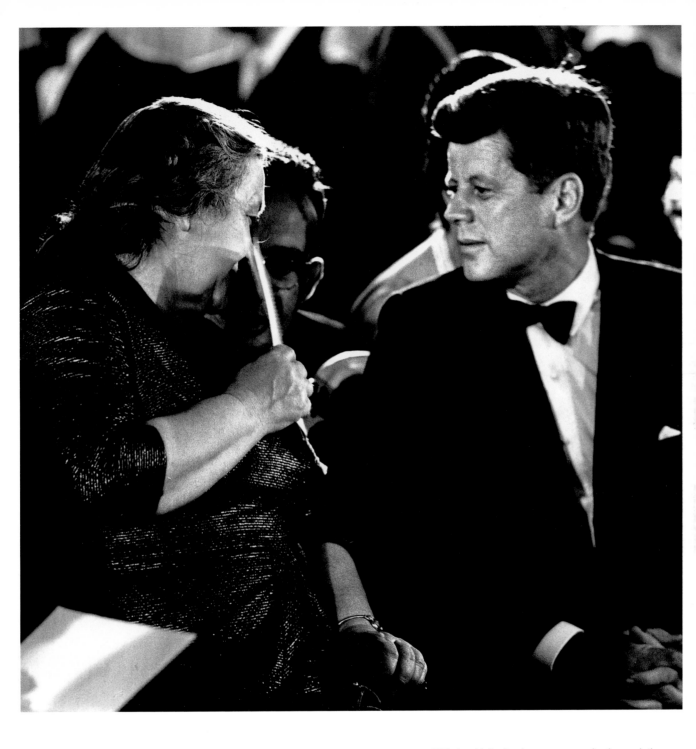

While hard talk about the state of the world was the main order of business in Vienna, there was a pause on the second night of the visit for a state dinner in Schönbrunn Palace. The Americans donned formal dress, while the Soviets wore business clothes. Khrushchev shares a repertoire of funny Russian stories, which Jackie clearly enjoys. JFK has a little tougher time with Khrushchev's wife, Nina, but he would later say she was pleasant company.

Left: The state dinner at the Vienna Summit paled by the standards set in Paris, but it was a happy surprise for some of the American entourage who didn't expect the Soviet-occupied city to muster the glitter of its pre-World War II days.

Right: Members of the Bolshoi Ballet, brought in from Moscow for the evening's entertainment, pose for Jacques.

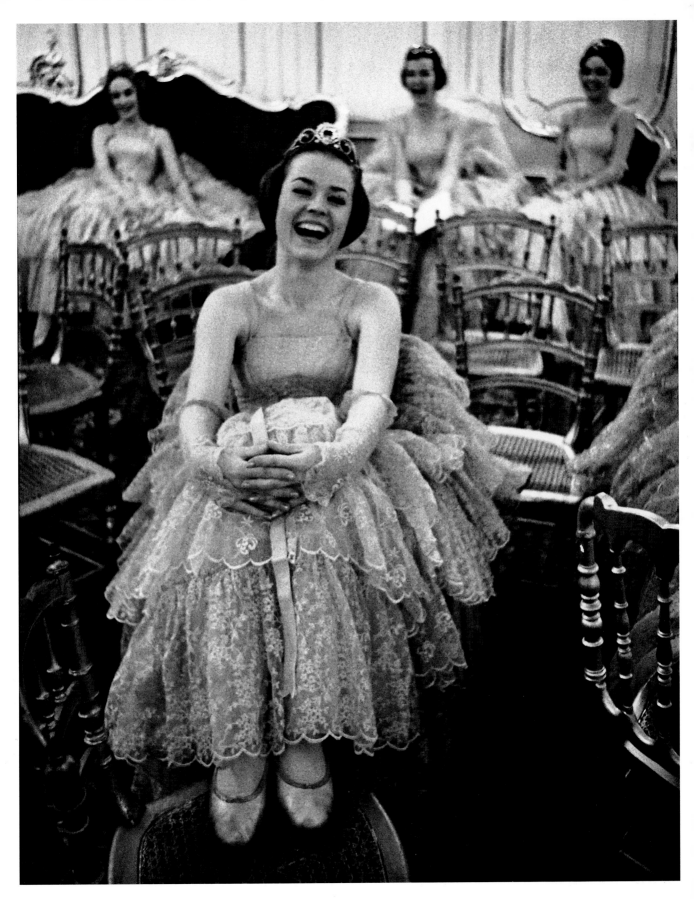

Left: Jackie watches the Lipizzaner stallions perform. The American first lady kept her fashion show going, amid the more sedate clothing of her hosts, and there was every indication that both the Austrians and Russians loved it. Jackie's Social Secretary Letitia Baldridge, wearing a hat, sits in the center of the back row.

Godfather
London

On his return from Vienna, President Kennedy stopped off in London, ostensibly to play the role of godfather at the christening of a new niece, Anna Christina Radziwill, daughter of sister-in-law Lee. Kennedy liked London. If Ireland was his ancestral home, then England was his adult neighborhood.

His favorite book was Lord David Cecil's *Melbourne*, the story of William Lamb, prime minister to Queen Victoria. It was a romantic saga of young men and women at the height of the British Empire, serving their queen in Parliament, in the army, and in diplomatic circles all over the globe with great courage and brilliance. But at home and on their country estates, their passions ran free—and no one told. It was, perhaps, a hint of the life Kennedy envisioned for himself.

Jack had been in England before World War II when his father was U.S. ambassador to the Court of St. James. He saw the war coming and had helped his father minister to American citizens caught when a German U-boat sank the *Athenia*. Jack's Harvard thesis on the gathering war clouds was turned into a best-selling book, *Why England Slept*.

The other reasons for Jack's pause in his global journey was that he was sick and he was exhausted. His back had been injured in a tree-planting ceremony in Canada before the trip and it ached throughout the journey, despite the best efforts of doctors and Navy corpsmen who treated it with massage and hot packs. The president needed a rest, as well as time to think about the future. Before he left Vienna, Khrushchev had grown dark and dangerous, calling West Berlin "a bone in my throat" that he intended to remove.

The rough nature of the summit had begun to leak out. Kennedy wanted to prepare answers to the questions that would surely greet him back on U.S. soil. But meantime, there was one of those family rituals that so often mixed with official business. At his sister-in-law's home at 4 Buckingham Place, President Kennedy slipped briefly into his other personality, the one from long ago when friends were in the top brackets of wealth and position and the struggles of those below were largely out of earshot. He mingled with actor Douglas Fairbanks Jr., long-time friend of the family; Randolph Churchill, the alcoholic son of Winston; and Hugh and Lady Antonia Fraser, the author. But those watching found Kennedy restless and not always attentive to the baptism ceremony.

Photographer Jacques Lowe found freedom in this short stop. He had been restricted by harsh authorities in Paris and Vienna and herded with the huge press crowd. Now he was with Jack and Jackie and soft-spoken friends, his lenses unfettered. He worked sprite-like in the Radziwill's elegant London quarters.

Jacques focused on everything inside and outside the private events: the famous people, the street crowds that assembled when they learned the young president was in town, even the White House press corps pleading with Press Secretary Pierre Salinger for more access and insight into what had transpired in Vienna.

Jacques's time with Kennedy was nearing an end. The president was hemmed in by world events and could not be the exclusive subject for an inside photographer. Others demanded some of the same access and Kennedy granted it. Jacques adjusted to the new reality, choosing to move beyond the White House although ready to answer any calls from the family. But they grew less frequent as Kennedy was buffeted and consumed by a troubled world.

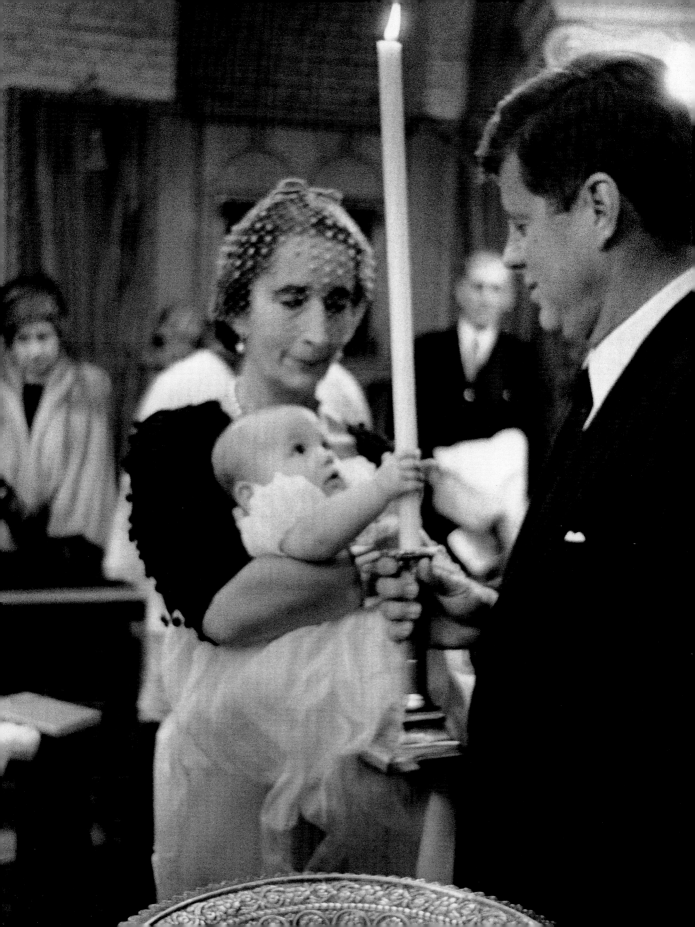

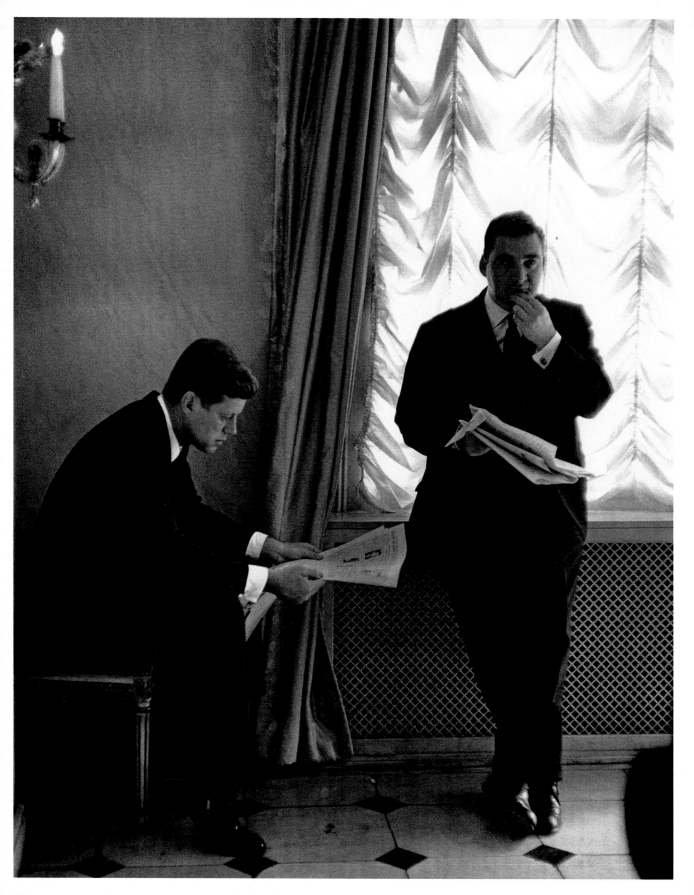

Previous page: President Kennedy stops briefly in London following the Vienna Summit to serve as godfather to Anna Christina Radziwill, the infant daughter of sister-in-law Lee. The godmother is Countess Christina Radziwill Potocka, the baby's aunt.

Left: After the christening, Lee and Stanislas Radziwill host a reception in their home at 4 Buckingham Place. A restless and preoccupied Jack slides away from the festivities for a minute to discuss news reports of the summit, many of them unfavorable, with Press Secretary Pierre Salinger. *Right:* Salinger briefs American reporters who were following the president. While in London, Kennedy also called on Prime Minister Harold Macmillan to report on the summit and dined with Queen Elizabeth.

Jack and Jackie
acknowledge the
cheers of well wishers
assembled on the street
outside the Radziwill
home. Jackie had
decreed the christening
private, and Jacques
ended up as the only
photographer at the event.
Other photographers
covering the White House
protested loudly to
Salinger, but Jackie
would not bend.

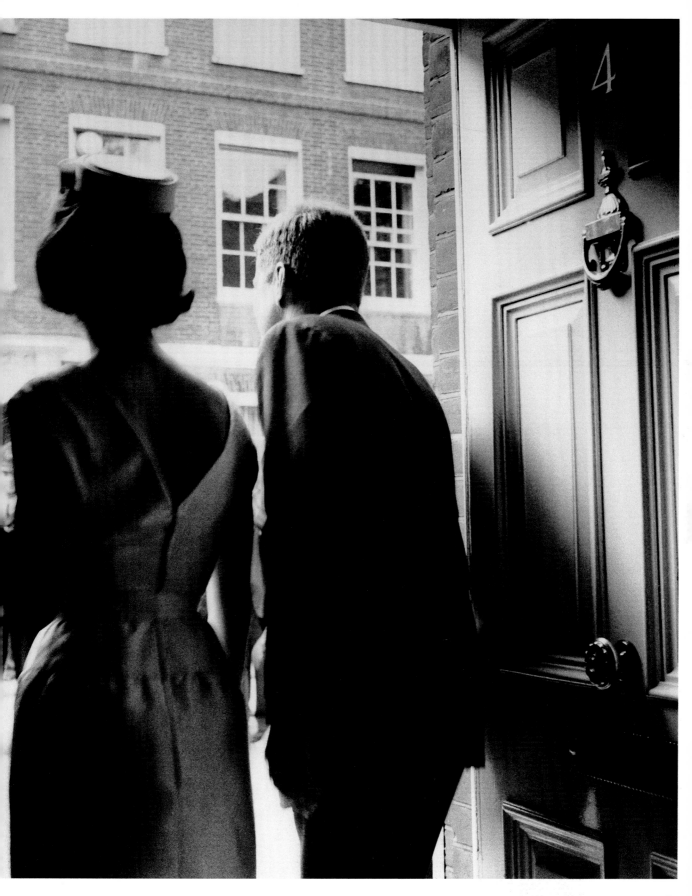

The most powerful
man in the world calms
himself and takes part
in a simple human ritual
of blessing. Many who
watched later marveled
at how easily Jack Kennedy
could move from a rough
confrontation with Nikita
Khrushchev one day
to assisting at a baby's
baptism the next.

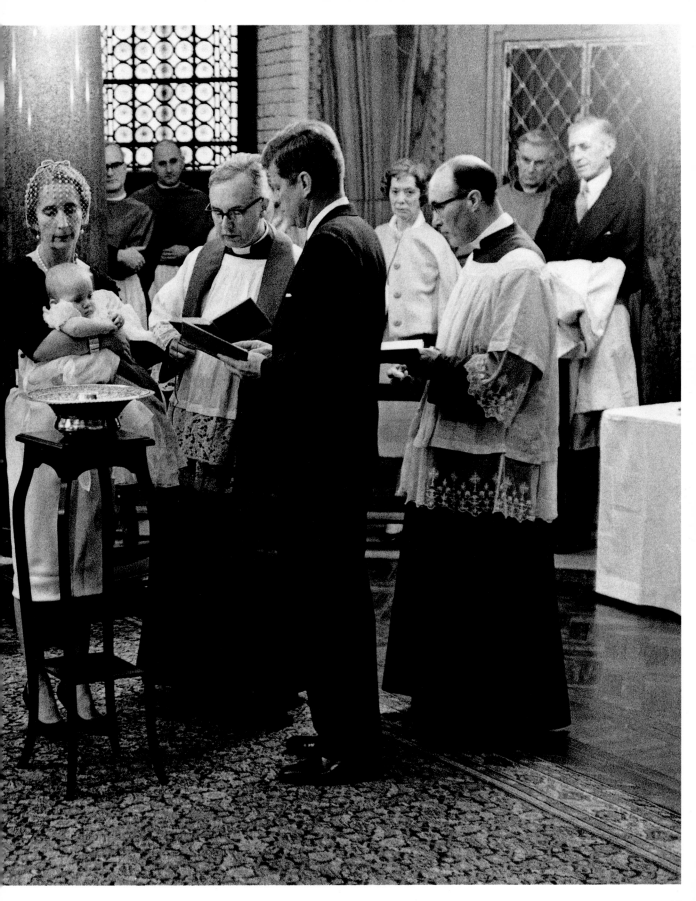

403

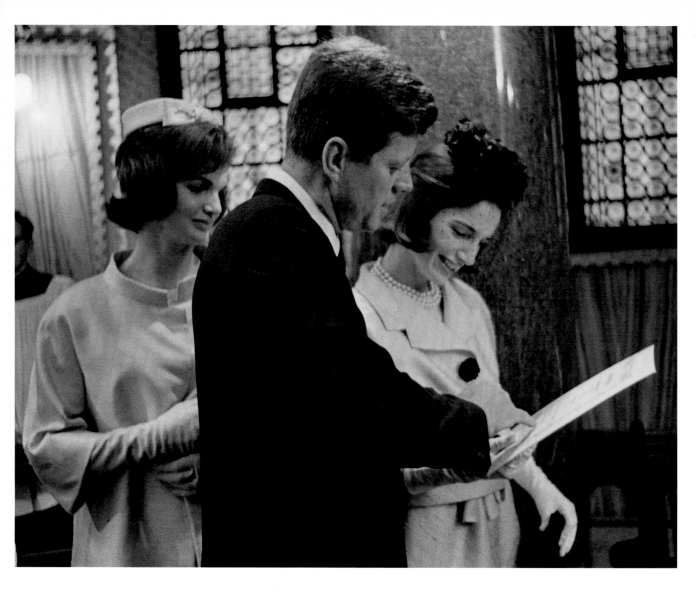

Above: Jack looks over
the baptismal certificate
with Jackie and Lee.
Right: The godfather
casts a watchful eye on
his niece, Anna Christina,
who by all accounts
behaved well.

404

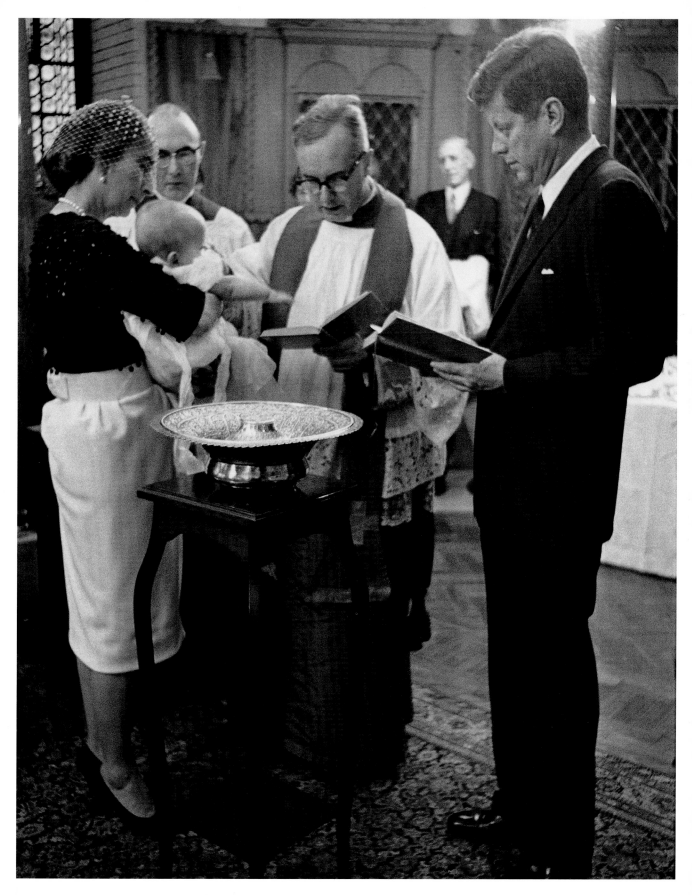

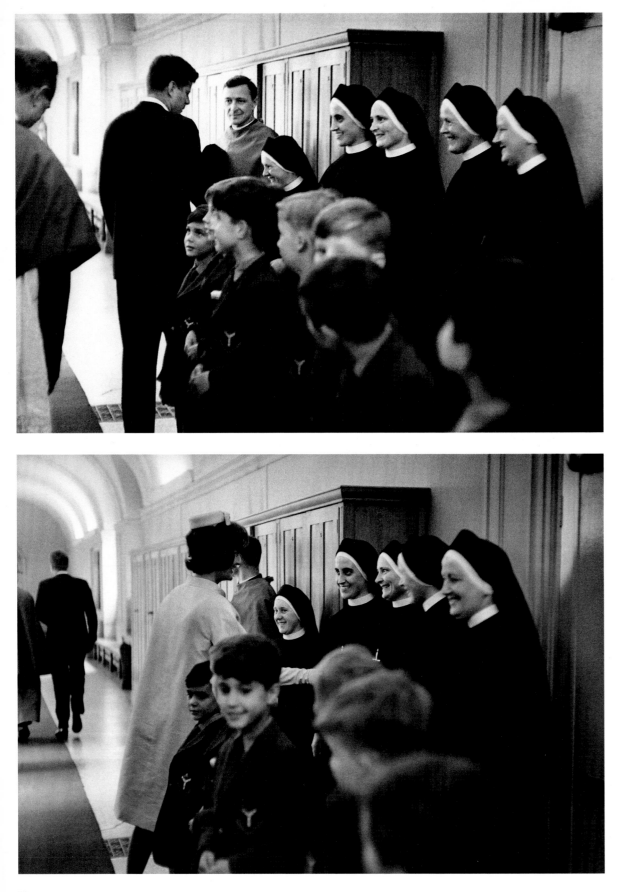

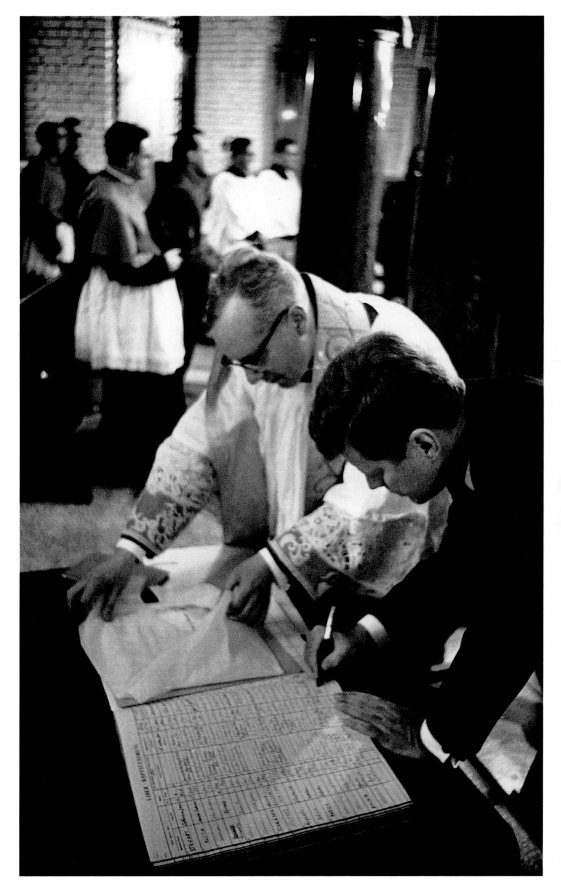

Left: Almost everywhere the Catholic president and first lady paused in their travels, groups of nuns seemed to magically appear— always delighted to be greeted by the Kennedys. *Right:* Jack signs baptismal documents at Roman Catholic Westminster Cathedral.

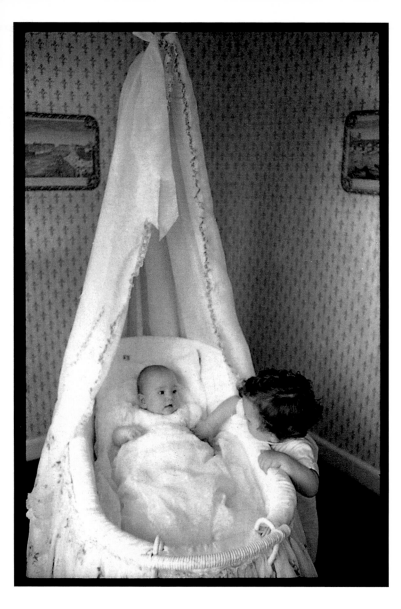

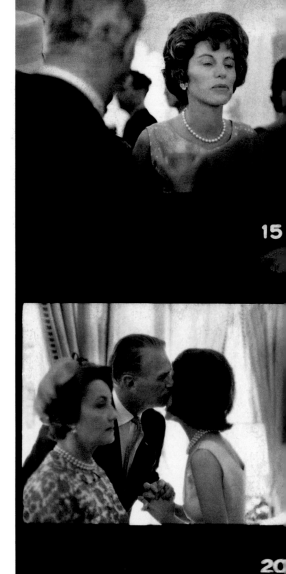

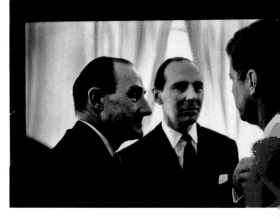

Above: Anthony Radziwill
sneaks a peek at his
newly christened sister.
Right: Guests at the
reception in the Radziwill
home include Prime Minister
Harold Macmillan, in the top
frames of Jacques's contact
sheet. Jack's friends,
among them newspaper
columnist Joe Alsop and
David Ormsby-Gore, also
were in attendance.

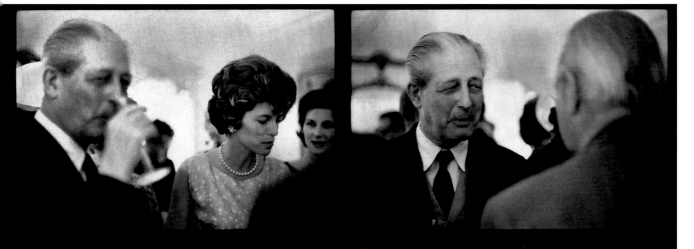

16

17

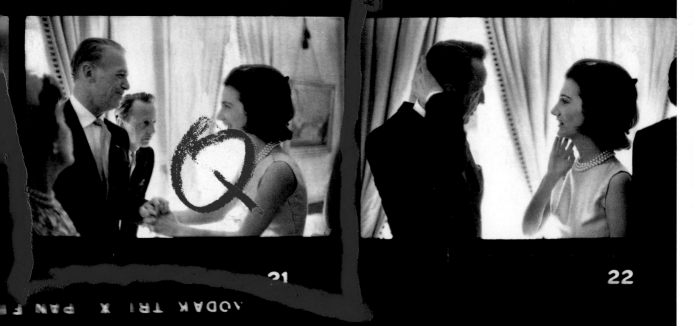

21

22

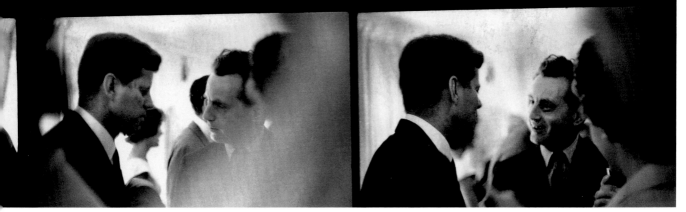

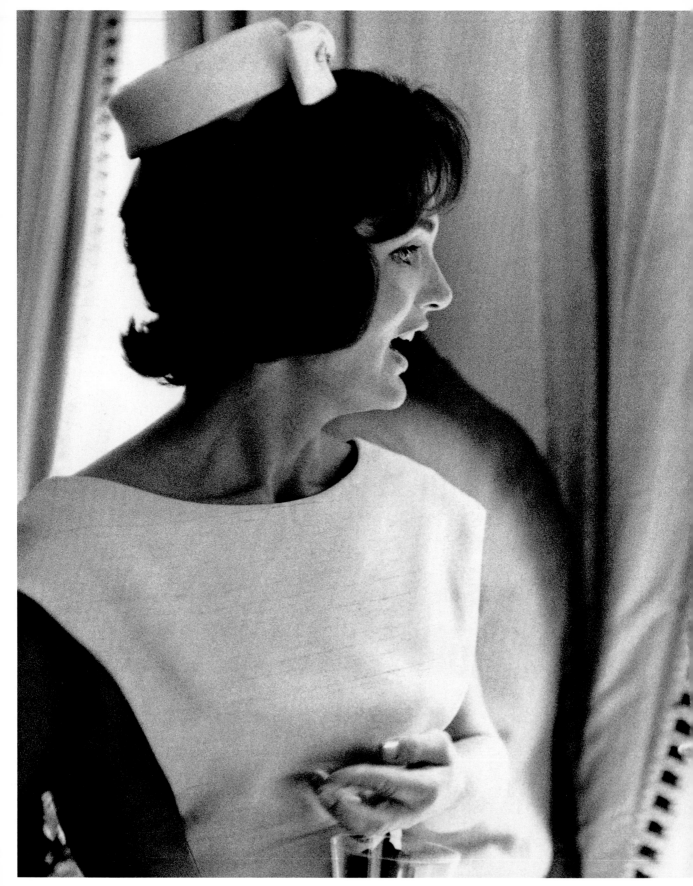

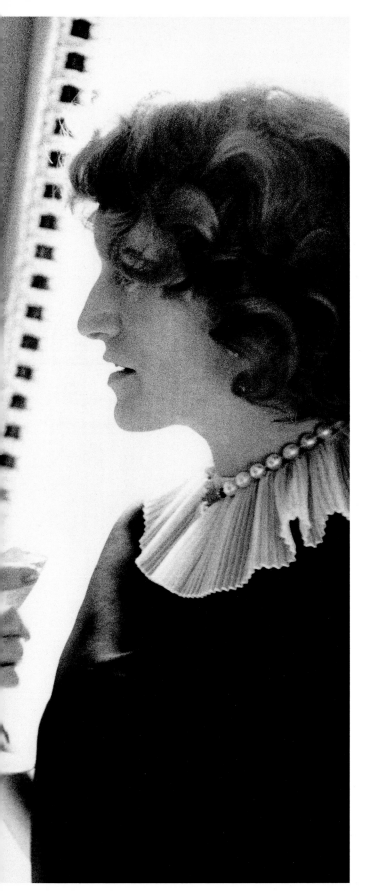

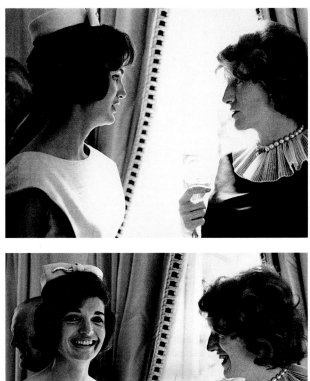

Jackie chats with Lady
Elizabeth Cavendish, who
Jacques described as
"the cream of British
society." Also at the
christening party were
Douglas Fairbanks Jr.,
Randolph Churchill, Hugh
and Lady Antonia Fraser,
and the Duke and
Duchess of Devonshire.

411

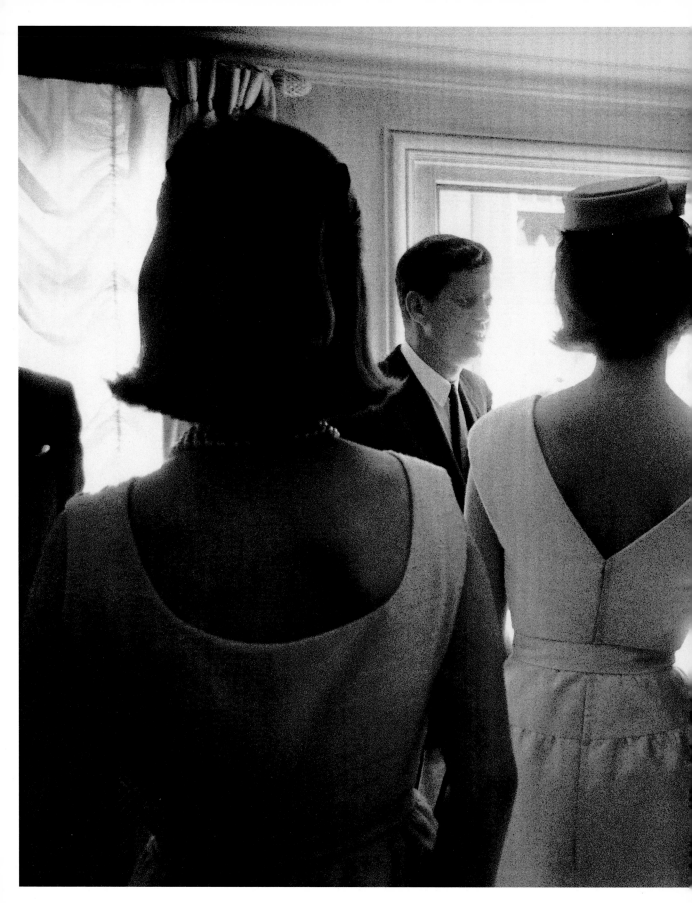

The president and Jackie,
in a pillbox hat, wait with
Lee and her husband
Stanislas, far right,
to greet guests as they
arrive.

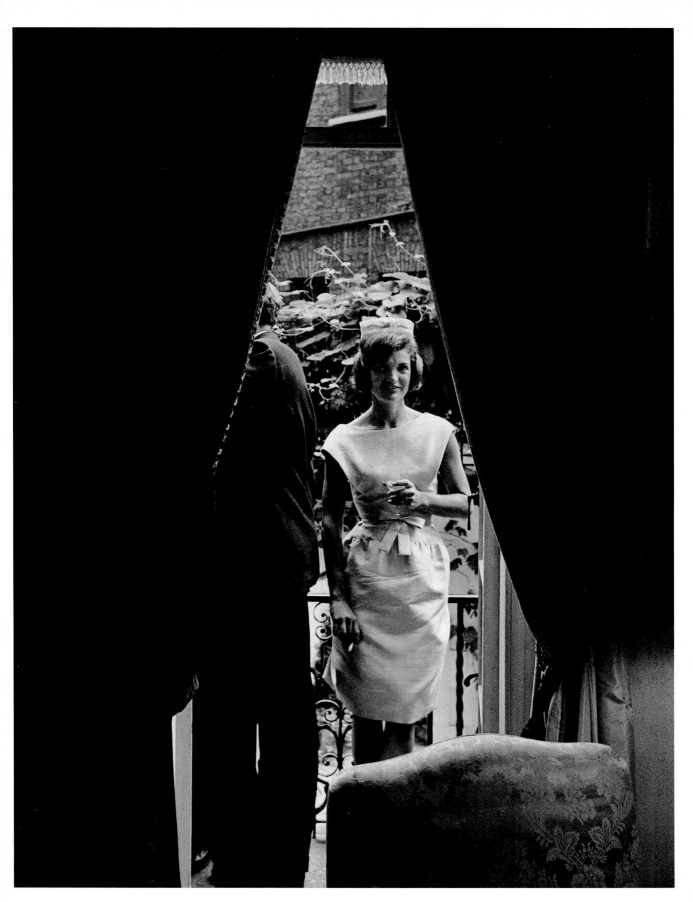

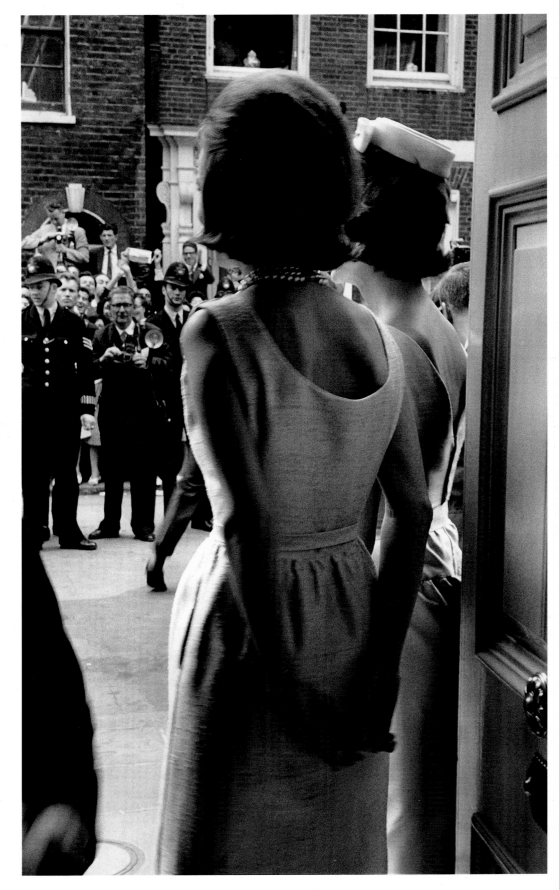

Left: Jackie returns from the garden at her sister's home, still marvelously stylish despite the long journey through Paris and Vienna.
Right: Jackie and Lee take another look at the throngs waiting outside the Radziwill home in hopes of catching sight of the Kennedys.

Funeral

Washington, D.C., and Arlington

Washington and the nation were gripped by grief when John F. Kennedy was buried on a melancholy hillside at Arlington National Cemetery surrounded, as he had wished, by others who had honorably served the country. Like him, many of them had died before their time.

Jackie wanted the services to be simple and yet to have echoes from the most profound moments of American history. Kennedy's shattered body rested in the White House on the catafalque that had been used for Abraham Lincoln. When Kennedy was taken down Pennsylvania Avenue to lie in state beneath the Capitol dome, it was a response to an ancient national yearning.

Many people came mute and crumpled and stood in line for hours before they shuffled past the casket with troubled looks or with heads cast down on their rosary beads. The mourners mouthed quiet prayers for Kennedy and his family, for the United States, for the city of Dallas, and for humankind.

Jacques Lowe heard the news of Kennedy's assassination in New York, where he had moved after he edged out of the White House orbit but not beyond Kennedy's claim on his heart. He was walking along 28th Street when he suddenly noticed the city around him had halted. Stricken clots of people stood beside parked cars with radios on. Jacques stopped to ask what had happened. "The president has been shot," a man answered. Jacques was uncomprehending. "What president?" he asked. "President Kennedy," the man replied. Jacques started running toward his home.

Jacques returned to Washington for the president's funeral, but the experience was strange and incomplete for him. There was no inside access. There was no inside. A stranger held the presidency and would soon take over the White House. The Kennedy clan would disperse and Washington would be the provenance of Lyndon B. Johnson.

What Jacques could do on that day of cosmic grief was take a few pictures of the funeral procession with the Kennedy family members at the center. What was left of a youthful legend would take root in those hours and grow with each new generation of Americans.

He walked beside the veiled and grieving Jackie from the White House to St. Matthew's Cathedral. It was a strange and silent march, through an unattractive section of downtown Washington. Jacques's cameras focused on the phalanx of Kennedys that led the somber procession, followed by dignitaries from around the world. Imperious Charles de Gaulle astonished—and gratified—everyone with his presence.

Jacques snapped pictures of three Kennedys he had photographed so often before, but in joyous times: Jackie, Ted, and Bobby, now almost gaunt from their ordeal, their energy supplanted by grief. There was still disbelief, as if everyone might suddenly wake and the nightmare end.

Then it was over. Jacques took one last picture of Jack Kennedy's burnished casket reflecting a setting sun. High above, Air Force One flew mournfully in a farewell salute. Jacques surely felt a tug, a reminder of how it had been in those years when the roar of that plane's motors was a summons to new adventure.

When Bobby was assassinated in 1968, Jacques fled to Europe and remained there for eighteen years. When he came back, the hurt still present, he started afresh his books of photographs and exhibits chronicling his time in Camelot. We add to it with this volume, which itself emerges from another tragedy. We do it because in Jacques Lowe's pictures lies a shining moment of our history—and his.

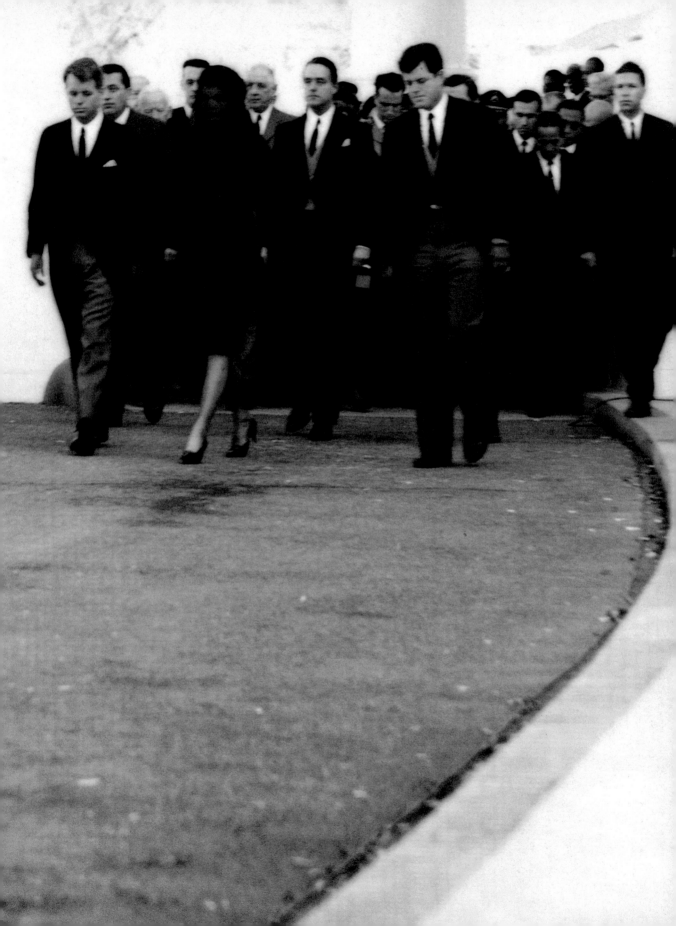

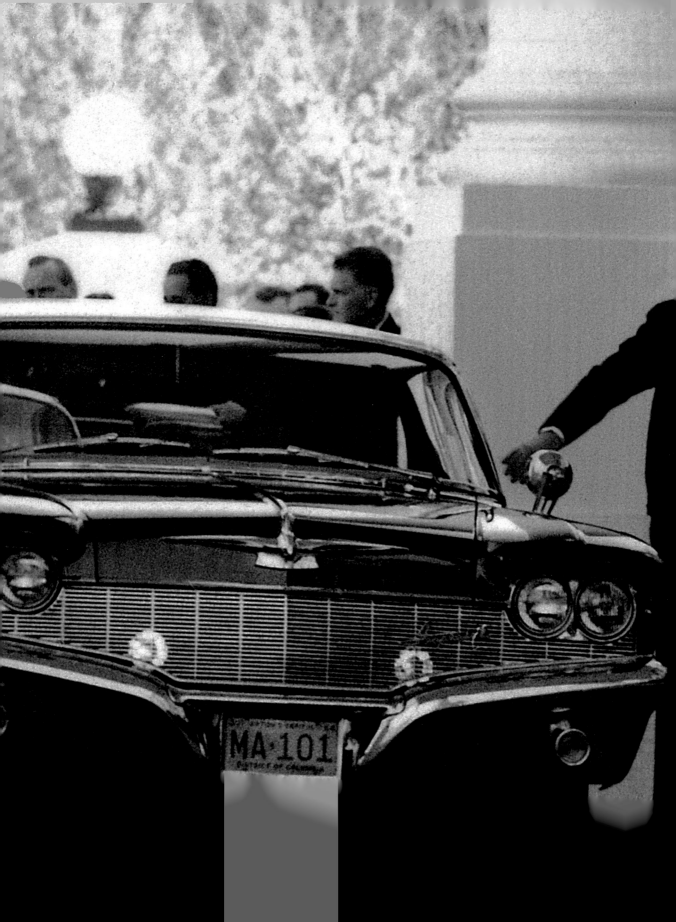

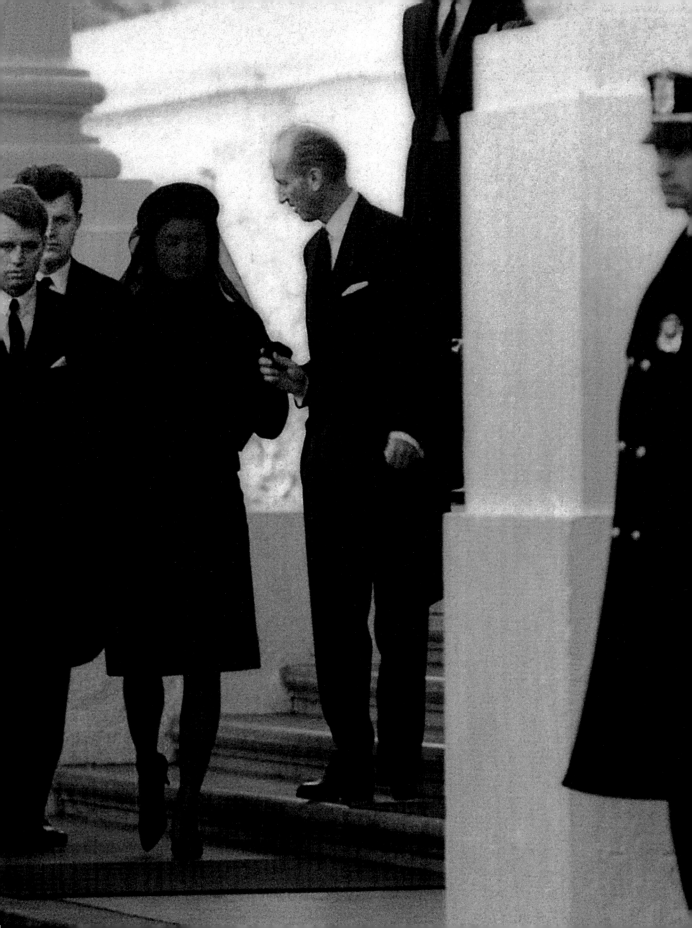

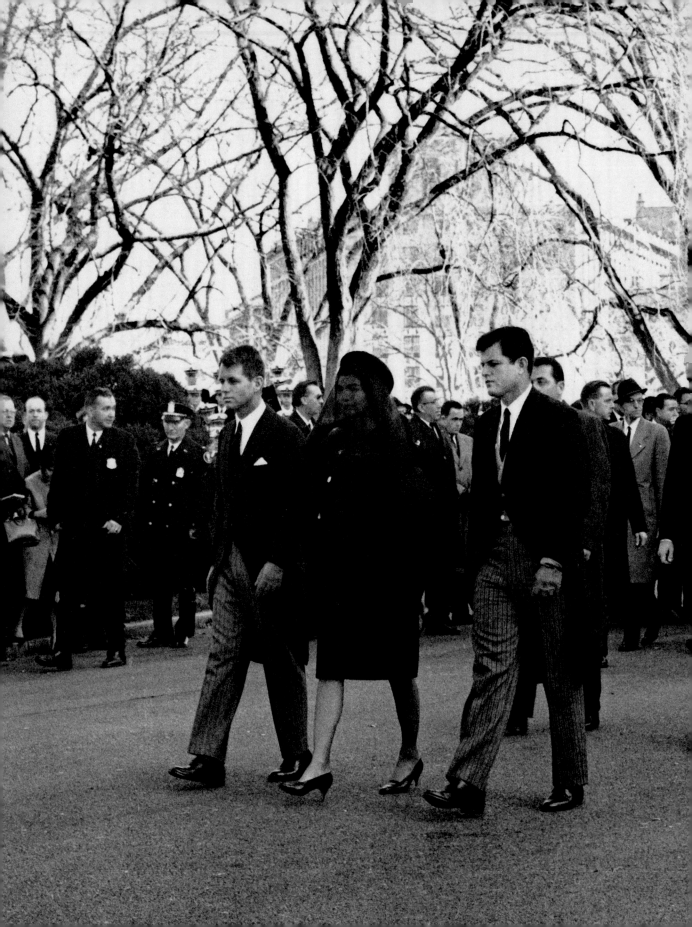

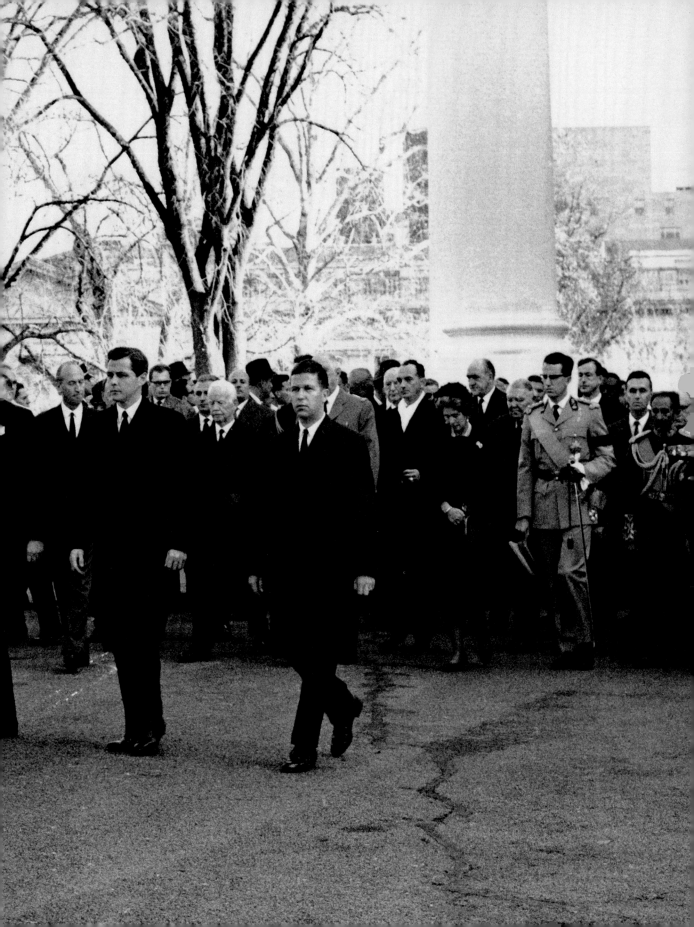

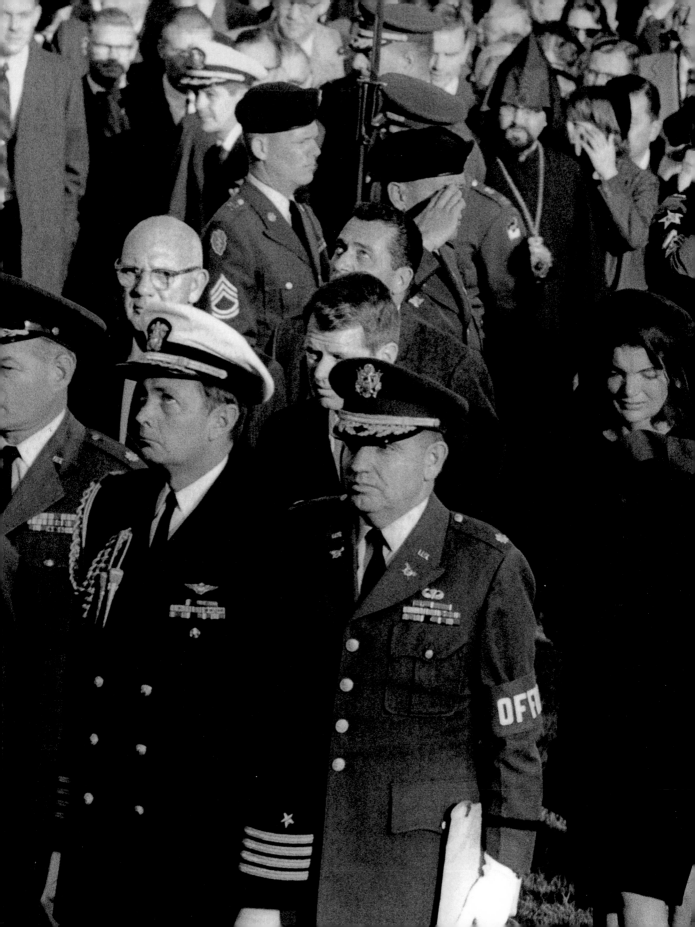

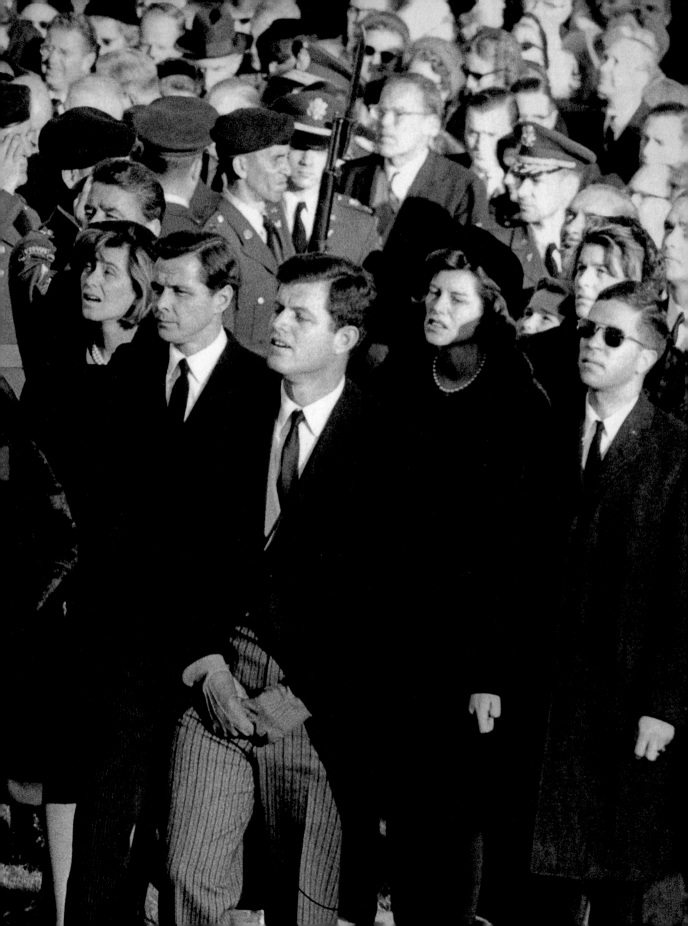

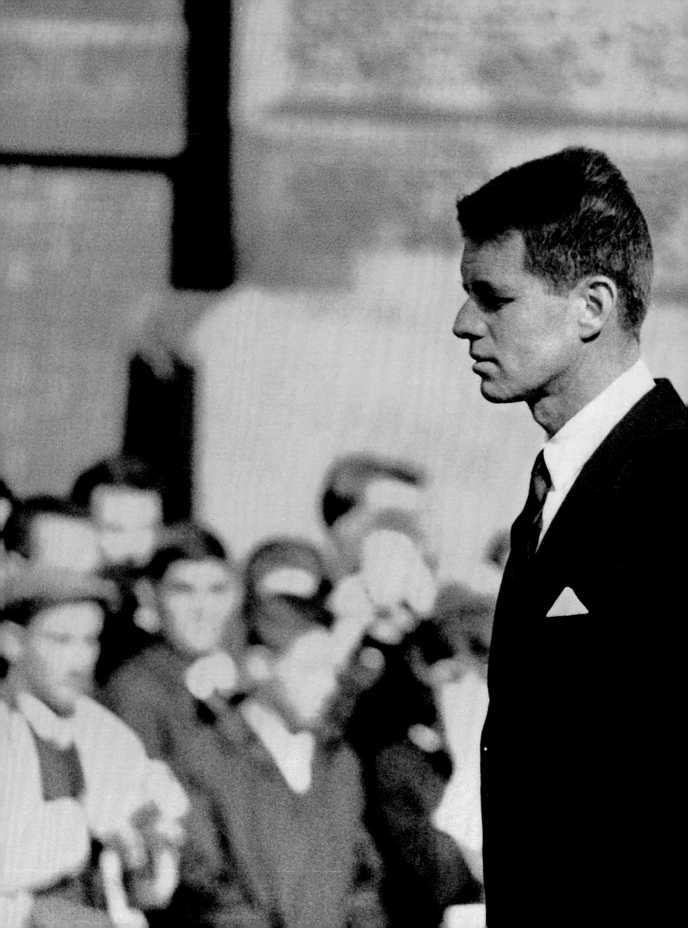

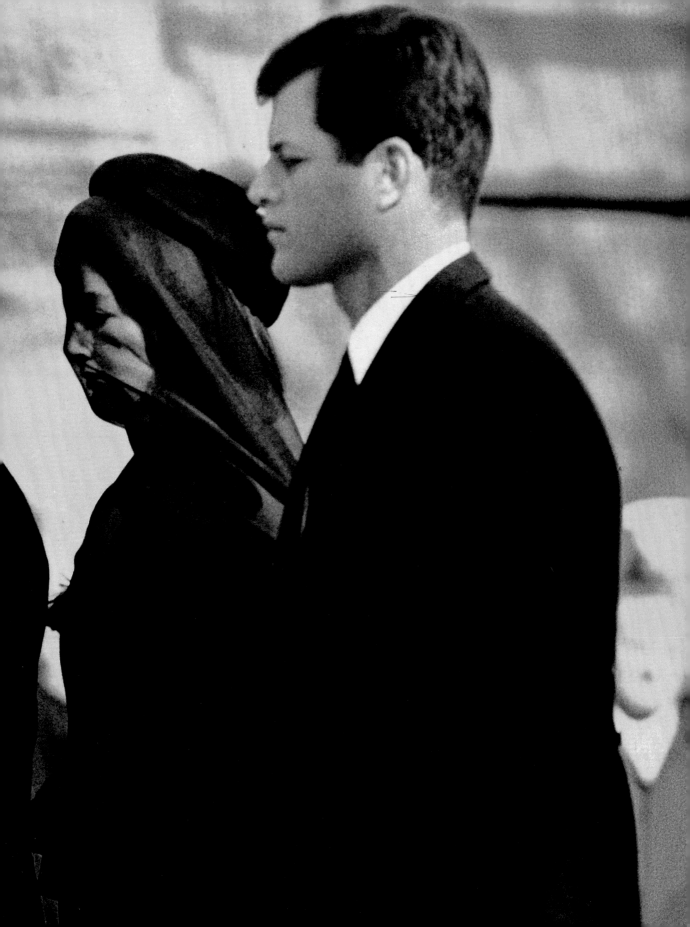

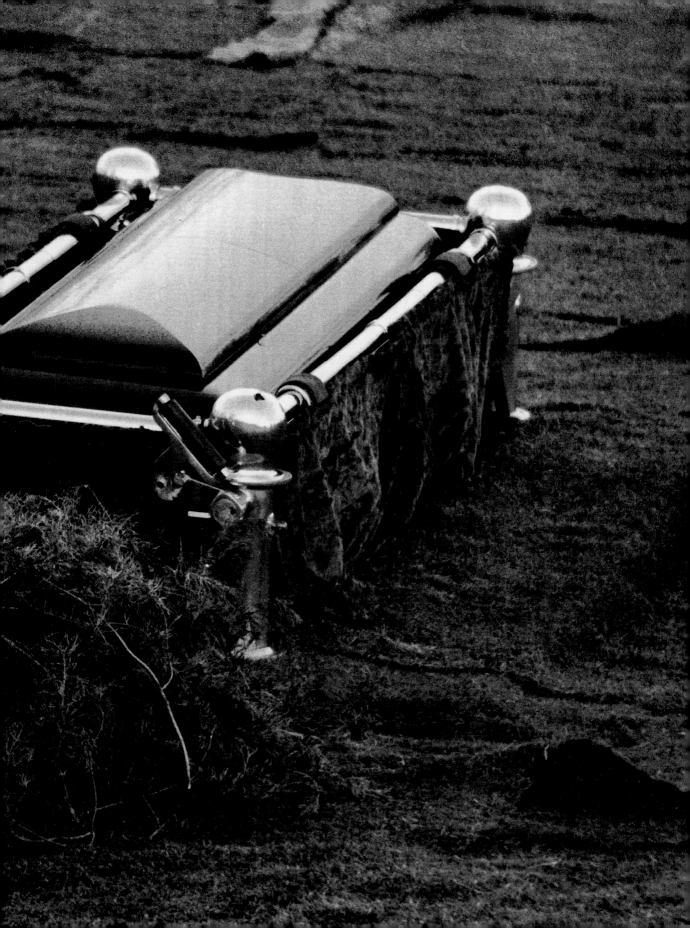

Farewell
Tom Wolfe

© ESTATE OF JACQUES LOWE

Author's photograph
by Jacques Lowe for
Tom Wolfe's most recent
novel, *A Man in Full*.

*Remarks delivered at an October 9, 2001,
memorial service at St. Peter's Church in New York,
after a film tribute to Jacques Lowe.*

Jacques was such a presence. You have to see those glasses
pushed up on his forehead, and you have to see the pipe—you
don't see many pipes any more—and you have to hear that
laugh. Who can forget it?

And that voice. In a way, we were very fortunate that
Jacques Lowe didn't come here until he was 18, because he
always had that voice that we Americans are pushovers for:
the Cultivated European. He learned English from the movies
and from the *New York Daily News* and the *New York Daily
Mirror.* And he still sounded like the Cultivated European.

Clay Felker, who was editor of *New York* magazine, brought
Jacques and me together. I don't know why exactly we hit it
off so well. Our backgrounds couldn't have been more
different. I grew up in a very tranquil environment in
Richmond, Virginia. Jacques grew up in Europe in one of the
most turbulent periods of that region's history. But we were
exactly the same age and in the same business, and we did
a lot of stories together as a photographer-and-reporter team.
For whatever reason, we got along famously.

And then, of course, came the terrible day of Jack
Kennedy's death. Jacques was really stricken. No other
photographer was as close to President Kennedy and his
family. They loved his work and they loved him, as we
all did. If he had ever wanted to be the official White House
photographer, I'm sure the job would have been his. But that
would have been too confining for a man of Jacques's
gargantuan energy. Nevertheless, he and his camera were
privy to very private and important moments in Kennedy's
brief but exciting reign.

The day after the assassination, I happened to be at
Jacques's studio on Sixth Avenue. It was a loft studio and
I will always remember he was the first person I ever met who
had wall-to-wall sisal carpeting, which became all the rage
about 10 years later. Jacques was always "in." We were at
Jacques's studio and we heard this voice, "Jacques! Jacques!
Where are the pictures?"

It was Clay Felker. The rest of us were still in a state of
shock, but Clay is the ultimate journalist. Jacques said, "What
pictures, Clay? What are you talking about?" And Clay said,
"The ones of Lyndon Johnson, of Jack and Bobby in the hotel
room persuading Lyndon Johnson to run for vice president!"

Clay was already looking ahead to the next president.
Jacques had that picture. It was a truly historic picture.
It captured a real turning point in history, because Lyndon
Johnson's acceptance of that invitation at that moment in that
hotel room was one of the major things that helped Jack
Kennedy be elected. And Jacques was there.

In my life, Jacques has a tremendous amount to do with
the fact that—and this did me so much good—I became
known as "the man in the white suit." My first book was
coming out. It was a collection of magazine articles, and

I needed a picture for the dust jacket. Of course, I went to Jacques.

Jacques knew me so well. He knew that I had three suits in the world. I was making $130 a week. I had a dark gray suit. I had a light brown suit. And I had a white suit that I bought in a shop because I was hired at the *Herald Tribune* in the summertime, and a white suit in the summertime wasn't that rare where I grew up. But it was the heaviest of all three suits, and I had started wearing that white suit in the winter to the great consternation of many people.

Jacques said: "Could you bring that white suit to the studio? And we'll take pictures for your book." So Jacques took the picture. It was a remarkable picture. It had me in a white suit sitting on a school desk, and it was re-printed so widely that, in many people's eyes, for better or worse, I was a real character, the guy who wore white suits all year round.

The image that photo created saved me a lot of trouble, because when I was interviewed after my first book came out, I didn't have to say anything interesting. After the interviews, they'd say, "Oh, what an interesting guy! He wears white suits in the dead of winter." It was all because of Jacques Lowe's picture. He had put me on the map.

Jacques had his studio on Sixth Avenue, but he and Brenda were living at 54 East 58th Street. Right now, that's the back entrance to the Four Seasons Hotel. It must have been a fabulous townhouse at one time. Jacques had the fourth floor, which consisted of two great big rooms. He and Brenda invited me over many times and those evenings with both of them were absolute magic. Just try to think of Jacques—Jacques is young and he has that laugh and that presence and he serves that Alsatian red wine. I just couldn't forget those evenings.

Those evenings were so great that when Jacques said, "I'm moving, would you like the apartment?" I had to snap it up. Also, the rent was $212 a month. So I moved in.

Just before I moved, I said to Jacques: "This building has a problem. The front door is always open." On the second floor was a hairdressing establishment; so they couldn't keep the front door to the building closed. I told Jacques that it posed a security risk.

"That's true," Jacques agreed. "But I'll tell you what I do. If you'll notice, the door to this apartment is so bad, there's a two-inch space between the bottom of the door and the floor. What I do is get a pair of boots and I put them in front of the door and I put the light on and the radio on and when the burglars come up the stairs, they see a light on under the door and they see these two feet and hear the radio, and they go on to someone else." And so that's what I did. I was there for almost three years and there was never a break-in—not one. All the rest of New York was being ravaged, but that place was never touched.

Still, once Jacques and Brenda were gone from the apartment, something was wrong. What I saw there was a dump. The floors were sloping, the woodwork was battered, there was a kind of make-believe bathroom and a make-believe bedroom, a kitchen that was no bigger than this podium. There were a lot of things wrong. What had happened to the magic? The magic had left.

Just before I finally departed that apartment myself, I needed Jacques again to do the cover of another book, *The Electric Kool-Aid Acid Test*, which was the first long book I had written. So Jacques came over to the apartment and I said, "Jacques, I don't know what to do. The woodwork is battered. The floor is in splinters." And there were these steam risers—these pipes with asbestos peeling off them. He shook his head as if to say, "You poor devil."

"Bring me some sheets, some white sheets," Jacques ordered. So I brought him some white sheets. He put one on the floor. He put one of them here, he put one there. He took a picture of me, and he used the asbestos-covered pipe like some carefully thought-out design element on the right-hand side of the photograph.

He had turned that poor hovel into the kind of all-white apartment that people died for in those days.

Jacques had a very stern side, and if he was unhappy, you heard about that, too. He was a man of great emotions. With the death of Martin Luther King Jr. and the death of Robert Kennedy, following the death of Jack Kennedy, Jacques was very angry. He was also very disheartened. So he went to Europe.

When he finally returned, he moved into a loft studio on Duane Street with this enormous, marvelous north window. That was before the area was called Tribeca.

Tribeca grew up around Jacques Lowe. In came actor Robert De Niro. In came the movie business. In came chef Daniel Bouley. In came Nobu restaurant and all the rest of Tribeca. As I was saying, Jacques was always first.

It was after Jacques's return that my family and I had the great fortune of meeting his daughter, Thomasina, and learning just how much Jacques loved his five children. I'll tell you how much Jacques loved his children: Jacques took Thomasina to Club Med. You have to realize Jacques, the Cultivated European, had not been born and bred for Club Med, where total strangers greet others all day long by first name—"Hi, Jacques!"—which you have to wear stuck onto your shirtfront in big letters.

It was during this period that Jacques became one of the leading American portrait artists, on par with Arnold Newman, his mentor, on par with Irving Penn and all the other greats. Jacques was a genius in the use of light and shadow, particularly in that north-facing studio, and I had the good fortune of having known Jacques so long that he would still do my book covers. He did the cover for *A Man in Full*. He did the cover for *Hooking Up*, which came out last year.

My fondest memory of all is when Jacques invited my wife Sheila, myself, and our two children to his studio. He had been to our house and he had seen Sheila and me in checks—I had on a checked suit and she had on a checked suit, just by coincidence. He asked, "Does your daughter

Left: Jacques Lowe's author photo of Tom Wolfe for his first book, *The Kandy-Kolored Tangerine-Flake Streamline Baby.* *Right:* Portrait of Jacques Lowe taken for the jacket of his book *JFK Remembered.*

have checked clothes?" I said, "She has a checked skirt." Tommy, our son, who was only three, had a checked jumper. So Jacques had us all come down and have our pictures taken in his studio. We have that portrait in our living room right now and we refer to it as "The Czech Family." It's a great picture.

By now, Jacques is getting older and beginning to have trouble walking. Nevertheless, at the age of 63—and I know what it's like to be 63, it's not as bad as being 71, but you're getting along—he went to Somalia. At that time, in 1993, it was the most dangerous place in the world. But Jacques was such a journalist, such a great photojournalist, that didn't stop him for one second.

In 1999, just before he went into a serious illness and at a time he couldn't get around very easily—Jacques was 69 years old and on his own—he went to Cameroon for a project that was going to embrace a lot of African countries. He was interested in Africans, African music, African flora and fauna, and all sorts of other things. Jacques arrived at the airport just after a busload of tourists had gone away from the airport, into the interior a little bit. These tourists were coming back now and were dressed only in their underwear. Bandits had taken everything else they had.

Jacques told me that he was furious when he landed. A 17-year-old extracted a landing fee from him—with an AK-47. And I asked, "Well, Jacques, weren't you terrified?" Jacques gave me the same look that Chuck Yeager once gave me when I asked him if he had been fearful before he flew the X-1, the rocket airplane in which he became the first man to break the sound barrier. It was a look of incomprehension of the irrelevant.

On an Indian summer day, like today, I had my last meal with Jacques. It was across the street from his studio, in a restaurant called City Hall. It was an outdoor café. Duane Street during daylight hours at that time—in fact, until September 11—was wonderfully serene, so Jacques and I sat in the sun. By this time, Jacques was having extreme difficulty walking. It was very hard for him to even walk across Duane Street to the restaurant.

We sat down and I said, "Jacques, I'll have to go soon. I can't be here more than about 45 minutes. I have an appointment." We started talking about our lives, remembering so many things. Almost 45 minutes had passed—so I took out my cell phone and I called and broke that appointment. We kept talking.

That was a truly sublime moment, going over with an old friend, a dear friend, a great friend, the memories of our lives, on a beautiful New York day out in the sunshine. I finally did leave for a later appointment. I wish I hadn't done that. I wish I could have stayed to experience every last possible minute. Because I was with a great, great friend who only incidentally happened to be a great artist, a great and courageous journalist, and a man who lived and suffered and thrived against great odds. He has left that legacy to his children, Jamie, Victoria, Sacha, Thomasina, Kristina.

I cherish that last meal. I cherish every minute of Jacques.

© BOB ADELMAN

Acknowledgments

It took the work of many minds, hearts, and hands to make our tribute to an idealistic photographer and his great subject. To begin the book required the blessing of the Estate of Jacques Lowe—his children Jamie, Victoria, Sacha, Kristina, and particularly Thomasina. At a difficult time, with the support of Hugo Fleischmann, Thomasina Lowe gave her full cooperation at every turn and, especially, in opening the remains of the photo archive, a national treasure. Her melancholy tale of the lost negatives is painful and memorable.

Michael Rand, photo editor and art director extraordinaire, lent his sophisticated European eyes and intelligence to weaving a deeply affecting tale by canny selections from innumerable, disparate images. We owe the elegance of the book to the talents of graphic designer Adam Brown. Jacques was fortunate to have every photographer's dream agent for his own, Woodfin Camp. Woody, with the able help of Jacques's assistant and studio manager, Michelle Wild, located and dated important photos at any time of day or night. They imparted crucial knowledge of their friend's working methods and landmark photographs. John Loengard, the Dom Perignon of photo editors, discovered many of the previously unseen surprises in the contact sheets. Developments in computer scanning made the enlargement of Jacques's contact-sheet images possible, and Colleen Clear at Quad Graphics sensitively and carefully revived nearly lost images.

Jacques's photographs sparked the dean of White House correspondents, Hugh Sidey, to reach back into his memories. A reporter's reporter, he was constantly checking with his extraordinary sources to clarify complexities and confirm facts. His evocative writing, rich with insider detail, matches the photographs in intimacy and affection for Jack. Tom Wolfe and Robert F. Kennedy Jr. generously offered their eulogies celebrating Jacques's historic achievements as a photographer and voiced for many the painful personal loss of a dear friend.

Armed with dictionaries and style manuals, Mary Dempsey imperturbably and seamlessly wrangled text from a number of sources into a coherent whole. Media maven Judy Twersky, Jacques's friend and spokesperson, cheerfully shared her storehouse of invaluable information about his life and work. Like a modern-day town crier, Matthew Ballast has ingeniously and persuasively spread the word so thoroughly that anyone who watches, reads, or listens to media knows of our book.

Photography's champion and our editor, Michael Sand, instantly embraced the project in its infancy. As the book developed, many of his insightful suggestions were incorporated, and his enthusiasm and support were unstinting.

Many books are issued, but Jill Cohen has assuredly published *Remembering Jack* with great panache.

Bob Adelman
Miami Beach

Photo Consultant and Researcher: Woodfin Camp
Copyeditor: Mary Dempsey
Research: Judy Twersky
Jacques Lowe Studio Manager: Michelle Wild